Medical Art Therapy with Adults

Medical Art Therapy with Adults

Edited by Cathy A. Malchiodi

Foreword by Richard A. Lippin

Jessica Kingsley Publishers
London and Philadelphia

Chapter 3 reprinted with permission from the American Art Therapy Association, Inc. Originally published in *Art Therapy: Journal of the American Art Therapy Association* 14 (2), 1997. All rights reserved. Figure 8.14 on p.205 reproduced with the kind permission of the Wellcome Institute Library, London.

First published in the United Kingdom in 1999
by Jessica Kingsley Publishers
116 Pentonville Road
London N1 9JB, UK
and
400 Market Street, Suite 400
Philadelphia, PA 19106, USA

www.jkp.com

Copyright © 1999 The contributors and the publisher
Printed digitally since 2008

Library of Congress Cataloging in Publication Data
A CIP catalog record for this book is available from the Library of Congress

British Library Cataloguing in Publication Data
Medical art therapy with adults
1. Art therapy
I. Malchiodi, Cathy
615.8'5156

ISBN 978 1 85302 679 9

Contents

FOREWORD BY RICHARD A. LIPPIN 9

INTRODUCTION BY CATHY A. MALCHIODI 13

1. The Role of Art Therapy in Post-Stroke Rehabilitation 25
*Judith Wald, Art Therapist, New York Presbyterian Hospital, White Plains;
Assistant Professor Art Therapy, College of New Rochelle, New York*

2. Expanding Treatment Possibilities for
Chronic Pain through the Expressive Arts 43
*Paul M. Camic, Associate Professor and Director Health Psychology Training;
Director Applied Creative Arts, Chicago School Professional Psychology, Chicago*

3. Art Therapy with Laryngectomy Patients 63
*Susan Ainlay Anand, Clinical Instructor, Department of Psychiatry and Human
Behavior, University of Mississippi Medical Center, Jackson; and Vinod K. Anand,
Chief of Otolaryngology, University of Mississippi Medical Center,
Jackson, Mississippi*

4. Dreamwork and Sandtray Therapy
with Mastectomy Patients 87
*Vija B. Lusebrink, Professor Emerita, School of Allied Sciences, University of
Louisville, Kentucky*

5. Coping with Cancer through Image Manipulation 113
*Ellen Urbani Hiltebrand, Art Therapist and Coordinator, Healing Arts; Art
Therapist, Legacy Health System, Portland, Oregon*

6. Enlightenment in Chemical Dependency Treatment Programs:
A Grounded Theory 137
*Holly Feen-Calligan, Coordinator, Art Therapy Program,
Wayne State University*

7. Beyond Words: The Art of Living with AIDS 163
Emily Piccirillo, Art Therapist, Washington, DC

8. Tuberculosis: Art Therapy with Patients in Isolation 189
Irene Rosner David, Director Activity Therapy, Bellevue Hospital Center, New York City; and Shereen Ilusorio, Art Therapist, Bellevue Hospital Center, New York City

9. External Stress: The Impact of Illness
on the Family Structure 211
Shirley Riley, Family Therapist and Clinical Art Therapist, Los Angeles, CA

10. Art Therapy and Cancer: Images of the Hurter and Healer 227
Virginia M. Minar, Art Therapist, Las Vegas, NV

11. Studio-Based Art Therapy for Medically Ill
and Physically Disabled Persons 243
Mary K. McGraw, Clinical Director, Art Studio-Center for Therapy, MetroHealth Medical Center, Cleveland, OH

RESOURCES 263

THE CONTRIBUTORS 265

SUBJECT INDEX 270

AUTHOR INDEX 279

In memory of Ken and Paul

Acknowledgments

I first want to thank the authors whose expertise and commitment made this project a pleasure to envision, shape, structure, edit, polish, and put into its final form. It is a treat for an editor to work with people who are not only excellent writers, but also practicing clinicians who can describe their work with medical populations with authenticity and authority. Without them this book would not be possible.

Thank you to my husband, David Barker, for providing advice on medical literature and most of all, for teaching an artist about science. A special thank you is extended to Rick Lippin, MD, founding President of the International Arts-Medicine Association for writing an inspirational foreword to this book. His seminal work in the field of arts-medicine helped set the stage for the recognition and growth of medical art therapy as a potent modality in health care with patients of all ages. It is truly a privilege that Rick be a part of this volume.

Last, but definitely not least, thank you once again to Jessica Kingsley for recognizing the importance of this book and her staff for making the process of editing, revising, and proofing so seamless and pleasurable.

Foreword

The enterprise of medicine is currently undergoing an extraordinarily painful but necessary transition as both a reflection of and a bellwether for huge shifts in world culture. I and several others have characterized these seismic shifts as a new Renaissance. In a speech I delivered in Israel in 1989, I stated that 'our renaissance had indeed arrived and that its names were holism and humanism and that the arts were both its manifestation and its nourishment'.

While many experts contend that molecular biology and the human genome project are revolutionizing 21st century medicine, I believe rather that medicine's real revolution is being driven by spectacular advances in modern neuroscience and that these advances with all their profound implications will significantly dwarf, if not render almost childlike, the promises of more reductionism. Nor do advances in so-called alternative/complementary medicine reflect a real revolution, in my opinion, unless there is significant inclusion of mind-body or energy medicine. But the current growth and acceptance of alternative/complementary medicine by medical leaders does reflect the public's willingness to embrace or even demand significant changes from current medical practice. In my view of a neuroscience-driven medical revolution, the arts play a major if not central role. All great healers, both historic and contemporary, have intuitively known this but we now have a unique confluence of real world scientific, psychological, social and economic factors that have set the stage for wide acceptance of the full integration of the arts with medicine.

For example, what special characteristics do the arts possess that make them such potent and relevant healing agents for the 21st century? Among them are the capacity for the arts to facilitate self awareness, self discovery and self knowledge – which is increasingly viewed as a cornerstone of mental health. In this regard I believe the arts are without peer. The current

attack on the human potential movement as being self centered and selfish is a naive, dangerous and regressive view.

Furthermore, engaging in the arts provides a re-affirmation of the life force (eros) at a time when the very survival of our species and our home we call planet earth, is increasingly dependent on our conscious individual and collective decision to choose life and health over death and destruction. Furthermore, sometimes I like to say that we are human 'doings' not just human beings. Thus the arts provides a sense of self efficacy or even self mastery, allowing patients to move toward an empowered and mature state away from a dependency and victimhood mentality. Also, the act of creating and sharing art can be immensely pleasurable and I have previously expressed my view that engaging in responsible pleasure is perhaps the single most underutilized source of health in our times. E. B. White said: 'Every morning I awake torn between a desire to save the world and an inclination to savor it. This makes it hard to plan the day.' To which William Schultz, Executive Director of Amnesty International USA, added: 'But if we forget to savor the world, what possible reason do we have for saving it? In a way savoring must come first!'

Finally, in recent years I have come to realize that perhaps the greatest power of the arts is that it provides an opportunity for the creator of art to give the ultimate gift and healing power of love (Diamond 1997, Schwartz and Russek 1997). I recently came to the realization that in our lifetimes we would elucidate a mechanistic basis for Arts-Medicine and that it would be scientifically proven that all healing art forms have an energy – a measurable electric force field which is love.

While the visual arts stand with other art forms such as music, poetry, drama; their special uniqueness lies in my opinion in two distinct areas. Since the visual arts usually involve tangible materials, as both process and product, they are less transient than other art forms such as music. Their state of permanence means that they may more readily serve as heartfelt gifts from one human being to another, to a group of people, or to the world community at large (McNiff 1992). Within these works resides the loving energy of their creators. Also, the visual arts provide image and in many cases tactile experiences (eg., sculpture) and take on increasing importance in world culture as an antidote to the excesses of language and information overload (Shlain 1998). Finally, for the clinician, images produced by patients provide a wealth of diagnostic material unable or unwilling to be expressed through words or other art forms.

The modern creative arts therapy professions have made a significant contribution since their post-World War Two beginnings, especially in mental health settings. But until very recently they have been undervalued by the broader medical profession which has deified technology. And while Western medical technology is nothing less than miraculous, its excesses are beginning to bite back – backfire if you will (Tenner 1996). Concurrently, the modern Arts-Medicine movement has found its own core technology – modern neuroscience with all its glorious and profound scientific advances, but also its transcendental applications which other modern medical technologies lack (Chopra 1993). Thus, borne out of a great and current human need for modern man to experience wholeness, connectedness, and meaning, the creative arts therapies are being integrated into all modern medical fields, from high-tech neonatology to high-touch hospice work, and anything in between.

When I first read the term 'Medical Art Therapy' (Malchiodi 1993), I knew immediately that this was a term and discipline whose time had arrived. In this remarkable book, pioneering art therapist Cathy Malchiodi assembles experts who provide deep insight and practical wisdom on the application of Medical Art Therapy with adults suffering from conditions of major importance to all of us such as stroke, chronic pain, cancer, AIDS, and others. In the introduction to the book, Malchiodi states that: 'the task medical art therapy now faces is to identify just how art making impacts people's overall physical well-being'. This is a call for rigorous, peer reviewed, publishable research.

While I agree with this need for research, I also believe that this book and hopefully more like it provide the clinical examples and tools to responsibly apply these safe and effective therapies now, in a broad range of clinical medical settings as some courageous creative art therapists have already done. Several years ago, in remarks to assembled arts therapists, I noted, using often-heard but still meaningful language, that: 'I thought that I had caught a glimpse of the promised land in Arts-Medicine, but only by standing on the shoulders of leaders of the creative arts therapy movement, which has persisted and grown for over 50 years in the US and abroad.'

With this book by Cathy Malchiodi and others, we can now say with confidence that in just a few years time we have entered into this promised land – just in time for the new millennium.

Let us express our gratitude for Cathy Malchiodi's competent and courageous leadership and for this book. Also, let us take the time to have a

long and heartfelt celebration before we get back to the necessary and sometimes difficult healing work at hand. But first let us celebrate – the power and beauty of the arts, like no other force known to man invites us to do so.

Dr Richard A. Lippin,
Founding President, International Arts-Medicine Association
(IAMA)
January 1999

References

Chopra, D. (1993) *Ageless Body, Timeless Mind.* New York: Harmony Books.

Diamond, J. (1997) *A Prayer on Entering: The Healer's Hearth a Sanctuary.* South Salem, NY: Creativity Publishing.

Lippin, R.A. (1989) 'Arts medicine: a case for a comprehensive definition – implications for interdisciplinary and international cooperation.' International Conference on Medicine for the Performing Arts, Mitzpe Rachel, Israel.

Malchiodi, C. (1993) 'Medical art therapy: contributions to the field of arts medicine.' *International Journal of Arts Medicine 2,* 2, 28–31.

McNiff, S. (1992) *Arts as Medicine.* Boston, MA: Shambhala.

Schwartz, G.E. and Russek, L.G. (1997) 'Dynamical energy systems and modern physics: Fostering the science and spirit of complementary and alternative medicine.' *Alternative Therapies 3,* 3, p.46.

Shlain, L. (1998) *The Alphabet Versus the Goddess: The Conflict between Word and Image.* Viking Press.

Tenner, E. (1996) *Why Things Bite Back: Technology and the Revenge of Unintended Consequences.* New York: Alfred A. Knopf.

Introduction

Art Therapy and Medicine: Powerful Partners in Healing

Cathy A. Malchiodi

It has been noted that imagery has consistently played an important role in the treatment of illness for thousands of years (Achterberg 1985; McNiff 1992). At the beginning of the twentieth century Carl Jung (1955) utilized dreams and visual images to investigate and understand his patient's physiological status. More recently, attention has been drawn to understanding how guided imagery and drawing can help people cope with and recover from serious or life-threatening illnesses (Achterberg and Lawlis 1980; Lusebrink 1990; Simonton, Simonton and Creighton 1978).

It is only in recent years that art therapy, a modality based on the belief that the process of art making is healing and life enhancing (American Art Therapy Association (AATA) 1994), has come to be recognized for its unique contributions in the treatment of physical illness. The term *medical art therapy* has been applied to the specialized 'use of art expression and imagery with individuals who are physically ill, experiencing trauma to the body, or who are undergoing aggressive medical treatment such as surgery or chemotherapy' (Malchiodi 1993, p.66). While the designation 'medical art therapy' is increasingly being used to describe the contemporary application of art therapy in medical settings, the practice of medical art therapy is actually several decades old. The British artist, Adrian Hill, noted that art making was helpful in his recovery and that of other patients hospitalized for tuberculosis (1945; 1951). For this reason, Hill could very well be called one of the first 'medical art therapists,' setting the stage for the development and expansion of art therapy in medical milieus (Malchiodi 1999).

Since the time of Hill's work, art therapists and other health care professionals have been active in introducing, developing, and applying medical art therapy in a variety of settings with both child and adult populations. In the last two decades, medical art therapists and health care practitioners have documented their work within health care environments and with a variety of adult medical populations (Baron 1989; Dannecker 1991; Dreifuss-Kattan 1990; Landgarten 1981; Long *et al.* 1989; Lusebrink 1990; Maiorana 1989; Malchiodi 1997, 1998; Rosner 1982; Rosner David and Sageman 1987; Wolf, Willmuth and Watkins 1986; to name a few). More recently, the hospital arts movement has enhanced the promotion and development of art programs in health care settings with adults (Kaye and Blee 1997; Palmer and Nash 1991).

This first chapter introduces the reader to the use of medical art therapy with adults. In particular, it outlines how medical art therapy has been utilized to enhance rehabilitation and recovery, to help patients cope with diagnosis, surgery, disability, medical treatments, and symptoms, and to find a personal meaning for the experience of serious or life-threatening illness. While art therapy provides many unique benefits to individuals experiencing physical illnesses, there are several which are emphasized throughout this text and are described below: art expression as form of 'opening up;' art expression as personal empowerment; art therapy as a form of complementary therapy; and art expression as transformation and transcendence.

Art expression and 'opening up'

Pennebaker (1997) in *Opening Up: The Healing Power of Confiding in Others,* verifies the important psychological and, in particular, physiological benefits that self-expression offers in amelioration of trauma and loss. His research on the impact of expressing traumatic experiences such as illness through writing or confiding in others underscores the health-giving effects which result from the simple experience of opening up. Pennebaker's studies have demonstrated that people who express their secrets, traumas, and feelings to themselves and others, have livelier immune responses, healthier psychological profiles, and far fewer incidences of illness. While his research speaks to the importance of talking and writing about traumatic or overwhelming experiences, he notes that art expression has the potential to have similar health-giving capacities.

With most patient populations described in this book, art expression is used to help people 'open up,' by making visible their thoughts, feelings, and

perceptions through drawing, painting, and other art experiences. Opening up through self-expression can help people explore, release, and understand the source of emotional distress, ameliorate and alleviate trauma, and repair and resolve conflicts. Opening up through art expression can also contribute to health and wellness: sharing powerful or disturbing feelings is now recognized to be important to overall physical well-being. For example, there is strong evidence that expressing feelings about one's experiences with serious illness within a group has the potential to enhance health. David Speigel, a psychiatrist and researcher at Standford University Medical Center, conducted a series of studies that indicated that talking and relating to others about the experience of life-threatening breast cancer actually can extend one's lifespan (Speigel *et al.* 1989). While a similar study has yet to be conducted using art therapy as a group modality with cancer patients, Spiegel's investigation does not point to the possibility that opening up and sharing one's feelings through art expression with others may also have a similar positive impact on health.

While art expression serves as a way to express feelings and perceptions, it also has the potential to provide health care professionals with important information which patients cannot or do not always express with words. From his experiences with cancer patients of all ages, physician Bernie Siegel (1986) observes that drawing is an easy and reliable way to reveal otherwise unexpressed feelings and beliefs. A few very simple drawings have often helped him understand patients' perceptions of their illnesses, revealing a patient's unexpressed conflicts about treatment. For example, while a person may say that chemotherapy is helpful in eliminating his or her cancer, on an unconscious level the person may be feeling that the treatment is poison and may indicate this through a drawing or other art expression. These unrecognized beliefs, emotions, and perceptions about illness and medical interventions are important in developing an appropriate wellness program for the patient.

As many art therapists I have found that drawings and other types of art experiences are useful in understanding how people really feel about their illness, treatment, and course of their condition. Art expression is particularly helpful because people who are seriously ill often have two explanations for their condition, one verbal and one non-verbal (Malchiodi 1998). The verbal explanation is often their medical description of the illness which involves a rational recounting of their condition based on medical knowledge. The other, the non-verbal one, is a more personal and often private perception of

their illness. This personal explanation may or may not be conscious, and may involve apprehension, confusion, misunderstanding, fear, or anxiety. It is also more likely to be revealed through a non-verbal modality like art rather than directly communicated with words. In both individual and family work (see Riley, Chapter Nine), art has the capacity to provide patients and their families with a non-verbal 'voice' to express both the rational and less rational beliefs about their perceptions of illness or disability.

Art expression as personal empowerment

Undoubtedly, art expression is a way to convey painful, confusing, and contradictory experiences of illness that are difficult to communicate with words alone. In addition, the very act of drawing, painting, or constructing can be a personally empowering experience in contrast to the loss of control that generally accompanies illness. For example, patients who are seriously ill often lose control of their time during their hospitalization because of the hospital's schedule and necessary medical treatments; they also may lose control of their bodies due to disease, medical intervention, surgery, or disability. In these circumstances art expression can help people regain some measure of control in their lives by providing an active process involving the freedom to choose materials, style, and subject matter, to play freely with color, lines, forms, and textures, and to create what one wants to create. This element of choice can contribute to feelings of autonomy and dignity when other aspects of life seem out of control.

Piccirillo (see Chapter Seven) notes that art expression naturally encourages the important experience of mastery in the art maker. The benefits of achieving a sense of mastery can be far-reaching: increased self-esteem, enhanced self-confidence, and development of adaptive coping skills. She observes that 'a generalized sense of security' (p.178) results from art making and a perception of one's ability to control events, at least to some extent. In this way, art making can provide an experience of normalcy, even if only for the time one is engaged in creative activity.

In addition to shifting attention away for illness, art making can also bring clarity to those patients whose illnesses have compromised their cognitive and interpersonal skills. For example, Wald's work with stroke patients (see Chapter One) as well as individuals with dementias (Wald 1983) demonstrates the power of art expression to help people become more focused, seek interaction with others, and engage in meaningful

self-expression. In this sense, art expression can become a potent tool in empowering individuals who have been disempowered by medical illness or disability to become more active participants in life.

Art therapy as a complementary therapy

Complementary therapies which employ the use of imagery and art expression have been used for several decades (Achterberg and Lawlis 1980; Lusebrink 1990; Simonton *et al.* 1978) and it has been observed that one of medicine's oldest and most powerful healing tools is imagery (Achterberg, Dossey and Kolkmeier 1994). Throughout history, the imagery of dreams and visions has been use to enhance health, particularly in healing rituals and ceremonies. Many health care professionals have reported that guided imagery is particularly valuable in the treatment of patients with cancer, autoimmune and immune diseases, and chronic pain and may improve some patients' outcomes (Achterberg *et al.* 1994; Siegel 1986). As Lusebrink notes, images are a 'bridge between body and mind, or between the conscious level of information processing and the physiological changes in the body' (1990, p.218). Both health care professionals and patients are beginning to realize that creative approaches involving imagery and image making can have a positive effect on the body, mind, and spirit.

With the recent interest in alternative and complementary forms of treatment there is a renewed attention to how the body and mind connect and communicate with one another. Medicine has recognized the value of creative modalities in health and wellness and subsequently, art therapy has been declared a 'mind-body intervention' by the National Institutes of Health Office of Alternative Medicine (National Institutes of Health 1994), Washington, DC. Mind-body interventions are techniques used to enhance the power of the mind to influence the body in ways which encourage and stimulate health and well-being. More commonly recognized mind-body interventions included meditation, yoga, tai chi, and biofeedback, techniques which have been proven to facilitate the mind's capacity to affect the body. It has been noted that art making can also be a complement to medical treatment and the creative process may be an important aspect of health and well-being (Malchiodi 1995; 1998).

Although there has been very little research on the use of art expression as a mind-body intervention for people with physical illness or disability, some art therapists have begun to explore just how art expression functions in this capacity. For example, Camic (see Chapter Two) believes that art expression,

in combination with other approaches, can be of value in helping patients address symptom management and identify what triggers symptoms. Paradigms in health psychology, cognitive-behavioral therapy (CBT), and meditation inform Camic's interventions, and his groundbreaking work with pain through expressive arts therapies demonstrates how we can begin to understand the effectiveness of art expression as a way to express and manage symptoms.

As a medical art therapist who works with people with cancer, AIDS/HIV, and other serious illnesses, I have learned about the capacity of art expression as a mind-body intervention with patients by witnessing their art making process and by listening to what they say about their experiences with art expression. Patients often report that being absorbed in a meaningful creative activity such as drawing, painting, or constructing is a time of relief and escape from pain and other physical ailments, as well as from powerful emotions such as depression, anxiety or fear. Patients also note that art making is conducive to achieving a relaxation response – that is, a relaxed state of being that is known to build the immune system and alleviate some symptoms of illness. Lusebrink (Chapter Four) and Hiltebrand (Chapter Five) also advocate a more holistic understanding of art therapy with individuals with a serious illness; their work with cancer patients emphasizes the unique potential of art expression and imagery to impact both mind and body.

Medicine, complementary therapies, and health psychology are also beginning to explore how engaging in a creative process such as art making may actually produce positive physical changes in the body. According to Chopra (1993) creative experiences are known to actually enhance brain functioning and structure, brain scans show increased blood flow to the brain during periods of creative thought, and any creative activity that is enjoyable gives rise to alpha wave patterns typical of restful alertness, the relaxed but aware state found in meditation. Serotonin, the chemical in our bodies that alleviates feelings of depression, is also increased during creative activity. Therapeutic art programs in hospitals have been found to provide many benefits, including reduction of stress, increased capacity to communicate feelings about symptoms, and improvement of blood pressure, heart rate, and respiration through exposure to the arts (C.E. Koop Center 1998).

Chopra (1993) notes: 'Beyond any body of evidence about aging and how to prevent it, the single most important factor is that you make something creative from your existence' (p.230). This, according to Chopra

and others, is at the root of continued health into our older years as adults. Research may eventually find that staying creative though activities such as art making actually extends the life-span and are a necessary part of health maintenance, just as important as good nutrition, exercise, and stress reduction.

Lastly, art expressions also seem to have the uncanny ability to convey information about physiology and somatic state in some patients. Many authors who have studied imagery, art expressions, and dreams have observed how images can be visual premonitions of somatic changes in the body (Achterberg *et al.* 1994; Bach 1990; Furth 1988). Lusebrink notes in Chapter Four that images are 'multileveled in that they incorporate perceptual, affective, cognitive, and symbolic, as well as psychophysiological aspects' of the self (p.89). In her work with mastectomy patients she capitalizes on the rich content of dreams through sandtray therapy, assisting patients understanding the metamessages inherent to their images. Anand and Anand (Chapter Three), Rosner David and Ilusorio (Chapter Eight), and Minar (Chapter Ten) make similar observations about how art expression can reflect both psychological and physical effects of illness.

Art expression as transformation and transcendance

Oliver Sacks, the well-known British neurosurgeon and author, describes the important quality of 'awakening' that the arts provide physically ill or disabled individuals: 'Awakening, basically, is a reversal … the patient ceases to feel the presence of illness and the absence of the world, and comes to feel the absence of his illness and the full presence of the world' (1990, p.53). In my own work as a medical art therapist I find that during art making people often shift away from the presence of illness in their lives, momentarily forgetting that they are sick or disabled. They essentially become 'awakened' to experiences other than their illness.

As previously noted, many patients discover that they can often rise above illness, overcome pain, and get past fears and anxieties associated with the disease while engaged in art making. These are, in a sense, experiences of transcendence, of going beyond one's illness and more fully enjoying and experiencing life. Confronting illness, whether through art or other approaches, also often involves an experience of transformation. McGraw (Chapter Eleven) notes: 'Physically ill persons experience losses, both real and perceived … Active participation in the creative process offers the opportunity to expand and grow' (p.247). McGraw's many decades of work

as an art therapist at the Art Studio at MetroHealth Medical Center emphasizes the natural capacity of art making to encourage transformation and healing in people with disabilities or physical illnesses. Her observation underscores the potential that art expression has to encourage growth, change, and reparation in individuals experiencing disease or loss of physical functioning.

In working with people who are confronting serious, life-threatening illnesses, I also find that they use art expression in a transformative way. Many people use the art process to author a new story for their lives and, as a result, creating a new sense of who they are. This 're-authoring' of life stories may be different for each person. However, it often includes one or more of the following aspects: development of new outlooks; discovery of answers to the unanswered questions (e.g. Why did I become ill? Why did God do this to me?); revisions in the way one lives life; creation of solutions or a resolutions to personal struggles; creation of a new 'post-illness' identity; or discovery of a meaning for why one's life has been altered by illness, disability, or physical trauma.

Conclusion

As demonstrated throughout this brief introduction, medical art therapy holds great promise as an important component of patient care and has been recognized for its potential to help patients express feelings, achieve a sense of personal empowerment, and transcend debilitating symptoms and emotional traumas associated with illness and disability. However, we still lack a complete understanding of how art therapy works with individuals with physical illnesses, because many professionals who practice medical art therapy have not published their ideas and research. There is little in the way of hard evidence in the form of traditional clinical studies to prove medical art therapy's effectiveness as a treatment (Camic 1998; Kelly 1997). At the start of this chapter I mentioned that imagery has played an important role in health for thousands of years. The task medical art therapy now faces is to identify just how art making impacts people's overall physical well-being.

Although research into the efficacy of medical art therapy is just beginning, fortunately perceptions of the importance of art expression in health care settings are changing due to the work of the authors in this book. Because of their contributions many health care professionals and facilities are realizing the benefits of creative approaches to treatment such as art therapy and incorporating these approaches as a part of their patients' overall

wellness programs. Medicine is also beginning to recognize that patients' art expressions may reflect physical changes, symptoms, and pain experienced during illness and that art making helps patients express and understand the physical, emotional, and spiritual aspects of confronting the loss of one's health. These qualities found in art making are not always available through traditional medical interventions and other forms of healing.

In the chapters which follow, the reader will learn more about how medical art therapy helps adults with physical illnesses or disabilities to open up through art expression, to repair, preserve, or enhance many areas of normal functioning, to regain a sense of empowerment and mastery, and to reconstruct and restore the self. The authors, each advanced practitioners in the area of medical art therapy, demonstrate through clinical experiences and case material how art therapy within medical settings encourages adult patients to confront and overcome traumatic and life-threatening aspects of serious illness, transform suffering, and create a vision for the future.

While these chapters have been written by professionals with extensive experience in art therapy, this book is intended to serve as a guide for all health care professionals who wish to understand more about how art expression can complement medical treatment. Bernie Siegel (1986) once said, 'I wish all physicians would add a box of crayons to their diagnostic and therapeutic tools' (p.114). His observation underscores the need for all health care practitioners and medical settings to recognize the important role of art therapy in enhancing health, ameloriating physical and emotional trauma, and restoring and repairing the self.

References

Achterberg, J. (1985) *Imagery in Healing: Shamanism and Modern Medicine.* Boston: New Sciences Library.

Achterberg, J., Dossey, B. and Kolkmeier, L. (1994) *Rituals of Healing: Using Imagery for Health and Wellness.* New York: Bantam.

Achterberg, J. and Lawlis, J.F. (1980) *Bridges of the Body/Mind: Behavioral Approaches to Health Care.* Champaign, IL: Institute for Personality and Ability Testing.

American Art Therapy Association (1994) *Mission Statement.* Mundelein, IL: AATA, Inc.

Bach, S. (1990) *Life Paints its Own Span.* Zurich: Daimon.

Baron, P. (1989) 'Fighting cancer with images'. In H. Wadeson, J. Durkin and D. Perach (eds) *Advances in Art Therapy.* New York: John Wiley and Sons.

C.Everett Koop Center (1998) [Online] *ArtCare Program.* Available at: http//www.koop.dartmouth.edu/programs_arts_5.htm1/.

Camic, P.M. (1998) 'Psychology, Art and Healing'. Unpublished paper presented at the American Psychological Association Annual Meeting, San Francisco, CA.

Chopra, D. (1993) *Ageless Body, Timeless Mind*. New York: Harmony Books.

Dannecker, K. (1991) 'Body and expressions: Art therapy with rheumatoid arthritis patients'. *American Journal of Art Therapy 29*, 110–117.

Dreifuss-Kattan, E. (1990) *Cancer Stories: Creativity and Self-Repair*. Hillsdale, NJ: The Analytic Press.

Furth, G. (1988) *The Secret World of Drawings*. Boston: Sigo Press.

Hill, A. (1945) *Art versus Illness*. London: George Allen and Unwin.

Hill, A. (1951) *Painting out Illness*. London: Williams and Norgate.

Jung, C.G. (1955) *Modern Man in Search of a Soul*. New York: Harcourt Brace Jovanvich.

Kaye, C. and Blee, T. (1997) *The Arts in Health Care: A Palette of Possibilities*. London: Jessica Kingsley Publishers.

Kelly, J. (1997) 'Revealing and healing illness with art therapy'. *Alternative and Complementary Therapies 4*, 107–114.

Landgarten, H. (1981) *Clinical Art Therapy*. New York: Brunner/Mazel.

Long, J., Appleton, V., Abrams, E., Palmer, S. and Chapman, L. (1989) 'Innovations in medical art therapy: Defining the field'. *Proceedings of the American Art Therapy Association 20th Annual Conference* (p.84). Mundelein, IL: AATA, Inc.

Lusebrink, V. (1990) *Imagery and Visual Expression in Therapy*. New York: Plenum Press.

Maiorana, W. (1989) 'When art is all there is: Art therapy in the treatment of a man with Parkinson's disease'. *American Journal of Art Therapy 28*, 51–56.

McNiff, S. (1992) *Art as Medicine*. Boston: Shambhala.

Malchiodi, C.A. (1993) 'Medical art therapy: Contributions to the field of arts medicine'. *International Journal of Arts Medicine 2*, 2, 28–31.

Malchiodi, C.A. (1995) 'Art Making as Complementary Medicine'. Unpublished syllabus, 26th Annual Conference of the American Art Therapy Association, San Diego, CA.

Malchiodi, C.A. (1997) 'Invasive art: Art as empowerment for women with breast cancer'. In S. Hogan (ed) *Feminist Approaches to Art Therapy*. London: Routledge.

Malchiodi, C.A. (1998) *The Art Therapy Sourcebook*. Los Angeles: Lowell House.

Malchiodi, C.A. (ed) (1999) *Medical Art Therapy with Children*. London: Jessica Kingsley Publishers.

National Institutes of Health (1994) *Alternative Medicine: Expanding Medical Horizons*. NIH publication #94–066, Washington, DC: Author.

Palmer, J. and Nash, F. (1991) 'The hospital arts movement'. *International Journal of Arts Medicine 1*, 1, 34–38.

Pennebaker, J. (1997) *Opening Up: The Healing Power of Confiding in Others*. New York: The Guilford Press.

Rosner, I. (1982) 'Art therapy in a medical setting'. In A. DiMaria, E. Kramer and I. Rosner (eds) *Art Therapy: A Bridge Between Worlds, Proceedings of the 12th Annual Conference of the American Art Therapy Association*. Reston, VA: AATA.

Rosner David, I. and Sageman, S. (1987) 'Psychological aspects of AIDS as seen in art therapy'. *American Journal of Art Therapy 26*, 1, 3–10.

Sacks, O. (1990) *Awakenings*. New York: HarperPerennial.

Shapiro, B. (1985) 'All I have is pain: Art therapy in an inpatient chronic pain relief unit'. *American Journal of Art Therapy 24*, 44–48.

Siegel, B. (1986) *Love, Medicine, and Miracles*. New York: Harper and Row.

Simonton, C., Simonton, S. and Creighton, J. (1978) *Getting Well Again*. New York: St. Martin.

Speigel, D., Bloom, J., Kraemer, H. and Gottheil, E. (1989) 'Effect of psychosocial treatment on survival of patients with metastatic breast cancer'. *The Lancet 2*, 888–891.

Wald, J. (1983) 'Alzheimer's disease and the role of art therapy in its treatment'. *American Journal of Art Therapy 22*, 57–64.

Wolf, J., Willmuth, M. and Watkins, A. (1986) 'Art therapy's role in the treatment of anorexia nervosa'. *American Journal of Art Therapy 25*, 39–46.

The Role of Art Therapy in Post-Stroke Rehabilitation

Judith Wald

Introduction

'Stroke is the third leading cause of death in the United States and the leading cause of disability among adults … Three million people are alive with varying degrees of neurological impairment. Consequent burdens in human and economic terms are enormous' (U.S. Post-stroke Rehabilitation Guideline Panel 1995, p.1). This chapter will review the physical, cognitive, sensory-perceptual, psychological, and social aspects of strokes to give the reader a better understanding of the multiple issues involved. Art-based assessments based on findings of left brain/right brain functions and impairments by Howard Gardner (1976) and by occupational therapists and art therapists will be discussed. Finally, this chapter will follow how individual patients work through their post-stroke rehabilitation issues in art therapy.

Medical description: physical, cognitive, sensory/perceptual aspects

In ancient times, it was called 'a stroke of God' (Gardner 1976, p.12). 'Medically, a stroke is called a cerebrovascular accident (CVA), but to the person who has one, it is a "stroke" because it is like being hit on the head with a blunt instrument' states Dahlberg and Jaffe (1977, p.17), a psychiatrist and stroke survivor. Some researchers relabeled stroke a 'brain attack' due to its suddenness and catastrophic results; they likened it to earthquakes, with

most extensive damage occurring not during but after the initial shock with massive nerve cell destruction (Gorman 1996).

The World Health Organization defines a stroke as 'a vascular lesion of the brain, resulting either in a neurological deficit persisting for more than 24 hours or in death' (Birkett 1996, p.20). Seventy-five percent of strokes are caused by brain infarctions, 15 per cent by intracerebral or subarchnoid hemorrhages; the remainder are of other or unknown causes. Most strokes are ischemic, caused by blockage of blood vessels from a clot or narrowing (thrombosis), thereby reducing blood flow to the brain; brain cells die from lack of oxygen.

Gradual accumulation of fatty materials causes this occlution, or a clot near the heart or near a major artery breaks loose and blocks the small artery in the brain. In hemorrhagic stroke, the blood vessel bursts, and blood that leaks into the brain causes damage. A *TIA, a transient ischemic attack*, has the same symptoms as a stroke, but lasts less than 24 hours and does not cause permanent brain damage. While a TIA is not a stroke, it is an important warning sign to alert one to seek treatment to help prevent a future stroke. Factors increasing possibility of stroke are obesity, diabetes, high blood pressure, and inflammation or infection of blood vessels. Three quarter of strokes occur in people 65 years or older; however, a person can have a stroke at any age, even in infancy. (One of our fellow art therapists had a stroke in her twenties during childbirth.)

Strokes range from benign (which are often undetected and unreported) to imminent death when a large portion of the brain is destroyed. Strokes of intermediate severity are nevertheless 'serious enough to permanently affect … functioning … [Survivors] seldom return to work or resume "premorbid" pace of activity; yet they are likely to get around, to express themselves possibly, to interact with other persons, to experience happiness and despair, to share feelings with others' (Gardner 1976, pp.12–13). While most rapid neurological and functional recovery occur one to three months post-stroke, some continue to progress, particularly in the areas of language and visuospatial functions (U.S. Post-stroke Rehabilitation Guideline Panel 1995). It is with these survivors of moderate stroke that this chapter will address the role of art therapy in post-stroke rehabilitation.

Each survivor's experience is unique, for brain damage is selective, sometimes devastating large areas of the brain while leaving other parts intact. Damage to connective tissue may isolate intact regions. Researchers are divided between the localizers who think each brain function has its

center, and the holists who say that all areas of the brain function in all activities. I will discuss art therapy implications from both points of view, and limit mention of further medical aspects of stroke to those which affect art therapy performance.

Physically, a large proportion of strokes cause weakness (hemiparesis) or paralysis (hemiplegia) on one side of the body, which may involve the whole side or only the arm or leg. This weakness or paralysis occurs on the opposite side of the body injured by the stroke, due to fiber crossover in the brain. Other physical deficits may be problems with balance or coordination; *ataxia* is failed muscular coordination and *apraxia* is inability to produce volitional movement. Physical pain, numbness, and/or odd sensations make mobility or relaxation difficult. One may tire quickly, limiting involvement in activities.

Cognitive deficits include problems with memory, thinking, attention, or learning. Poor judgment may cause unsafe actions if one lacks awareness of the effects of the stroke. Being unaware of or ignoring things on one side of the body (bodily denial, neglect or inattention) can result in eating from only the half of the plate or drawing on half of the paper. Problems using language include *receptive aphasia*, which is difficulty understanding speech or writing, or *expressive aphasia*, being able to understand but unable to think of words to speak or write. Left hemisphere lesions are usually implicated in aphasia. *Dysarthia* causes difficulty saying words clearly.

Impaired sensory-perceptual apparatus can cause visual field cuts, right-left disorientation, visual-spatial distortion, disordered concepts of verticality, figure-ground difficulties. *Visual agnosia* is the inability to recognize objects. Concepts of body image and schema may be confused and disoriented. *Constructional apraxia* involves an inability to visualize, to transpose 2-dimensional instructions into a 3-dimensional structure, such as a craft kit. Therapists need to be aware of these sensory-perceptual impairments that show up frequently in the art work, and help the person compensate.

Psychosocial aspects

Psychological sequelae are dominated by a reactive depression; it is normal for a stroke survivor to feel depressed about the problems caused by a stroke. Some survivors experience a major depressive disorder, characterized by loss of interest in things that were premorbidly enjoyed, feeling slowed down or restless, feeling worthless or guilty, having problems with concentration,

memory, thinking, making decisions, difficulty or excessive sleeping, loss of energy, anxiety, feeling pessimistic, hopeless, headaches, digestive or sexual problems, thoughts of death or suicide. The clinician needs to sort out which of the above are physical or psychological. Depression needs to be treated with medication and/or psychotherapy, as neglecting treatment makes recovery from the stroke more difficult.

The site of the infarct may cause depression or another mood disorder, such as anger, irritability, loss of normal affect, emotional lability, inappropriate euphoria. Birkett summarized that research has found that post-stroke depression 'has certain specific features … not merely a reaction to a depression situation. This entity may depend on the location of the infarct, and there is evidence that it is especially associated with left anterior infarcts. Other negative moods, such as anxiety and irritability, may mimic depression in stroke' (1996, p.228). Gardner (1976) noted that Broca's aphasics tend to retain their previous personalities; their emotional responses are appropriate, with understandable frustration at tasks failed and depression from lack of progress. Wernicke's aphasics tend to have a convivial frame of mind, being less aware of what is wrong with them; however, a certain number develop a paranoid streak.

Localized brain lesions can cause functional psychological effects, though consensus of researchers is conflictual (Birkett 1996). Frontal lobe damage results in apathy or disinhibition, left frontal lobe damage can cause depression, visual hallucinations. Prefrontal lesions are said to cause personality and emotional disorders. Visual hallucinations implicate occipital lobes or midbrain, aggression and seizures arise from the temporal lobe, and mania from right thalamus damage. Premorbid psychosis must be taken into consideration first, however. Behavioral mental disturbances are most prominent with right hemisphere damage; due to their greater mobility and ability to verbally express themselves, they are more capable of expressing negative feelings, often described as quick and impulsive. However, it should be noted that left hemisphere damage that causes right handed paralysis and loss of speech makes detection of mental deficits difficult as they can't speak, express themselves, or perform standard tests requiring communication or copy drawings to test visual spatial ability. Flexible, practical, and imaginative approaches and techniques implicit in art therapy can be used to work through these issues with the patient, as well as help a treatment team or caregivers.

Other emotional changes reported by caregivers are uncooperativeness, which can be a direct result of physical frustration. A stroke survivor may be unable to control his emotions, known as 'emotional incontinence,' crying easily at the least provocation. Disinhibition, euphoria, mania, even psychosis can occur, the latter most likely if the person was premorbidly psychotic.

Fatigue, depression, unobvious neurological deficits, another medical disorder, medication, dementia, cognitive impairments, social factors, and personality can factor negatively in a patient's recovery from a stroke, causing apathy. Rehabilitation requires motivation on the part of the patient to overcome and adjust to these numerous and various handicaps. Apathy and failure to rehabilitate occur when a patient fails to take part in his own rehabilitation. Personality factors deterring recovery include perfectionism, with an unwillingness to accept compromise; pessimism, not believing one can be helped; dependence, feeling comfortable at a dependent level and not wanting to change this. One third of stroke survivors become completely dependent, in fear of another stroke, and severely curtail activities; they won't use public transportation, go to social activities, the library, or work (Birkett 1996).

Adjusting to a new lifestyle is a difficult process: 'While fundamental aspects of personality may remain unaffected, the person's entire life-style has been in a single moment radically disrupted. This upheaval takes its toll on the patient's family and friends as well as on himself' (Gardner 1976, p.19). Previous family difficulties are usually exacerbated and could result in the splitting off of a marginal family member.

Dahlberg described the social loss he experienced when his stroke handicapped his ability to communicate with aphasia, the loss of speech, noting that human communication is the goal of language. He continued, 'at the root of the language process is the emotional need for communication with another individual. Man is a social animal and generally detests the feeling of loneliness' (Dahlberg and Jaffe 1977, p.111). Severe comm-unication disorders can result from damage to any part of the system, from vision, hearing, vocalization, muscles, analytic apparatus. Disorientation, sensory deprivation, and 'locked-in' syndrome can also cause loneliness and depression, and a vicious cycle takes over. Concludes Dahlberg, 'the depressive needs companionship but his behavior drives people away … [He becomes…] self-preoccupied … and brings out the depressive potential in all of us' (Dahlberg and Jaffe 1977, p.62).

Carmi and Mashiah (1996) similarly describe the feelings of loneliness, abandonment and desire to make contact, communicated in the art work of a right hemiplegic with slight motor impairment of speech (dysarthia). It is within an art therapy group that psychosocial losses can be most effectively dealt with, as I will later observe.

Left brain/right brain functions and injuries

Gardner (1976) has studied and summarized the pathology of left brain/right brain functions and injuries in terms of artistic representations in former artists and non-artists who had strokes. His research is most valuable to the therapist's evaluation and treatment of the stroke survivor. The following is a summary of his findings.

Left hemisphere functions are considered to be verbal, analytic, abstract, rational, temporal, digital, and propositional. With left hemisphere lesions, drawings show:

1. Simplified versions of an object, oversimplification, even primitivism.

2. Appropriate and recognizable sketches of general shape and configuration, but childlike, grossly deficient in essential internal details. There are omissions of elements, three-dimensionality, and simplified angles.

3. Better appearance than a right hemisphere patient because of relatively intact sense of space, orientation, proportion (see Figure 1.1).

4. Simpler classification and less differentiation, like their language deficits. (1976, pp.303–305)

Studies of former artists after a left hemisphere stroke revealed the artists still painting at a high level, even in the presence of extensive aphasia. Other artists who had to use their undamaged non-dominant left hand developed a new style of art, including fantasy elements that could indicate personality changes.

The brain's right hemisphere main functions are preverbal, synthetic, concrete, emotional, spatial, analogic, appropositional. It is considered to be dominant in drawing or construction capacity. Persons with right hemisphere lesions typically perform poorly at visual and spatial tasks, like distinguishing between two geometric patterns.

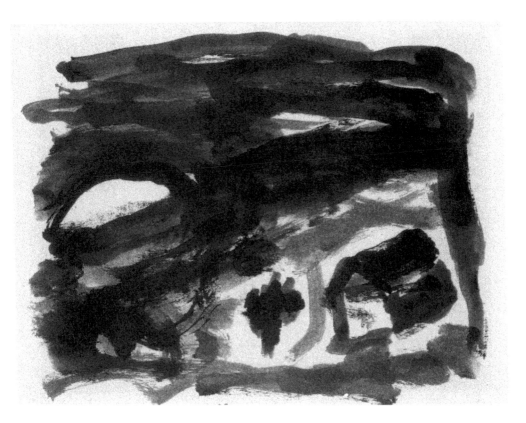

Figure 1.1

With right hemisphere lesions, the viewer needs to piece together the bizarre, askew, disorganized drawing. The drawings show:

1. Loss of contours, distortion of the general outlines of an object; the overall shape can be almost unrecognizable.

2. Details of the internal structure are preserved, such as windows and doors of the house.

3. Distorted spatial relationships of component parts, misplacement of details, impaired sense of proportion.

4. Neglect, with the left side of the drawing incomplete or ignored (see Figure 1.2).

5. Change in emotionality.

6. Despite adequate perception of details, general gestalt is deficient.

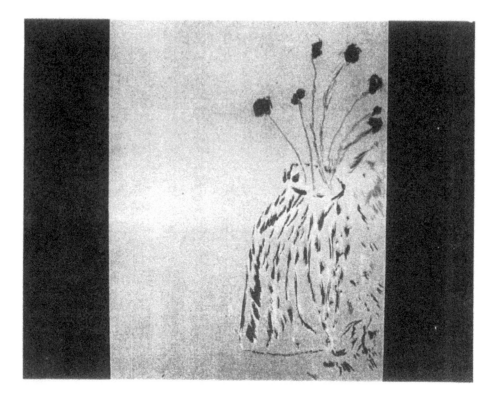

Figure 1.2

Artists with right hemisphere lesions continue to do art work. Initially, the artist will neglect the left side of the canvas in the first weeks after the stroke, but within a few months most neglect is clear up. Residual traces of neglect appear in the overall placement of the subject towards the right side of the canvas, or in less careful execution of the left side of the work, with fuzziness or incomplete lines or features. There is less inhibition about what aspects of subject matter should be included, due to a loosening of defenses. The overall execution is bolder, more direct, less articulated.

While lesions in either hemisphere will adversely affect drawing ability, they will in general result in heightened post-stroke expressiveness or primitivism. Gardner (1976) notes that despite the dominance of spatial relations and visual forms in the right hemisphere, there may be relatively minor distortions in former artist's work; he suggests that superior pre-morbid art backgrounds and overlearned skills account for this and/or

that spatial abilities are more widely represented in the artist's cortex. Psychological factors, such as depression or intense emotionality following close brushes with death, can account for increased expressiveness as well.

Art-based assessment

An art-based assessment can help the multi-disciplinary rehabilitation team evaluate the strengths and weaknesses of the stroke survivor, and develop appropriate individualized treatment goals. Particularly with language loss, it can also provide the survivor with an alternate tool of communication. Art can be used to test the ability to draw free hand and to copy, with representational art showing more clearly the results. Gardner noted that 'a severe aphasic can draw with accuracy' (1976, p.96), while one with excellent language abilities (right hemisphere damage) will reveal deficiency in drawing and perceptual-motor skills.

As previously mentioned, art retention depends on a number of factors: age when the skill was learned, how well it was mastered, and which neurological areas were involved. Visual memory can be better than cognitive memory, and visualization of events can aid in recall and recovery. Gardner surmised that 'aphasia thus raises the questions of whether we think in words primarily, in sentence-length units, in images, or perhaps, even in imageless entities ...' (1976, pp.28–29). Dahlberg and Jaffe (1977) noted that the right half of the brain, the more non-verbal artistic side, matures earlier than the left half. They suggested that the brain can turn to other senses – visual, hearing, touch, to gather information when language mechanisms and messages are lost.

The following art-based assessment is suggested for its multi-disciplinary background and implications:

1. *Copy a geometric shape*: tests for right brain damage, spatial concepts, ability to concentrate, to follow directions.

2. *Draw a clock*: tests for concept retention and execution, neglect (Clinifoto 1973). Numbers not contained within the clock indicate general brain damage. Numbers may 'escape' from the clock; numbers may be in reverse order. Numbers omitted on one side indicate neglect. Visual agnosia occurs with marks instead of numbers, upside down numbers, the drawing not recognizable as a clock.

3. *Self-portrait:* tests for conceptualization and execution, body-image,
 affect, psychological state. In Clinifoto (1973) the person was asked
 to draw a man. The subject's attitude was noted, such as enthusiasm
 or avoidance. According to their research, a small sized drawing
 indicated depression, dementia, or low self-confidence. A
 sophisticated drawing may reflect the person's premorbid intellectual
 level. Inability to draw and interrupted lines may be due to apraxia.
 Repetitive scribbling may be due to perseveration. Incorrect
 placement of parts, not related or connected to one another, may
 indicate visual agnosia. Hemiplegia will result in a disturbed sense of
 body image. Paralysed parts may be omitted and reappear in the
 drawing as the ability to walk is regained. Severe denial is seen in the
 omission of the involved side, a profile, and absence of all extremities.
 Drawing of a wheelchair may acknowledge acceptance of losses and
 new body image.

 Bach, Tracy and Huston (1971) noted that a right-handed person
 with left hemiparesis would do well following this directive.
 However, a right-handed person with right hemiparesis often could
 not use his right hand and often had difficulty understanding the
 directive, due to receptive aphasia. They suggested that in the latter
 case, ask the person to draw with the non-dominant left hand; also
 show a stick figure of a person, and remove it before he starts the
 picture.

 They reported that their use of the self-portrait evaluation helped
 predict which patients were capable of achieving independence in
 activities of daily living (ADL). However, those 'patients who lack
 body image are incapable of being independent in drawing and
 ambulation' (Bach, Tracy and Huston 1971, p.1480). They clarify,
 'hemiplegics with lesions of the minor hemisphere, who showed
 severe denial on their self-portraits, were not able to be independent.
 These patients were not aphasic and appeared to have a minimal
 deficit. For this reason, these patients were thought by many of us to
 be stubborn, lazy, and not interested in their training program before
 this study' (1971, p.1479). The patients were often criticized by
 hospital personnel for being dependent; because they did not have
 aphasia and could use their dominant hands, they appeared more
 capable than they were. Lesions on the non-dominant hemisphere
 may produce subtle effects such as right/left identification of one's

own hands but not of external objects, poor judgment in solving simple problems, but unaware of one's lack of judgment.

Repeated self-portraits that showed increased denial paralleled their regression in ADL's, and probably indicated subsequent cerebral insults during their stay on a rehabilitation unit. Increased graphic denial, behavioral regression and confusion was also found to be caused by too much sedation or medical problems such as urinary tract infections, fecal impactions, and abnormalities in electrolytes. After these medical problems were resolved, Bach, Tracy and Huston (1971) observed less denial in the self-portrait.

Besides the cognitive and functional information obtained by self-portrait, there is the psychological reaction of the survivor to the stroke and altered body image. First person narratives of celebrity stroke survivors, Agnes de Mille and Patricia Neal, 'relate how dreadful it is to suffer a stroke and describe the frustrations of being unable to talk and the humiliations of disfigurement' (Birkett 1996, p.221). In further art therapy sessions, they may mourn and grieve for these body image losses.

4. *Silver Stimulus Cards*: tests cognitive, sensory-perceptual, manipulative skills and emotional outlook. 'The objective [is] to obtain information about [one's] ability to perceive, form, and represent concepts non-verbally as well as verbally,' writes Silver (in Sandburg, Silver and Vilstrup 1984, p.135).

The directive is to choose two pictures (from a set of fifty line drawings of people, animals, places and things) to copy or use as a stimulus, combine them in a logical drawing, adding whatever one wishes. Then make up a story about the drawing.

Executive functioning, organizational reasoning, problem-solving skills, visual-spatial functioning, field neglect, hand movements, dexterity skills, use of dominant or non-dominant hand, story-writing, speaking skills can all be evaluated in the drawing and story. Depression and fantasies can appear in the story, as well as in the choice and use of the cards. Climbing the mountain is often chosen as a metaphor for overcoming obstacles and regaining one's health.

5. *Additional suggestions*: to test for affect are 'choose colors that represent how you are feeling, and make a design or picture' or a free choice painting. Ability to abstract, conceptualize, imagine, express thoughts and feelings are also addressed.

Art therapy goals

General rehabilitation goals, applicable to all treatment modalities are:

1. To assist the patient to gain a maximum level of mobility and independence.

2. Planned withdrawal of support as goals are met.

Special art therapy goals for stroke survivors are:

1. To assess physical, cognitive, sensory-perceptual, psychological, and social strengths and weaknesses.

2. To improve the patient's awareness of his individual problems.

3. To teach compensatory techniques to deal with deficits.

4. To improve functional, manipulative ability.

5. To assist the patient mourn, grieve, and accept change in body image.

6. To support a patient's efforts to work through his emotional reaction to his losses and limitations.

7. To assist a patient find inner strengths and old and new resources and 'coping mechanisms.'

8. To allow release of feelings about rehabilitation treatment, living situation.

9. To provide an opportunity to resocialize in an art therapy social support group.

10. To provide a non-verbal visual means of communication, self-expression, and interpersonal exchange.

Art therapy sessions

This author's experience with stroke survivors was in out-patient rehabilitation settings, senior residences, and nursing homes, with groups of mixed diagnoses (stroke, rheumatoid arthritis, Parkinson's disease, diabetes, early dementia). Their individual impairments were as varied as their social, educational, and economic backgrounds. What they all had in common was loss – of their former healthy bodies, of their previous life-styles, of their ability to control their lives. They were one another's main social comrades, coming twice a week to spend a day together engaged in physical, social, artistic, and recreational activities.

The art therapy setting was quiet, with minimal auditory distractions to compensate for perceptual deficits. Paintings and crafts were displayed on the walls and shelves for multi-sensory stimulation. They worked on individual and group arts and crafts projects chosen according to their interests and functional abilities. For those lacking physical dexterity (such as shaking or fine/gross motor control), media that do not require great control or that will assist with control include paint, clay, and markers. They were reminded to wear eyeglasses if needed, the correct ones (reading versus distance glasses), and to make sure the lenses were clean. Hearing aides were encouraged to be used and kept in good working order. Routine, consistency, cues, and repetition helped improve function. To compensate for visual deficits, I placed objects in the intact visual field, and kept the working space uncluttered and the materials well-organized. Directions were given simply, slowly, with one to two step commands and easy sequencing.

Those who expressed an interest in painting were introduced to watercolor and acrylics. Independent exploration and self-expression were encouraged. For the more alert that needed a starting point, a simple directive was given to create an outdoor scene that included a lake, mountains, trees, and a house. A demonstration of a wet-on-wet sunset was a good introduction to watercolor. For the moderately alert, these directives gave a focus to improve concentration. Flowers in a vase (see Figure 1.2) provided reality orientation for the moderately disoriented, who could be more playful in their interpretations. All artistic attempts were encouraged and accepted.

Phil was a noted journalist, in his fifties, who was unable to return to work after his stroke. He attended a writing group at a Senior Center, and a 'painting group' in a nursing home that had both inpatients and outpatients. He had never painted, but his creativity and expressiveness came through in the visual arts as well. A left brain stroke left him with right hemiparesis, with some difficulty holding and controlling the paintbrush. Typical of left-hemisphere lesions, his paintings were quickly executed, simplified, appropriate and recognizable (see Figure 1.1). His bold spontaneous style and expressiveness, possibly due to the stroke, resulted in bright, colorful paintings. His paintings were part of an art show, a source of personal pride and accomplishment in a new found interest and talent to help compensate for his lost writing career.

Sometimes, a patient may not feel like doing art, and the therapist needs to be flexible by allowing one to just watch or explore pictures and objects instead. Apathy, isolation, loneliness, learned helplessness, and dependency

can result in reluctance to try, low self-esteem or difficulty working independently or with others. Offering a choice of activities and materials can help motivate individual interest. Genser (1985) was able to regain the interest of a former artist in his art activities after a 16-year hiatus, following strokes that disabled him with aphasia and right hemiparesis. Noting that 'fear of learning the extent to which his last stroke had destroyed his abilities' (p.93) had probably caused him to reject traditional art materials, Genser introduced collage materials that he could manipulate, as well as much support, interest, respect, and empathy.

Group work

It is in an art therapy group that psychosocial losses can be most effectively addressed. Group size can vary from four to fifteen, with assistance from volunteers and other therapists in a larger group. My group sat together at large tables to encourage cohesion and social interaction. Their discussions and interactions while working on art were spontaneous, and a special camaraderie formed among these stroke survivors who came from all walks of life.

Fran was a cultured Jewish woman in her early eighties whose stroke had left her cognitively and verbally intact, but confined to a wheelchair. She used to go often to the theater in New York City, but was too proud to be seen there in a wheelchair. She felt she was a burden to her daughter and son-in-law, with whom she lived. While her pride prevented her re-entry into society and from enjoying her interest in the theater, it was her sense of humor that helped her adapt. Dependent on the staff for assistance in embarrassing tasks such as toileting, she gave us gifts of perfume samples as 'compensation to help us suffer through.' The twice-a-week day program was her only social outlet. Having established a good rapport with her, she agreed to join the art therapy group.

Fran expressed annoyance about her lazy eye and limited vision that the eye doctor had said nothing more could be done to correct. She did her artwork with her eyes almost touching the paper, focusing as best as she could. Fran joked about her attempts at painting, and her cheerful banter and lively personality were contagious in the group. Her leadership qualities reemerged, and she enjoyed being the center of attention. Her paintings were cheerful and colorful. Their right upwards slant indicated a perceptual impairment called 'disordered concept of verticality,' but I found it more therapeutic to tell her that despite the clouds above, she must be an optimist,

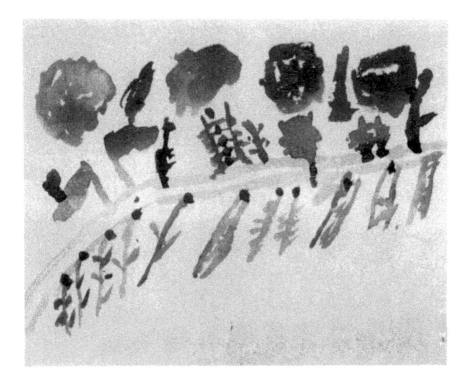

Figure 1.3

as her flowers seemed to climb upwards (see Figure 1.3). She was proud to see her paintings framed and displayed on the wall of the art room.

For a group clay project, I asked the group to come up with a theme that each person could contribute to. Hearing music coming from the next room, one patient suggested a group of musicians in a band. Each person created a musician, and Fran's was the largest, of course, the cellist (see Figure 1.4). In the art therapy group, she could feel accepted, whole, 'the star.'

Paul, a retired shopkeeper in his seventies, was wheelchair bound and had lost his ability to speak. Left brain lesions caused his speech loss. Right hemisphere lesions caused visuo-spatial deficits, visual neglect, as evidenced by his drawing of a vase of flowers on one side of the page. He needed to be approached on his unaffected side when directions were given. The staff learned to position his art paper, as well as his food, in the visual field. Gradually, more items were placed towards the affected side to reinforce

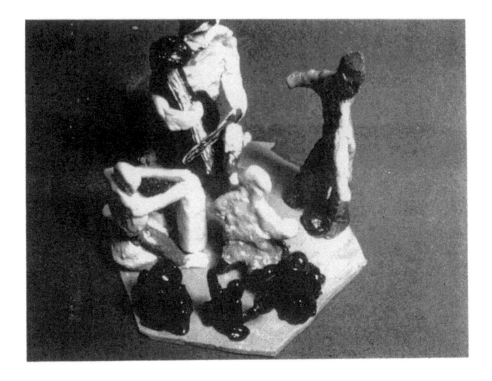

Figure 1.4

head turning. A contrasting colored paper was placed under white paper to decrease figure/ground confusion. Despite these handicaps, Paul's premorbid sweet nature reemerged in the art group; he smiled, nodded to communicate, and tried to do his best. He learned to get attention by tapping on the table – it was not surprising that he made the bongo drummer for our group clay band (see Figure 1.4).

A younger and most mobile group member was Patrick, a middle-aged Irish-American who could no longer work as a salesman. Patrick walked with the support of a cane, and helped and encouraged others. He was dealing with slurred but understandable speech, dysarthia, and body-image change of facial distortion and disfigurement on one side. Physically ataxic and apraxic, he sometimes shook and lacked fine/gross motor control. This 'clumsiness' caused frustration and resistance. Positive encouragement and support, and media that required less control were introduced. Tools and materials were modified to help him compensate for his manipulative

difficulties – for example, a sponge was taped to the brush handle for easier grip, paper was taped to the table. Markers and paint, materials that required less pressure to make a mark, were also offered. Despite his awkwardness in art, Patrick enjoyed the sociability of the group. In the group clay band, he created the standing musician, who was somewhat lopsided, like his own stance (see Figure 1.4). This was the bandleader, leading and encouraging others.

The last stroke patient who contributed to the clay band was Fanny. She was a working-class woman in her sixties who used a walker. Her stroke also left her with cognitive impairments, including a shortened attention span. Fanny quickly and impulsively made the three smaller non-differentiated figures that she glazed in one color (see Figure 1.4). Being a diabetic, she was quick to sneak a forbidden cookie when the staff turned their heads.

Conclusion

In this chapter I have reviewed the physical, cognitive, sensory-perceptual, psychological, and social aspects of stroke, and seen their manifestations in specific survivors in the art therapy group. I noted left brain versus right brain functions and impairments in drawings, and how an art therapy assessment and interventions assisted dependent, depressed stroke victims in reaching a maximum level of mobility and independence. In art therapy sessions, the stroke survivor communicated verbally, non-verbally (especially with speech impairment), and visually his thoughts and feelings about the trauma to his self-identity and body image. Learning and practicing compensatory means of adaptation, drawing on premorbid personality strengths, he or she gradually became motivated in struggles to make gains, and felt more in control. With the empathy and support of the therapist and the art therapy group, the stroke survivor can accept the residual deficits and limitations, the ultimate goal being to find renewed purpose and joy in living.

Dedication

In memory of my mother, Dr Gertrude Slater Greenblatt, who passed away of a stroke after I wrote this chapter.

References

Bach, P., Tracy, H.W. and Huston, J. (1971) 'The use of self-portrait method in the evaluation of hemiplegic patients'. *Southern Medical Journal 64*, 12, 1475–1480.

Birkett, D.P. (1996) *The Psychiatry of Stroke*. Washington, DC: American Psychiatric Press, Inc.

Carmi, S. and Mashiah, T. (1996) 'Painting as language for a stroke patient'. *Art Therapy 7*, 4, 265–269.

Clinifoto (1973) 'When the stroke patient draws a picture: A clue to disability'. *Geriatrics 28*, 2, 101–105.

Dahlberg, C.C. and Jaffe, J. (1977) *Stroke*. New York: W.W. Norton and Co.

Gardner, H. (1976) *The Shattered Mind*. New York: Random House.

Genser, L. (1985) 'Art as therapy with an aging artist'. *American Journal of Art Therapy 23*, February, 93–99.

Gorman, C. (1996) 'Stroke: Damage control'. *Time: The Frontiers of Medicine 148*, 14, 30–35.

Sandburg, L., Silver, R. and Vilstrup, K. (1984) 'The stimulus drawing technique with adult psychiatric patients, stroke patients, and in adolescent art therapy'. *Art Therapy 1*, 3, 132–140.

U.S. Post-stroke Rehabilitation Guideline Panel: Gresham, G.E. *et al.* (1995) *Post-stroke Rehabilitation*. Rockville, MD: U.S. Department of Health and Human Services, May, #16.

CHAPTER TWO

Expanding Treatment Possibilities for Chronic Pain through the Expressive Arts

Paul M. Camic

Introduction

Nearly everyone has experienced pain at one time in his or her life. A hammer misses its intended nail, a toe comes into contact with an uncooperative sidewalk, or a long car drive leaves our back and neck cramped and sore. In each of these situations the pain subsides after a relatively brief period of time. This pain is commonly referred to as *acute pain*; pain that is brief and lasts less than six months and is an expected reaction to injury or illness. The treatments required for acute pain are sometimes simple; some rubbing of a hurt body part, applying a cold or hot compress, rest, or a good stretch and change in posture. Other injuries involving acute pain may be more serious and require extensive treatment such as surgery or prescription medication. After a relatively short period of time, the injury heals and the pain subsides.

Many people though, after an accident or following surgery or suffering with a chronic illness, may continue to experience pain. This ongoing, continuous pain is no longer acute but has become chronic. The International Association for the Study of Pain (1979) has defined *chronic pain* as 'an unpleasant sensory and emotional experience associated with actual or potential tissue damage, or described in terms of such damage … exceeding a criterium of six months.' (p.249) Key components of this definition include the length of time an individual is in pain and his or her expected response to customary medical treatment. If pain should persist longer than one to six months (depending on the etiology) and the response to the pain is not

consistent with usual medical expectations, the terms *chronic pain syndrome* or *chronic pain behaviors* are often used to describe this condition.

Chronic pain has been generally used to describe nonmalignant pain that persists longer than the recovery period expected by a physician (Bonica 1977). Current thinking has expanded this explanation to include the term *benign chronic pain* when there is not a life threatening illness/disease (e.g. lower back pain, tension headache, shingles, arthritis, etc.). When a life threatening illness is present (e.g. cancer, AIDS, ALS, etc.) an explanation is usually given that describes the etiology of the pain (e.g. chronic pain due to pancreatic cancer). The length of time an individual has pain during a life threatening illness may vary widely and the less than six month criteria may not be applicable. Chronic pain can be associated with many different psychophysiological and pathophysiological illnesses and injuries as well as differing prognoses. In actual clinical practice a therapist is likely to see clients with long term pain; it may be caused by a variety of presenting problems and may either occur continuously or intermittently.

The cost to society to care for people with chronic pain is staggering. Billions of dollars are spent annually worldwide to treat pain (Hardin 1998). In the United States over 20 million people suffer with some type of pain at any given moment (Turk and Nash 1993). The economic and social costs in lost wages, lowered productivity, disability benefits and litigation are significant. In addition, the impact of chronic pain on a person's emotional well-being can be devastating. Chronic pain has been linked to depression, anxiety, marital discord and other psychosocial problems (Camic 1989; Hardin 1998).

We live in a culture in North America, and to some extent in Europe, where we expect an immediate response to our medical needs. In no other medical problem is this seen more clearly than with the symptom of pain. Both physicians and patients are on a mission to find the cause of the pain and to cure it as soon as possible. This 'search and cure' strategy is possible with some types of pain. If you break your arm or have stomach pain from eating or drinking too much, there are relatively immediate and rapid responses that will reduce if not eliminate your pain. However, this approach is not useful for conditions where the pain is ongoing or chronic. In cases of chronic pain, pain management rather than curing pain is necessary. This strategy is the focus of this chapter.

The goal of this chapter is to provide a basic understanding of biopsychosocial aspects of chronic pain and its management through

expressive art therapies. In addition, the approaches to treating chronic pain that are generally accepted practice in Western societies will be reviewed. This is followed by a case study where, utilizing a group workshop format, visual art making, writing, and sound/music were a significant component of treatment. The final section of the chapter discusses clinical implications of including the expressive arts in pain management treatment and presents some basic suggestions for future research.

Biopsychosocial aspects of chronic pain

In order to work with people with chronic pain a basic understanding of the mechanism of pain transmission is necessary. A more complete description of these mechanisms are beyond the scope of this chapter but can be found elsewhere (Hardin 1998; Melzack 1996; Melzack and Wall 1965). Pain is a complex phenomenon that involves mind-body interaction. The importance of mind-body interaction as a treatment perspective has not always been valued by professionals in medicine and psychiatry. Initially pain was thought about as a relatively simple stimulus-response mechanism where the intensity of pain sensations were related to the degree of tissue damage caused by the stimulus (Boring 1942), the stimulus being a disease (e.g. cancer) or an injury (e.g. tissue damage due to heavy lifting). In essence this model stated, the more extensive the tissue damage the greater the pain.

Pain that could not be explained by the stimulus-response model lead to the development of psychoanalytic and psychosomatic theories of pain etiology. Within this framework, pain is seen as a symbolic representation of repressed memories or emotions being expressed in a physical symptom (Sternback 1978). The symptom of pain is not the focus of treatment. Rather, pain is seen as a defense mechanism to protect the ego from being overwhelmed from unwanted thoughts or emotions. Patients began, in the 1950s and later, to be classified as having 'real' pain or pain of a psychogenic nature. This dichotomy in diagnostic classification, with its origins in the theories of the seventeenth-century philosopher Descartes, kept problems of pain compartmentalized into pain of a physical origin or pain of an emotional or psychological origin.

The contributions of the Canadian and British researchers Melzack and Wall (1965) and the American William Fordyce (1974), proved to be exciting advances that removed pain from a mind versus body problem and placed it into the perspective of an interaction between mind and body and environment. This perspective of examining patients from a biological,

social, emotional and psychological perspective is widely known as the *biopsychosocial approach* (Knight and Camic 1998). This approach to patient care redirects attention away from the cause and cure orientation of acute care and focuses on a multidimensional orientation to care. Rather than only examining the patient's medical and biological data, the biopsychosocial approach attempts to integrate other factors in assessment and treatment. It is within this paradigm that the expressive arts therapies (drama/performance, writing/poetry, music, storytelling, visual art, dance/movement) have a theoretical and practical home.

Before specifically addressing the expressive arts' therapeutic role in the management of chronic pain I want to briefly introduce the Gate Control Theory (GCT) of chronic pain (Melzack and Wall 1965). This theory came about as a result of many clinical observations of people with chronic pain and research into the mechanisms of pain transmission. A concise description of the GCT is provided by Hardin (1998, pp.125–126):

> While this theory combined many components of previous models, it added the concept that pain signals were transmitted from the site of injury to the spinal cord where the signals are modulated before they go to the brain for perception. The site in the spinal cord where this modulation occurs is referred to as the 'gate', which can be affected not only by the intensity of the initial stimulation in the periphery, but also by factors in the spinal cord itself and by *messages coming back from the brain*. (Italics added)

The gate is controlled by both transmissions from the site of injury and from transmissions from the brain. The messages from the brain (which are referred to as efferent or descending tract messages) are presumed to be influenced by emotional and cognitive factors. If these factors cause the gate to open there will be a perception of increased pain. If, on the other hand, these messages allow the gate to close, there will be a decrease in pain perception. For a more detailed description of the GCT and for a review of revisions made to this theory over the past 30 years please see Melzack (1996).

As you can see, increases and/or decreases in chronic pain involve multiple factors; biochemical, cognitive/perceptual, emotional/affective, sensory, and social/environmental. Length of time one experiences pain and initial etiology are also contributory factors. In order to effectively treat a person with pain, practitioners must not only be aware of these factors, but also be able to use a range of interventions. In the biopsychosocial treatment

of pain, cognitive-behavioral approaches to pain management have been widely accepted as preferred methods of treatment when emotional, behavioral, cognitive and/or social factors exacerbate pain (Camic 1989; Hardin 1998; Keefe, Dunsmore and Burnett 1992; Miller 1992).

The role of the expressive arts in pain management

The cognitive-behavioral approach mentioned in the previous section does not help everyone who has chronic pain. Expressive arts have the potential to add treatment 'tools' to the health practitioner's (or institution's) portfolio along with medical intervention, pharmacotherapy, physical therapy, occupational therapy, and cognitive-behavioral or other approaches. Unfortunately, few comprehensive pain management programs include any of the expressive arts as part of the treatment mileau. A physician, physical therapist, health psychologist, and occupational therapist generally comprise the team that makes up a pain management clinic or service (Segraves 1989). The pain management literature found in medicine and psychology journals rarely entertains the possibility that expressive arts therapies could be useful in working with pain. Fortunately there have been studies that support the use of expressive arts in the treatment of chronic pain. This research, while in its infancy, is important and needs to be expanded.

The expressive arts I have used most frequently in pain management include the visual arts (drawing, painting, sculpture, collage), writing (poetry, narrative, journaling) and music (creating sounds – client as performer – and listening – client as audience). Art therapy has been used successfully with arthritis, migraine headache and oncology patients, underscoring its potential in pain management of both child and adult populations (Long 1997; 1998; Long and Sedberry 1994). I have been working within the field of pain management for over 15 years and in that time I have come to rely on the use of visual arts to help distract patients from pain, to help them make meaning of the pain, to relax, and to mourn the loss of physical functioning. Unfortunately, at the time of this writing, there are few reported studies using art therapy with chronic pain patients; I find this astounding. As I visit my father suffering through the middle and end stages of cancer during the writing of this chapter, I feel fortunate that I have been able to help him come to terms with the pain of his disease by using drawing and collage. We have spent several hours working together on these projects where previously he lay in bed in agony. Certainly some of his response is related to his son's visiting, but that is not the entire story. His use of drawing and painting, as

well as using photographs dating back to 1919, old newspaper articles, letters, and so on, to make a collage, have helped him make sense of the end period of his life as well as to serve as a distraction.

Writing is another useful tool in the management of pain. It allows people to have a voice when compromised by physical illness or emotional pain. Therapeutic support for the benefits of writing has been described by Gergen and Gergen (1988) and Pennebaker (1993), among others. Poetry in particular can allow people to create meaning in illness, and meaning in the events of their lives. Having the ability to comprehend meaning-in-pain can have a profoundly positive effect on our clients. Throughout much of Western literary history, poetry has been the medium that is often used to express strong emotions and experiences. Its use in therapy has been limited, mostly I believe, by a lack of knowledge about poetry as a therapeutic tool and by the lack of direct familiarity of poetry by many therapists. If a therapist does not write or read poetry, he or she is unlikely to use it with a client (Wilson 1998).

The use of music and sound has yielded more research on chronic pain management than other expressive arts. Generally speaking, there are more published studies concerning the use of music/sound and music therapy than all other expressive therapies combined. Reasons for this include the ability to control the independent variable (sound) more readily than with other arts; greater significance placed on research training in graduate music therapy programs; and music's facile availability and popularity as a medium.

The use of music in pain management has clearly been overlooked by most of the major pain treatment centers in North America. Yet several studies have supported the use of music as a primary or adjunctive treatment. While it is beyond the scope of this chapter to provide a thorough review of this body of research, I would like to touch upon those factors that lead to the inclusion of music/sound as a component in the workshop. Music has the ability to induce calm and a sense of well-being (Keegan 1987). Music has been shown to provide a range of physiological effects including regulation of heart rate, breath, and internal body rhythms (McLellan 1988) and immune functioning (Tsao *et al.* 1991). In a study by Zimmerman *et al.* (1989) on patients with cancer-related pain, the playing of preferred taped music was shown to reduce both suffering and the actual sensation of pain. This supports the belief that music has a direct influence upon sensory parameters. Another study by Scartelli (1984) showed how sedative music enhanced relaxation training. A later study examining the interaction of guided

imagery and sedative music demonstrated enhanced body temperature and a change in the production of stress hormones (Rider, Flyod and Kirkpatrick 1985).

Music has also been used to increase the pain perception threshold of patients with rheumatoid arthritis (Schorr 1993), reduce post-surgical pain (Rider 1987), and lower pain due to severe endometriosis (Colwell 1997). In a survey of music therapists using music for pain relief, Michel and Chesky (1995) found that the rationales for the use of music included relaxation, distraction, change in a patient's mood and to stimulate imagery. One theoretical framework for the use of music in pain management is based on the rationale that music can alter components of the pain experience and thus decrease the perception of pain (Magill-Levreault 1993). The areas where music may impact pain include affective, cognitive and sensory. For an overview of the use of music in medicine see David Aldridge's excellent review (1993).

Case study: using music, visual art and writing in a pain management group

This section is devoted to a detailed description of a group treatment workshop developed to help patients manage chronic pain. This was designated as a 'clinical research workshop' to indicate to clients the experimental nature of our work. The description 'workshop' was used rather than 'therapy' or 'treatment' because this was seen as a project to increase healthy functioning away from the 'sick role' that therapy or treatment often implies. Rather than viewing the workshop as something 'done to' a client, it was presented as something that is collaborative where the client maintains an active role in taking responsibility for her/his getting better (Allen 1995). For the purposes of the research we limited acceptance of clients to the specific criteria that follows: (1) pain duration of at least two years and not related to a malignancy or a life threatening illness; (2) all known and available medical and surgical procedures have been employed or ruled out; (3) no active substance abuse; and (4) an age range of 25–45 years old. (In purely clinical work, without a research agenda, these criteria can be relaxed or eliminated). This latter criteria was decided upon for several reasons. First, this was the range of the majority of patents seen in the pain management clinic. It also allowed a more homogeneous developmental sample from which to make some generalizations and placed subjects (clients) at a point early or in the middle of their work life expectations.

Twelve people were referred for the initial evaluation and seven were accepted into the group workshop. Referrals came from physical therapy (3), occupational therapy (2), neurosurgery (3), neurology (1), anesthesiology (1) and psychiatry (2). Clients were informed of the experimental nature of the workshop and were asked to sign a consent to participate. The workshop met once a week for ninety minutes over fifteen weeks in a fully handicapped-accessible building. Due to the experimental nature of the workshop, participants were not charged a fee. Ethical guidelines of the American Art Therapy Association and the American Psychological Association were followed throughout the study.

The organization and development of the workshop was inspired by several sources: a biobehavioral understanding of art making, empirical support for the use of music, writing and visual arts in pain management, and cost effective attributes and potential. Other foundations from which I drew in developing the group include the following:

(1) Cognitive-behavioral therapy (CBT) for pain management (see Turk, Meichenbaum and Genest (1983) for an excellent model using CBT for pain).

Using CBT as a theoretical/clinical framework from which to incorporate expressive therapy interventions: CBT acted as a guide to help develop the justifications for using expressive arts and to explain why they were effective. For example, at times it is useful to become distracted from chronic pain rather than continuing to focus on it. Creating sounds, using guided imagery prior to drawing or painting, working on an art piece, and so on, can all act as ways to distract someone from focusing on pain. The reinforcement a person receives from a decrease in pain perception is less suffering, enjoyment in creativity, fun/play (all subjective states), and so forth. These subjective states act as motivators to continue the art-related activities.

(2) Mindful meditation as a Zen philosophical belief which encourages focusing on the present as the only 'place' where change can occur (Suzuki 1970).

The use of mindful meditation before beginning any expressive arts exercise to help focus participants in the present moment, rather than in the past or on what the future may bring: it is not necessary to be fully acquainted with Zen Buddhist beliefs to make use of this exercise. A basic premise in using mindful meditation is the need to help people refocus on the present. Worry about whether the pain will increase or decrease confound a person's ability

to manage the pain in the present. In order to help participants create a mental place to begin expressive arts activities, a ten-minute meditation exercise is introduced during the second group session along with an explanation about the usefulness of remaining focused in the present.

(3) Existential philosophy and therapy as a perspective designed to help live one's life more fully and deeply (Moon 1990).

The use of existentialism in this workshop is introduced not as a complex academic treatise, but as a cognitive guide to help one come to terms with the meaning of events in one's life: it is introduced to participants through exercises and group discussion and art making in weeks 3, 4, 12 and 14. Questions such as 'What is the meaning of pain to you?' and 'How can you create meaning for your pain in your life at the present time?' help to begin discussion.

(4) Art making behavior as a basic human need (Allen 1995; Dissanayke 1988; 1992; Kent and Steward 1992).

Art making and art observing behaviors can influence our immune functioning (Tsao et al. 1991), affect and emotions, cognition, and perception (Gfeller 1990). Art making was a significant focus of this workshop; as an act of creation it is viewed as essential to the healing process: art making and to some extent art observing, requires personal involvement. The readiness to become involved in these experiences will likely affect how beneficial we find them. In addition to readiness of personal involvement, '...the evocation of feeling-into [empathy] and identification, the psychophysiological processes whereby we come temporarily to resonate to external objects and events as if their dynamics, motives and experiences occurred in us...' (Kreitler and Kreitler 1972, p.28) is essential if expressive arts therapies are to have an impact upon our clients.

(5) Guided mental imagery as both visual expression and therapy (Lusebrink 1990).

Imagery has several functions including: promotion of divergent thinking, increased self-control, increased resources for dealing with stress and as a way to facilitate creative understanding and gain insight. In this workshop imagery was used to increase relaxation, assist in concentration, facilitate openness to the creative process and to increase reflective distance. The

decision to add imagery was based on the premise, 'Art expression enhances right hemispheric functioning and imagery formation. Right hemispheric functioning affects expression. The perception of different external visual images ... activates right hemispheric activity ... right hemispheric functioning can (also) be activated with high imagery words and words high in affective value' (Lusebrink 1990, p.40). In the perception of pain sensation, emotional activation occurs. It is emotional activation, not the sensory experience of pain, that causes psychological distress. Imagery, music and visual expression all have the potential to increase or decrease hemispheric activity directly or through an alteration in pain perception.

Structure of the workshop

All potential participants were first assessed by a health psychologist or psychology intern (under the supervision of a licensed psychologist), to determine appropriateness for the workshop. If all criteria were met (described above) an explanation of the workshop philosophy (a focus on pain management), workshop goals, structure, and the responsibilities of the participant and facilitator were discussed. The workshop met for 15 weeks in weekly 90-minute meetings. Participants were all male and ranged in age from 29 to 44 years. Five were of European-American descent, one African-American and one Hispanic-American. All members were heterosexual and five were married. Five were not working due to disability and two were employed part-time.

Pre-workshop assessment included the administration of the Beck Depression Inventory (BDI) (Beck *et al.* 1961), the State-Trait Anxiety Inventory (STAI) (Spielberger, Gorsuch and Luskin 1970) and the Multidimensional Pain Inventory (MPI) (Kerns, Turk and Rudy 1985). The BDI is a well-known, easily administrated measure for depression taking about ten minutes to complete. The STAI is also straightforward to complete, taking 15–20 minutes. It also has strong reliability and validity measures and is one of the most widely used instruments to assess anxiety. The MPI was developed specifically to assess how well a person is coping with chronic pain and is based on a cognitive-behavioral model of pain. It examines the patient's perception of pain, what activities are affected by pain, and how others respond to the individual's pain.

In addition to these measures a semi-structured clinical interview was administered (Camic 1989, pp.64–69). This interview can be modified and shortened depending on the information the clinician seeks. If the client is

being referred from a health care professional well acquainted with the presenting problem, a less detailed interview is necessary. At the end of the pre-workshop assessment, data is obtained in several domains: level of depression and anxiety, coping style, perception of pain, activity level, and a qualitative description of the client's experience of pain, as well as a pain history. While some practitioners may find these measures too extensive and time consuming, I would argue that they provide a basis from which we can measure the effectiveness of our work. It also strikes me as not providing the best service to our clients if we as clinicians have not first performed a thorough assessment.

Session 1 introduces the guiding philosophy and principles behind chronic pain management. Participants are introduced to art making materials, music and writing and presented with a detailed overview of what will occur in the workshop. Time is left for questions and discussion in this, and all meetings to follow.

Session 2 continues the introduction to visual art making materials and techniques. This includes graphite and colored pencils, charcoal, tempera and acrylic paints, Cray-pas, crayons, pastels, different types of paper, adhesive materials (different types of glue and tapes), oil based non-hardening modeling clay as well as air drying clay that can be painted, scratchboard, 'found objects', collage and assemblage. Mindful meditation is introduced and practiced for ten minutes with written take-home practice recommendations.

Session 3 begins with ten minutes of mindful meditation practice and continues with visual art making. Participants are encouraged to try different mediums. Discussion centers around problems with art making materials, self-criticism and pain control. Questions and comments such as 'How is this going to help with my pain?' and 'I'm not an artist', 'I can't do this', 'I'm not any good at this', were voiced. The facilitator asks 'What is the meaning of pain to you?' to all members.

Session 4 begins with ten minutes of meditation practice followed by about 30 minutes of discussion. Issues concerning the meditation practice, pain control, art materials are voiced. [Clinical observation: there was a hint of less complaining and self-critical behavior beginning this week.] The remainder of the session (about 45 minutes) is devoted to introducing music and sound (Rogers 1993). Participants are asked to bring tapes or CDS for next week's meeting.

Session 5 and all remaining sessions begin with meditation practice with guided imagery, the latter technique is introduced at this session (Achterberg and Lawlis 1984). Guided imagery is used to facilitate visual art making activities, as a direct response to pain sensations, and as a way to gain relaxation. After the meditation practice and imagery discussion, participants are invited to play the recorded music they brought to the meeting. All workshop members (including the facilitator) respond to the music with a drawing or painting. A general discussion develops around the role of music in participants' lives. This is the first meeting where complaints of pain were not voiced.

Session 6 is the last session where a new component of the workshop is introduced. This allows participants nine remaining workshop sessions to incorporate the mediums, techniques and artistic disciplines within their work. After imagery and meditation practice the use of writing is introduced. Narrative, journal writing (Gladding 1992, pp.71–85) and poetry (Fox 1997; Lerner 1994; Wilson 1998) are presented through easy to understand exercises. An example of an exercise in writing poetry which was incorporated, is described by Wilson (1996, personal communication):

> 'Using a Post-It-Note (or similar product) write 1 to 3 words on each of 10 notes, describing how you feel when … (e.g. you get up in the morning; right now, at this moment; when you are in control of your pain, etc.). After you have completed writing, arrange the notes in any order that pleases you.' This order may in fact be a circle, a vertical line, or take a more customary poetic form.

The intent in utilizing writing, as a component of the workshop, is to provide another '…means for evoking experience which are at the disposal of language, in poetry and prose alike' (Kreitler and Kreitler 1972, p.247).

Session 7 begins with meditation and guided imagery. A client is asked to make a music selection and the group, including the facilitator, respond in any visual medium of their choice. This may include any of the visual arts options available (i.e. painting, drawing, clay, etc.). This work lasts one hour. Clients are then asked to respond to the music and the art work they have created through writing a poem. This is the first session where all workshop components (visual art, music, writing, meditation and imagery) are utilized. Many participants do not complete the poems in the time remaining and take them home to finish.

Session 8 begins with each participant silently reading their own poem, followed by meditation. Imagery is suggested by the facilitator, not as a

facilitator-guided imagery exercise, but one that evokes the image of the poem. For some this was a calming, distracting or relaxing image, but for others it was a violent, painful, angry one. For some in the group there was an increase in pain during this exercise, while for others, this was not the case. As you can imagine, the discussion that followed was quite lively! In running a group on your own, the reader may find a range of client responses after this exercise. We found that, even for the people who experienced increased pain, there was a sense of 'discovery', as one man put it, of the power of poetry to evoke images and emotions. Participants also realized the importance of poetry as another way to experience pain, perhaps somewhat less frighteningly, and with a sense of more control over their perception of it.

In the remaining time after this discussion, two participants each selected a piece of music that reflected their emotional and cognitive state. The group responded after each piece with a brief period of discussion. [Clinical note: depending on the length of discussion, additional pieces of music can be selected during this session. To insure that everyone in the group was able to share their music choices at least twice during the 15 weeks, I made a list of participants and asked them to note down when they played a piece.]

Sessions 9–13 were less structured than the previous meetings. Each began with meditation and guided imagery with the difference being that group members were asked to volunteer to lead this opening 'ritual' of our workshop. There was little hesitation to do this on the part of participants – the imagery was rich and involved industrial scenes, neighborhoods in the city well known to all, as well as forest walks and beaches. Discussions during these weeks were varied and open-ended. Some evolved around specific pain control strategies, others in dealing with family members, returning to work, accepting new physical limitations, masculinity and art making, and so on.

As previously stated, participants brought in music and the group responded to these pieces in writing, visual art work and discussion. One reset cast was very colorfully decorated in collage and a short (four-minute) opera was staged in response to this. Issues such as dealing with anger toward health care professionals (primarily physicians), insurance companies/ managed care organizations/workman's compensation were, at first, gingerly brought up, then approached with gusto. As a facilitator I wanted to both encourage this discussion, but also did not want the group to become overly focused on these, possibly destructive and damaging emotional issues.

Sessions 14 and 15 were times for preparing to say good-bye, but also times to be creative by revisiting newly experienced pain management tools and developing relapse prevention strategies (Marlatt and Gordon 1980). The facilitator took the lead by introducing relapse prevention preparation and underlining the significant work each participant had done over the course of fifteen weeks. Specific cognitive, behavioral, cognitive-behavioral and art-based procedures were reviewed. The group decided to jointly work on a collage that would be cut up and distributed to all group members on the last meeting as a reminder of their work together. One member also suggested the group create a musical piece and record this. Musical instruments consisted of African tribal and Native American, as well as 'found objects'. The composition was coordinated by two members and a seven-minute recording was made (multiple recordings of this tape were later sent to all participants).

Post-workshop evaluation: In order to evaluate the effectiveness of the workshop, qualitative and quantitative research methods were selected to assess change over the course of treatment. Quantitative measures, which were described earlier in the chapter, were administered at weeks 5, 10 and 15. The qualitative research methods of triangulation, visual analysis, and content analysis were used to examine the content of journals, art work and taped recorded workshop sessions, as well as clinic and hospital records (please see Stake 1995 and Yin 1989 for a complete description of case study research). One of the research questions involved knowing what were the significant factors useful for participants in this workshop (i.e. how did participants make use of the different components of the workshop, etc.) While data analysis is currently being reviewed, it appears that being able to distract oneself from pain and seeing oneself as being able to create – although still in pain – were important to all participants. In addition, depression levels in six of the seven participants were lower as seen on the BDI and through self-report. Anxiety levels, as measured by the STAI and through self-report, were decreased for all individuals and self-report pain management abilities were reported to be increased by six members. Five members organized home studio spaces complete with a place to write and make visual art and listen and/or play music.

Conclusion

This preliminary study utilized visual art making, poetry, narrative writing and journal writing, music/sound, mindful meditation and guided imagery

in a fifteen week workshop-based venue for seven men with chronic benign pain. These mediums were incorporated into a cognitive-behavioral therapy paradigm along with an appreciation for Zen and existential philosophical traditions. The men who participated in this workshop had previously been treated by a variety of health care professionals who utilized an array of interventions including surgery, medication, electrical stimulation, psychotherapy, occupational therapy and cognitive-behavioral therapy.

While not discounting the benefits of cognitive-behavioral therapy for chronic pain patients, it was not sufficient to help these individuals deal with their pain. By incorporating art-based interventions within a cognitive-behavioral frame of reference, I hoped to offer these men an alternative treatment that would aid in their abilities to live with pain. Fifteen weeks in the life of any adult is a very short period of time. The results from this preliminary intervention study do indicate that chronic pain management therapy can benefit from the inclusion of expressive arts therapy.

While additional research is necessary, these results are particularly promising for several reasons. No participant had any recent experience with any of the creative arts for a number of years. Only two participants received formal music training (in their high school years) and none had formal training in the visual arts after the age of fourteen. None of the participants completed college and all either currently held or previously held employment in 'blue-collar' positions. Basically, the men seen in this study did not have a particular appreciation for the arts prior to the study nor had they engaged in any of the arts (other than letter writing and listening to music) for at least eight years.

As practitioners of expressive arts therapies expand the boundaries of who they work with, it is essential that research be conducted to document these experiences. Even treatment failures need to be documented and reported, so refinements in our work can occur. However, expressive arts therapists and researchers apparently choose not to publish their work in these publications (Camic 1998). If clinicians and health care administrators who work in pain clinics do not have the opportunity to review clinical studies involving expressive arts approaches to pain, it is unlikely they will discover what this approach has to offer. There is also a potential bias against using the arts as a health care intervention because they do not appear 'scientific' or clinically proven. This is somewhat a chicken-and-egg problem; if they are not tried out as an intervention we will not discover their potential

and if the clinicians using the arts do not write about their work no one will learn about its value.

New research initiatives are needed to further develop our knowledge in how the visual arts affect pain. A research background is not necessary but relationships with researchers are necessary. This is the time, if you are not inclined to undertake the research by yourself, to develop collaborative relationships with doctorally-trained researchers and clinical researchers. My current experience in working as a research consultant with the Open Studio Project in Chicago (Allen 1995) has been a rewarding one for myself and the three art therapists who jointly direct the work of the Project. While one of the art therapists (Dr Pat Allen) has research training, the four of us have, through common interests and good, old fashioned hard work, been able to use each other's talents and skills to collaboratively study the Open Studio process. I urge all expressive therapists to consider a role for research in your life.

References

Achterberg, J. and Lawlis, G.F. (1984) *Imagery and Disease.* Champaign, IL: Institute for Personality and Ability Training.

Aldridge, D. (1993) 'Music therapy research 1: A review of the medical research literature within a general context of music therapy research'. *The Arts in Psychotherapy 20,* 11–35.

Allen, P.B. (1995) *Art is a Way of Knowing.* Boston: Shambhala.

Beck, A.T., Ward, C.H., Medelson, M., Mock, J. and Erbaugh, J. (1961) 'An inventory for measuring depression'. *Archives of General Psychiatry 4,* 53–63.

Bonica, J.J. (1977) 'Neurophysiologic and pathophysiologic aspects of chronic pain'. *Archives of Surgery 112,* 750–761.

Boring, E.G. (1942) *Sensation and Perception: The History of Experimental Psychology.* New York: Appelton-Century.

Camic, P.M. (1989) 'Psychological assessment of the chronic pain patient: Behaviors, cognition, and dynamics'. In P.M. Camic and F.D. Brown (eds) *Assessing Chronic Pain: A Multidisciplinary Clinic Handbook.* New York and Berlin: Springer-Verlag.

Camic, P.M. (1998) 'Psychology, Art and Healing'. Unpublished paper presented at the American Psychological Association Annual Meeting, San Francisco, CA.

Colwell, C.M. (1997) 'Music as distraction and relaxation to reduce chronic pain and narcotic ingestation: A case study'. *Music Therapy Perspectives 15,* 24–31.

Dissanayke, E. (1988) *What is Art For?* Seattle and London: University of Washington Press.

Dissanayke, E. (1992) *Homoaestheticus: Where Art Comes From and Why.* New York: Free Press.

Fordyce, W.E. (1974) 'Pain as a learned behavior'. *Archives in Neurology 4,* 415–422.

Fox, J. (1997) *Poetic Medicine: The Healing Art of Poem Making.* New York: Tarcher-Putnam.

Gergen, J.K. and Gergen, M.M. (1988) 'Narrative and self as relationship'. In L. Berkowitz (ed) *Advances in Experimental and Social Psychology*. New York: Academic Press.

Gfeller, K. (1990) 'The function of aesthetic stimuli in the therapeutic process'. In R.F. Unkefer (ed) *Music Therapy in the Treatment of Adults with Mental Disorders: Theoretical Bases and Clinical Interventions*. New York: Schirmer Books.

Gladding, S. (1992) *Counseling as an Art: The Creative Arts in Counseling*. Alexandria, VA: American Counseling Association.

Hardin, K.N. (1998) 'Chronic pain management'. In P.M. Camic and S.J. Knight (eds) *Clinical Handbook of Health Psychology*. Seattle and Toronto: Hogrefe and Huber.

International Association for the Study of Pain (1979) 'Pain terms: A list with definitions and notes on usage'. *Pain 6*, 249–252.

Keefe, F.J., Dunsmore, J. and Burnett, R. (1992) 'Behavioral and cognitive-behavioral approaches to chronic pain: Recent advances and future directions'. *Journal of Consulting and Clinical Psychology 60*, 528–536.

Keegan, L. (1987) 'Holistic nursing: An approach to patient and self care'. *AORN-J 46*, 449–506.

Kent, C. and Steward, J. (1992) *Learning by Heart: Teachings to Free the Creative Spirit*. New York: Bantam.

Kerns, R.D., Turk, D.C. and Rudy, T. (1985) 'The West Haven-Yale Multidimensional Pain Inventory'. *Pain 23*, 345–356.

Knight, S.J. and Camic, P.M. (1998) 'Health psychology and medicine: The art and science of healing'. In P.M. Camic and S.J. Knight (eds) *Clinical Handbook of Health Psychology*. Seattle and Toronto: Hogrefe and Huber.

Kreitler, H. and Kreitler, S. (1972) *Psychology of the Arts*. Durham, North Carolina: Duke University Press.

Lerner, A. (1994) *Poetry and the Therapeutic Experience*. St. Louis: MMB Publishers.

Long, J.K. (1997) 'Medical Art Therapy in the Treatment of Migraines'. Unpublished paper presented at the Fourth Annual International Symposium in Pediatric Pain, Helsinki, Finland.

Long, J.K. (1998) 'Medical art therapy: Using imagery and visual expression in healing'. In P.M. Camic and S.J. Knight (eds) *Clinical Handbook of Health Psychology*. Seattle and Toronto: Hogrefe and Huber.

Long, J.K. and Sedberry, D. (1994) 'Pain Reduction in Pediatric Oncology: Integrating Medical Art Therapy, Hypnotherapy, and Play Therapy'. Oral presentation at the Third International Symposium on Pediatric Pain: Children and Pain: Integrating Science and Care. Philadelphia.

Lusebrink, V.B. (1990) *Imagery and Visual Expression in Therapy*. New York: Plenum.

Magill-Levreault, L. (1993) 'Music therapy in pain and symptom management'. *Journal of Palliative Care 9*, 42–47.

Marlatt, G.A. and Gordon, J.R. (1980) 'Determinants of relapse: Implications for the maintenance of human behavior change'. In P.O. Davidson and S.M. Davidson (eds) *Behavioral Medicine: Changing Health Lifestyles*. New York: Brunner/Mazel.

McLellan (1988) *The Healing Forces of Music*. New York: Amity House.

Melzack, R.M. (1996) 'Gate control theory: On the evolution of pain concepts'. *Pain Forum 5*, 128–138.

Melzack, R.M. and Wall, P.D. (1965) 'Pain mechanisms: A new theory'. *Science 150*, 971–979.

Michel, D.E. and Chesky, K.S. (1995) 'A survey of music therapists using music for pain relief'. *The Arts in Psychotherapy 22*, 49–51.

Miller, L. (1992) 'Psychotherapy of the chronic pain patient II: Treatment principles and practices'. *Psychotherapy in Private Practice 11*, 69–82.

Moon, B. (1990) *Existential Art Therapy: The Canvas Mirror*. Springfield, Illinois: Charles C Thomas.

Pennebaker, J.W. (1993) 'Putting stress into words: Health, linguistic and therapeutic implications'. *Behaviour Research and Therapy 31*, 539–548.

Rider, M.S. (1987) 'Treating chronic disease and pain with music-mediated imagery'. *Arts in Psychotherapy 13*, 113–120.

Rider, M.S., Flyod, J.W. and Kirkpatrick, J. (1985) 'The effect of music-mediated imagery and relaxation on adrenal corticosteroids and the re-entrainment of circadian rhythms'. *Journal of Music Therapy 22*, 46–58.

Rogers, N. (1993) *The Creative Connection: Expressive Arts as Healing*. Palo Alto, CA: Science and Behavior Books.

Scartelli, J.P. (1984) 'The effects of EMG biofeedback and sedative music, EMG biofeedback only, and sedative music only on frontalis muscle relaxation ability'. *The Journal of Music Therapy 21*, 67–68.

Schorr, J. (1993) 'Music and pattern change in chronic pain'. *Advanced Nursing Science 15*, 27–36.

Segraves, K.B. (1989) 'Bringing it all together: Developing the clinical treatment team'. In P.M. Camic and F.D. Brown (eds) *Assessing Chronic Pain: A Multidisciplinary Clinic Handbook*. New York and Berlin: Springer-Verlag.

Spielberger, C., Gorsuch, R. and Luskin, R. (1970) *Manual for the State-Trait Anxiety Inventory*. Palo Alto, CA: Consulting Psychologists Press.

Stake, R.E. (1995) *The Art of Case Study Research, Second Edition*. Thousand Oaks, CA: Sage.

Sternback, R. (ed) (1978) *The Psychology of Pain*. New York: Raven.

Suzuki, S. (1970) *Zen Mind, Beginner's Mind*. New York and Tokyo: Weatherhill.

Tsao, C.C., Gordon, T.F., Marantoc, C.D., Kerman, C. and Murasko, D. (1991) 'The effects of music and biological imagery on immune response (S-IgA)'. In C. Dileo-Maranto (ed) *Applications of Music in Medicine*. Washington, DC: National Association for Music Therapy.

Turk, D.C., Meichenbaum, D. and Genest, M. (1983) *Pain and Behavioral Medicine: A Cognitive-Behavioral Perspective*. New York: Guilford.

Turk, D.E. and Nash, T.E. (1993) 'Chronic pain: New ways to cope'. In D. Goleman and J. Gurins (eds) *Mind/Body Medicine: How to Use Your Mind for Better Health*. Yonkers, NY: Consumer Reports Books.

Wilson, L.E. (1998) 'Interdisciplinary Arts and the Vocabulary of Expression'. Unpublished paper presented at the American Psychological Association Annual Meeting, San Francisco, CA.

Yin, R.K. (1989) *Case Study Research: Design and Methods, Second Edition*. Newbury Park, CA: Sage.

Zimmerman, L., Pozehl, B., Duncan, K. and Schmitz, R. (1989) 'Effects of music in patients who had chronic cancer pain'. *Western Journal of Nursing Research 11*, 298–309.

Further Reading

Achterberg, J. (1985) *Imagery in Healing: Shamanism and Modern Medicine.* Boston: New Sciences Library.

Aldridge, D. (1996) *Music Therapy Research and Practice in Medicine.* London: Jessica Kingsley Publishers.

Syrjala, K.L. and Abrams, J.R. (1996) 'Hypnosis and imagery in the treatment of pain'. In R.J. Gatchel and D.C. Turk (eds) *Psychological Approaches to Pain Management: A Practitioner's Handbook.* New York: Guilford.

Art Therapy with Laryngectomy Patients

Susan Ainlay Anand and Vinod K. Anand

Introduction

Life with cancer is a dynamic time period that is disruptive to 'normal life' as perceived by the patient. The diagnosis is invariably confronted with trepidation and succeeded by concern for loss of life and material possessions, and apprehension about family relationships. There are many distinctions in the psychological distress experienced by cancer patients based on the body part involved (i.e. breast cancer, cancer causing disfigurement that is difficult to hide), prognosis, and type of treatment required. The therapeutic approach has to recognize these differences and the particular coping styles of the individual.

In the United States alone, approximately 12,500 new cases of laryngeal cancer are diagnosed and treated each year. Many of these patients require total laryngectomy (removal of the voice box) for 'curative attempt' and adjunctive radiation and chemotherapy. Laryngectomy patients suffer from serious psychological consequences related to loss of normal voice and impairment of several vital functions including respiration, swallowing, smell, taste, and chewing. Because of these impending changes, patients approach laryngectomy with heightened anxiety, and experience depression, grief, and altered body image following surgery.

Art therapy experiences with adult cancer patients have been described (Baron 1989; Dreifuss-Kattan 1990; Jeppson 1982; Lichtenthal 1985; Malchiodi 1994; Mango 1992; Minar 1992; Minar *et al.* 1991; Rudloff 1985; Tate 1989). Art therapy for patients diagnosed with cancer of the head and neck region requires special understanding and a team approach for

physical and emotional rehabilitation. The psychological aftermath of total laryngectomy is predominately related to aphonia (loss of natural voice) and therefore these patients are uniquely suited to a nonverbal form of therapeutic intervention such as art therapy.

This chapter will present our experience of managing laryngeal cancer patients over the past 14 years and discuss the following issues:

1. need for therapeutic intervention in identifying psychological issues

2. success of this modality in helping patients overcome psychic distress

3. difficulties experienced in rendering this treatment

4. need to educate the physician and nursing community about psychological aspects and therapeutic options

5. need to educate the art therapy community regarding the special medical and therapeutic needs of this group

6. role of individual and group art therapy

7. family dynamics and intervention strategies

8. *role of art therapist on the laryngectomy treatment team.*

Description of setting and population

The University of Mississippi Medical Center is a 593-bed teaching hospital which provides medical services to patients from considerable distances. From 1982 to present we managed 109 patients with laryngeal cancer at this medical facility. The average age at time of diagnosis was 58.3 years+- 10.9 SD (Standard Deviations). It is interesting to note that 36 per cent of patients had symptoms of cancer for over 6 months. Moreover, in our population, 72 per cent had advanced disease. In 26 patients, an airway compromise required them to undergo emergency tracheotomy prior to definitive laryngeal surgery.

Most patients with laryngeal cancer come from a poor socioeconomic background and have a history of heavy tobacco and alcohol use. Of the patients treated at our facility, smoking and drinking were significant risk factors in 97 per cent and 79 per cent respectively, with 80 per cent consuming both heavily. Consequently, many of these patients had pre-existing psychological problems, limited coping skills, and a number of medical conditions including emphysema and malnutrition.

Clinical aspects of laryngectomy

A basic knowledge of laryngeal anatomy is essential to the therapists who encounter laryngectomy patients. The human larynx (voice box) is a complex structure with an intricate link to the central speech areas in the brain. The vocal cords allow phonation and protection of lungs from aspiration. They are also the most frequent site of cancerous development in the larynx. Anatomically, the larynx may be considered to have three distinct compartments: supraglottis, glottis (vocal cords), and the subglottis. The so-called 'food pipe' has an intimate relationship with the larynx as shown in Figure 3.1a.

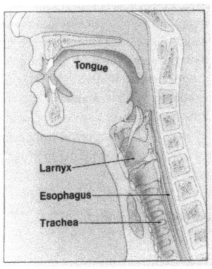

Figure 3.1a Normal laryngeal anatomy

Figure 3.1b Post laryngectomy view of neck with stoma

Patients with laryngeal cancer present with hoarseness, sore throat, swallowing difficulty, earache, weight loss, and difficulty in breathing in advanced cases. For diagnostic evaluation, imaging studies (computed tomography, magnetic resonance scan) are often needed. Diagnostic confirmation requires a biopsy in the operating room. Fortunately, spread to sites other than the neck is uncommon. Early cancers of the larynx can be effectively cured by radiation therapy or laser surgery without affecting the ability to speak or swallow with cure rates as high as 90 per cent. For more advanced cancers of the larynx, 'conservation' surgical procedures (i.e., supraglottic laryngectomy, hemilaryngectomy, partial laryngectomy, subtotal or three quarters laryngectomy) may achieve the goal of cancer removal while maintaining the ability to phonate and swallow.

Although early laryngeal cancer is effectively treated by such conservative approaches, total laryngectomy is often the only surgical procedure that provides a reasonable hope of cure in advanced cases. This entails removal of the entire larynx and without further intervention, loss of the natural ability to speak. Other treatment modalities such as radiation therapy and chemotherapy may be used in conjunction in an attempt to improve possibility of cure. For advanced cases requiring total laryngectomy, cure rates are estimated to be about 50 per cent.

Psychological aspects of laryngectomy
Preoperative period

Given a diagnosis of laryngeal cancer, patients generally respond with shock and grief, followed by anxiety and/or depression. Predisposition for depressive reactions to illness and surgery and feelings of guilt and punishment are also common in this group (Dhooper 1985). The preoperative period is characterized by patient fears about their impending disability, concern for social acceptance, recurrent cancer, dependency, surgical procedures, and postoperative deficits, especially aphonia (Nahum and Golden 1963; Shapiro and Kornfeld 1987). Concerns about disfigurement may exist, due to the need for tracheostoma and the possible necessity for neck dissection in which various muscles and neck nodes are removed. Adequate preoperative counseling appears to diminish these fears (Kommers, Sullivan and Yonkers 1977; Nahum and Golden 1963). Some patients feel that a visit by a rehabilitated laryngectomee helps to alleviate anxiety (Gardner 1966; Johnson, Casper and Lesswing 1979). Breitbart and

Holland (1988) have suggested the need for rehabilitation to begin before surgery to assess for psychiatric disturbances related to alcohol abuse such as withdrawal, cognitive impairment, and dementia.

Immediate postoperative period

During hospitalization after surgery, patients are confronted with loss of natural voice production, abnormal appearance of neck, and decreased ability to taste and smell causing alterations in self-concept (Nahum and Golden 1963). The laryngectomee must also deal with changed breathing patterns because of the creation of a new 'stoma' (see Figure 3.1b). Laryngeal surgery constitutes one of the most rapid and aggressive assaults on body image (Dropkin 1980). As a result, patients experience varying degrees of depression and may harbor suicidal thoughts (Barton 1965; Byrne et al. 1993). Frustration and anger due to inability to communicate needs often exists. Providing the means for some form of communication (i.e. board computer) following surgery is vital to healing and recovery (Weber and Reimer 1993). With prolonged hospital stays, patients may exhibit increased adjustment reactions such as regression and helplessness, withdrawal, and noncompliance (Bronheim, Strain and Biller 1991).

While reactive behavior to surgery usually occurs within the immediate postoperative period, some patients may experience anger and depression weeks or even months later. A team approach among staff is helpful in preparing patients and their families for the emotional fallout expected from major head and neck surgery. Staff can help patients identify possible difficulties that may be encountered postoperatively and suggest coping strategies, which will contribute to a more positive treatment outcome (Breitbart and Holland 1988; Herzon and Boshier 1979; Johnson et al. 1979; Lucente, Strain and Wyatt 1987).

Rehabilitation

Successful adaptation following laryngectomy surgery appears to be linked to mastery of effective communication (Bronheim et al. 1991). While some patients are able to learn esophageal speech (by swallowing air and 'burping' it out through food pipe), patients who have been irradiated postoperatively and older patients do not achieve such successful outcome. Inability to achieve esophageal speech is often viewed as another failure and contributes to existing sense of loss, low self-esteem, and continuing depression (Byrne et

al. 1993). Depression may also be linked to the patient perception that others will not make serious attempts to comprehend communication (Shapiro and Kornfeld 1987). Additionally, geographically isolated patients have marked tendency for depression (Byrne *et al.* 1993). Patients who continue to have difficulties with speech production have increased incidences of disability and failure to return to work, as reported by their spouses (Dhooper 1985). Due to the tremendous impact newly acquired speech has on the adaptive and rehabilitative process, subsequent attempts to achieve communication combined with support mechanisms are necessary (Wetmore *et al.* 1985). Radiotherapy, often used as an adjunct to surgical interventions, creates physical difficulties for the patient and has psychiatric effects such as anxiety (Bronheim *et al.* 1991).

Recurrence

Cancer patients, including those with laryngeal carcinoma, fear recurrence. Patients may require further diagnostic procedures, hospitalization, chemotherapy, or radiation therapy. Management of the terminally ill laryngectomy patient is complex due to problems with impaired voice. Families may have difficulty accepting and grieving due to inability to talk through feelings with the patient (Lucente *et al.* 1987). Patients with communication problems and major change in body image may experience difficulty maintaining an active rather than passive stance in their orientation toward life and death (Shapiro and Kornfeld 1987). Some patients may exhibit behavioral changes related to psychological problems of an organic or functional nature. Periods of denial are common and may serve a productive purpose as long as delivery of care is not sacrificed. Patients with recurring cancer experience a wide range of grief reactions including anger, guilt, shame, and depression.

The patient's family

Laryngectomy surgery affects the entire family due to the severity of dysfunction experienced by these patients. Communication problems between patients and their spouses were reported in 44 per cent of one sample (Kommers *et al.* 1977). Mathieson, Stam, and Scott (1990) found that wives of laryngectomy patients often complained of increased psychological and physical problems. Sexual activity may decrease due to psychological problems, stoma, and medical problems related to the illness. Financial stress

is often experienced because of unemployment following surgery and incurred medical expenses. Johnson *et al.* (1979) reported that major unanticipated difficulties were cited by family members related to psychological change in patient's attitude and mood, communication problems, family reactions to physical changes, and social embarrassment of patient and family due to speech, stoma, and loud coughing. Lucente *et al.* (1987) recommended family and group therapy for patients who experience recurrent lesions or require prolonged medical treatment.

Case examples

Case 1

JS was 46 years old when scheduled for laryngectomy surgery. He was divorced, unemployed, and living with his mother. His admitting diagnosis was carcinoma of the larynx with metastasis to lymph node. He was scheduled for total laryngectomy and left neck dissection the next morning. JS had received a preoperative visit by his physician to discuss risks of surgery, including, but not limited to loss of voice, shoulder weakness, fistula drainage to other nerves and vessels, stroke, and further surgery. He had also been seen by the speech pathologist to review the nature of the surgery and effects on speech and breathing. Various methods of laryngeal speech were discussed and he was supplied with communication pictures.

The initial art therapy session occurred the night before surgery. Following a brief description of art therapy, JS said he had never received art instruction in school but he agreed to participate requesting small paper and felt pens. Spontaneous artwork was apparently difficult for this patient and attempts were made to provide more structure by suggesting a theme to develop in imagery. JS continued to express self-doubt and asked if he could draw later when alone. Interventions at this time were designed to offer support and encourage self-expression. Subsequently, it was determined that continued efforts to encourage use of materials might increase already heightened anxiety in this patient. JS said, 'I think I am doubting myself. I've never amounted to anything'. He also stated that he had no family members present for surgery and identified fellow employees at a previous job as most supportive to him. He described his current feeling as 'alone'. JS requested paper and felt pens for drawing in his room at a later time.

JS was again seen in his room on day eight following surgery. He was now on liquid diet and able to get out of bed. His affect appeared flat and he

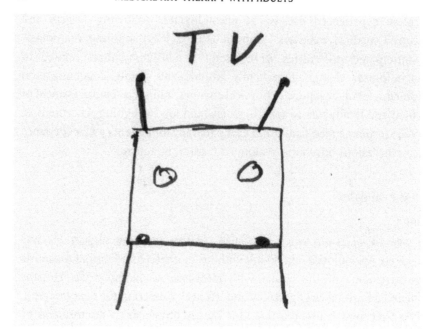

Figure 3.2 JS, 'TV'

occasionally cried during the session. JS was able to communicate through gesture and simple written words. He wrote 'talk' as his most serious problem since surgery. When asked to complete a drawing, he drew a television (Figure 3.2) and was able to communicate that it represented 'boredom' and his fear that he would no longer be able to do the things he enjoyed in life.

Details of the television suggest an angry face with sealed mouth. A second drawing in pastels was completed with a few red lines in the upper left-hand corner and then a centrally placed blue color to create a cloud-like shape described as 'the sky' and 'a nice day'. Use of denial seems apparent in this second piece as JS struggled with highly charged emotions. JS then revealed that his teeth would be extracted the next day. Issues related to loss of body parts and control over life were discussed. He indicated that he had no ability to pay for dentures or an electro-larynx. He requested markers and paper to remain in the room despite no known attempts to use them spontaneously.

Case 2

JR was 54 years old at the time of his total laryngectomy. He had a history of heavy tobacco and alcohol use. JR was not married and lived with a sister and her family. He reported good family support during hospitalization. Removal of teeth and radiation treatment upon discharge had been scheduled. JR completed one drawing during his first art therapy session five days following surgery. Through handwritten notes, he described this drawing as his home in the country and explained that he drew himself sitting on the porch to illustrate his favorite activity at home (Figure 3.3).

The drawing appears empty and incomplete. Disorganization evident in parts of the drawing may indicate heightened anxiety that has influenced his ability to cognitively integrate objects within the picture. The road on the left side of the paper appears to be cut off as if it can go nowhere. Following this drawing, JR communicated through writing that he feared death and expressed concerns for family members that he would 'leave behind'. He also questioned whether he would be able to adjust to a lifestyle that would limit recreational activities such as fishing due to an increased risk of drowning (water can easily enter lungs through the stoma).

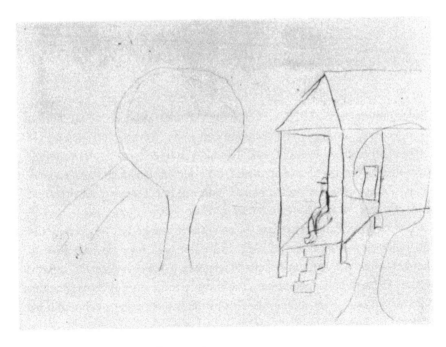

Figure 3.3 JR, 'My home in the country'

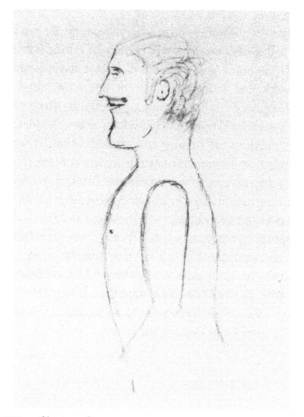

Figure 3.4 LW, profile view of man

Case 3

The beginning session of art therapy for LW was initiated one week after laryngectomy surgery. He communicated by writing on paper. He complained that his neck felt 'stiff'. Some resistance to using art materials was noted. Given a variety of art media, LW selected small paper and a pencil. He drew a few lines and wrote, 'when I make one line, I see two'. On a second sheet of paper, he completed a drawing of a person (Figure 3.4).

Sketchy line quality is used on the chin, neck, and body. The open mouth and bulky appearance of the neck and chest area may be indicative of changes in body image and emotional response to loss of voice. During this session, LW avoided opportunities to address feelings and concerns about his disease, surgery, or rehabilitation. This avoidance is perhaps echoed in his decision to draw the figure in profile.

Figure 3.5 TS, 'Fish'

Case 4

TS was a 50-year-old man at the time of his surgery. He was married, but separated from his wife and lived alone in a rural area. He had a history of excessive alcohol and tobacco use. TS was employed at a lumber company prior to surgery, but due to the danger of inhaling sawdust through the stoma, he was advised to resign and apply for disability. TS was initially seen for art therapy on day seven after surgery. His affect appeared flat with depressed mood. For communication purposes, he pointed to pictures and was able to nod when attempts to understand him were correct. The first drawing completed was described as a fish (Figure 3.5).

Blue pastel was added below the fish to indicate water. The drawing seems to convey the impression of 'a fish out of water' perhaps reflecting the threat of death and sense of alienation experienced by this patient. A second drawing, created with blue marker, depicts a primitive looking head with the word 'apple' (Figure 3.6).

The face lacks a nose and the open mouth appears empty. The patient was able to communicate that he was tired of liquid food and would be happy once he resumed a normal diet. Sketchy line quality below the chin suggests anxiety over this area of the body.

Following discharge from the hospital, TS was seen in art therapy several more times while at the hospital for radiation treatments. Sessions followed

Figure 3.6 TS, Head with word 'apple'

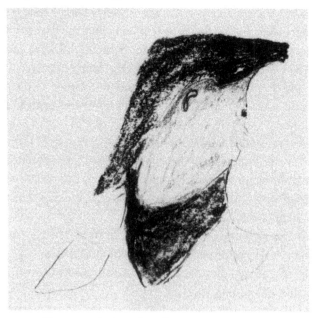

Figure 3.7 TS, Self-portrait, 'thinking about the disease'

brief meetings with the speech pathologist, who was providing instruction on the use of an electro-larynx. Despite successful attempts to speak with this device, TS was unable to afford one of his own and had to leave sessions without one. During the first week of radiation treatment, a drawing was completed in art therapy using pencil and pastels (Figure 3.7). It was described as a picture of him 'thinking about the disease'.

This drawing speaks to the regressed state TS must have been in while in the hospital when he completed the drawing of a head (see Figure 3.6); the change in style is dramatic. The side view of head and neck is consistent with the side of the neck receiving radiation. The head turned to the side suggests evasiveness and perhaps difficulty confronting the physical effects of laryngectomy. TS was wearing a bib, a protective piece of material covering the stoma to filter out foreign material and he included this in his drawing (suggesting that the bib was now integrated into TS's body concept). However, the head, bib and neck are blended together with lack of definition between these parts. Attention to the ear with excessive erasures and darkened lines alludes to anxiety over this region. Perhaps TS was attributing greater importance to listening in order to hear what others say and thus avoid requests for repeated information.

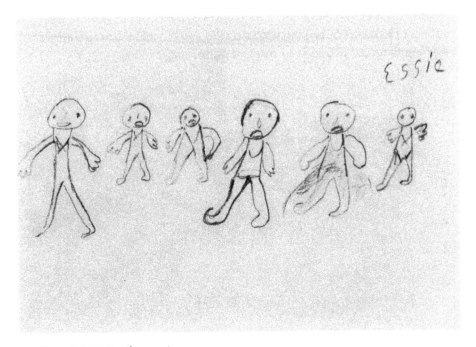

Figure 3.8 TS, Family portrait

One week later, TS attended another art therapy session that was dominated by themes of earlier loss. At the beginning of the session, he appeared reluctant to use art materials and stated that he was experiencing heartburn as a side effect to radiation. Subsequently, TS completed a simple cube drawing in pencil. When asked what the shape represented, TS said he would like it to be a gift for his wife with a car inside for her to visit him. TS disclosed that he missed his wife and desired a closer relationship with her. The final drawing of this session was a requested family portrait (Figure 3.8).

Each member of the family depicted in the drawing was labeled with the initials of their name. TS briefly discussed the death of a son who had been hit by a car at the age of eleven. This child was identified as the figure on the far right. All of the figures are depicted with a detail resembling a bib in the neck region suggesting preoccupation of the neck.

Case 5

SM was seen in his hospital room during cobalt treatment one month after laryngectomy surgery. He was able to communicate with an electro-larynx, but was difficult to understand. SM appeared irritable and withdrawn. Following unsuccessful attempts to elicit a free drawing, a suggestion was made to draw a circle and add details to turn it into something. After writing a series of numbers, SM completed a face (Figure 3.9). On the top and right side of the head, SM added a small worm-like shape.

Figure 3.9 SM, Face with numbers

The face does not have a mouth or perhaps it is sealed over. Eyes appear anxious. SM refused to describe his artwork. This drawing suggests complicating factors in the psychological realm and the need to alert team members to consult Psychiatry for evaluation of this patient.

Case 6

DC was 54 years old when she participated in art therapy sessions. Three years prior to this time, she had a total laryngectomy with modified radical neck dissection and total teeth extraction. Following surgery, DC decided to leave her job as a security guard at the hospital because of her difficulty in adjusting to laryngeal speech methods. While attempts had been made to learn esophageal speech, DC had opted to use an electro-larynx. She was now able to communicate well with this device. During her first art therapy session, DC stated that she had adjusted well to the diagnosis of cancer and the effects of laryngectomy surgery. She said that 'feeling different' was the most frustrating aspect of her current situation – 'People often stare at me'. She also said there are times when she leaves her home without an electro-larynx because, 'I forget that I don't have a voice'. While hesitant to use art materials during this initial session, DC was able to complete a detailed pastel of her fishing at a reservoir (Figure 3.10).

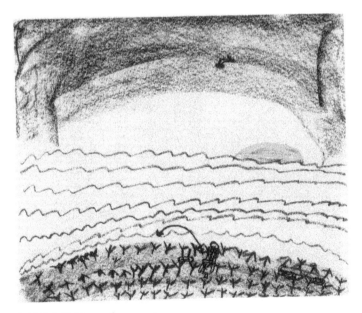

Figure 3.10 DC, Fishing at the reservoir

There are several transparencies in this drawing, disproportion between objects, and repetition of detail in the surrounding environment. This is in contrast to the lack of detail on the figure. The drawing suggests anxiety over the environment (particularly one containing water) and attempts to manage the world in a highly structured manner.

Case 7

JM was a 72-year-old man when he was seen in an art therapy session with his wife of 50 years. He had laryngectomy surgery eight months prior to this time. At the time of diagnosis, his cancer was advanced and required extensive surgical resection and radiation treatment. This couple was referred to art therapy to assess for and encourage expression of problems experienced in the family. After a brief description of art therapy, JM and his wife were offered art materials to illustrate how cancer and laryngectomy surgery had affected their lives. Mrs JM stated that they had not experienced many problems. She repeatedly expressed her discomfort with art materials and said she hoped her husband's physician would not be disappointed in her inability to produce a drawing. On a separate sheet of paper, JM used markers and drew a graph-like line depicting his emotional experience from the time of surgery to the present (Figure 3.11).

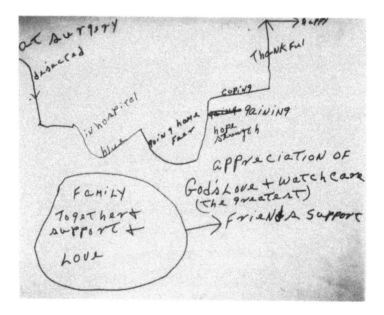

Figure 3.11 JM, Graph-like line depicting emotional experience

He used words and colors to describe the various feelings he had experienced throughout this time. Upon completion of this drawing, JM freely discussed the 'downs' felt after surgery and during hospitalization. JM said the most difficult time had occurred after discharge from the hospital when he experienced tremendous fear. Mrs JM agreed and talked about her feelings of inadequacy when faced with the provision of complicated medical interventions in the care of her husband. JM continued to describe the rest of his picture as representing an upward swing in recent months when he began to cope, adjust, and gain physical strength. During the week prior to this session, JM had acquired a new electro-larynx to communicate. Both JM and his wife said they were hopeful that persistent problems with speech would lessen with this new device. Family, friends and medical staff were viewed as extremely supportive throughout the course of medical intervention and rehabilitation. Religious faith was cited as the most useful tool in coping with this illness. JM said he blamed himself for the cancer due to his decision to smoke. He also stated that he felt guilty for 'having made my family go through this'.

Art therapy interventions and art-based assessments

Art therapy is most effective with laryngectomy patients when used as part of a treatment team approach. Generally, the treatment team is comprised of the physician/surgeon, radiation therapist, oncologist, dentist, nurse, speech pathologist, social worker, physiotherapist, respiratory therapist, and dietitian. At the facility described in this paper, an art therapist is also part of this team.

During art therapy sessions, a variety of art media is offered that can be easily transported to the patient's room and used in a small work area. Drawing boards are given to patients who prefer to remain in bed while hospitalized. Art media should be easy to use and offer success-oriented experience. A sense of continuity from session to session is achieved by providing the same materials throughout the course of treatment. Additional art supplies are added to meet individual needs. Examples of art materials appropriate for this patient population include: variety of paper, pencils, paints, felt pens, pastels, oil pastels, clay, and collage materials.

For assessment purposes, patients may be asked to draw a person, self-portrait or family portrait. Occasionally, patients are directed to 'illustrate their disease' or expectations for surgery. The process of directing patients to complete specific art forms is individual and based on therapeutic

needs addressed in each session. For example, patients who are apprehensive to participate in the use of art materials may be encouraged to draw their fears or feelings following a brief description of the effects of color and line on art expression and/or instruction in technique. However, an unstructured approach seems to be most valuable in providing patients with an expressive outlet that maximizes their sense of control. The therapist designs interventions based on individual patient needs and according to the physical and psychological characteristics of each stage of treatment.

Preoperative session

Patients are usually admitted to the hospital the day before surgery to complete preoperative tests. The preoperative art therapy session is generally conducted in the patient's hospital room at bedside. At this time, patients frequently exhibit regressed psychological states and verbalize feelings of helplessness, anxiety, and fear. Patients may be reluctant to discuss or acknowledge the extent of their illness and the impact surgery will have on their lives. Knowledge of psychological effects and medical procedures is helpful in attempting to meet patient needs as they arise during this initial session. The goals for preoperative art therapy interventions are to:

1. establish a therapeutic framework for art therapy interventions

2. establish trust with patient and family members

3. assess artwork and behavior for premorbid personality characteristics

4. assess patient response to illness and medical treatment through artwork and discussion

5. offer art making as a means to reduce anxiety and as an outlet for self-expression

6. assist in team assessment of alcohol abuse and possible effects on the patient's ability for adaptation and rehabilitation.

Postoperative sessions

Patients return to their room from the intensive care unit once medically stable and usually within two days. However, patients continue to receive liquids and medications through an intravenous route and require a nasogastric tube for feedings. Regular visits by a respiratory therapist are necessary to help expel mucus. The speech pathologist makes arrangements

for patients to be supplied with communication booklets or boards comprised of pictures instead of words prior to surgery. Speech therapy sessions generally begin prior to discharge. Dental work may be required in preparation for radiation treatment. Length of stay in the hospital, barring no significant postoperative complications, is seven to ten days.

Following surgery, patients are confronted with loss of natural voice and experience the full impact of their disability and disfigurement. Psychological effects on the patient's self-concept are inevitable. Especially significant is the alteration in body image. Frustration and anger at staff or self are not uncommon.

Art therapy interventions are scheduled according to patient rate of recovery as evidenced by decreased levels of discomfort, food intake, and mobility. Appropriate timing for art therapy interventions can be achieved by checking in on the patient each day. Regular visits seem to help establish rapport and strengthen the therapeutic alliance for subsequent sessions. Often, immediate postoperative sessions are conducted in the hospital room three to five days following surgery. Once sessions are possible, the therapist can attempt to facilitate patient expression of feelings related to laryngeal cancer and postoperative effects. Art therapy may be the patient's only avenue to express these feelings and begin reintegration of physical changes. Art therapy treatment goals during the postoperative period include:

1. assessment for depression and anxiety

2. provision of art materials for ventilation of feelings

3. use of art making for addressing loss and grief issues

4. increasing self-esteem through mastery of art media

5. art making to address body image alteration

6. providing support to patient and family members.

Sessions during rehabilitation

Following discharge, patients must begin the rehabilitation process at home without the constant support of medical staff. Patients and their families are generally uneasy about their ability to provide adequate medical care. Self-care is preferred and encouraged, but some patients may exhibit increased dependency and demand assistance from their spouses or family members. Frequently, family members encounter alterations in mood, anxiety or fear along with the patient. Follow-up medical appointments are

often scheduled approximately every two to three months. Patients requiring radiation treatment begin a six-week outpatient course of treatment. Speech therapy is offered to ease communication problems as patients usually learn to use an electro-larynx in a short period of time. Esophageal speech instruction is oftentimes postponed until radiation treatment is completed and patients experience less discomfort.

Art therapy sessions are ideally scheduled on days when patients return to the hospital for medical treatment or clinic appointments. Some of our patients are referred for follow-up to medical facilities closer to their homes. Art therapy interventions may cease or be limited if access to an art therapist or someone with adequate knowledge of art therapy is not available in these facilities. For patients who continue treatment in our hospital, sessions are conducted in an office adjacent to the clinic. Art therapy goals during the rehabilitation period include:

1. providing support to the patient and family

2. ongoing assessment of psychological reactions to illness and ability to adapt to postoperative deficits

3. encouragement of self-expression

4. strengthening self-concept.

Family art therapy sessions

Patients are typically seen alone for art therapy, but family sessions are scheduled when patients or staff request assistance in assessing and managing problems within the family. Interventions at this time are geared towards supporting the patient and family members through the long-term stress of treatment. While family art therapy sessions may occur at any time in the treatment and rehabilitation of the laryngectomy patient, sessions ideally begin preoperatively to assist in the educational and therapeutic aspects of this early counseling. Art therapy goals when working with families of laryngectomees include:

1. addressing family reaction to diagnosis of cancer, dysfunction, and disability

2. enhancing communication

3. assessment of psychological effects on family members

4. offering opportunities for self-expression related to the impact of laryngectomy.

Art therapy groups

Therapeutic benefits of groups seem to be of value in laryngectomy patients. The benefits of groups include: peer support, realization that one's problems are not unique, and the opportunity to build social and communicative skills. On-going group meetings are frequently established in hospitals or through agencies providing services to cancer patients. Laryngectomy groups or 'Lost Cord Clubs' can be formed as chapters within the International Association of Laryngectomees. These groups provide education and support to patients and their families.

Art therapy sessions were routinely offered in conjunction with a Lost Cord Club at our hospital. Usually eight to ten members and their family members attended monthly meetings that were facilitated by a speech therapist. Members of the group varied from early to late stage in the rehabilitation process. Most communicated with an electro-larynx, while a few were able to use esophageal speech. Volunteers from this group were asked to visit patients awaiting laryngectomy surgery in the hospital. Following a general meeting, patients were invited to participate in an art therapy group. A variety of art materials were available to complete both individual and group artwork. Most of the time, patients were encouraged to develop a theme for murals. Art therapy goals for these groups were to:

1. encourage awareness and expression of problems experienced in rehabilitation

2. practice speech methods during discussion of artwork

3. increase communication skills

4. build social skills

5. provide a setting for peer support with open expression of feelings through art and discussion.

Conclusion

Art therapy can make a significant impact on the management of laryngectomy patients. Art-based assessments and art therapy interventions provide the team with insight into the patient and family responses to illness

and impact of surgery. A protocol to refer patients to art therapy should be established with other team members to ensure early referral, particularly during the preoperative period of the patient's hospital stay.

In our experience, patients were initially hesitant to use art materials in therapy. Poor interpersonal and communicative skills combined with lack of previous exposure to art media appeared to contribute to this problem. Constant reassurance and interventions targeting reduction of anxiety over art production are integral aspects of art therapy sessions especially during the preoperative period. Due to heightened levels of anxiety manifest in this population, the therapist must determine the efficacy of the interventions and perhaps delay use of art materials until the patient becomes more comfortable with them. Low energy levels due to the disease process, radiotherapy and depression may necessitate brief sessions.

Any therapist working with laryngectomy patients must be well versed in the medical interventions and psychological aspects of laryngectomy. Special considerations of this patient group include prolonged rehabilitative efforts directed at resolution of swallowing difficulties, radiotherapeutic complications, chemotherapeutic needs and requirements for speech rehabilitation. Many patients view their problems as solely medical rather than psychological in nature. A team approach to treatment and rehabilitation which includes art therapy, appears to lessen the resistance some patients have to interventions aimed at reducing psychological effects of cancer diagnosis and surgery.

Participation in art therapy and the resulting artwork can assist the treatment team in determining psychological changes and adaptation to laryngectomy surgery. Fear, loss and changes in lifestyle, depression, and/or interpersonal relationships are typical themes observed in patient artwork. Body image alteration and integration is also frequently reflected in figure drawings and problems within the family are often revealed through family art therapy sessions.

Most importantly, art therapy appears to be an ideal treatment modality for laryngectomy patients who may suffer severe deficits in communication following surgery. Paper or sketchbooks left in hospital rooms at all times offer patients opportunities for expression of feelings and needs through graphic or written communication. Because postoperative communication is difficult, recognition of nonverbal cues by the therapist is key so that he or she can verbally articulate them for the patient. As patients begin to use an

electro-larynx or esophageal speech later in rehabilitation, art therapy becomes another safe arena to practice growing communication skills.

References

Baron, P. (1989) 'Fighting cancer with images'. In H. Wadeson, J. Durkin and D. Perach (eds) *Advances in Art Therapy*. New York: John Wiley and Sons.

Barton, R.T. (1965) 'Life after laryngectomy'. *Laryngoscope 75*, 1408–1414.

Breitbart, W. and Holland, J. (1988) 'Psychological aspects of head and neck cancer'. *Seminars in Oncology 15*, 1, 61–69.

Bronheim, H., Strain, J.J. and Biller, H.F. (1991) 'Psychiatric aspects of head and neck surgery Part I.: New surgical techniques and psychiatric consequences'. *General Hospital Psychiatry 13*, 3, 165–176.

Byrne, A., Walsh, M., Farrelly, M. and O'Driscoll, K. (1993) 'Depression following laryngectomy. A pilot study'. *British Journal of Psychiatry 163*, 173–176.

Dhooper, S.S. (1985) 'Social work with laryngectomees'. *Health and Social Work 10*, 3, 217–227.

Dreifuss-Kattan, E. (1990) *Cancer Stories: Creativity and Self-Repair*. Hillsdale, NJ: Analytic Press.

Dropkin, M.J. (1980) 'Changes in body image associated with head and neck cancer'. In L. Marino (ed) *Cancer Nursing*. St. Louis, MO: CV Mosby Company.

Gardner, W.H. (1966) 'Adjustment problems of laryngectomized women'. *Archives of Otolaryngology 83*, 57–68.

Herzon, F. and Boshier, M. (1979) 'Head and neck cancer – emotional management'. *Head and Neck Surgery 2*, 112–118.

Jeppson, P.M. (1982) 'Creative approaches to coping with cancer: Art therapy and the cancer patient'. *Proceedings of the 13th Annual Conference of the American Art Therapy Association*. Mundelein, IL: AATA.

Johnson, J.T., Casper, J. and Lesswing, N.J. (1979) 'Toward the total rehabilitation of the laryngeal patient'. *Laryngoscope 89*, 1813–1819.

Kommers, M.S., Sullivan, M.D. and Yonkers, A.J. (1977) 'Counseling the laryngectomized patient'. *Laryngoscope 87*, 1961–1965.

Lichtenthal, S. (1985) 'Working with a terminally ill young adult'. *Pratt Institute Creative Arts Therapy Review 6*, 11–21.

Lucente, F., Strain, J.J. and Wyatt, D.A. (1987) 'Psychological problems of the patient with head and neck cancer'. In S.E. Thawley and W.R. Panje (eds) *Comprehensive Management of Head and Neck Tumors, Vol.1*. Philadelphia: W.B. Saunders.

Malchiodi, C.A. (1994) 'Invasive art: Art as empowerment for women with breast cancer'. *Proceedings of the 25th Annual Conference of the American Art Therapy Association*. Mundelein, IL: AATA.

Mango, C. (1992) 'Emma: Art Therapy illustrating personal and universal images of loss'. *Omega – Journal of Death and Dying 25*, 4, 259–269.

Mathieson, C.M., Stam, H.J. and Scott, J.P. (1990) 'Psychosocial adjustment after laryngectomy: A review of the literature'. *Journal of Otolaryngology 19*, 331–336.

Minar, V. (1992) 'Living with cancer: Images of the hurter and the healer'. *Proceedings of the 23rd Annual Conference of the American Art Therapy Association*. Mundelein, IL: AATA.

Minar, V., Erdmann, J., Kapitan, L., Richter-Loesl, S. and Vance, L. (1991) 'Confronting cancer through art: A collaborative effort by hospital, patient and therapist'. *Proceedings of the 22nd Annual Conference of the American Art Therapy Association.* Mundelein, IL: AATA.

Nahum, A.M. and Golden, J.S. (1963) 'Psychological problems of laryngectomy'. *Journal of the American Medical Association 186,* 3, 1136–1138.

Rudloff, L. (1985) 'Michael: An illustrated story of a young man with cancer'. *American Journal of Art Therapy 24,* 2, 49–62.

Shapiro, P.A. and Kornfeld, D.S. (1987) 'Psychiatric aspects of head and neck cancer surgery'. *Psychiatric Clinics of North America 10,* 1, 87–100.

Tate, F.B. (1989) 'Symbols in the graphic art of the dying'. *The Arts in Psychotherapy 16,* 115–120.

Weber, M. and Reimer, M. (1993) 'Laryngectomy: Grieving disfigurement and dysfunction'. *Canadian Nurse 89,* 3, 31–34.

Wetmore, S.J., Kreuger, K., Wesson K. and Blessing, M.L. (1985) 'Long-term results of the Blom-Singer speech rehabilitation procedure'. *Archives of Otolaryngology 111,* 106–109.

Dreamwork and Sandtray Therapy with Mastectomy Patients

Vija B. Lusebrink

Cancer as a life threatening illness affects the whole person, including the physical body, emotions, and cognitive, social, and spiritual aspects of one's life. The anxieties and stress being diagnosed with cancer are compounded by the invasive nature of medical treatments and their side effects. Stress also influences the immune system by depressing its functioning (Achterberg and Lawlis 1980). Complementary therapies involving relaxation and imagery are used to help cancer patients to lessen the stress of facing their illness and the side effects of treatment. Relaxation and imagery enhance body/mind interaction and increase the responsiveness of the immune system (Decker and Cline-Elsen 1992; Gruber *et al.* 1988; Gruber *et al.* 1993), and lessen the side effects of chemotherapy (Burish and Jenkins 1992; Burish, Snyder and Jenkins 1991).

The focus of this chapter is on the convergence of dreams and sandtray therapies as imagery based approaches in working with mastectomy patients who have recently undergone surgery and/or are dealing with intensive chemotherapy treatments.

The function of dreams

The main function of dreams is to integrate previously acquired knowledge and input from visceral and sensory channels with the present experience. The organization of dream processes can be seen as based on the same set of psychophysiological operations which are common to all states of consciousness integrating information from different memory storages

(Koukkou and Lehmann 1993). Emotions play an important role in the formation of dream sequences. In dreams, the previous day's experiences with the highest emotional tone influence the recall of memories associated with similar emotions and intensity (Kramer 1993). These emotions and the dreamer's reaction to the dream images influence the subsequent scenes of a dream (Klinger 1978; Lusebrink 1990); different emotions and concepts may be presented in dreams by their antitheses (Cartwright and Lamberg 1992). The thematic content of dreams through the night generally reflects problem-solving sequences, whereby a dream states the problem and in the subsequent scenes works on the solution. Through this integrative process the dream contains and resolves some of the emotional surge present in it. The dreamer's emotional state upon awakening in the morning is influenced by the dream mood. Serious traumas may result in repetitive dreams, in which the traumatic events may be restated in the dreams but without any progress towards their resolution (Kramer 1993). Over a period of time repetitive dreams may change to recurrent dreams. Recurrent dreams are associated with stressful experiences; they are characterized by their negative dream content, whereby the recurrent themes present some variations in content. Eventually the trauma or stress may be worked through and absorbed through connections with older memories, and the dreams may return to their usual themes (Hartman 1996; Zadra 1996).

Dreams, somatic changes and illness

The physiological and biochemical changes in the body may be represented in dreams through metaphorical images. The content of women's dreams in the different phases of their menstrual cycle, in the different trimesters of their pregnancies, and in menopause are influenced by and reflect the changes in their bodies (Cartwright and Lamberg 1992; Garfield 1990; Van de Castle 1994). Dream images in prodromal dreams can indicate impending disease such as cancer. Traumatic dreams can become markers of a dysfunctional state in the individual and imply the presence of diseases such as asthma, cardiac dysfunctions, tuberculosis, gastrointestinal disorders, and cancer (Cartwright and Lamberg 1992; Siegel 1990; Smith 1990). Surgery may be emotionally experienced in dreams as a physical attack (Cartwright and Lamberg 1992). Illnesses can bring about increased dream recall. The dreams generally indicate the presence of illness through increasingly stressful content before the onset of the symptoms. Dreams in illness can provide important sources of information; they can be indicative of the

seriousness of the illness and can reveal its location (Siegel 1990). Dreams can also indicate healing and health remedies. Images of light have been associated with healing (Van de Castle 1994).

Personality of the cancer patient

The personality of the dreamer influences the recall of dreams and responses to dreams. Breast cancer patients have been found to have greater emotional suppression than controls, and to be less hostile and irritable in stressful situations than patients with benign breast lesions (Eysenck 1988; Grassi and Cappellari 1988; Jansen and Muenz 1984). Some authors have considered the C type personality – retiring, nonassertive, unexpressive, unable to recognize their own feelings – as the prototype for a cancer patient (Temoshok and Dreher 1993; Temoshok and Heller 1984), but opinions in this respect differ (Levenson and Bemis 1991). Breast cancer patients may also exhibit alexithymic characteristics, namely, the inability to identify and describe feelings, distinguish between feelings and bodily sensations, and communicate feelings to others; they also may have difficulty in remembering dreams and daydreaming, and prefer focusing on external instead of internal experiences (Todarello et al. 1989). Alexithymic characteristics in general are associated with a high physiological arousal but a low self awareness of it.

Imagery and sandtray therapy

Images are multileveled in that they incorporate perceptual, affective, cognitive, and symbolic, as well as psychophysiological aspects (Lusebrink 1990). Imagery serves as a means of communication between mind and body (Achterberg and Lawlis 1980). Sandtray therapy and art therapy are complementary therapies which use visual expression of imagery in working with cancer patients. The representation of dream images through sandtray figurines or through art media, such as drawing, painting, or sculpting, retains the expressive qualities of the images and their spatial relationships. Visual representation of the dream images reinforces awareness of the image in consciousness, and enhances their reintegration in the psyche and reincorporation in subsequent dreams.

Sandtray therapy with its presence of a given field, namely a tray partially filled with a fine sand and plethora of available figurines and objects, provides means of expression for the spatial, temporal, figurative, and

affective relationships between the images. Sandplay as a form of active imagination provides a tangible record of the images (Bradway and McCoard 1997). It also offers possibilities to explore associations and emotions, leading to changes in and transformation of the imagery with the related healing, emotional and spiritual growth, and expanded consciousness (Ammann 1991; Bradway and McCoard 1997; Kalff 1980; Ryce-Menuhin 1992; Weinrib 1983).

The multileveled nature of images forms a span from the physical /physiological realm through personal experiences, memories and personal unconscious to archetypal symbolism. Archetypal symbolic images reflect the potentials or inherent possibilities for actions and emotions in the collective unconscious, and are likely to manifest themselves during major traumatic experiences (Jacobi 1959). The use of archetypal figurines in the sandtray showed correlation with the Openness factor (Lusebrink 1994–1995) on the NEO Personality Inventory (Costa and McCrae 1989; McCrae 1993–1994) indicating the presence of permeability of different levels of consciousness.

Spatial and temporal placements of the sandtray figurines and their configurations may represent different periods in the past, and reflect different levels of the images, either related to personal history or alluding to their archetypal content. Spatial arrangements and the location of groups of figurines within the area of the sandbox may be indicative of the temporal references of their meaning. Similar to the location of forms in different areas of the paper in projective tests (Hammer 1958), the right area of the tray may refer to the future whereas the left area may refer to the past. Ryce-Menuhin (1992) differentiates the different levels of meaning of the figurines according to the areas of the tray used: the upper right can refer to the conscious material, the lower part to the personal unconscious with its bottom area as collective unconscious, and the upper left to the collective unconscious or archetypal material. This division, though, has not been observed to be consistent by other sandplay therapists (Bradway and McCoard 1997), including the present author. The spatial organization of up/down, right/left, and center has intrinsic value in itself in organizing one's external and internal orientation. These directions correspond to the center and axes of mandalas as maps of psychic orientation.

Approaches to sandtray therapy with cancer patients

Sandtray therapy can be either nondirected or directed (Tennessen and Strand 1998). The particular approach used in sandtray therapy depends on the therapist's theoretical orientation and the client's needs and level of information processing. The present discussion gives the rationale for some of the methods used in sandtray therapy with mastectomy patients.

Sandtray therapy incorporates a strong sensory element in the use of the sand. At the start of each session the touching of the sand and rhythmical movements of hands over the smooth surface of the fine sand increase the individual's sense of relaxation. This in turn enhances imagery formation and opens receptivity to the symbolic aspects of imagery instead of being limited to concrete meaning. The change in the levels of consciousness from a concrete, external reality orientation to a more introspective symbolic level can create a bridge to internal images and dream consciousness.

Since cancer affects all aspects of a person's life, an initial sandtray representation of 'Your world now' gives an overview for the client and the therapist about the client's reactions to life threatening illness. Further, representation of the interaction of the cancer with chemotherapy and immune system helps cancer patients clarify their attitude – conscious, subliminal, or unconscious – towards the treatment. Their perception of the strength and vitality of their immune system and the cancer cells (Achterberg and Lawlis 1980) is represented by the figurines.

Sandtray therapy lends itself to dream representations through displaying the most important dream scenes or a whole dream sequence in the same tray and portraying dream actions with the figurines. Dreams represent a continuation of the dreamer's waking life experiences and reenact her intrapersonal and interpersonal concerns. Rediscovery and expression of affect associated with dream images in sandtray therapy through the action with the figurines can precipitate a transformation of the imagery and its effects on the immune system and healing. The representations of dreams through the figurines can be reality oriented, metaphoric, or symbolic, as are the dream images themselves. Individuals may have different degrees of conscious understanding of the symbolic aspects of the meaning of different dream images. Lack of verbal and affective associations to the images indicate the predominant unconscious and/or archetypal nature of the dream images.

In the Jungian approach, sandplay therapy has been likened to dreamwork in that sandplay consists of a series of figures and scenes (Bradway and McCoard 1997). The *nondirected Jungian approach* to sandplay

therapy is based on a slow transformation of the images and attitudes over a period of time. The Jungian approach designates this type of work in the sandtray as sandplay or 'playwork for the psyche'. The therapist avoids intruding on the client's sandplay experience and at the same time with her presence provides an environment of accepting containment. The images expressed in sandtray configurations are dealt with on a nonverbal level through a series of sandplay sequences without being discussed or interpreted (Bradway and McCoard 1997). In circumstances of limited time, more directed interventions may be preferred.

In a *directed approach* to sandtray therapy the therapist is more immediately involved in promoting conditions that facilitate change (Tennessen and Strand 1998). The term sandtray therapy is used throughout this chapter indicating the directed approach to the client's expressions in the sandtray. In the directed approach, the therapist may suggest a general theme for the sandtray, but avoids intruding in the client's work while the client is actively involved in the sandtray. The images expressed in the sandtray are dealt with using various approaches after the completion of the sandtray, including the nondirected approach, or having the client explore changes in the sandtray or role play with the figurines depending on the client's needs.

Visual and verbal exploration of the sandtray images and configurations can emphasize either their cognitive or symbolic aspects and the associated feelings. Depending on the ego strength of the individual, some of the meaning of the sandtray configurations can be brought to consciousness with visual and verbal clarifications of the images, affect, and associations. The visual and verbal exploration also can help in the discovery of different dream dimensions and the pairs representing the opposites of these dimensions (Cartwright and Lamberg 1992). Part of the visual clarification can be obtained through denoting the spatial arrangements of the figurines in relation to each other. The differentiation of the topical or affective areas can be seen in actual barriers set between the different areas. Sequential organization is reflected in the order the figurines are placed in the sandtray and gives an indication of the associations between the figurines. A sequence of topical areas may be defined by initial placement of a few figurines in different areas of the sandtray and elaborated upon later, or an area may be fully developed before the next one is started. Sequential organization can also unfold in a circular pattern, echoing the borders of the sandtray.

Role playing with the figurines, having them represent either interpersonal or intrapersonal concerns, opens possibilities for exploring associations and

feelings represented through the images as well as relating to the situations and problems from different viewpoints. This approach is helpful in dealing with interpersonal problems and in acquiring assertiveness skills. For cancer patients these ways of interacting are important, because their active participation in the treatment and decision making may help the individual to regain some sense of control. Representations of disturbing dream scenes can be changed through role play into acceptable resolutions (Cartwright and Lamberg 1992).

The different approaches used in sandtray therapy in working with mastectomy patients and their dreams are illustrated in the case studies discussed below.

Case examples

The following examples of dreamwork and expressions in sandtray are from a short term study using sandtray therapy with breast cancer patients. The issues addressed over the eight-week interventions were the following: depiction of 'your world now', coping with the stress of dealing with cancer and mastectomy, interpersonal concerns, relaxation, visualization of the interaction between the immune system and the cancer cells, dreams, and spiritual support. Each week at the beginning of the session the subjects were asked to fill out a Feeling Thermometer, a sheet with seven vertical bars representing the following feelings: sad, happy, angry, scared, peaceful, and two blank bars for feelings of the subject's choice. They were also given a sheet with an outline of a woman's body where they could indicate the location of pain and other sensations in their bodies. Each session was concluded with relaxation exercises and healing guided daydreams.

Of the eight subjects participating in the study, four reported their dreams, even though all the individuals were asked in each session whether they could remember any dreams from the previous week. The lack of dream recall for some of the subjects may have been associated with secondary alexithymia due to the chronic nature of cancer, as compared to the acute phases and interventions. One of the characteristics of alexithymia is the individual's inability to remember dreams (Todarello *et al.* 1989).

The following are dreams from two case histories of mastectomy patients working in sandtray therapy. The two dream series represent two different reactions and dream responses to acute cancer. The italics in the dream texts indicate that the author's attention was drawn to these words during individuals' reports of the dreams or sandtray configurations. The focus in

the following narratives is mainly on the subjects' dreams and their representation in sandtray.

Mrs N's dreams and sandtray configurations.

Mrs N was a 47-year-old married professional woman with two daughters. Her cancer had been discovered in a routine check-up and she had undergone a double mastectomy a week prior to joining the sandtray study. The cancer was caught at a relatively early stage and only one of her lymph nodes was invaded by the cancer. Mrs N was under a great deal of psychological stress as the cancer had taken her by surprise, especially since she had always taken good care of her health. She had a strong faith, but now she was angry at God, and experienced a fear of dying. She had difficulties sleeping and had lost a considerable amount of weight in the last few weeks since the diagnosis.

In the first session she told about a dream where somebody in an open field grabbed her breasts and ran away with them. She was chasing him, but could not catch him. She woke up angry. In representing her 'world now' she included all her family and an angel for her faith. At first she buried the figure representing herself, a nude pregnant woman, but then resurrected her because she said that she 'will fight with all her might'. She had a supportive husband and many supportive friends.

In the second session she brought in three dream narratives. The first dream was a replay of the discovery of her cancer and the following surgery. She felt terrified in the dreams. The second dream dealt with her and her daughter giving support to her father who in the dream had leukemia. Then in the dream she realized that she had cancer and felt confused. She chose to portray the third dream in the sandtray. In this dream she was driving with her husband and oldest daughter who both got out on the ridge of a hole with steep sides and green grass at the bottom. Her husband and daughter somersaulted into the hole and waved at her. She was terrified that she would not be able to help them to get out, because her arms were weak as a result of the surgery. In the sandtray she role-played the interaction between the figures and shared her frustration at not being able to help them and that they would have to take care of themselves.

In the third session she was very concerned about the effects of the drugs. In the sandtray she represented a dream where she was on her knees in a closet throwing out things and then noticed herself as a separate figure in a coffin with her head turned looking back at her. In the meantime the active

Figure 4.1a Sandtray representation of Mrs N's dream (third session): Self with fences as 'sawhorses' approaching the other part of self lying in a 'coffin'.

Figure 4.1b Sandtray transformation of Mrs N's dream: The other part of self is upright and the cancer battle has been inserted in the middle – a jester as the cancer, hippopotamus as chemotherapy, and rabbits as her immune system.

part of her pulled a couple of wooden sawhorses out of the closet for support, and then noticed that the figure in the coffin had her head turned back straight. She woke up thinking: 'I will die', but she was not terrified in the dream (Figure 4.1a).

In processing the sandtray configuration she was asked to use the Gestalt method of identifying with and speaking for the different parts in the scene. She chose the sawhorse supports to represent the cancer treatment, which she took over to the supine figure and then helped the figure to get up. In the middle of the sandtray she created a scene of her cancer battle, with the treatment as a hippopotamus with its mouth open, the cancer as a jester, and her immune system as rabbits, since they 'were gentle' (Figure 4.1b).

In the fourth session she shared that she was terrified of the treatment, and angry about it and the cancer. She was asked to explore further the images of chemotherapy, the cancer and her immune system in the sandtray and give a form to her feelings about them. In addition to choosing a totem pole figurine for her anger, she ended up including an evergreen tree as hope and protection for her healthy cells from the chemotherapy.

For the fifth session she brought in a dream of the surgeon dangling her lymph nodes in front of her. She stated that the psychological stress associated with her illness and treatment was for her harder to take than the physical stress in her body. She was angry about the cancer and felt betrayed by her body. Her sandtray figurines represented her confrontation with the dream image of the surgeon. She placed an angel at her side for protection and added a baby at the other side to represent her impatient side.

In the sixth session Mrs N's mood had stabilized to some extent; her Feeling Thermometer showed, for the first time, a marked increase in peacefulness. She brought in several dreams. The first dream was a comforting repetitive dream she had had in her childhood of being inside a Volkswagen 'beetle' while being chased by a dog. In the second dream she had taken a toy from a cedar chest – a soft white plastic truck – and had placed it in a sink to soak in bleach with the other dishes. Her comment was that this was very out of character since in reality she would have washed the dishes first. Her association with white was 'clean'.

Mrs N choose to represent the third dream in the sandtray (Figure 4.2). In the first scene (upper middle) she was with Tony, a popular, humor loving disc jockey, and a nondescript person to her right. They were being told by a voice (represented in the sandtray as a 'bad guy'): 'You have to run.' In the next scene (lower left) somebody was in her office going through her

professional journals. She knew that Tony's fishing license was there, and if the bad guy found it, Tony would be found. Then the dream scene switched to a department store (upper left) where a 'black guy' was polishing glass. She warned him that he must run, because he, too, could be found. The 'guy' replied that he would stay to clean. In the last scene (right) she found herself on the Pacific coast climbing stairs. Her sister was following her and Mrs N helped her. For her, the overall theme of this dream representation was running versus climbing. The climbing out was the most important part and she associated it with climbing out of the pit. She characterized her sister as the opposite of her who would be more scared and less involved in helping herself if she had cancer than Mrs N. Her associations with Tony were a sense of humor which she felt she had lost because of her cancer.

Mrs N wanted to change the sandtray configuration by having the chemotherapy eating the 'bad guy'. She introduced a pig as the chemotherapy because 'pigs eat anything', whereas her immune system was represented by sheep because 'they are gentle'. She said that after finishing the first version of the sandtray she had still felt like running, but after the changes she felt more powerful. It was also interesting to note that in the

Figure 4.2 Sandtray representation of Mrs N's dream (sixth session): Center – self, 'black guy', and Tony confronted by the 'bad guy'; lower left – Mrs N's office scene; upper left – department store scene; right – climbing up with sister.

previous week's guided imagery (Dessoille 1966) session, she had had a stream that was flowing from the ocean and in this week's guided imagery session the stream was flowing from the source.

In the seventh session Mrs N was feeling and looking much better, and had gained some weight. She had had a couple of dreams, both of which were puzzling to her. In one dream she was driving with a man in an ambulance with organ transplants. She had Christmas Club money which needed to be spent. Mrs N said that she enjoyed Christmas with friends and going to Christmas parties, but she did not use Christmas Club accounts.

In the second dream she was facing many 'white clad people in robes' who told her: 'You cannot do that!' She woke up from the dream confused. It was important for her to portray the people in white in the sandtray. Since there were only a few white figurines available, the therapist suggested to use white tissue paper as an indication of their white robes (Figure 4.3). In role play, using the sandtray figurines, she explored the possibility of changing her position of being confronted to one of being supported. With the support of the people and an added angel she confronted the cancer.

Figure 4.3 Sandtray representation of Mrs N's dream (seventh session): White robed people, self, and an angel confronting the cancer (totem pole).

In the last session she was asked again to portray her 'world now'. She created a scene of herself and her family surrounded by friends and backed by a protective barrier of evergreens, which in an earlier sandtray had represented hope for her. She buried the cancer image instead of herself as she had done in the first sandtray. She said she was still afraid of dying and put an Indian as a guard over the cancer. In exploring her associations with death, Mrs N remembered from her childhood a family member who had been fun loving, but had died prematurely in a car accident. In the left corner of the sand she role-played saying 'good-bye' to this person.

In reviewing the photos of her sandtray configurations Mrs N was able to see her strength in her dreams. She felt that the dream of herself in the coffin had been the most important one, and working through it in the sandtray by providing herself with supports, had been the turning point for her in dealing with her illness. She also elaborated on her previous dream where the white clad people had told her: 'You cannot do it'. In reality she had 'done it' by pursuing her education and had become a faculty member at a university, even though at that time people had said that women could not enter many professions.

Discussion

Mrs N's dreams fell into two groups. In one group are the dreams which dealt with the physical trauma of mastectomy and cancer, including the dreams of losing her breasts and the surgeon dangling her lymph nodes. The second group reflect the psychological stress of having a life threatening illness. These dreams combined two levels: on the emotional level she felt terrified and helpless, but on the intuitive level her dreams sent her messages that she had the inner strength and resources to deal with the illness and trauma. The sandtray therapy and her images in the sand helped Mrs N to express her fear and see the support and strength she had behind the fear. The dream of her husband and daughter in the pit showed that they were fine and the grass on the bottom of the pit was green. In the closet dream she was able to find support; in the last dream the 'black guy' did not flee, but continued to clean and she herself was climbing out of the pit.

The use of the sandtray figurines helped her to clarify the meaning of her images and provided images for her sensations and intuitions. Mrs N explained that she chose white rabbits as a representation of her immune system because they were gentle and not harmful to her body. Her dreams and sandtray images incorporated and uncovered that the color white was

important for her as meaning 'clean'. This helped to clarify one of the aspects of the white clad people in her dream, even though these images appeared to imply a symbolic component, possibly of archetypal origin.

Role-playing different parts of the representations in the sandtray helped her to form associations with the images and express the affect related to them. The reversal of her position in the sandtray in regard to the white clad dream people helped her to confront the cancer. This action reinforced the message of her earlier dream of driving the ambulance, that is, being in charge of her actions. This presented a positive image as opposed to dreams of cars going out of control and crashing, reported in the literature as indicative of the spreading of cancer (Siegel 1990).

The presence of opposites and the theme of reversal were manifested in the closet dream where another part of self was lying in a coffin looking at her, but 'turned her head straight' after Mrs N found support. Her dream of Tony incorporated reversal: she was being urged to run and was urging Tony and the 'black guy' to run, whereas the 'black guy' was staying put and cleaning. In this case the man appears to stand for a basic, instinctive part of her. At the end of this dream the opposites, herself and her sister, were joining together in climbing out of the pit. Mrs N's guided imagery at the conclusion of this session also displayed reversal in the direction of her stream.

The theme of 'being in the pit' was echoed in the dream with Tony in 'climbing out of the pit', reflecting an integration of the earlier image. The representation of both of these dreams in the sandtray reinforced the images and the metaphors and contributed to the insight. As pointed out by Jung (1968), the first dream in therapy may present the problem and its possible solution; the termination dreams echo and elaborate the initial theme and present the solution arrived at by the individual.

Mrs A's dreams and sandtray configurations

Mrs A, a 71-year-old retired professional woman, divorced, with three grown children, had undergone mastectomy half a year prior to joining the sandtray study. She was in remission, but her cancer had been an aggressive type, and she had had ten lymph nodes removed. There was a history of cancer in her mother's family. Mrs A did not express her feelings much. She especially had difficulty expressing her anger, but now at times she felt angry with God.

In the sandtray configuration of her 'world now', she portrayed herself as a milkmaid carrying the weight of two pails on her shoulders. She said that

she needed support and placed a bridge leading to the right where she would be with her friend in a peaceful place. She was encouraged to write down her dreams.

In the second session she shared two dreams. In one she had spilled milk and voices were saying: 'Let it dry, let it dry'. Her associations with this dream were that on the previous day she had spilled milk on her dress while carrying a tray at a meeting. Her friends had given her many suggestions on how to clean her dress. She also thought about the saying that one cannot put spilled milk back in the bottle. In the other dream she saw a room where the walls were covered with black and white cow posters, and someone said that it was a 'male room'. She said that she had seen such a poster at her friend's house, but she did not have any associations with the words 'male room'. She chose not to explore the dreams in sandtray, but rather portrayed her immune system as a 'baby beluga' whale as an image from her granddaughter's favorite song, her chemotherapy (tamaxifen) as a St Bernard, and the cancer as a starfish. She was aware of the necessity to have an aggressive immune system to fight the cancer, but that was 'not her style'.

In the third session she brought in two dreams. The first one was about a 'radio drama' with her drama club where people were arguing and were irritated. She had to make a report. Her only association was with her previous day's meeting at her club, where everybody had been nice, even though she had been concerned that some people would not like a radio drama. In the meantime she had been concerned about a nodule next to her mastectomy incision, but the physician had assured her it was not a cause for concern. She did not make any association of her physical concerns with the dream. In the second dream she heard a voice saying: 'Liz had to undergo an operation to cure her, but this would give her only additional time'. She also wondered why her mother was in her dream, saying: 'Tell me why is something reported'. The only associations she had with this dream were that she knew two Lizes at church who both had had mastectomies. She did not have any affective responses to these dreams nor to the previous dreams. In the sandtray, she chose to portray the upcoming visit with her daughter and granddaughter and she placed a bridge between herself and her daughter and granddaughter. In her representation of her immune system and chemotherapy, she used the previous images of a whale and a St Bernard, but chose the figurines of a crab, snake, lobster, and alligator as the cancer. She ended the session by role-playing a confrontation with her physician in regard to her health concerns.

In the fourth session, Mrs A reported that she had had persistent pain and fullness in her abdomen for the past several days, and that she had difficulties with sleeping and eating. In the meantime she had undergone some tests, but she had to wait for the results of a biopsy for a full diagnosis. She remembered a few dream segments. In the first one she was sorting and sequencing things, and was irritated that others could not do it. In the second dream she had to sort tapes into categories but again she did not have any help. The third segment just had an image of a glass and medicine, and she panicked. In the final dream somebody drove her to therapy in a bed. She panicked since there was no way home. Mrs A did not have any cognitive associations with these dreams. She did not display much affect in telling them, even though she had checked on her Feeling Thermometer that she was extremely scared. In the sandtray she chose to explore her feelings about her diseased ex-husband who had been an alcoholic.

Mrs A's biopsy had shown that the cancer had metastasized to her liver and she needed to undergo intensive chemotherapy. When she came in for the sandtray therapy two weeks later, she was weak. She shared that she was relying on a Higher Power and positive thinking to help her with her pain and the difficulties with the treatment. At this point she also shared that her mother had died from cancer of the pancreas. Mrs A had thought about the sandtray in the meantime, and how she would portray her battle with cancer. She selected more aggressive images than before for the chemotherapy and immune system: a jester and two knights in 'shining armor', respectively. Two dinosaurs and an alligator were designated as the cancer. She also placed a bridge in the upper right corner. Her relaxation exercises and guided imagery of a peaceful and healing place were also expanded, to help her deal with the side effects of the aggressive chemotherapy.

By the sixth session, Mrs A had proceeded with her chemotherapy and tried to counteract its side effects with massage therapy in addition to her relaxation and imagery exercises. She had also had some dreams, but she did not remember them. In the sandtray she chose to portray an anticipated trip with her family. She also incorporated a black and white cow behind a fence with a bridge remarking that in reality there would not be any cows there.

By the seventh week, Mrs A was feeling stronger. She reported a dream in which she was negotiating buying a new car with a car dealer. The car dealer's wife and Mrs A's son were impatient and wanted to go to lunch, leaving the negotiations for later. In reality a bus had backed into her car, and she was dealing with estimates for the repair. She did not make any

associations between the dream and her illness, but was emphasizing a need for a body repair. In the sandtray she chose the images of two beluga whales to represent the 'good chemo' and a hippopotamus with his mouth open for the 'bad chemo'. For the immune system she selected a silvery sprite-like figure, which she named Peter Pan; she placed it on a bridge. She described the characteristics of Peter Pan as 'joyful ... sincere ... happy ... innocent ... childlike...', '...some of the best parts of human spirit...'. The images for cancer this time were an alligator, snake, and tiger. Mrs A had some difficulties deciding on the images for the 'bad chemo' and her cancer, in that she used the image of the hippopotamus interchangeably for the chemotherapy and her cancer. For her, both were associated with unpleasant sensations of fullness. One of her goals in sandtray therapy became the need to support the chemotherapy treatments and differentiate their effects from those of the cancer. She stated that the sandtray therapy, relaxation, and guided imagery were helpful in dealing with the chemotherapy.

The following week, she had a dream of being in her childhood kitchen, where she was trying to get organized, but the people around her were not paying attention to her. She portrayed this scene in the sandtray, and her associations with this dream were of the family kitchen as a warm place. She was the only child of loving parents; her father had been severe and his favorite saying was 'let's get organized', but this saying had provided her with feelings of security and comfort. Mrs A enjoyed organization in her life and now felt that she could not plan ahead because of the effects of the chemotherapy and cancer. On the left side of the sandtray she also added her immune system – Peter Pan on a bridge, good chemo – a whale, and bad chemo – hippopotamus. She buried the cancer – alligator, snake and lion – on the lower right side of the tray (Figure 4.4). She still had some confusion whether to use the hippopotamus for the 'bad chemo' or the cancer, since both made her feel full and uncomfortable. At the end she placed the whale on one side of the bridge and the hippopotamus on the other side of the bridge in the upper part of the tray.

The sandtray therapy sessions were extended for two more weeks to provide additional support for Mrs A and her reactions to the chemotherapy. In her ninth session, she was feeling stronger and chose to represent in the sandtray her trip with her family and a bridge between the two, and her battle with the cancer. In this sandtray the whales were the good and bad chemotherapy, and Peter Pan was again her immune system. This time she selected the hippopotamus for her cancer along with the alligator and snake.

Figure 4.4 Sandtray representation of Mrs A's dream (eighth session): Upper right – dream representation of childhood family kitchen; upper middle – hippopotamus as the 'bad chemo', sprite/Peter Pan on the bridge, whale as her immune system, and self; lower right – half buried figurines of snake, alligator, and lion representing the cancer.

In her last sandtray she included a black and white cow as the image of the uncomfortable feeling of fullness, along with a snake and a tiger as representations of the cancer. Peter Pan as the immune system and two whales as the chemotherapy blocked them in the left side of the tray. On the right side of the tray she placed a bridge to the future and activities she would like to do, and she started crying as she talked about that. The bridge had been a constant image in all her sandtray configurations but two, as had been her positive thinking despite the pain and discomfort. A couple months later the cancer flared up again and she died within a week.

Discussion

In this case a number of dreams were shared in the therapy sessions, but Mrs A chose to work in the sandtray only on the last dream. In the sandtray expressions, her main theme was the battle with cancer and dealing with the chemotherapy through different images. Her representation of her immune system started out as a beluga whale in the first couple of sessions, and changed to the image of a silver sprite/Peter Pan in the last four sessions. Her images of cancer changed from a starfish in the second session to groups of three of four much more aggressive images of an alligator, snake, tiger or lion, crab, and hippopotamus. There was some confusion for her about the image of the hippopotamus being either the 'bad chemo' or the cancer. This lack of differentiation between the image of cancer and chemotherapy could be construed as a bad prognosis. The sandtray explorations, though, along with the relaxation exercises and guided imagery were very helpful to her in tolerating the side effects of the chemotherapy. Her physician had remarked that Mrs A was tolerating the treatment as a 40-year-old.

Mrs A's dreams can be divided into three groups. The dreams during the first three weeks seemed to give a warning before the manifestation of Mrs A's strong pain. The dream of the room with the black and white cow posters was puzzling in the beginning since Mrs A did not have personal responses to it. The color black in dreams has been associated with a threat of death (Siegel 1990). The dream about the spilled milk may have had some reference to the spreading of the illness. The next session of dreams were about reports: in one of them she had to make a report and was irritated, another was about an operation to buy time, and in the third one she heard her mother asking for the reason of a report. The presence of her mother asking for a report may be seen as a warning since she had died of pancreatic cancer. These report dreams could shed light on the meaning of the words 'male room' from the dream of the room covered with cow posters. 'Male' could be seen here as a homonym and imply 'mail room', since dreams often use similar sounding words with different meanings to get the message across. In this context the 'mail room' could be seen as 'posting' or reporting the images of black and white cows.

In the corresponding sandtray sessions she preferred to portray the interaction between the cancer, chemotherapy, and her immune system. The cancer in one session was represented by a starfish, but in the next it changed to images of a crab, snake, lobster, and alligator after the report dreams. Her representation of her immune system in both cases remained a whale. After

directed exploration of the scene she added a group of people as a support for her, and role-played her upcoming interaction with her physician.

The second group of dreams, after the manifestation of pain and discomfort, had images of medicine and going to hospital, and were associated with feelings of panic. However, in the sandtray she chose to work on issues about her diseased ex-husband. As she started her intensive chemotherapy, in the sandtrays she expressed her strong reaction to the chemotherapy, and in the following sandtray, representing an anticipated pleasant trip, Mrs A inserted a black and white cow behind a fence.

The third group of dreams dealt with negotiating for a new car and her childhood memories associated with 'getting organized'. It is interesting to note that the same day she reported the dream of negotiating for a new car, she changed her representation of her immune system to the sprite/Peter Pan in the sandtray expression of her cancer battle. The childhood kitchen dream in the following session, was the only one she represented in the sandtray as bridging former feelings of security and comfort with her present frustrations: her illness and subsequent inability to 'get organized'.

Even though Mrs A did not portray her dreams in the sandtray, except for one, her sandtray expressions were intertwined with her dreams and her responses to her illness. The best example of this interaction is the image from the cow posters in the dream reported in the second session. This image was ultimately placed in the context of Mrs A's illness in the last session, as the black and white cow reappeared in the sandtray, and was placed in the group with cancer images.

Mrs A's sandtray expressions were mainly directed towards reality and her family, and dealing with the cancer treatment, but three images stand out as representing a different origin and depth: the cow, the bridge, and Peter Pan. These images appear to indicate different levels of symbolism: references to the physical body, transition, and the spiritual aspects of the psyche. The image of the cow ultimately referred back to her own physical discomfort, associated with the metastasizing cancer. A bridge was present in eight out of ten sandtray configurations. Bradway and McCoard (1997) perceives the bridge as a transcendent function which helps the psyche to surpass irreconcilable opposites, such as instinct and psyche. Bradway paraphrases Jung's statement that 'an active unconscious along with an ego capable of receiving it' (p.83) are necessary to activate the transcendent function. The silver sprite/Peter Pan figure, representing for Mrs A her immune system, appears to indicate archetypal roots and a spiritual aspect with its silver form

and wings. The archetypal image of a fairy or a female sprite with wings also appears in the classic Greek Psyche, which means soul and also butterfly (Walker 1988). The sprite/Peter Pan figure was present in Mrs A's last four sandtray configurations. One can only speculate that with the introduction of the archetypal image, her psyche was prepared to accept her fate.

Discussion of dreamwork in sandtray therapy

The case examples presented here illustrate different aspects and different levels of dream imagery expressed in sandtray therapy working with mastectomy patients. The case examples represent two different responses in reaction to the presence of cancer and treatment. Both cases were rich in meaningful dream imagery and metaphors. In the first case, the dreams dealt with the psychological trauma and stress of the illness. In the second case, the dreams appeared to deliver warnings with increasing intensity of the physical danger of the metastasizing cancer. The dream images ranged from trauma related recurrent dreams to dreams incorporating past memories to dream images with archetypal implications. The reinforcement of the dream images through their representation in the sandtray allowed the images to be processed on a nonverbal level without denying their symbolic origin. These images could have provided material for further exploration, which was not possible due to the short term study.

Time is an important factor for cancer patients in acute crisis, and the directed approach to sandtray therapy allows the patients to deal with the key issues and overwhelming affect – or absence of it – in face of the life threatening situation. For both women the most immediate issues were their illness and the side effects of their treatment. The relaxation exercises and the sandtray portrayal of their immune system, treatment, and cancer were helpful in reducing the adverse reactions to the treatment. The sandtray provided relief and a concrete tie to reality during the anxiety provoking and overwhelming experience. The representation of internal experiences through the metaphors of the figurines helped to make the transition from concrete external reality to internal symbolic images. It also provided an intermediate stepping stone for the psyche to interact with the immune system. The expression of the images and affect through the small sandtray figurines and objects also helped the individuals to regain some sense of control and distance. The directed approach, though, did not negate the existence of the transcendent levels of the psyche which had been activated by the illness.

Several aspects of the sandtray therapy dovetail the characteristics of dreams and their function of affective integration. Each of the figurines can have multileveled meanings and can represent images with symbolic components. The therapist's acknowledgment of the potential for images to have multileveled meanings is essential, otherwise a premature interpretation may rob the client of deeper connections within the psyche. The sandtray expressions support the emergence of symbolic archetypal images, as it provides a ground in external reality where the images can take root and are then reincorporated in the psyche on their path towards consciousness. The sandtray representations of dream images are reflections of internal physical and intuitive symbolic experiences, and serve as a mirror in reality for internal growth and change.

Conclusion

For cancer patients, the stress and trauma facing the illness and undergoing intense treatment are reflected in their dreams. The acute phase of the illness and/or interventions contribute to the intensity of emotions present in the dreams and as a result facilitates the recall of dreams, countering repressive personality characteristics. Sandtray therapy provides a supportive environment and visual means for the representation of the dream images. The sandtray perceptually contains the dream images and action sequences within the frame of the tray. The dream images and action sequences are brought to consciousness by their representation through the figurines and objects, which in turn enhance the differentiation of the images and related associations. The constellations of the figurines can represent affectively, spatially, and/or temporally connected situations and physical experiences.

The images in dreams and their representations in sandtray are multileveled, incorporating physical, affective, cognitive, and symbolic references. Dreams and sandtray expressions help to process emotions, and integrate previous experiences. Expressions in sandtray therapy, similarly to dreams, can work through emotions and change moods present in traumatic dreams. Opposites present in dreams can be represented in the sandtray, and transcended through their integration.

Sandtray therapy also helps to deal with different aspects of cancer. The enhancement of relaxation through sandplay contributes to the decrease in side effects in the treatment of cancer. The change of moods arrived at by working through dream images and the associated affect can influence the functioning of the immune system. Negative dream affect and negative

reaction to dream images may work in a circular manner by amplifying the negative influence on the immune system. Changing the perspective on dream images can alter the affect associated with it and thus enhance the functioning of the immune system. Ultimately, sandtray expressions help to bring unconscious dream images closer to consciousness and to constitute transcendent images. This facilitates healing of the psyche and the physical body or reconciliation with and acceptance of the ultimate outcome of the illness.

References

Achterberg, J. and Lawlis, G.F. (1980) *Bridges of Body/Mind: Behavioral Approaches to Healthcare.* Champaign, IL: Institute for Personality and Ability Testing.

Ammann, R. (1991) *Healing and Transformation in Sandplay.* La Salle, IL: Open Court.

Bradway, K. (1979) 'Sandplay in psychotherapy'. *Art Psychotherapy 6,* 2, 85–93.

Bradway, K. and McCoard, B. (1997) *Sandplay: The Silent Workshop of the Psyche.* London: Routledge.

Burish, T.G. and Jenkins, R.A. (1992) 'Effectiveness of biofeedback and relaxation training in reducing the side effects of cancer chemotherapy'. *Health Psychology 11,* 1, 17–23.

Burish, T.G., Snyder, S.L. and Jenkins, R.A. (1991) 'Preparing patients for cancer chemotherapy: Effect of coping preparation and relaxation interventions'. *Journal of Counseling and Clinical Psychology 59,* 4, 518–525.

Cartwright, R. and Lamberg, L. (1992) *Crisis Dreaming: Using Your Dreams to Solve Your Problems.* New York: HarperCollins.

Costa, P.T. and McCrae, R.R. (1989) *NEO Personality Inventory.* Odessa, FL: Psychological Assessment Resources, Inc.

Decker, T.W. amd Cline-Elsen, J. (1992) 'Relaxation as an adjunct in radiation oncology.' *Journal of Clinical Psychology 48,* 3, 388–393.

Dessoille, R. (1966) *The Directed Daydream.* New York: Psychosynthesis Research Foundation.

Eysenck, H.G. (1988) 'Personality, stress, and cancer: Prediction and prophylaxis'. *British Journal of Medical Psychology 61,* 57–75.

Garfield, P. (1990) 'Women's body images revealed in dreams'. In S. Krippner (ed) *Dreamtime and Dreamwork: Decoding the Language of the Night.* Los Angeles: Jeremy P. Tarcher.

Grassi, L. and Cappellari, L. (1988) 'State and trait psychological characteristics of breast cancer patients'. *New Trends in Experimental and Clinical Psychiatry 4,* 2, 99–109.

Gruber, B.L., Hall, N.R., Hersh, S.P. and Dubois, P. (1988) 'Immune system and psychological changes in metastatic cancer using relaxation and guided imagery: A pilot study'. *Scandinavian Journal of Behavior Therapy 17,* 1, 25–46.

Gruber, B.L., Hersh, S.P., Hall, N.R.S., Waletzky, L.R., Kunz, J.R., Carpenter, J.K., Kverno, K.S. and Weiss, S.M. (1993) 'Immunological responses of breast cancer patients in behavioral interventions'. *Biofeedback and Self Regulation 18,* 1, 1–23.

Hammer, E.F. (1958) *The Clinical Applications of Projective Drawings.* Springfield, IL: Charles C. Thomas.

Hartman, E. (1996) 'Who develops PTSD nightmares and who doesn't'. In D. Barrett (ed) *Trauma and Dreams.* Cambridge, MA: Harvard University Press.

Jacobi, J. (1959) *Complex/Archetype/Symbol in Psychology of C. G. Jung. Bollingen Series LVII.* Princeton, NJ: Princeton University Press.

Jansen, M.A. and Muenz, L.R. (1984) 'A retrospective study of personality variables associated with fibrocystic disease and breast cancer'. *Journal of Psychosomatic Research 28,* 1, 35–42.

Jung, C.G. (1968) *Man and his Symbols.* New York: Dell.

Kalff, D. (1980) *Sandplay: A Psychotherapeutic Approach to the Psyche.* Santa Monica, CA: Sigo Press.

Klinger, E. (1978) 'Modes of normal conscious flow'. In K.S. Pope and J.L. Singer (eds) *The Stream of Consciousness.* New York: Plenum Press.

Koukkou, M. and Lehmann, D. (1993) 'A model of dreaming and its functional significance: State shift hypothesis'. In A. Moffitt, M. Kramer and R. Hoffmann (eds) *The Functions of Dreaming.* Albany, NY: State University Press.

Kramer, M. (1993) 'The selective mood regulatory function of dreaming: An update and revision'. In A. Moffitt, M. Kramer and R. Hoffmann (eds) *The Functions of Dreaming.* Albany, NY: State University Press.

Levenson, J.L. and Bemis, C. (1991) 'The role of psychological factors in cancer onset and progression'. *Psychosomatics 32,* 2, 124–132.

Lusebrink, V.B. (1990) *Imagery and Visual Expression in Therapy.* New York: Plenum Press.

Lusebrink, V.B. (1994–1995) 'Personality factors and sandtray expressions'. *Imagination, Cognition and Personality 14,* 2, 89–113.

McCrae, R.R. (1993–1994) 'Openness to experience as a basic dimension of personality'. *Imagination, Cognition and Personality 13,* 1, 39–55.

Ryce-Menuhin, J. (1992) *Jungian Sandplay: The Wonderful Therapy.* London: Routledge.

Siegel, A.B. (1990) *Dreams that can Change your Life: Navigating Life's Passages through Turning Point Dreams.* Los Angeles: Jeremy P. Tarcher.

Smith, R.C. (1990) 'Traumatic dreams as an early warning of health problems'. In S. Krippner (ed) *Dreamtime and Dreamwork: Decoding the Language of the Night.* Los Angeles: Jeremy P. Tarcher.

Temoshok, L. and Dreher, H. (1993) *The Type C Connection: The Behavioral Links to Cancer and Your Health.* New York: Penguin.

Temoshok L. and Heller, B.W. (1984) 'On comparing apples, oranges, and fruit salad: A methodological overview of medical outcome studies in psychological oncology'. In L.L. Cooper (ed) *Psychological Stress and Cancer.* New York: Wiley.

Tennessen, J. and Strand, D. (1998) 'A comparative analysis of directed sandplay and principles of Ericksonian psychology'. *The Arts in Psychotherapy 25,* 2, 109–114.

Todarello, O., LaPesa, M.W., Zaka, S., Martin, V. and Lattanzio, E. (1989) 'Alexithymia and breast cancer'. *Psychotherapy and Psychosomatics 51,* 51–55.

Van de Castle, R.L. (1994) *Our Dreaming Mind.* New York: Ballantine Books.

Walker, B.G. (1988) *The Woman's Dictionary of Symbols and Sacred Objects.* San Francisco, CA: Harper and Row.

Weinrib, E.L. (1983) *Images of the Self: The Sandplay Therapy Process*. Boston, MA: Sigo Press.

Zadra, A.L. (1996) 'Recurrent dreams: Their relation to life events'. In D. Barrett (ed) *Trauma and Dreams*. Cambridge, MA: Harvard University Press.

Coping with Cancer through Image Manipulation

Ellen Urbani Hiltebrand

Introduction

It is estimated that almost every American family will have at least one member diagnosed with cancer. While cancerous cells are generated in all humans, the healthy body typically prevents the growth and metastasis of these abnormal cells (Cunningham 1992). However, animal and human studies indicate that viruses, radiation, chemicals/carcinogens, and genetic factors can increase the incidence of cancer in an experimental setting (Baird 1991; Bovbjerg 1989; Holland 1989; Stearns *et al.* 1993). It is also believed that nutrition and stress may contribute to both cancer incidence and progression.

The argument that stress may influence cancer stems from an association between extreme stress (in conjunction with the previously mentioned factors) and physiological illnesses such as asthma/allergies, ulcers, heart disease, and herpes outbreaks (Bloom and Speigel 1984; Cunningham 1992; Holland 1989; Stearns *et al.* 1993; Sutherland 1991). The connection between Type-A personality – a person who responds to stressors aggressively – and heart disease has been well publicized in the media. This has led to the supposition that one's thoughts and feelings in response to external stressors cause psychosocial stress, resulting in chemical changes within the body (Cunningham 1992; Holland 1989; Thackwray-Emmerson 1988). The extent to which psychological or personality factors influence stress perception and manifestation in the human body is the basis for much research into a mind-body connection, particularly as it relates to disease development and recovery.

While cancer has long been considered immune from the influence of the mind, research on the effect of the mind on the body in other illnesses indicates that the mind may influence cancerous growths as well. However, a large body of research has been unable to provide a definitive answer: data exists which both corroborates and disproves psychosocial involvement in cancer promotion and retardation (Bloom and Speigel 1984; Bovbjerg 1989; Cunningham 1992; Holland 1989; Stearns *et al.* 1993; Thackwray-Emmerson 1988; Weitz 1983). While it is clear that genetic and carcinogenic factors have a far greater impact on cancer risk, Holland (1989) states that psychological or social factors could potentially act as co-factors in promotion and progression of malignant change in a cell that had already begun carcinogenic changes (pp.705–706).

Support for this theory comes from research indicating that patients often experience a cluster of stressors or a significant emotional trauma 6–18 months before cancer is apparent (Evans 1926; Holland 1989; Rossman 1987; Simonton, Matthews-Simonton and Creighton 1978; Weitz 1983). Furthermore, personality variables are frequently noted in both research and clinical observations of cancer patients. A prospective study by Grossarth-Maticek *et al.* (1985) on 1,353 residents of Cverenka, Yugoslavia, who were studied over a ten-year period highlights two of the psychosocial factors which most researchers concur may have the greatest likelihood of affecting cancer incidence: chronic hopelessness/helplessness and/or an inability to adequately express emotion.

Low emotionality and cancer incidence

Holland (1989) notes the large body of research (Bahnson and Bahnson 1966; Cox and Mackay 1982; Greer and Morris 1975; Kissen 1967; LeShan 1959; Temoshok and Fox 1984; Todd and Magarey 1978) using retrospective studies which supports the suggestion that emotions play a role in cancer risk. Findings from each of the studies point to a personality profile which includes the tendency to deny and suppress negative emotions or inadequately express feeling states. It should be noted that retrospective studies have been criticized due to methodological problems such as lack of control for site (in some studies), treatment, and demographic variables, as well as the view that an individual's perception of past events may be changed by cancer diagnosis (Holland 1989). While more reliable studies have recently been conducted, these findings nonetheless concur with those

Figure 5.1 Assessment drawing by a 46-year-old man

arrived at by a number of other clinicians (Cunningham 1992; Dreifuss-Kattan 1990; Lusebrink 1990).

Figure 5.1, an assessment drawing completed by a 46-year-old man with cancer, demonstrates this inability to express emotion through the paucity of color, lack of detail, incomplete and stick-figure designs, isolated graphics, and mere 30-second time investment in completing the drawing. The lack of emotional expression in this art corresponded to an absence of verbal or behavioral expression in the patient whom staff also described as withdrawn and uncomplaining. 'He never makes a fuss about his treatment,' one nurse said. 'In fact, he never gives any indication of how he's feeling about any of this (his diagnosis, etc.). I know he must be a mess inside, but you'd never know it to talk to or look at him. He's like a blank slate.'

In studies tracking psychosocial variables and disease progression in melanoma patients, Temoshok and Fox (1984) reported that at 18 months follow-up those clients who were identified as lacking the ability to adequately express dysphoric emotions had either died or relapsed. Another study by Derogatis, Abeloff and Melisaratos (1979) on 35 women with stage III and IV breast cancer concluded that long-term survivors (>1 year)

expressed anger and other dysphoric emotions with much greater frequency than the short-term survivors (<1 year) who appeared compliant and outwardly optimistic. A significant drawback to the latter study is the authors' failure to track the number of positive lymph nodes at the time of surgery, even though this is generally acknowledged to be the most accurate measure of potential for recurrence and death (Holland 1989). Furthermore, the majority of short-term survivors had received more extensive chemotherapy treatment, indicating that the more invasive illness in these patients may explain the data. In addition, one must question whether the long-term survivors' protracted experience encouraged more outspoken expression of negative feelings, thereby confounding the conclusions.

While further research is certainly needed in this area, some preliminary findings suggest that repression of emotions may play a part in cancer incidence and progression. It appears that nonexpression of emotions, including those traditionally thought of as 'negative' or painful such as fear and aggression, can be psychologically toxic in some cases (Dreifuss-Kattan 1990). This unexpressed emotional energy may lead to physical arousal and psychosomatic symptoms (Izard 1977) which may adversely affect cancer prognosis through hormonal and immunological pathways (Holland 1989). However, it should be noted that the theory that significant emotional stress may reduce disease immunity in some patients is quite different from proposing that emotions cause cancer (Stearns et al. 1993). Emotions are a natural and healthy aspect of human life. Emotions do not cause disease; in fact, the expression of emotions may have beneficial effects on the psychological and physical state of the body through these same pathways, thereby accelerating the functioning of the immune system (Achterberg 1985).

Hopeless/helpless affect and cancer incidence

The other research variable which continues to be actively pursued is an affective state described as hopelessness/helplessness, which is often defined as having a perceived lack of control over life changes and challenges (Bovbjerg 1989; Cunningham 1992; Holland 1989; Kobasa et al. 1985).

Figure 5.2, a free collage completed by a 14-year-old boy with cancer, is titled 'Change' which he described as illustrating the many changes occurring in his life over which he has no control. Like ET, a popular movie character (who appears in the upper left corner of his collage), this boy wants to go home more than anything, but feels trapped in the hospital while

Figure 5.2 'Change', free collage by a 14-year-old boy

treatments continue. The image of a war-torn nation may be a metaphor for the battle being waged within his body, while the images of destruction and death may represent a hopeless/helpless affect.

As an outcome predictor in human cancer, hopelessness/helplessness and/or lack of control has been the focus of a great deal of attention. This is due in large part to animal studies in which rats lacking control over external stressors (inescapable shock) exhibited increased tumor growth and shorter survival than those provided with the means to control the shock (Sklar and Anisman 1979, 1981; Visintainer, Volpicelli and Seligman 1982). Furthermore, those animals allowed to escape the shock, and thereby control it, demonstrated significantly reduced tumor growth. 'Because the experimental animals and the yoked controls differ only in their ability to control the shock, the studies underscore the possible psychological effects on tumor growth' (Bovbjerg 1989, p.730).

Clinicians acknowledge that cancer patients often display hopeless/helpless affect, and express a desire to recover control of their situation. 'The intense need to regain control of events in patients with cancer has led to extrapolation of these (above-listed) concepts to the clinical arena. Regaining a sense of control has been seen as not only promoting coping but also enhancing host resistance to tumor growth. Clearly, it is an intriguing hypothesis that needs further testing' (Holland 1989, p.721). Documented evidence with patients in hospital burn units indicates that those who are actively encouraged to participate in their own care feel more in control of their situation than their counterparts, and, as a group, exhibit faster recovery and better prognostic outcomes (Appleton 1993). This finding may support the premise that enhanced coping through increased perception of control may benefit cancer and other patients as well.

It is again important to point out that a hopeless/helpless affect does not cause cancer. Schmale and Iker (1971) tracked healthy women regarded as high-risk for cervical cancer due to genetic factors, and used psychological measures, such as the presence of a hopeless/helpless affect, to accurately predict (73.6 per cent of the time) which women would incur a cancer diagnosis. As they laboriously document, however, their findings do not indicate that feelings of hopelessness/helplessness generate cancerous conditions. All the women studied apparently had a genetic predisposition to cervical cancer; the effect of a hopeless/helpless affect appeared only to be a relevant secondary contributor.

Psychoneuroimmunology as it relates to oncology

While an elaborate description of the manner through which psychosocial stress influences physical functioning is beyond the scope of this chapter, it is essential to convey a picture of the hormonal and immunological pathways through which ideas and perceptions in the mind may influence potential changes in the body. Throughout the past two decades, practitioners in the field of psychoneuroimmunology have received much attention as they labor to uncover interactions between psychological states, the mind, and the immune system. According to George Solomon (1985), one of the pioneers in psychoneuroimmunology, 'all disease is multifactorial in cause, onset and course, … disease is the result of interrelationships among specific etiologic agents (such as bacterial, viruses, and carcinogens) and genetic, endocrine, emotional, and behavioral factors' (p.1). Thus, it is essential to bear in mind that thought is only one of myriad factors which collaboratively influence

physiology (Bovbjerg 1989; Cunningham 1992; Sutherland 1991). Nonetheless, Holland (1989) notes that many researchers (Ader 1981; Riley, Fitzmaurice and Spackman 1981; Sklar and Anisman 1981) are using findings from the field of psychoneuroimmunology to reexamine the possibility that psychological factors may influence tumor growth through the immune and endocrine systems.

Incidence of some tumor growth and metastasis is known to be affected by hormonal factors which may be influenced by emotional states through what is known as the psychoneuroendocrine axis (Lippman 1985). Findings by Roszman and Brooks (1985) indicate the immune system can be compromised through direct manipulation of neuroendocrine activity, implying that neuroendocrine efferent pathways exist between the brain and the immune system (Bovbjerg 1989). One theory is that the perception of psychosocial stress influences thoughts (elector-chemical events) which lead to neuroendocrine (chemical and hormonal) changes affecting the physiology of the body (Cunningham 1992; Sutherland 1991). In such a case, the pituitary, adrenal gland, and other neurohumoral mechanisms are actively involved.

One pathway through which the mind may affect cancer progression or retardation is illustrated in Figure 5.3 (Cunningham 1992). When a stressful circumstance is perceived, the pituitary gland, a small organ located under the brain, is stimulated to release various hormones. A product of the pituitary called adrenocorticotropic hormone (ACTH) stimulates the cortex, or outer part, of the adrenal glands (situated above the kidneys) to release corticosteroid or stress hormones, which have effects on many of the body's functions in ways that may affect tumors. These molecules, together with others such as adrenaline from the inner part of the adrenals, change patterns of blood flow through the tissues, for example, reducing inflammatory reactions and influencing clotting mechanisms. Such actions can both affect primary tumors and change the likelihood of metastatic (distant) growths developing (Cunningham 1992, p.64).

Furthermore, it is postulated that increased levels of corticosteroids suppress immune functioning (Holland 1989; Sutherland 1991). Thus, a mechanism exists by which mental events, including a stressful lack of control or inability to express emotion, may cause diminished immune activity, potentially allowing those tumors with immune involvement to grow more rapidly (Cunningham 1992).

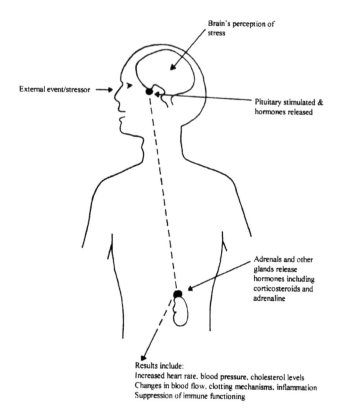

Figure 5.3 A pathway by which stress may affect physiological functioning in the human body

According to Bovbjerg (1989), 'the central research finding in the field of psychoneuroimmunology is that neural activities can influence the immune system. Psychosocial factors (presumably reflecting as yet unknown neural processes) have been shown to influence a number of different immune responses in humans as well as experimental animals' (p.727). While the effect on cancer development is still unproven, stress can adversely affect general health in two ways: 'It creates the conditions within the body that themselves give rise to disease (elevating cholesterol levels, creating hormonal imbalances, and harming various organs), at the same time depressing the body's ability to fight illness by weakening the immune system' (Sattilaro 1984, p.99).

Psychosocial influences on disease, and cancer in particular, are not cited in order to blame patients for possible ways in which they may have

contributed to the onset of disease; the influence of psychosocial stress has been shown to pale in comparison to tumor biology and external factors as relates to cancer incidence. Instead, it is suggested that addressing patients' psychosocial state as an adjunct to medical interventions may have potential benefit, as 'the same psychosocial factors that are hypothesized to alter risk have also been examined for their effect on survival' (Holland 1989, p.718). In addition, research into the impact of stress on disease vulnerability has led to the conclusion that there are belief systems and learned behaviors which can counteract stress, thereby preventing stress-associated symptoms and illnesses (Maddi and Kobasa 1984). It is known that psychotherapeutic interventions which enhance coping skills are able to reduce human perception of stress. If these same interventions focus on expressing emotion and addressing issues of hopelessness/helplessness – two psychosocial factors which may be most closely correlated with cancer incidence – here may be a possibility of influencing some neoplastic growths by enhancing the effectiveness of the immune system (Holland 1989).

Role of imagery with adult oncology patients

Throughout the ages, imagery has been used by people the world over as a means to express feelings and organize or control their experiences (Gaezer Grossman 1981), particularly in relation to issues of health. According to Achterberg, Dossey and Kolkmeier (1994), one of medicine's oldest and most powerful healing tools is imagery. Throughout recorded history, imagery arrived at through dreams, daydreams and visions has been used to promote health, and has always been 'a major source of medical, artistic, and scientific creativity' (Achterberg et al. 1994, p.37) particularly in indigenous healing rituals (Rossman 1987).

Images are a 'bridge between body and mind, or between the conscious levels of information processing and the physiological changes in the body' (Lusebrink 1990, p.218). Just as a bridge provides one with the structural means to travel in two directions, so too imagery is the container which carries perceptions from body to mind or mind to body. As a method of expressing and externalizing internal (physiological) sensations, images provide the means to translate bodily sensations into a concrete form, enabling increased organization and comprehension of physical functions. For example, when seeking treatment for a muscle cramp, most people describe their physical pain in images with which they are familiar. It is easier to recognize and describe the physical sensation as a 'knot' or a 'vise grip'

then it is to verbalize the elaborate biochemical reaction actually taking place.

Images are not only a way for the body to interface with the mind, but also a way for the mind to interface with the body through the internalization of conscious perceptions. Just as thoughts have been demonstrated to have an effect on neural activity, imagery can also influence bodily systems and actuate both the autonomous nervous system and the immune system (Achterberg 1985). If one imagines s/he is running, nerves and muscles respond and contract to such a degree as to be measurable with an electromyograph (Achterberg *et al.* 1994; Rossman 1987), and everyone has likely experienced the effects of sexual imagery and fantasy (Cunningham 1992). While the exact mechanism by which mental images cause physical responses remains elusive, no one disputes that thought initiated the process.

While it is generally acknowledged that imagery effects limited physiological reactions and can be useful in alleviating a variety of conditions such as pain and asthma, very few scientifically sound studies have been undertaken to document the potential physiological influence of imagery on a disease such as cancer. While some researchers have claimed that imagery has been successful in influencing immune functioning and disease progression (Gruber *et al.* 1988; Gruber *et al.* 1993; Thackwray-Emmerson 1988), this is yet unproven by traditional standards involving empirical research. However, 'there is no serious dispute among people who have worked with imagery about its abilities as an invaluable tool for diagnosing mental attitudes, a way of connecting with mental information and potential that might otherwise be inaccessible' (Cunningham 1992, p.110).

Lusebrink (1990) acknowledges the extensive research evidence (Achterberg 1985; Achterberg and Lawlis 1980; Korn and Johnson 1983; Sheikh and Kunnendorf 1984; Simonton *et al.* 1978) supporting the theory that 'imagery can be used as a healing agent to supplement conventional medical procedures' (p.219). Imagery can be used to address issues of hopelessness/helplessness and emotional expression, thereby increasing patients' coping ability and reducing psychosocial stress, which may positively influence physical processes. Imagery increases patients' feelings of control by encouraging active participation in their own treatment, thus lessening the likelihood that they will remain passive, helpless recipients of care. Furthermore, imagery rituals can offer relief from cancer pain through

relaxation and distraction, increasing feelings of hope as control over this factor is achieved.

Lusebrink (1990) considers the relationship between emotions and imagery to be symbiotic, which can be capitalized upon when using imagery in healing. 'Emotions closely interact with imagery: Emotions color and modify imagery; in turn, imagery can evoke and amplify emotions. Imagery becomes part of the metaphoric and symbolic representations of emotions and shares their neuromuscular and neurophysiological components' (Lusebrink 1990, p.221).

Emotions that are not expressed manifest either through their sensory-motor components or through dream images. Stress and conflicting messages not translated into images continue to affect emotions and, later, physiological functioning (Achterberg 1985). 'The process of translating body sensations and emotions into symbolic images gives the individual a means to deal with stress on a cognitive level' (Lusebrink 1990, p.222).

One of the simplest and most efficient ways of translating body sensations and emotions into symbolic images is through art. The therapeutic process of art making recognizes and allows for the expression of unconscious beliefs and feelings through symbols and images, which can be less threatening than through words alone (Naumberg 1973). When the resultant imagery is explored for its symbolic aspects, in conjunction with the verbal and cognitive, art therapy directs patients toward conscious understanding, synthesis, and healing (Rubin 1984). 'Art provides a means to capture and recreate the images seen in one's mind, and provides a concrete picture that often reaches beyond the images originally envisioned to tell a story about cancer patients' lives including their feelings toward their illness, their treatment, and themselves' (Baron 1989, p.148).

Rosner David and Ilusorio (1995) found that patients' art frequently reveals images and themes associated with disease manifestations, prognosis, and emotions and beliefs about serious illness. Many other researchers have established a link between the progression of physical illness and imagery manifest in patients' art work, indicating that creative work reflects both psychological and physiological states (Cotton 1985; Crown 1989; Gaezer Grossman 1981; Locke Sogn 1981; Mango 1992; Rudloff 1985; Sabini 1981; Sourkes 1991; Tate 1989; Wheelwright 1981). The visual expression of the images defines and reinforces the structure of the imagery themes, and elaborates the relationship between the symbolic images reflecting the bodily processes (Lusebrink 1990).

Reducing feelings of helplessness through art therapy

Choice and control are important human needs which are often compromised in physical illness, leaving patients feeling increasingly passive and helpless (Rosner David and Ilusorio 1995). As far as a patient's illness and medical regimen are concerned, s/he cannot exercise many options. In such cases, creative expression may be particularly beneficial as choice and control are essential components in the art making process (Kern-Pilch 1980; Rosner David and Ilusorio 1995).

While all patients are invited to participate in art therapy, in order to encourage feelings of control they can choose whether or not to participate on any given day. In contrast to most hospital procedures, art therapy is one of the few interventions the patient can decline to have (Councill 1993; Russell 1995). Those patients who do choose to participate in art therapy are offered further choice and control through the selection of art materials and themes, with the art therapist guiding and encouraging the patient as deemed necessary (Lichtenthal 1985; Russell 1995). Furthermore, the ability to control media becomes an opportunity for the projective control of feelings of helplessness.

In Figure 5.4, a 32-year-old woman was able to express her need for control onto the art work through her excessive use of art materials, insistence on re-cutting all the precut pictures, and by surrounding her finished work with a frame. Although her chronic illness and lengthy hospitalization placed her in a rather helpless situation, this collage suggests the client was able to interact with the art media in such a way as to promote autonomy and establish structural control and safety.

Art therapy can also reduce feelings of helplessness by advancing the patient's potential to participate more fully in his/her own health care. In these situations, the therapist may help the patient move 'from his initially helpless position, similar to that of an infant, to an understanding of his own active role in treatment; this is a constructive move toward health' (Dreifuss-Kattan 1990, p.54).

Figure 5.5, created by LJ, a 38-year-old breast cancer patient, illustrates one way in which art expression can deepen the patient's understanding and transformation of his/her experience, fostering increased adaptivity and locus of control. Having undergone a mastectomy and radiation/chemotherapy, LJ looked forward to returning to work. However, she often found herself overwhelmed by emotions in the workplace, saying '…it was all I could do not to burst into tears. I was an emotional basket-case;

Figure 5.4 Collage by 32-year-old woman

Figure 5.5 Art work by a 38-year-old breast cancer patient

completely out of control.' Her attempts to compensate by denying all expression of emotion left her feeling as if she was helpless to cope with the pain and frustration related to her cancer experience.

In an individual art therapy session, LJ created a collage in which she chose a specific color and shape to represent each of these emotions. After completing the art work, she folded it in half and stored it in an envelope which could be opened and resealed using a string closure; she carries this art work with her at all times. By consciously displacing her feelings onto the art work, LJ achieved a necessary reflective distance from her emotions. She then identified the office as one place where the art – the container for her emotions – is best left in a sealed envelope. 'Now, if I start to get upset at work, I just have to look at my art folded up and sealed shut, and I feel calmer. But sometimes on the weekend or at night, when I'm home alone, I take the art out and put it on the counter. That signals for me that it's okay to experience those emotions, and I can cry or get upset without feeling like it's inappropriate.'

Reducing feelings of hopelessness through art therapy

According to Aldridge (1993), 'hope has been identified as a multifaceted phenomenon that is a valuable human response even in the face of a severe reduction in life expectation' (p.288). This definition of hope does not refer simply to hope for a cure, which is impossible in many cases and would be unethical to promote. Instead, severely ill patients are encouraged to hope for and actively pursue fulfillment in relationships and a healthy emotional life, thereby increasing life-quality measures even as the physical body weakens. However, uncontrollable pain and discomfort have been identified as hope-hindering (Herth 1990); Sampson (1994) contends that there is significant undertreatment of pain in cancer patients. While psychological and psychosocial interventions for pain are generally not as effective as analgesics, art therapy is a possible method for helping burn patients cope with pain (Appleton 1993; Long 1995; Russell 1995). From this work with burn victims, it can be extrapolated that similar interventions may benefit cancer patients as well. Two art therapy methods found to decrease painful symptoms and thereby increase hope are relaxation and distraction.

For patients faced with long hospital stays, art therapy may offer one of the only opportunities to move attention away from their physical suffering. Art work can serve as an alternative focus for these patients, directing concentration externally and relieving pain through distraction. This occurs

Figure 5.6 Clay sculpture by a 47-year-old woman

because the patient is often so intently focused on the art process – handling the materials and constructing the piece – that s/he temporarily 'forgets' the pain (Councill 1993; Kern-Pilch 1980; Russell 1995). Furthermore, Appleton (1993) notes that 'pain is directly linked to stress response, (and as such) the relaxation benefits of art activities assist in pain control' (p.72).

Art therapy was helpful in pain management for C, a 47-year-old woman who molded the clay sculpture in Figure 5.6. She was new to the art therapy group, and chose not to participate in either the art activity or verbal discussion. Her frequently shifting body movements, tense jaw and hand muscles, and lack of eye contact expressed C's feelings of stress and tension.

At a subsequent meeting, C arrived early, and the therapist invited her to help choose the art media which the group would be using during that session. 'I don't want to do any art,' she reiterated, 'but I think everyone else might like to use the colored clays.' The therapist then laid the clay on the end of the table closest to C. Before anyone else arrived, C quietly leaned over and scooped up a small ball of yellow clay and spent the entire session molding a baby from her ball of clay. The baby began as a figure with crossed limbs, similar to C's behavior within the group. But as the session progressed, the baby's arms and legs opened up, until it appeared to be reaching out with

one hand to those around it. While C still did not actively participate in the session, she visibly relaxed and sat unmoving in her seat, leaning against the back of the chair and cradling her sculpture softly in her hands.

The next week, however, in a move that seemed to correspond to the opening of the baby's limbs, C also reached out to the group and spent much of the session talking about her cancer experience. Months later, she remarked about her first experience with the clay sculpture: 'Just squeezing the clay in my hands made me feel less tense,' she said. 'I was concentrating so much on the way the clay felt, and on what I was making, that I forgot to worry about how I felt.'

Because patients' ego boundaries are compromised in states of extreme relaxation, it is especially important to provide directives and media which compensate by offering external boundary modulation and increased control. Figure 5.7 illustrates one such intervention, in which the patient used colored pens on 8.5" × 11" paper to create a Spirograph drawing. The repetitive circular line drawing inherent in this method forces one to be rhythmical, leading to a relaxed state (Tokuda 1973), yet the plastic rings within which one moves provide for containment and boundary modulation.

Figure 5.7 Spirograph drawing

In addition, the mental focus required to organize and render the design shifts concentration from internal processes to external stimuli, thereby temporarily distracting the patient from his pain. Thus, hopelessness brought on by unrelieved pain may be reduced in art therapy sessions through relaxation techniques coupled with distractive interventions.

Increasing emotional expression through art therapy

Rossman (1987) notes that 'strong, persistent emotions need to be expressed or resolved, as their chronic denial may lead to physiological imbalance and disease' (p.22). Art therapy, as opposed to many other psychotherapeutic interventions, can help people externalize feelings which they feel cannot be communicated verbally. The opportunity to say something without words through line, form, and color is often met with enthusiasm and relief (Langford 1983). Thus, art therapy is able to provide patients with an active, creative medium through which they can express a full range of emotions, thereby assisting in the healing process (Dreifuss-Kattan 1990; Russell 1995).

Furthermore, art can contain emotional energy that might otherwise manifest in a destructive manner (Kern-Pilch 1980). 'My aggressive energy finally found a constructive outlet in artwork,' art therapist Mary Lynne Ricci (1993 p.97), said in relation to her emotions regarding extensive hospitalization as a young woman. 'I felt some peacefulness; the artwork provided a healthy way to deal with conflicting feelings and supplied previously unachievable pleasure by constructively redirecting my energy' (p.98).

Often patients are able to safely express emotions through art work during art therapy sessions, as with the patients who created the art work in Figures 5.8 and 5.9. Based on Barbara Sourkes (1991) 'color-feeling wheel,' each patient was asked to think of feelings s/he felt in relation to his/her most recent cancer experience (hospitalization, surgery, chemotherapy, etc.). Ten cards listing typical emotions, and one stating 'Other Feelings,' were offered to the patient as stimuli. The patient was then encouraged to list his/her feelings on the side of an 8.5" × 11" sheet of white paper and choose a colored marker to correspond with each feeling. By offering patients the opportunity to organize and write their feeling states before drawing, the therapist supports defenses such as intellectualization while at the same time allowing for expression of affect. When facilitating the expression of emotion with cancer patients, who can easily be overwhelmed by powerful

Figure 5.8 Art work by a 31-year-old man

Figure 5.9 Art work by a 30-year-old woman

feelings, it is important to encourage the use of adaptive coping and defense mechanisms such as this in order to contain the experience.

Containment can be provided by encouraging the patient to color in or design part of a pre-drawn circle for each feeling, using the colored markers. In Figure 5.8, a 31-year-old man continued to use intellectualization through compartmentalization and writing in his circle, but also expressed affect, particularly depression, through his art. He identified the blue area as 'an ocean that's so big a person could get lost out in the middle of it ... Sometimes I feel so lost in that blue ocean that I think about just checking out.' The opportunity to externalize his feelings through art enabled this patient not only to express emotion, but also to acknowledge suicidal thoughts which he had previously been unable to disclose.

Likewise, D, the 30-year-old woman who designed Figure 5.9, was able to project and contain emotion through the art experience. As she began working, D's accelerated breathing, scribbling style, and forceful, rapid movements indicated great stress associated with the expression of emotion. In order to provide for both her physical and emotional safety, D was encouraged to concentrate on tracing and coloring in her word list as opposed to simply drawing in the circle. By tracing, outlining, and drawing boundaries around her words, D was better able to contain and control her experience. In addition, by concentrating on words and forms, she achieved a perceived distance from her overwhelming emotions.

Conclusion

This chapter attempted to explore the reciprocal nature of imagery in art, mental state, and physical health. Art therapy has the potential to direct patients toward expression of emotion and decrease of hopeless/helpless affect, thus enhancing patients' ability to cope with illness and potentially influencing physical health through the modulation of psychosocial stress and immune functioning. As the development and progression of cancer may be affected by psychosocial factors and possible immune system involvement (Bovbjerg 1989; Cunningham 1985), possibilities exist through which enhanced coping may influence the course of illness. However, further research is needed in this area, as there has been a scarcity of published studies in the field of art therapy which connect the effect of image manipulation with psycho-physiological effects in the body. Outcome studies tracking and comparing patients with similar physical conditions are needed. If it can be shown that imagery and creative expression through art

influence the patients' mental status and physical health, it will be a leap forward for those hoping to incorporate therapeutic arts programs into medical settings.

Art therapy offers patients the opportunity to express emotion, enhance relaxation, increase communication, reduce pain, and empower themselves through vital participation in a life-affirming activity. However, professionals as well as patients must bear in mind that psychosocial stress is only one of many factors potentially influencing the development of, and recovery from, cancer. People generally do not willingly encourage cancerous growth; nor can they will it – or draw it – away. Imagery and art therapy alone cannot cure a patient. Nonetheless, this method of intervention may enable the patient to feel more involved in his/her treatment and more able to cope with stress associated with illness. This improved attitude may have far-reaching, and astonishing, physiological implications.

References

Achterberg, J. (1985) *Imagery in Healing: Shamanism and Modern Medicine.* Boston: New Science Library.

Achterberg, J., Dossey, B. and Kolkmeier, L. (1994) *Rituals of Healing: Using Imagery for Health and Wellness.* New York: Bantam Books.

Achterberg, J. and Lawlis, J.F. (1980) *Bridges of the Body/Mind: Behavioral Approaches to Health Care.* Champaign, IL: Institute for Personality and Ability Testing.

Ader, R. (1981) *Psychoneuroimmunology.* New York: Academic Press.

Aldridge, D. (1993) 'Hope, meaning and the creative arts therapies in the treatment of AIDS'. *The Arts in Psychotherapy 20,* 285–297.

Appleton, V. (1993) 'An art therapy protocol for the medical trauma setting'. *Art Therapy: Journal of the American Art Therapy Association 10,* 2, 71–77.

Bahnson, C.B. and Bahnson, M.B. (1966) 'Role of the ego defenses: Denial and repression in the etiology of malignant neoplasm'. *Annals of the New York Academy of Sciences 125,* 846–855.

Baird, S. (ed) (1991) *A Cancer Source Book for Nurses.* Atlanta, GA: American Cancer Society, Inc.

Baron, P. (1989) 'Fighting cancer with images'. In H. Wadeson, J. Durkin and D. Perach (eds) *Advances in Art Therapy.* New York: John Wiley and Sons.

Bloom, J. and Speigel, D. (1984) 'The relationship of two dimensions of social support to the psychological well-being and social functioning of women with advanced breast cancer'. *Social Science and Medicine 19,* 831–837.

Bovbjerg, D. (1989) 'Psychoneuroimmunology and cancer'. In J. Holland and J. Rowland (eds) *Handbook of Psychooncology: Psychological Care of the Patient with Cancer.* New York: Oxford University Press.

Cotton, M. (1985) 'Creative art expression from a leukemic child'. *Art Therapy,* 55–65.

Councill, T. (1993) 'Art therapy with pediatric cancer patients: Helping normal children cope with abnormal circumstances'. *Art Therapy: Journal of the American Art Therapy Association 10*, 2, 78–87.

Cox T. and Mackay, M. (1982) 'Psychosocial factors and psychophysiological mechanisms in the etiology and development of cancers'. *Social Science Medicine 16*, 381–396.

Crown, H. (1989) 'A shared journey: Art therapy in the treatment of a woman with Pick's disease'. *The American Journal of Art Therapy 28*, 45–50.

Cunningham, A. (1985) 'The influence of mind on cancer.' *Canadian Psychology 26*, 1, 13–29.

Cunningham, A. (1992) *The Healing Journey.* Toronto, ON: Key Porter Books.

Derogatis, L., Abeloff, M. and Melisaratos, N. (1979) 'Psychological coping mechanism and survival time in metastatic breast cancer'. *Journal of the American Medical Association 242*, 1504–1508.

Dreifuss-Kattan, E. (1990) *Cancer Stories: Creativity and Self Repair.* Hillsdale, NJ: The Analytic Press.

Evans, E. (1926) *A Psychological Study of Cancer.* New York: Dodd, Mead and Company.

Gaezer Grossman, F. (1981) 'Creativity as a means of coping with anxiety'. *The Arts in Psychotherapy 8*, 185–192.

Greer, S. and Morris, T. (1975) 'Psychological attributes of women who develop breast cancer: A controlled study'. *Journal of Psychosomatic Research 19*, 147–153.

Grossarth-Maticek, R., Kanzir, D.T., Schmidt, P. and Vetter, H. (1985) 'Psychosocial and organic variables as predictors of lung cancer, cardiac infarct and apoplexy: Some differential predictors'. *Personality and Individual Differences 6*, 313–321.

Gruber, B., Hall, N., Hersh, S. and Dubois, P. (1988) 'Immune system and psychological changes in metastatic cancer patients using relaxation and guided imagery: A pilot study'. *Scandinavian Journal of Behavior Therapy 17*, 1, 25–46.

Gruber, B., Hersh, S., Hall, N., Waletzky, L., Kunz, J., Carpenter, J., Kverno, K. and Weiss, S. (1993) 'Immunological responses of breast cancer patients to behavioral interventions'. *Biofeedback and Self Regulation 18*, 1, 1–22.

Herth, K. (1990) 'Fostering hope in terminally ill people'. *Journal of Advanced Nursing 15*, 1250–1259.

Holland, J. (1989) 'Behavioral and psychosocial risk factors in cancer: Human studies'. In J. Holland and J. Rowland (eds) *Handbook of Psychooncology: Psychological Care of the Patient with Cancer.* New York: Oxford University Press.

Izard, C.E. (1977) *Human Emotions.* New York: Plenum Press.

Kern-Pilch, K. (1980) 'Anne: An illustrative case of art therapy with a terminally ill patient'. *American Journal of Art Therapy 20*, 3–11.

Kissen, D.M. (1967) 'Psychosocial factors, personality and lung cancer in men aged 55–64'. *British Journal of Medical Psychology 40*, 29–43.

Kobasa, S., Maddi, S., Puccetti, M. and Zola, M. (1985) 'Effectiveness of hardiness, exercise, and social support as resources against illness'. *Journal of Psychosomatic Research 29*, 525–533.

Korn, E.R. and Johnson, K. (1983) *Visualization: The Uses of Imagery in Health Professions.* Homewood, IL: Dow Jones-Irwin.

Langford, R. (1983) 'The patient as artist'. *Nursing Times 7*, 50, 8–10.

LeShan, L. (1959) 'Psychological states as factors in the development of malignant disease: A critical review'. *Journal of the National Cancer Institute 22*, 1–18.

Lichtenthal, S. (1985) 'Working with a terminally ill young adult'. *Pratt Institute Creative Arts Therapy Review 6*, 11–21.

Lippman, M.E. (1985) 'Psychosocial factors and the hormonal regulation of tumor growth'. In S.M. Levy (ed) *Behavior and Cancer*. San Francisco: Jossey-Bass.

Locke Sogn, D. (1981) 'The art of children with cancer'. *The Washington Post Magazine*, October 18, 30–33.

Long, J. (1995) 'Establishing medical art therapy in a new outpatient pediatric pain management service'. Oral presentation at the 26th Annual American Art Therapy Association Conference, San Diego, CA.

Lusebrink, V. (1989) 'Art therapy and imagery in verbal therapy: A comparison of therapeutic characteristics'. *The American Journal of Art Therapy 28*, 2–3.

Lusebrink, V. (1990) *Imagery and Visual Expression in Therapy*. New York: Plenum Press.

Maddi, S.R. and Kobasa, S.C. (1984) *The Hardy Executive: Health Under Stress*. Homewood, IL: Dow Jones-Irwin.

Mango, C. (1992) 'Emma: Art therapy illustrating personal and universal images of loss'. *Omega 25*, 4, 259–269.

McWhinnie, H. (1985) 'Carl Jung and Heinz Werner and implications for foundational studies in art education and art therapy'. *The Arts in Psychotherapy 12*, 95–99.

Naumberg, M. (1973) *An Introduction to Art Therapy*. New York: Teachers College.

Ricci, M.L. (1993) 'Portrait of an illness'. *Art Therapy: Journal of the American Art Therapy Association 10*, 2, 96–99.

Riley, V., Fitzmaurice, M.A. and Spackman, D.H. (1981) 'Psychoneuroimmunologic factors in meoplasia: Studies in animals'. In R. Ader (ed) *Psychoneuroimmunology*. New York: Academic Press.

Rosner David, I. and Ilusorio, S. (1995) 'Tuberculosis: Art therapy with patients in isolation'. *Art Therapy: Journal of the American Art Therapy Association 12*, 1, 24–31.

Rossman, M. (1987) *Healing Yourself*. New York: Simon and Schuster, Inc.

Roszman, T. and Brooks, W. (1985) 'Neural modulation of immune function'. *Journal of Neuroimmunology 10*, 59–69.

Rubin, J.A. (1984) *The Art of Art Therapy*. New York: Brunner/Mazel.

Rudloff, L. (1985) 'Michael: An illustrated study of a young man with cancer'. *American Journal of Art Therapy 24*, 49–62.

Russell, J. (1995) 'Art therapy on a hospital burn unit: A step towards healing and recovery'. *Art Therapy: Journal of the American Art Therapy Association 12*, 1, 39–45.

Sabini, M. (1981) 'Imagery in dreams of illness'. *Quadrant: The Journal of Contemporary Jungian Thought 14*, 85–104.

Sampson, C. (1994) 'Management of cancer pain: Guideline overview'. *Journal of the National Medical Association 86*, 8, 571–573.

Sattilaro, A. (1984) *Living Well Naturally*. Boston: Houghton Mifflin Company.

Schmale, A.H. and Iker, H. (1971) 'Hopelessness as a predictor of cervical cancer'. *Social Science and Medicine 5*, 95–100.

Sheikh, A.A. and Kunendorf, R.G. (1984) 'Imagery, physiology, and psychosomatic illness'. In A.A. Sheikh (ed) *International Review of Mental Imagery, Vol 1*. New York: Human Sciences Press.

Simonton, O.C., Matthews-Simonton, S. and Creighton, J. (1978) *Getting Well Again*. New York: Bantam Books.

Sklar, L. and Anisman, H. (1979) 'Stress and coping factors influence tumor growth'. *Science 205*, 513–515.

Sklar, L. and Anisman, H. (1981) 'Stress and cancer'. *Psychological Bulletin 89*, 369–406.

Solomon, G. (1985) 'The emerging field of psychoneuroimmunology – With a special note on AIDS'. *Advances 2*, 1, 1.

Sourkes, B. (1991) 'Truth to life: Art therapy with pediatric oncology patients and their siblings'. *Journal of Psychosocial Oncology 9*, 2, 81–96.

Stearns, N., Lauria, M., Hermann, J. and Fogelberg, P. (1993) *Oncology Social Work: A Clinician's Guide*. Atlanta, GA: The American Cancer Society.

Sutherland, J. (1991) 'The link between stress and illness: Do our coping methods influence our health?' *Postgraduate Medicine 89*, 1, 159–164.

Tate, F.B. (1989) 'Symbols in the graphic art of the dying'. *The Arts in Psychotherapy 16*, 115–120.

Temoshok, L. and Fox, B.H. (1984) 'Coping styles and other psychosocial factors related to medical status and to prognosis inpatients with cutaneous malignant melanoma'. In B.H. Fox and B.H. Newberry (eds) *Impact of Psychoendocrine Systems on Cancer and Immunity*. Lewiston, New York: C.J. Hogrefe.

Thackwray-Emmerson, D. (1988) 'Stress and disease: An examination of psychophysiological effects and alternative treatment approaches'. (Special issue: Stress counseling). *Counseling Psychology Quarterly 1*, 2–3, 229–234.

Todd, P.B. and Magarey, C.J. (1978) 'Ego defenses and affects in women with breast symptoms: A preliminary measurement paradigm'. *British Journal of Medical Psychology 51*, 177–189.

Tokuda, Y. (1973) 'Image and art therapy'. *Art Psychotherapy 1*, 169–176.

Visintainer, M., Volpicelli, J. and Seligman, M. (1982) 'Tumor rejection in rats after inescapable or escapable shock'. *Science 216*, 437–439.

Weitz, R. (1983) 'Psychological factors in the prevention and treatment of cancer'. *Psychotherapy in Private Practice 1*, 4, 69–76.

Wheelwright, J. (1981) *Death of a Woman*. New York: St. Martin's Press.

Enlightenment in Chemical Dependency Treatment Programs

A Grounded Theory

Holly Feen-Calligan

Introduction

This chapter describes a study which explores the role of art therapy in recovery from chemical addiction. This study is 'grounded' in the interview data of eleven art therapists, four psychiatrists and five individuals in recovery. The grounded theory method used to analyze the data involves identifying a 'central phenomenon' in the data. In this study, 'enlightenment' emerged as the central phenomenon. It is hoped that the results will inform practice through contributing to the development of the theoretical basis of art therapy in recovery from addiction.

Chemical addiction

Considered to be the largest and most serious public health problem facing our society, the cost of chemical addiction in health care, unemployment, poverty, and violence is immense (Chopra 1997; Steele 1997). Various approaches to treating chemical addiction, including Alcoholics Anonymous (AA), outpatient psychotherapy and inpatient rehabilitation programs, have at best experienced mixed success (Miller 1995). Employees of hospital based rehabilitation programs are well aware of the high relapse rates among their patients. Among those who remain substance free, many fail to achieve recovery in the full sense of the word, leading dissatisfied or unfulfilled lives. Adding to the treatment dilemma are statistics showing an increasingly

diverse patient population with more complicated medical problems
(Craddock *et al.* 1997) and reductions in health care funding available to
treat the problem (Van Leit 1995). Given this situation, alternative
treatments need to be explored.

One such alternative or complementary treatment is art therapy. The use
of art in chemical dependency treatment programs has been documented
since the 1950s (Ulman 1953) and the benefits of art therapy have been
addressed in the literature (Albert-Puleo and Osha 1976–77; Allen 1985;
Devine 1970; Foulke and Keller 1976; Moore 1983). Generally, art therapy
is believed to help circumvent verbal defensiveness, often thought to be
typical of addicts. Art therapy contributes to addicts' ability to get in touch
with feelings numbed by chemicals and contributes to increased personal
awareness of motivation for chemical use. Such personal awareness can be
empowering and help to provide the self-confidence and strength necessary
to pursue a life of sobriety 'one day at a time.' The process of mastering art
processes and interpretation of art works parallels mastery of painful feelings.
There is a reflective or even spiritual experience inherent to the creative
process (Burke 1985; Chickerneo 1990) that seems to help individuals to
trust spiritual concepts espoused in recovery programs such as 'Let go and let
God' (Feen-Calligan 1995).

Because many benefits of art therapy were observed when patients were
admitted for longer periods of stay than is typical in treatment programs
today, it is less clear just how art therapy has been adapted for shortened
hospital stays. No *theory* currently exists about the role of art therapy in
chemical addiction treatment programs. In order to determine practical uses
of art therapy in treatment programs given today's health care realities, it is
important to develop a theory of how art therapy can be used with this
population.

The 'grounded theory' tradition was selected as the method of data
collection and analysis because of its potential to contribute to the
development of theory. Grounded theory is a qualitative research method
developed in the 1960s by two sociologists, Barney Glaser and Anselm
Strauss (1967), that uses a systematic set of procedures to understand
processes and interactions in order to develop theory about a particular
phenomenon. The aim of this study is to generate theory about art therapy in
recovery from addiction, 'grounded in,' or based upon the interviews of art
therapists, psychiatrists, and individuals in recovery. The study sought to

answer the following question: What is the theory that explains the process of art therapy in addiction treatment?

Data collection and analysis

In the first phase of the study, eleven art therapists and four psychiatrists were interviewed about the process of using art with chemical dependency patients. A theoretical sampling procedure was used in which respondents were selected for what they could contribute to the evolving theory (Strauss and Corbin 1990). The art therapists were selected from a list of members of the Art Therapy/Addiction Counselor (AT/AC) Network, a peer-support group formed by members of the American Art Therapy Association. Among the art therapists, nine worked with adults, two with adolescents. Four art therapists worked in outpatient settings, in programs of one month to one year duration. Four worked in hospitals in psychiatric inpatient, outpatient and day treatment programs, in programs ranging from three days to three weeks. Others practiced in settings including a residential substance abuse program for women and children, a domestic violence program, and a residential adolescent substance abuse program, with a range in length of stay from three to six months. One art therapist was a supervisor of a county-wide substance abuse program. All art therapists lived and worked in the United States, in Michigan, Ohio, Illinois, Kentucky, Massachusetts, South Carolina and California.

Psychiatrists were selected because of their work in addiction psychiatry, and all were associated with major medical centers and had outpatient practices. Consistent with grounded theory procedures (Conrad 1978), psychiatrists were interviewed as a comparison group to help evaluate the conditions under which the art therapy model would hold. Although the focus of this research is upon adult medical settings, interviewing professionals in related settings helps the researcher 'to be theoretically sensitive to the range of conditions that might bear upon the phenomenon under study' (Strauss and Corbin 1990, p.161). Furthermore, a formal theory must emerge from studying phenomena examined under many different types of situations.

In order to understand more about an individual's first-hand experience with art therapy, the views of recovering individuals were solicited. The art therapists interviewed in the first phase were contacted a second time for recommendations of patients who might complete a questionnaire or consent to be interviewed. In the second phase of the study, four

questionnaires were completed by individuals who, at the time, were patients in treatment programs. One individual in longer term recovery was also interviewed. This individual had participated in an inpatient treatment program at the beginning of his recovery several years earlier, and had remained active in art. Although only one individual in longer-term recovery was interviewed, this person's experiences assist with relating conditions, actions/interactions and consequences to the phenomenon being studied (Strauss and Corbin 1990).

Interviews were conducted both face-to-face, and over the phone when necessary. All interviews were audio taped and transcribed, verbatim. Interviews ranged from 30 to 90 minutes in length. Interviews of psychiatrists and art therapists were open-ended and began by asking respondents to describe their work with patients, their view of the role of art therapy in the patient's recovery, how progress or successful outcome is assessed and the facility's philosophy of treatment. Other questions covered descriptive information about their practices and any other information thought to be relevant. Individuals in recovery were asked to describe their experiences with art therapy or making art and the relationship between art making and recovery. They were asked whether a particular work of art created had special meaning for them, and what therapists should understand about someone in recovery.

The transcribed interviews were mailed to the respondents for verification purposes requesting clarification or additions when necessary. Additional verification was provided through triangulation. That is, the responses from the psychiatrists verified those of the art therapists with regard to the causal conditions of chemical addiction and strategies to address the problems. Rich description allows readers to make decisions about the transferability of the findings.

Open Coding

The procedures for data analysis in grounded theory involve three types of coding procedures: open coding, axial coding, and selective coding. Open coding consists of naming and categorizing data. As interview transcriptions are reviewed, concepts or themes with similar properties are grouped together. The categories are arranged and rearranged until 'saturated;' that is, until I was satisfied that the concepts were similar and should be grouped together. Six major categories emerged in the open coding process. These categories were named using 'in vivo codes,' terms drawn directly from the

data. The in vivo codes (six major categories) were named: (1) spectrum disease, (2) underlying turbulence, (3) type of treatment program, (4) art as healing, (5) waves of treatment, and (6) health care changes. In open coding, not only are categories grouped together, but properties of the categories are also examined as well as dimensions or ranges of the properties. Considering the properties of categories helps the researcher to know that the categories are properly grouped together, or are saturated.

The first category, 'spectrum disease,' refers to the spectrum of problems an addicted person often has. There is a spectrum of severity and chronicity of problems experienced, and a range in ages of patients. Chemical addiction is a spectrum illness because it falls along a continuum of related disorders associated with it. Medical doctors often have great difficulty diagnosing the primary disorder, as substance abuse often is intertwined with a psychiatric disorder. Older chemically addicted patients also often have medical problems. Furthermore, there is a spectrum of treatment philosophies, ranging from addiction models (disease concept) to psychiatric models of treatment. Thus, one property of the spectrum disease is the diagnosis. The dimensions of diagnoses range from substance abuse as a primary disorder to a dual diagnosis coexisting with a psychiatric diagnosis. Table 6.1 lists the six categories, their properties and dimensions.

The second category, 'underlying turbulence,' reflects the addicts' motivation for use. Usually the motivation for use had to do with control. Controlling moods and feelings was commonplace, either to feel more high, or more low (in the case of bipolar, dually diagnosed individuals), or to numb out or fill an inner emptiness. Often there was a trauma, loss or stressor that precipitated use. This was true of individuals coming from families with or without histories of chemical dependence.

'Treatment programs' consisted of type of facility with which the respondents were affiliated – free standing or hospital based; inpatient or outpatient. This category includes type of treatment, other than art therapy, prescribed by the treatment program. Pharmacology, drug education, group or individual therapy and activity therapy are types of treatment mentioned in the data. The treatment program category also includes the approach to treatment, encompassing behavioral through uncovering/ analytic approaches.

Table 6.1 Open Coding of Art Therapy in
Chemical Dependency Treatment Programs

Category	Properties	Dimensionalized examples	
Spectrum disease	Diagnosis Problem manifested Treatment philosophy Age of patient	Primary substance abuse Biological/medical problems Addiction model (disease concept) Adolescent	Dual diagnosis Psycho-social problems Psychiatry model Older adult
Underlying turbulence	Control feelings Painkiller Reason for use	Feel less depressed Numb painful feelings Psychic pain Genetic predisposition	Feel less anxious Fill inner emptiness Physical pain Coping or learned behavior
Treatment program	Type of facility Treatment Type	Inpatient Free Standing Pharmacology Behavioral Group therapy	Outpatient General hospital Psychotherapy Uncovering Individual
Art as healing	Benefits Stages in art process Approaches Themes Media Art products	Self-expression Resistant Structured/didactic Absence of self Pencils Colorless	Self-awareness Reflective Unstructured/open studio Self-portraits Paint Colorful
Waves of treatment	Process Evidence of progress	Assessment Rough sea Patient statements	Ongoing evaluation Calm sea Patient behaviors
Health care changes	Shortened time in hospital Service Job changes	Days Less specialized Fewer staff	Months Generalized Increased responsibilities

The category, 'art as healing,' represents the 'benefits of art therapy;' for example, art is beneficial to encouraging expression of feelings and increased self-awareness. Respondents were aware of stages experienced by the individual making art. Resistance to making art was common at first; however as art was created, individuals became willing participants and reflective about their art. The healing in art often becomes evident in color use – from less to more color used, and from lack of human figures to inclusion of the self. Different approaches to art therapy were used with dimensions ranking between assigning art tasks through using open studio approaches. Art tasks mentioned by the respondents are listed in Table 6.2.

The metaphor, 'waves' was used by a psychiatrist to represent treatment progress, despite some temporary regression. In the course of treatment the waves become increasingly rough before they became calm again. Both professionals and individuals in recovery identified certain 'waves' in the treatment process, the violent rush of feelings followed by calm, experienced with a certain rhythm or expected regularity as treatment progressed.

The last category, 'health care changes,' emphasized the increasingly shorter treatment periods and more generalized services offered by treatment programs.

Axial Coding

Once major themes are identified, a second level coding procedure called axial coding was conducted. Axial coding puts the data back together in new ways by making connections between categories. Axial coding involves identifying a single category as the central phenomenon and exploring its relationship to the other categories. The central phenomenon is identified as well as the conditions that give rise to it, the context in which it is embedded, the action or interactional strategies by which it is handled, and the consequences of those strategies. In axial coding a paradigm model is created which visually portrays the relationship among the categories (Strauss and Corbin 1990). Figure 6.1 represents the axial coding paradigm model.

Selective Coding

The third set of coding procedures is selective coding, where the theory is developed. In selective coding, researchers build a story that connects the categories. A discursive set of propositions is generated and validated against the story (Strauss and Corbin 1990).

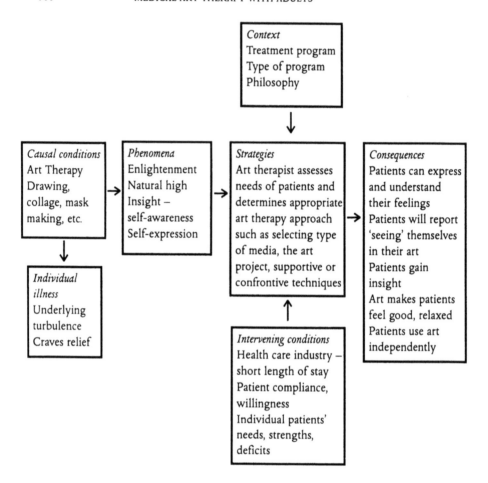

Figure 6.1 Axial Coding: Paradigm Model of Art Therapy in Chemical Addictions Treatment
 Programs

The experience of enlightenment in art therapy

The following sections describe the experience of enlightment through the
narratives of art therapists, psychiatrists, and people in recovery from
addictions. Enlightenment is defined as self-awareness or insight,
self-expression and a natural high. Being enlightened is critical to recovery
from addiction.

The individuals about whom this chapter is written have chosen the path
of recovery. They crave relief from the insanity of addiction. Initially, in
treatment programs, art therapy provides relief. According to one recovering
individual, 'I find myself doodling and looking at [the doodles], it relieves

pressure and is relaxing.' An art therapist agrees, 'patients just want to do art so they don't have to think about all this other stuff...' Art provides a quiet refuge away from the chaos of life (Brezine, cited in Bailey 1993). The hypnotic sketching sound of the pencil, back and forth, takes one away temporarily, and is comforting and soothing. 'Artwork provides the environment of calmness that acts as a hearing aid for the heart' (Bailey 1993, p.39). A person who has been alienated from the true self may experience a new sense of being, in the quiet. According to one recovering person, 'in a very simple and viable fashion the art therapy revealed the anxiety, frustration, pain, and hopelessness associated with my dependency in a gentle and fun process.'

Not only can an art group be quiet and relaxing, but it can be playful and fun. 'I looked forward to art therapy because it gave me the opportunity to be a kid again ... it allowed me to have fun during this earth shaking life change...' says one recovering individual. Everyone has a need for elation ... for the cessation of pain ... and to have an ecstatic dimension to our lives (Jung, cited in Segaller 1989). Chickerneo (1990) connected the playful quality of art as facilitator of spirituality in recovering alcoholics. The sense of contented bliss in art and play mimics what is sought through drink. 'The craving for alcohol was the equivalent on a low level of the spiritual thirst of our being for wholeness' (Jung, cited in Bauer 1982). The playful handling of art materials, the energy mobilized in the process, and the contemplative nature of art at once soothes, relaxes, energizes, and lifts one up to a 'natural high.' Someone experiencing a natural high feels 'en-lightened,' or relieved, as if a load had been taken off one's shoulders.

The enjoyment experienced through doing and working together with others in a room is reminiscent of a sewing circle or quilting bee. There is a feeling of belonging, of camaraderie, of pleasure, of fellowship. Says one recovering person, 'It showed how well we can work with one another and how people see things different[ly] from others.' The First Tradition of Alcoholics Anonymous states that most individuals cannot recover unless there is a group, and recovering individuals find that they cannot keep the gift of sobriety unless they give it away (Alcoholics Anonymous 1988). A psychiatrist believes:

If you provide a setting where the patient feels comfortable to begin their treatment, and start talking about their disorder, I think you've done 80 per cent of the work ... If the patient feels comfortable, if they feel less need to use resistance ... because you're sort of getting [therapy] to them in a way that they're not aware that ... through art they're starting to talk about their issues ... it's a unique process of its own.

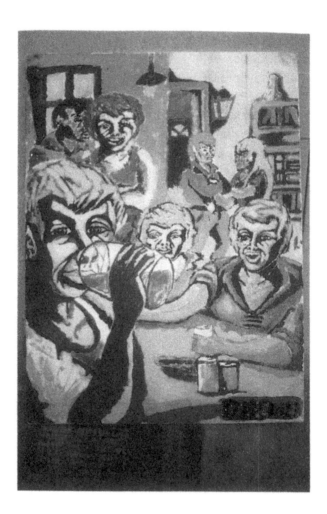

Figure 6.2 'This is my favorite because it is basically me. You go into a party and you want to be cool or want to look big or you want to be special and the only way you can do it is to do what the crowd says. It was me a couple years ago.'

The benefits of play, quiet reflection and working together are directly experienced as individuals dabble with art media. Through direct experience, we learn, we gain insight, we become 'enlightened.' A psychiatrist explains, '…you can't learn how to swim by *talking* about swimming. The only way you learn how to swim is by walking into that pool with a swimming instructor, and beginning to swim.' Considering the individuals who relapse because they didn't *do* their aftercare plans, makes *doing* seem ever so important. As Harms (1973) suggests, many addicts experience a lack of impulse for any activity. Therefore, to do *any* activity reduces the tendency toward lethargy and repeating old habits.

Self-expression is enlightening. One psychiatrist thought 'patients have major needs to be able to express their view of their problems … many of them have limitations in their ability to identify problems.' Self-expression implies the ability to find a voice for the feelings, and words to represent the problems. Words are important because:

> …whatever words [people] use are where their feelings lie. Not *my* words – just like notes on a page come from the composer, so those notes are important to the composer. If I were using my notes, they wouldn't help… . (psychiatrist)

Articulation of problems and feelings reduces their mystery and sense of being overwhelmed by them (Foulke and Keller 1976). Traumatic events can be mastered in the art work because the patient is now taking an active role. The process of expressing feelings on paper can be encouraged in a way that patients achieve some mastery over their feelings. According to one recovering individual, 'my recovery felt much more real and attainable as I pondered the picture I had created of what I thought my road to recovery would look like.'

One of the ways art therapy helps foster self-expression is its tendency to reveal the unexpected, and to connect with the emotional self the cognitive self may be blocking. An individual in recovery recalls, 'We had to draw ourselves on a rainy day. I drew just me – nothing or no one else around me and the raindrops were only around me. It made me aware of my self-centeredness.' An art therapist had this to say:

> I had a woman in my office … and we went through an early recollection, and harvested the meaning out of it … we had not done the art work. She then took out a picture … she drew of the early recollection and it changed the meaning entirely. She started to cry when

she was talking about it. She looked at the picture and said, 'Oh, my gosh. The meaning had been about needing help from others, and she looked at the picture and … because her friend's arms were around her in this early recollection from childhood, and she was sturdy and strong and tall just like the friend, but the arms around her, she realized it was about intimacy – that it was important to her not so much because she needed the friend's help but because the friend was close and touching her. It was pretty powerful … we had come up with a script from the early recollection, and we changed the script, because of the art work.

The potential of art to reveal the unexplained and the unexpected, to bring to conscious awareness inner desires and feelings means uncovering what addicts wanted to cover up by use of substances. Yet, there must be some uncovering to allow healing from within. Because,

> …just as with a burn wound, when you have a scab at the top, everything looks just fine, as if it were healing. We all know that unless you peel off those scabs and uncover the wound it can't heal from underneath, and won't. (psychiatrist)

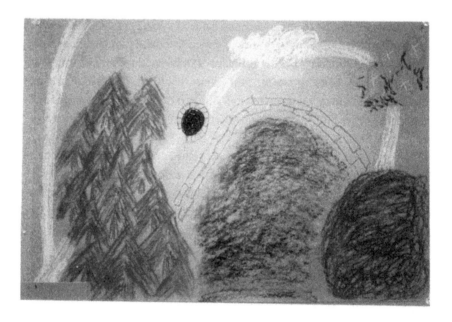

Figure 6.3 'The Road to Recovery': 'Although it is very simple, it represents a very big picture.'

Recovering individuals may experience this sort of powerlessness over the symbolism that arises in their art work, yet ironically, they are empowered by the symbolism as well. Individuals learn to recognize their personal symbols, styles and colors and learn what significance they have. Self-awareness is improved as the uniqueness of the individual is revealed, and patients become aware of personal strengths. 'These classes brought a lot out of talent out of me I didn't even know I had,' says one recovering individual. 'It showed me the direction I need to stay focused on, the direction I need to go in.'

The 'image' as concrete and permanent is important to this process. 'Words come cheap in some ways, and I think the symbols, the art work gives it greater meaning and a little more impact,' according to one art therapist. For example:

> One client ... in therapy for three weeks ... she is very focused and very involved in AA. She's got a sponsor. She says, 'I'm going to do this right, no matter what.' And I said to her, 'you know, you've never put yourself in any of your drawings – Where are you in this recovery?' 'I'm a spectator,' is what she said. (art therapist)

The art work can and does serve as concrete evidence of the individual's progress toward goals. Many programs used Step Books or workbooks wherein patients demonstrate through writing or drawing how they have made progress toward the Twelve Steps of AA.

> ...[Clients] had to set five measurable goals ... to accomplish within ... two weeks, and then they came back to their counselor. So maybe someone would set a goal for their first step they would do an 'inner-outer' [self] poster, for their second step they would do [a] 'sanity-insanity' [drawing], so maybe they would take that back and show their counselor, and talk about what they learned from that. (art therapist)

Art interventions

In the beginning of treatment, the combination of biological, psychological and social factors in the etiology and symptomology of the disease call for a thorough assessment on the part of the treatment program, necessary to understand all the factors in the individual's illness. 'A part of any illness is pathology which is destructive behavior, and treatment involves altered behavior' (a psychiatrist). Recovery presumes abstinence, but recovery in the

full sense of the word involves 'understanding the stress that's resulted in the culmination of the addiction wherein there may have been predisposition, but without the stress may not have necessarily occurred' (a psychiatrist). Recovery involves understanding the alienation and emptiness that lead to use of substances in the first place.

Certain interventions are used by art therapists, depending upon the needs of the patient, the philosophy of the treatment facility, the length of time someone might be in treatment and other intervening conditions. Many art therapists design art experiences based on the theme or lecture presented in the treatment program. The art therapist may assign an art project responsive to patients' needs, and in conjunction with the treatment milieu. The art therapy approach often requires balancing addiction and psychiatric considerations simultaneously (Miller 1995). A therapist might balance a disease concept focus (e.g. 'Just for today … I will not drink/use) with a more insight-oriented understanding of the self and feelings. Therapists may facilitate enlightenment in terms of 'a power greater than ourselves' or facilitate enlightenment through insight and personal awareness.

Often, patients who first enter treatment, are resistant to treatment, and in denial. In these cases, a therapist may use humor and play to encourage comfort with art making and engagement in therapy.

> I draw this little stick figure, and I show them and ask, 'Can you draw better than that?' They say, 'No.' And I say 'good, because otherwise I'd feel kind of intimidated if you did'. And then they laugh, and it's kind of an ice breaker, and then we go from there. And I say, 'The only thing I ask is that you put a little meat on that figure, because I'm not really into a lot of thin people, you know being full figured,' and they kind of laugh, and so nine times out of ten, I get some wonderful things. (art therapist)

The use of humor tends to deflect negative thinking that may prevent someone from participating in art. A therapist may assure patients 'it is best not to be an artist to do art therapy,' to help individuals become comfortable with their art expression.

> I say stuff like, 'everybody has a visual language. You had a visual language when you were little that was primary before you had a verbal language. When you dream you dream in your visual language … I'd like you just to trust yourself. If your little perfectionist pops up … put him out in the hallway so that you can be allowed to honor this part of yourself. I'd like you to just back off and give yourself, and whatever comes to your mind, I'd like you not to judge it … I'd like you to just

draw with your non-dominant hand ... And then I say, 'I'd like you to just try this once ... and don't decide what it means, don't even think about what it means. We'll get into that after you do it. We'll talk about it, and it you just give it an opportunity and see ... what comes out of it, you might find that it's useful for you'. (art therapist)

Some individuals have such low self-concept, they are afraid to succeed (an art therapist). They may say, 'I can't draw, I can't do that.' It is important that art therapists remember not everyone is quick or willing to try to put their thoughts and feelings in the form of art (a recovering individual) ... According to one recovering person, 'I think it's the word art that scares us. Remember we don't believe we can do anything right.'

As treatment progresses, some patients experience a period of darkness and pain. There is a confusing mix of emotions. Patients at once feel warmth, pain, closeness and distance. There are waves of progress and regression, more progress, less regression.

> ...the longer we go, the deeper and darker the [art] gets. And when they start really touching into those places that have been hidden and anesthetized for so long ... all the things that are coming out ... It's almost like something's been festering. (art therapist)

When there is obvious pain, therapists may use empathy, acceptance, validation, listening, and supporting. They may use metaphor to distance the pain. More fluid media such as oil pastels and paints foster freedom of expression, and to help individuals come to terms with painful areas in their lives. Verbal description of the art process and images depends upon what is sensed about the patient's needs and readiness to talk. Therapists may ask individuals to speak about some aspect of the art process they are comfortable to speak about. They may interpret certain issues as expressed in the art product, however they may choose to wait to discuss them until the individual is able to face certain realities in their lives without being so overwhelmed they return to drinking and drugging. Artistic expression itself is one step toward objectifying subjective concerns, toward facing realities.

A therapist may encourage continuing with art after discharge. Writing a journal may be used for increased self-exploration and to assist individuals in recognizing and drawing out triggers to relapse. Table 6.2 lists art tasks, or strategies mentioned by the respondents.

Table 6.2 Art tasks mentioned by the respondents
(Causal conditions/Strategies)

Whole body outline drawn actual size, filled in with the effects of substances on the body

Round robin pass around drawings to create stress, and how the stress is dealt with

Draw what happens after you use substances

Group murals

Draw your addiction and what would it say?

Draw your feelings

Draw: Who I am/Who I was/Who I hope to be

Writing songs about addiction

Progressive relaxation/guided imagery

Find and illustrate a 'power' symbol

Make a spiritual symbol: 'What gives you faith?'

Inner and outer consequences of substance abuse

Mandalas

Family portraits

Draw your drinking history and where this lead

What does depression look like?

The Amusement Park Technique (Hrenko and Willis 1996)

Draw: Who are you blaming?

Draw triggers to substance use

Likes and dislikes

Create a door of opportunity and a door of challenge

Bridge drawing (Hays and Lyons 1981)

Draw yourself using/yourself sober

Create a group tree and leaves representing things you are thankful for and things you have lost

Masks

Media

Pastels

Collage

Colored pencils

Markers

Music

Creative writing

Paint

Charcoal

Crayons

Colored paper

Sandtray

Intervening conditions

Intervening conditions are structural conditions that facilitate or constrain interventions offered (Strauss and Corbin 1990). Certain intervening conditions facilitate art therapy – psychiatrists who believe in it, and recovering individuals willing to give it a try. Yet, conditions existing within the broader health care industry are considered constraints. According to one psychiatrist, in recent years inpatient treatment has dramatically changed. There is less time to work with someone, and the focus is primarily detoxification and getting patients into a less intense level of care.

> In outpatient oriented treatment programs a lot of the things we used to do ... are not being done or they're being done in a very superficial, limited kind of way. In lots of instances they're just down to sort of a consultation, an analysis of what somebody needs and trying to arrange to get that done on an outpatient basis ... They're bumping everything down to the lowest level of cost ... in a model that is very analogous to what the auto industry has gone through. If a robot can do it then you don't have to be doing it. If a human is necessary, but if you can train someone at five dollars an hour to do it versus somebody at nine dollars an hour to do it, then you're going to have the five dollars an hour person do it. I think that's the kind of shrinkage we're seeing in the entire system. (psychiatrist)

An art therapist notes her job title change from art therapist to mental health worker/rehab coordinator, along with a change in job description – less art therapy and more of other kinds of case management services:

> We've been bought out by a company ... they own a hundred or so hospitals across the nation. They have this model hospital ... and they're trying to base their other hospitals on this model. It's ... a way to save money ... by lowering staff. About nineteen people got laid off in September, and the nursing-to patient ratio also decreased. I think it used to be 3 or 4 patients to one staff, now it's 5 to 1 ... I think everyone across the board is feeling the stress of it. I guess we're supporting one another within our units ... even though people get floated form unit to unit at times. We all talk about it and use humor a lot to get through it.

Other art therapists describe programs designed to be three weeks, that are now one week in duration. Patients who thought they were to be admitted for a certain length of time, were informed that day they were to be discharged, because the insurance wouldn't approve more time. One art therapist noticed that instead of one three-week stay, she might see someone

for three one-week stays over the course of a year, losing a day of progress in each transition. Therapists who were accustomed to prescribing painting or other longer term projects, found the length of time a patient stayed in the hospital did not allow for such involved projects. A therapist may have to balance creating art work, which involves time, against the time a patient is likely to be on the unit. This decrease in treatment time seemed to represent the greatest concern for art therapists.

The issues and difficulties encountered by those attempting to treat clients or plan treatment strategies is complicated by the changing nature of drug treatment client populations. Clinicians in treatment programs have always struggled with patients not ready for recovery, who are in denial, have not 'hit bottom', nor admitted powerlessness. Even patients who seem sincere in desiring recovery often relapse. Treatment programs today admit patients with multiple problems in addition to substance abuse that need to be addressed concurrently. 'It is hard to deal with them in a chemical dependency model, when there were patients much more fragile' (an art therapist).

> Our age range will go from 19–86. When you get to that high end you get a lot of alcoholic dementia, and associated nutrition problems and neurological problems … And then within the group, with the dual disorders, it could be alcohol, heroin or crack, or depression or schizophrenia. (art therapist)

Consequences

In spite of these conditions, many reported positive outcomes of art therapy. One art therapist believes:

> art therapy *can* be used well in conjunction with 'brief therapy' or at least shorter-term therapy because of the ability to cut through the initial, more superficial stages of the therapeutic process, and move to the deeper content and emotional impact of particular issues at a quicker pace. Also, art therapy assignments can be given over the evenings/weekends between therapy sessions that can build on what has already been processed in group. Art therapy lends itself to self-empowerment and awareness, and as a client begins to pick up on his/her own symbols, color use, style, etc., it becomes more self-motivating, which may ultimately impact long-term outcome measures. Journaling, dream work, etc. are very good on-going techniques.

When patients are progressively moving toward healthy awareness, there is increased insight: Something 'clicks.' Individuals begin sorting things out and taking responsibility for their recovery. '[In drawing] my personal solar system I realized where I stood with my family and where things in my life were' (a recovering individual). '[I drew a] bridge, a strong one, high above the water, with strong supports, guardrails, reaching the midpoint and now facing the reality that I am addicted. It's becoming easier' (an individual in recovery).

One art therapist noticed a transition in the colors used:

> They would start moving away from the darker colors, the reds and the blacks. They would start to invest more in the art ... and you would just see they would start using the projects to understand themselves, or they would use their journals ... But the other thing ... the symbol of the sun or a bright image in the center of something, usually in the beginning of treatment ... would be enveloped with darkness ... the patients would show their addiction of something like the light being blocked, like there'd be a dark black circle around. At the end of the treatment there would be this opening.

Figure 6.4 'Mike's Galaxy': 'With this I realized where I stood in my family and where things in my life were.'

Figure 6.5 'This is my recovery picture. The guy at the bottom is stuck inside the crack pipe, which is his addiction. He wants to get out, but he doesn't know how. He is chained to drugs. On top is my recovery machine. You go into it addicted on whatever chemical you choose to use and then you come out punching your addiction. At the bottom I have foot stomping alcoholism and drug addiction with an addict looking on who wants recovery.'

The individual in long term recovery interviewed paints all canvases in black first, then adds color on top:

> I never really know how to put really light colors together and match them really well. That's mainly why I always start with deep dark colors, and I put the light in as I go along. I got confused, I didn't know how to do it so I just painted all black and where these lines are, colors ... Everyone has a light and a dark side but they never admit the personalities they have.

'The light bulb that clicks on,' or 'the light at the end of the tunnel,' are common metaphors for enlightenment, for awareness or relief. In professional literature, Johnson (1990) discusses the transformation from darkness to light she found in adolescent and adult substance abuse patients' poetry and art work. She compares her findings with Whitfield's

simplification of the Twelve Steps: 'struggle, confusion, surrender, seeing the light.' (Whitfield, cited in Johnson 1990, p.301).

Propositions

Co-founder of Alcoholics Anonymous W.B. Bill (1987) describes his experiences with recovery:

> Suddenly the room lit up with a great white light. It seemed to me, in the mind's eye, that I was on a mountain and that a wind not of air but of spirit was blowing. And then it burst upon me that I was a free man. Slowly the ecstasy subsided. I lay on the bed, but now for a time I was in another world, a new world of consciousness. All about me and through me there was a wonderful feeling of Presence, and I thought to myself, 'So this is the God of the preachers!' (p.2)

Drawing from the story of enlightenment, the following propositions are offered.

1. The art experiences of recovering individuals in treatment programs contribute to a sense of enlightenment.

2. Individuals may experience one or more forms of enlightenment. Sometimes forms of enlightenment are experienced in succession, and sometimes simultaneously. Individuals may experience a natural high, a soothing, or playful sense of relief or a spiritual attunement. Self-expression is enlightening through sharing oneself and dividing problems. Last, self-awareness or insight is achieved through direct experiences with art.

3. Different interventions can be used by the therapist to encourage enlightenment, depending on the needs of patients, and the intervening conditions present. A therapist may foster enlightenment through recognizing the needs of the individual patients and responding to their needs through organizing the environment, the art materials, and the art directives and approach. Humor, education, and empathy are strategies employed. A therapist may match media with expressive needs – structured media may be used when individuals need support and containment. Fluid media may be used when individuals require assistance with uncovering and self-expression.

4. Certain conditions exist which impinge upon the success of an art therapy program: the decrease in the length or time, patients who are more ill, patients who do not want to participate, constrain the potential for enlightenment.

5. Art therapy works in conjunction with the two major philosophical approaches to chemical addiction – the disease concept and psychiatric models of treatment. Different forms of enlightenment promoted by art therapy parallel the two philosophies of treatment: The natural high/spiritual sense of enlightenment is akin to realizing a higher power that can restore sanity (Step 2) (AA 1988). Enlightenment experienced through insight or personal awareness augments the psychiatric model of treatment.

6. Art therapy offers benefits to short-term care: art assignments given over weekends or in the evenings help bring consistency to the treatment, and bridges the treatment program and the home environment. One reason why art therapy works, might be because it introduces how to work independently through journaling and doing art work on one's own. It requires doing, and changing behavior.

Conclusion

'Individuals who are relatively happy and who can live their lives without the use of drugs and alcohol,' according to one psychiatrist, 'is the desired outcome of chemical addiction treatment.' However, as another psychiatrist noted, statistics show 'a whole lot of people don't get better from getting an episode of treatment … [or] from multiple episodes of treatment, and part of that may not be the treatment, it may be the way that particular treatment is applied or utilized is less effective with that person…' Finding the most effective treatment for each person is a challenge. Art therapy deserves consideration for its potential to contribute to the treatment, the relative happiness of each individual living life without drugs and alcohol. The benefits of art therapy in chemical dependency treatment are many, yet art therapy, like health care in general, feels the constraints of cost containment. This study offers little in the way of solutions, yet, hopefully greater awareness of the issues can lead to problem solving.

 This study supports the value of art therapy in addiction recovery. The major finding concerns the phenomenon of enlightenment experienced in art therapy. Enlightenment in art therapy helps individuals to understand

important concepts in recovery such as 'letting go and letting God.' It emphasizes the value of quiet, reflective time or play time. Self-reflection is viewed as empowering. Greater self-awareness helps individuals to understand and resolve the stress which precipitated the substance use in the first place. Enlightenment can mean the difference between abstinence and recovery in the full sense of the word.

Although the art therapists expressed concern over the decreasing length of time patients were admitted to treatment, treatment strategies remained relatively unchanged over time. They may be fewer, or performed in shorter duration, yet the types of art interventions described in art therapy literature in years past are quite similar to those used today. It could be that no one has a better idea! Or, it could be that the interventions, despite the constraints upon them, are working to some extent, that they're trustworthy and not affected by the passing of time or the amount of time a patient is in treatment.

Recommendations for further studies would be to continue to interview individuals who have had art therapy in treatment programs, both current patients or individuals in longer term recovery for whom art has been important. Exploring the role of art in recovering individuals who were not in treatment programs would also provide important information about the potential uses or consequences of art. Artists who are addicts (and/or recovering addicts) and continue to make art would help the researcher be theoretically sensitive to the range of conditions that impact art and recovery.

It is my hope that this study helps to explain the theory of art therapy in recovery from chemical addiction. In the words of one psychiatrist, 'Treatment is an art. Treatment is art therapy, that's what treatment is, if it's good treatment.'

References

Albert-Puleo, N. and Osha, V. (1976–77) 'Art therapy as an alcoholism treatment tool'. *Alcohol Health and Research World*, Winter, 28–31.

Alcoholics Anonymous (1988) *Twelve Steps and Twelve Traditions* (37th printing). New York: AA.

Allen, P.B. (1985) 'Integrating art therapy into an alcoholism treatment program'. *American Journal of Art Therapy 24*, 10–12.

Bailey, J. (1993) 'How art heals'. *St. Anthony Messenger*, February, 36–41.

Bauer, J. (1982) *Alcoholism and Women*. Toronto: Inner City Books.

Bill, W. (1987) *As Bill Sees It*. New York: Alcoholics Anonymous World Services.

Burke, K. (1985) 'When words aren't enough ... a study of the use of art therapy in the treatment of chemically dependent adolescents with special focus upon the

spiritual dimension'. *Dissertation Abstracts International 46*, 08–A, p.2166 (University Microfilms No. AAD85–23,669).

Chickerneo, N. (1990) 'New images, ancient paradigm: A study of the contribution of art to spirituality in addiction recovery'. *Dissertation Abstracts International.* Order no. 9110801.

Chopra, D. (1997) *Overcoming Addictions.* New York: Harmony Books.

Conrad (1978) 'A grounded theory of academic change'. *Sociology of Education 55*, 101–112.

Craddock, S.G., Rounds-Byrant, J.L., Flynn, P.M. and Hubbard, R.L. (1997) 'Characteristics and pretreatment behaviors of clients entering drug abuse treatment: 1969 to 1993'. *American Journal of Drug and Alcohol Abuse 23*, 1, 43–59.

Devine, D. (1970) 'A preliminary investigation of paintings by alcoholic men'. *American Journal of Art Therapy 9*, 115–128.

Feen-Calligan, H. (1995) 'The use of art therapy in treatment programs to promote spiritual recovery from addiction'. *Art Therapy: Journal of the American Art Therapy Association 12*, 46–50.

Foulke, W.E. and Keller, T.W. (1976) 'The art experience in addict rehabilitation'. *American Journal of Art Therapy 15*, 75–80.

Glaser, B. and Strauss, A. (1967) *The Discovery of Grounded Theory.* Chicago: Aldine.

Harms, E. (1973) 'Art therapy for the drug addict'. *Art Psychotherapy 1*, 55–59.

Hays, R.E. and Lyons, S.J. (1981) 'The bridge drawing: A projection technique for assessment in art therapy.' *The Arts in Psychotherapy 8*, 207–217.

Hrenko, K.D. and Willis, R. (1996) 'The amusement park technique in the treatment of dually diagnosed, psychiatric inpatients'. *Art Therapy: Journal of the American Art Therapy Association 13*, 261–264.

Johnson, L. (1990) 'Creative therapies in the treatment of addictions: The art of transforming shame'. *The Arts in Psychotherapy 17*, 299–308.

Miller, N. (1995) *Addiction Psychiatry: Current Diagnosis and Treatment.* New York: Wiley-Liss, Inc.

Moore, R. (1983) 'Art therapy with substance abusers: A review of the literature'. *The Arts in Psychotherapy 10*, 251–260.

Segaller, S. (Producer/Director) (1989) *The Wisdom of the Dream, Vols 1,2,3.* [Film]. USA: Border Television.

Steele, C. (1997) 'On the front lines: Fighting drugs in Dayton'. *Community 2*, 2, 2–7.

Strauss, A. and Corbin, J. (1990) *Basics of Qualitative Research: Grounded Theory Procedures and Techniques.* Newbury Park, CA: Sage Publications.

Ulman, E. (1953) 'Art therapy in an outpatient clinic'. *Psychiatry 16*, 55–64.

Van Leit, B. (1995) 'Managed mental health care: Reflections in a time of turmoil'. *American Journal of Occupational Therapy 50*, 428–434.

Whitfield, C. (1987) *Healing the Child Within.* Deerfield Beach, FL: Health Communications, Inc.

Further reading

Clemmens, M.C. (1997) *Getting Beyond Sobriety: Clinical Approaches to Long Term Recovery.* San Francisco: Jossey Bass.

Donnenberg, D. (1978) 'Art therapy in a drug community'. *Confinia Psychiatrica 21,* 37–44.

Jellenik, E.M. (1960) *The Disease Concept of Alcoholism.* New Haven, CT: College and University Press.

Beyond Words

The Art of Living with AIDS

Emily Piccirillo

The public became aware of the existence of HIV/AIDS in the early 1980s, at a point in history when industrialized nations functioned under the illusion that the threat of plagues had long been eliminated by antibiotics, vaccines and the introduction of standard hygiene practices into daily life. Inverting some of our most basic assumptions, this epidemic, with its scope and severity, has caused dramatic changes in our modern world view, along with significant demographic shifts and a transformation of the health care system (Beaudin and Chambre 1996). No other single event has had such a profound effect on our country in the late twentieth century, and no aspect of the American way of life has gone untouched by its significance. It has exposed prejudices and cleaved society in disturbing ways, yet it has also compelled the most diverse factions to align around our greatest concern – survival itself.

It is certain that the presence of HIV (Human Immune Deficiency Virus) is the essential determinant in the development of AIDS (Acquired Immune Deficiency Syndrome). Although the initial hysteria about this epidemic may have subsided, AIDS is much more than a life-threatening illness and its presence raises deep and difficult questions for both the individual and society. People living with AIDS (PLWAs) continue to be affected by more than a virus; they are carriers of the many misleading interpretations and beliefs of society. Some prefer to define AIDS as a disease of identity that leaves its impression on all aspects of a person – body, mind, heart, spirit, and community (Edwards 1993). There are also many medical, legal, political, cultural, educational and ethical issues that are far from resolved.

Unique major characteristics of HIV/AIDS will always distinguish it from most other illnesses. From a purely biomedical perspective, AIDS is not a single illness but is categorized as a syndrome that is characterized by a broad, fluctuating spectrum of symptoms and opportunistic infections rather than a disease that follows a single predictable course. Symptoms can strike singly or in clusters as the immune system weakens. Its course varies wildly, with protracted periods of vague and nonspecific problems, often referenced at death as 'AIDS-related complications'. While the Center for Disease Control (CDC) has established strict criteria for the diagnosis of AIDS, the list of qualifying clinical conditions has undergone revisions in order to keep pace as the dimensions of the virus have grown.

Fortunately, tremendous progress has been made in understanding and treating the medical aspects of HIV/AIDS, so the newly diagnosed have tremendous prognostic advantage over the first decade of PLWAs. Since the beginning of the AIDS epidemic, the incidence of AIDS and deaths of persons with AIDS has finally begun to diminish (Fleming *et al.* 1998). This hopeful news occurs simultaneously with the increased prevalence of HIV/AIDS, largely due to treatment advances. Now classified as a chronic illness, it is no longer perceived as an immediate death sentence, especially for those with early diagnosis and access to the cutting-edge antiretroviral and combination therapies (Beaudin and Chambre 1996).

HIV is a contagious pathogen and with its primary adult modes of transmission being sensation-seeking behaviors – unprotected sex and intravenous drug use – it continues to carry strong personal and political stigmas. Despite some recent crossover into the middle-class heterosexual population, the virus continues to disproportionately affect drug users and gay/bisexual men and their partners. HIV/AIDS tends to exacerbate the scorn that 'populations at high risk' already bear. Historically they are marginalized and persecuted as 'different' for a combination of reasons (Franklin 1993).

While the geography of AIDS has spread steadily into rural areas, it is crucial to underscore that the demographics of PLWAs are still weighted heavily to urban people of color and of poverty (Maldonado 1997). Already challenged by unstable circumstances, HIV/AIDS further weakens their brittle worlds. Ironically, it is this familiarity with hard times that often fortifies these individuals for the sudden, frightening effects of the syndrome and the accompanying social backlash. One such PLWA chose to sign his art

'Pariah' due to his acute sense of himself as an unworthy outcast, thereby confronting the viewer on this issue.

Currently, among the newly infected, a higher proportion of women are contracting HIV (Rotherman-Borus, Murphy and Miller 1996). It is predicted that the face of AIDS in the year 2000 will be that of an African-American female youth. Statistically, infected women have tended to be the sexual partners of drug addicts or bisexual men, or are intravenous drug users themselves, yet with increasing frequency they are unable to identify such high risk behaviors (Stein 1998). The social impact of this reality increases due to the disproportionate childcare responsibilities of women and the chance of infection in their offspring (Meredith and Bathon 1997)

Lastly, HIV/AIDS has a multigenerational impact; seldom is only one member of a family infected. Siblings, children, aunts, uncles, cousins, parents, grandparents, and significant neighbors may be HIV+ as well. HIV/AIDS affects the entire extended family – consisting of an often crisis and crime-ridden, under-educated relational network that is characterized by single parents and multiple partners. The consequences of these combined circumstances are often both catastrophic and long-lasting, burdening those affected with experiences of chronic loss, and anticipatory, complicated, disenfranchised and unresolved grief (Elia 1997).

The people living with AIDS that are described in this chapter were residents in long term care facilities in New York City and Newark, New Jersey. Others were receiving treatment in Washington, D.C. They ranged from 18 to 80 years old, however most were in their twenties, thirties and forties. At the time of this writing, most have already passed on and they are counted among the 640,000 U.S. cases of AIDS documented by the CDC so far (Centers For Disease Control and Prevention 1997). Keep in mind that since there is no system for specifically reporting HIV infection, and with the elongating interval before advancement to AIDS, this figure fails drastically to reflect the extent of this epidemic (Forsyth 1995).

The impact of HIV/AIDS on physical and psychosocial areas and the appearance of related themes in the artwork

Physical

These are the hallmark indicators of AIDS in adults: pneumocystis carinii pneumonia, lymphomas, candidiasis, isosporiasis, coccidioidomycosis,

Figure 7.1 'Canvas'

cryptococcosis, cryptosporidiosis, histoplasmosis, progressive multifocal leukoencephalopathy, toxoplasmosis of the brain, salmonella septicemia, tuberculosis, invasive cervical carcinoma, Kaposi's sarcoma, cyto-megalovirus, herpes simplex, HIV encephalopathy and HIV wasting syndrome (Centers For Disease Control and Prevention 1997). As immuno-suppression becomes severe, all areas of functioning can be threatened. Latent pathogens already present in the body and ordinary environmental hazards, like tainted drinking water, can wreak havoc.

A frequent subject in the artwork of PLWAs, the human body is itself perceived as having its own expressive powers. The shared origins of the word 'symptom' with 'symbol' is illustrated in Figure 7.1 titled 'A Canvas,' inducing the viewer to visualize the illness. As a fluctuating form, the body serves as both a personal and communal medium of meaning and metaphor (Moore 1992). The rich theories and myths that have surrounded AIDS derive in part from the ambiguous and troubling ways HIV manifests as symptoms, and the infected body serves as the surface onto which these graphic ideas have been projected and inscribed. This piece also

communicates the tension and vulnerability as PLWAs wait for the physical symptoms to appear.

Because HIV is blood-borne, it circulates throughout the body, invading and damaging organ systems, being partial to the liver, heart, kidneys, skin, GI tract, eyes, cervix, throat, lungs and brain. Some of the symptoms are intermittent, or become chronic, or advanced. Others resolve, suddenly or gradually, spontaneously or with treatment. Side effects of medications further confound the clinical picture.

The central nervous and respiratory systems are hardest hit. Many secondary infections also target these areas. Neurological complications can manifest in thought and mood disorders, altered personality, distractability, restlessness or slowness, disinhibition, impulsivity, infantile regression, impaired perception, motor and language skills, disorientation, incoherence, and memory loss (Zegans, Gerhard and Coates1994). Differential diagnoses are extremely difficult, but without proper evaluation these conditions can be mistaken for other problems. For example, when a client arrives late for an appointment after forgetting the familiar route, this could be misinterpreted as depression, resistance (or even worse, as disrespect) rather than the progressive multifocal leukoencephalopathy it may indicate (Feldman 1993). It also seems that the effects of the virus on the mind cause the greatest anguish. Many fear they will 'go crazy' because of it.

Art therapy is a very useful modality for monitoring the cognitive and emotional functioning of clients as AIDS-related dementia sets in. Deterioration of rational processing becomes visible as compositions fall apart and the creative process loosens to the point of random discharge or tightens to rigid dependence on copying, tracing, and devices like rulers, stencils and erasers. Confusion is apparent as established skills vanish. Emotions run high, or become inappropriate; these limitations can also lead to apathy and withdrawal. AIDS can also cause organic psychosis, often with paranoid delusions, or visual and auditory hallucinations. The deterioration is usually uneven, creating marked discrepancies between areas of functioning. The condition fluctuates rapidly, even within an hour's time. Compensatory efforts, such as labeling, numbering and perseveration are telltale indicators. Interventions and cueing by the therapist can provide tremendous relief. Fortunately, medications can often help to mitigate these complications despite the progressive nature of most of them.

In contrast, health professionals may misperceive and exaggerate a client's problems, possibly seeing them as more globally impaired or lower

functioning than they actually are due to superficial signs of isolated effects of the virus. For example, if the speech centers are disrupted, a client may sound limited or psychotic. It may not be until the client begins to make art that the client's intelligence, keen awareness of reality and internal coherence become apparent. Art can unmask stunning strengths that would otherwise pass unappreciated, assisting with important differential diagnoses. Also, the art of such PLWAs can motivate health care providers to reconsider their basic assumptions, improving the quality of care and the general welfare of such clients.

Psychosocial

The multitude of special psychosocial issues that arise in the lives of PLWAs are astounding. Since many already live in difficult circumstances, it is virtually impossible to differentiate the intersecting stressors and psychological symptoms that are directly attributable to the presence of HIV/AIDS from the sequelae of daily living. For many disadvantaged PLWAs, the virus just means additional turbulence and trauma, with the threat and crisis of death increased. Regardless of socioeconomic status, problems that can accompany HIV/AIDS include abandonment by family and friends, loss of occupational functioning, savings or housing, reduced autonomy, changed and lost roles. The overwhelming demands test the constitution of even the hardiest clients.

Many PLWAs are both uniquely sensitive and remarkably resilient to their circumstances. Health care providers report a high incidence of post-traumatic stress disorder (PTSD) in PLWAs, similar to symptoms found in war veterans and abuse victims (Apfel and Telingator 1995). Those with lengthy histories of substance abuse may never have established a baseline stasis that can be used effectively when in severe distress. The demands of the diagnosis can so tax their internal resources and interpersonal skills that they enter a chronic state of crisis. Because of the (increasingly) prolonged and pervasive nature of this syndrome, dissociation, vigilance, hyperarousal, irritability and numbing are common symptoms. Personality disorders typically exacerbate. Depression is commonplace, with suicidal ideation and behaviors occuring more frequently than might be expected (Starace and Sherr 1998).

Many PLWAs fear alienation and are motivated to cooperate so as to not upset and possibly lose the support of health care providers. Others will put caregivers and therapists through many rigorous tests of trust, reliability and

allegiance as a 'real person,' already having been disappointed too many times by individuals claiming to be there for them. Some may react with entitlement, or with constant complaints while taking pleasure in watching others act out their feelings of impotence, anger and frustration. In the best case scenario, both client and health care provider acknowledge the need for a collaborative partnership, with all parties taking active responsibility for the course of treatment.

There are a number of distinctive psychosocial implications which may be present for PLWAs:

SECRECY AND DENIAL

HIV/AIDS is surrounded by a code of silence, with the issue of disclosure being a central concern (Tasker 1992). Many HIV+ persons choose to conceal their diagnosis as protection against hostility, ostracism and discrimination. Some prefer to avoid the difficult questions that might follow about how the illness was contracted and subsequent high risk contacts with others. For others, the whole subject remains unspeakable because they are still in shock.

Figure 7.2 'Out of the Closet'

Figure 7.2 illustrates the crisis that HIV/AIDS caused for one gay man. Titled 'Out of the Closet,' it captures how his serostatus forced him to simultaneously disclose his sexual orientation, exacerbating his stress level. It also captures the catastrophic impact HIV had on his community, and how a history of enforced secrecy and related shame helped to clear a wide path for HIV to spread rapidly. The skeletons play on the alternate expression 'skeletons in the closet' – a reference to personal experiences kept hidden to avert disapproval and may also reference the emaciated look of wasting syndrome. This artist complained that since he was one of the last surviving members of his social circle he could no longer stand being estranged from his parents. Eventually he was able to tell them about his situation and that he needed their support. Fortunately he was invited back into their lives and their home.

Health care providers may need to speak plainly in giving PLWAs permission to freely discuss HIV/AIDS, putting them at ease within the safety of the clinical setting. The frequency with which a clinician uses the word AIDS in conversation must reflect the PLWAs readiness to hear it; this determination requires careful attention to nonverbal cues and subtext in conversation.

Denial is a natural part of living with HIV and takes many forms. It is helpful to think of it as a neutral phenomenon, rather than an adverse defense mechanism, especially during the initial crisis of the diagnosis. The complete refusal to consider artmaking at that time can be a measure to keep the virus out of conscious awareness. Surely denial can compromise judgment and then result in avoidance of important responsibilities, causing ethical dilemmas. This needs to be addressed carefully and directly if others are in immediate danger (Adler and Beckett 1989). But for some PLWAs, denial can be a measure of their hope and pride as they get on with the business of living during symptom free intervals, or it may be employed only in relation to certain secondary complications (Schaffner 1990). Therapeutic sessions may go on indefinitely with the client never uttering 'HIV' or 'AIDS,' in sharp contrast to their willingness to speak in detail or make art about its impact on their life and how they want to manage it. Whether conscious or not, static or fluctuating, some form of denial may persist to the end, with the PLWA never directly identifying their syndrome by name. Such clients may be eager to create art about their illness while remaining adamant against displaying it for others to see.

Denial may be expressed through imagery in figures turned away from the viewer, faces shielded by sunglasses, masks or wide-brimmed hats. 'No trespassing' signs, fences, concentric bands of color or wide margins may be used to ward off danger. Rainbows, balloons, suns, stars and hearts may proliferate as a stereotyped reaction formation. Emotionally loaded material may be heavily layered, obliterated or conspicuously removed.

GUILT, SHAME, BLAME AND EMBARRASSMENT

HIV/AIDS triggers the human reflex to either assign or accept responsibility or fault when something goes wrong and causes pain. This reactivity has crippling consequences for people living with it as they grapple with the question, 'Why?' (Schaffner 1990). Due to the mysterious etiology of HIV/AIDS, the sensational conclusions that proliferated early on continue to resonate loudly today. As it became apparent that AIDS is usually transmitted by specific behaviors, moralizers took liberties in wildly interpreting this coincidence according to their judgmental belief systems. Since many faiths interpret suffering as punishment for sins, PLWAs may experience guilt, shame, blame and embarrassment.

Figure 7.3 'The Price'

It is difficult to remain immune to the pernicious belief that AIDS is the wrath of God or the work of the devil. Figure 7.3 entitled 'The Price' clearly illustrates this condemnation; when sharing this piece with the author, the artist cynically remarked, 'Crucifixion is still a very popular pastime.' As PLWAs try to solve the riddles of HIV/AIDS, their torment gets reinforced if they overhear harmful remarks such as, 'You got what you deserved.' Unless they receive counseling, PLWAs own this negativity, damaging their self-worth. Despite these existential dilemmas, some PLWAs are able to find tremendous strength in their spirituality. Others undergo conversions that can strain relationships. For PLWAs living on after the loss of loved ones and acquaintances, survivor guilt is common, as well as related feelings such as admissions of relief and regret.

ANGER AND FRUSTRATION

There are endless sources of anger and frustration for PLWAs. The newness of the illness and its panicked and fictional interpretations have contributed a political component that few diseases have carried. The birth of the social action group ACT-UP was a direct result of the fury and outrage that the gay community experienced as the government failed to respond to the early phase of the epidemic. The continued limited access to the most effective therapies persists as an enormous problem. Ongoing threats of legislating a mandatory registry, or tatooing, quarantining and criminalizing PLWAs keeps the community vigilant. Since some PLWAs have engaged in past unlawful deeds, they often struggle to distinguish HIV/AIDS from the aspects of themselves that do truly belong to the darker side of themselves (Geiser 1989). The angry energies that PLWAs commit to constructive and assertive action seem to contribute to their longevity. Making artwork can contribute to this transformation of rage into courage.

In Figure 7.4, 'Bad Boy,' this artist deconstructs a specific source of his misgivings by breaking down some of the oppressive vocabulary of disease. Simply by spelling out ordinary words, he is able to articulate his resentment of these dehumanizing labels and phrases. He is keenly aware of how perceptions of persons with any medical condition tend to become the illness itself – they quickly go from having a disease to being the disease. While being objectified and reduced to a set of clinical problems, the etymology of core terms like 'invalid' and 'disable' threaten to contaminate the person with feelings of essential badness. This narrative has devastating implications for PLWAs due to the especially cruel and critical views of this virus that

Figure 7.4 'Bad Boy'

continue to prevail. Some PLWAs have been called 'sick' in the past because their lifestyles or habits were seen as taboo, perverted, or repugnant. With the introduction of a very real contaminant into their bodies, this coincidence plays on accusations of being 'unclean' and 'corrupt.' When asked about his preference for creating art on napkins, styrofoam plates and trays from the kitchen, this artist explained, 'Because this is what my diet consists of now – morning, noon, and night.'

UNCERTAINTY AND FEAR

The origin of HIV/AIDS is unknown and continues to be characterized by mystery. There is an endless search for answers about its origin and implications; imagery by PLWAs is filled with question marks, puzzle shapes, keys and mazes. Many clients feel trapped and draw boxes, cells and prison bars to depict this. Uncertainty defines all aspects of HIV's impact and manifests readily in fear and anxiety. Because PLWAs have to dually contend with AIDS the disease and AIDS the public event, the locus of danger is both internal and external, creating a range of possible repercussions that is diffuse and unsettling. Worries about infecting others make everyday intimacies seem potentially fatal due to fear of being 'toxic'.

Figure 7.5 'The Terror Within'

In certain ways, society's pejorative perceptions have been more contagious than the illness itself. 'The Terror Within' (Figure 7.5) establishes a graphic association between HIV/AIDS and other sensational social dramas, emphasizing the dreadful magnitude of this virus' reputation. Since the world seems shattered for PLWAs at first, collage is a powerful medium for 'putting the pieces together.' In fact, what the artists discover is that they end up creating something very new and different with the familiar elements, since their lives are so changed. The resulting images often share a view of world as polarized, either/or, black and white, us and them, guilt and innocence, positive and negative (Franklin 1993). Fear of death and anticipatory mourning recur in many signifiers in the art, like the grim reaper, coffins and tombstones.

The ambiguous disease process involves unpredictable symptoms and treatments; even experimental drugs are coded with seemingly arbitrary numbers and letters. PLWAs are confronted by the monumental task of sorting through mountains of information, often contradictory and obscure; many rely on the extensive informal network that has grown up among clients for sharing the latest news. Even literate and knowledgable clients can be flooded by confusion and tortured by their decisions, at times choosing to

take bold and innovative measures beyond their doctor's training, experience and advice. A PLWA may recognize the need to scale back personal goals in response to their symptoms, but choices about the future are very difficult when a disease can fluctuate suddenly. Not many persons with major illnesses also face the chance of losing their support system, especially as their physical status declines – at the very time they need it most.

Uncertainty presents several ways in the art-making process. Many PLWAs exhibit doubt and indecision over simple and small creative choices and others admit they find art-making scary. The 'messiness' of media is a common objection, often the reason given for declining an invitation to make art.

Features of the fight or flight response are often apparent; due to the variability of the disease process, both responses are inevitably employed. Frequent images of stabbed hearts, armed combat and ticking bombs depict the daily battles and suspenseful moments. Many PLWAs have already been the targets of physical attacks and taunts due to their unconventional lifestyles or minority status. The virus' lethal potential has further antagonized some members of society to reach the drastic conclusion that PLWAs are murderous, suicidal, or both (Franklin 1993). PLWAs express both realistic and paranoid fears that the irrational climate of HIV/AIDS will provoke another wave of violence and injustice.

The impact of HIV/AIDS can begin to feel like air or water – an element of the environment, as much a pervasive part of the shifting atmosphere as the weather. Feeling buffeted about by fierce invisible forces, some PLWAs globalize their primal fears as if surrounded by imminent disasters that are far beyond their control. Like an act of nature, HIV/AIDS becomes equated with the hazards of avalanches, earthquakes, volcanos erupting, tornadoes, and tidal waves in artwork. Dinosaurs, whose catastrophic demise remains a mystery, appear frequently in their art.

Other PLWAs use metaphors based on games to include the virus in their artwork, expressing it as 'a roll of the dice' or that it is 'all in the cards' in order to highlight ideas about stakes, odds, and luck – the uncertainty of life. HIV/AIDS comes to represent 'a killer hand' that has already been dealt; it cannot be bluffed or easily cheated and has to be played out. They emphasize the fact that even the most skilled, smart and strategic player cannot predict what the future holds.

Intervention and treatment planning

Before discussing the specific uses of art therapy as an intervention with
PLWAs, it is important to highlight the special skills that are advisable for
healthcare providers in their work with this clientele. Many of the issues and
stressors, even the stigmas, that clients face get shared by health
professionals, heightening the challenge of providing care. Because these
skills were highlighted in a previous chapter about HIV/AIDS (Piccirillo
1999), they are briefly summarized below.

Knowledge of HIV/AIDS and its sequelae

Any therapist working with PLWAs must be well-educated in this disease
process, its clinical manifestations, treatments, and implications. In addition
to knowledge of HIV/AIDS, knowledge of addictions and recovery, and
how they influence the development of personal identity is important and
beneficial to the therapeutic process (O'Neill 1997).

Knowledge of death and bereavement

Knowledge of the various ways individuals anticipate, experience and think
about death and dying guides the therapist in counseling PLWAs well in
advance of their final days (McGoldrick et al. 1986). A thorough inquiry into
these beliefs will strengthen the therapeutic alliance and these concerns
should be routinely addressed during care (Kaldjian, Jekel and Friedland
1998). Because HIV/AIDS services involves both trauma and grief work, it
is also necessary for each health professional to have attended to one's own
related personal experiences and losses and to be aware of how they
influence the services provided (Elia 1997).

Cultural competence

A comprehensive awareness of diverse heritages, races, religions, lifestyles,
and socioeconomics is essential to working with people living with
HIV/AIDS (Zegans et al. 1994), including an appreciation of differing
attitudes toward doctors and therapists. It may be a tall order, but working
knowledge and respect for the customs and values of the main cultures of
Americans helps cement and sustain an authentic therapeutic alliance. It must
be noted that HIV/AIDS requires segments of American society to interact
that otherwise might seldom come in contact or choose to associate, and

these exchanges often occur under duress; the health professionals that work within this diversity should accept and anticipate the possibility of conflicts between clients and in their own relationships with them in order to process them successfully.

Self-knowledge

Understanding the personal reasons and motivations for working with PLWAs will help greatly when feelings of vulnerability, helplessness, failure, fear and anger inevitably arise (Winiarski 1991). HIV/AIDS revises the therapeutic stance, putting the therapist through personal changes and requiring shared experiences that challenge traditional roles, in other words, hospital and home visits and memorial services (Eversole 1997). It is particularly helpful to keep in regular contact with case managers to share responsibilities and private counseling and peer supervision for health care providers offer safety valves for the release of emotions and the processing of problems that come with this work (Schaffner 1990).

Tolerance for frustration

Many PLWAs have limited education, job skills, experience with healthcare and psychosocial services. These frustrations are compounded by the 'bureaucratic runaround' that HIV+ persons and their advocates face in order to set up and maintain their treatment (Paige and Johnson 1997). Therapy with PLWAs also can be difficult to initiate because energies are focused on navigating the system in order to attend to immediate practical matters such as ensuring adequate funds for rent and utilities. Once engaged, therapy can be difficult to sustain due to the unpredictability of symptoms, transportation problems, location and hours of therapy, and sudden crises, (i.e., the need to care for a sick child).

Unique benefits of art therapy with PLWAs

Without a cure in sight, AIDS has energized the field of complementary treatments and holistic medicine, challenging the limits of the scientific response to sickness and suffering. With this renewed interest in ancient and alternative healing techniques, the creation and use of imagery continues to gain recognition as an effective development in modern health care, and proving itself as a powerful modality for boosting a compromised immune

system (Edwards 1993; Malchiodi 1998). The combination of individual and group art therapy tends to be most beneficial in the care of PLWAs.

Art therapy has the comprehensive capacity to provide for the five central needs of people living with HIV/AIDS: mastery, communication, enjoyment, belonging, and legacy. (These capacities were also highlighted in work with children with or affected by HIV/AIDS (see Piccirillo 1999).)

Mastery

Risk is an essential element in both getting AIDS and making art. This association can deter some PLWAs from considering the creative process; others recognize it as a reparative opportunity – a chance to reclaim unknown possibilities in a positive way. The very core of the art therapy process involves being active, converting 'This is happening to me' into 'I am influencing my world'. It involves 'doing and undoing' which directly counteract feeling helpless, passive or victimized, proving that personal motivation pays off. The experiential nature of art therapy helps people to safely discharge emotions and to organize and transform their chaos, encouraging the development of inner resources and adaptive strategies (Franklin 1992). Art also externalizes problems and makes them available as concrete material for the therapeutic process. Experiences that involve consequential thinking in which causal relationships can be observed and influenced to satisfaction are both convincing and corrective for PLWAs.

The proficiency that comes from the repeated exploration of an art material teaches about its expressive potential, its limits and its hazards as the individual tries to manipulate and shape results. This cultivation of problem-solving skills translates into a capacity to make productive choices, to anticipate complications, and to respond with confidence. Elevating self-esteem, art-making can be an experience of coping effectively. From the command of the art process comes a generalized sense of security and a realistic appreciation of the extent to which any single person can control events.

Many PLWAs have had restricted access to creative experiences, in part due to their illness or crisis-ridden households, their low socioeconomic status, or to limited art exposure in school. Therefore, there must be a strong educational component to the application of art therapy in order for the clients to grasp the techniques necessary to effectively use the media for expression.

Mastery can be encouraged by providing structure through the thoughtful organization of space and supplies, simple demonstrations and task segmentation. Multiple and distinct steps in art activities can sustain a client's involvement, reduce frustration and build excitement. Care must be given to introduce materials and processes that are not too complicated or sophisticated. If the therapist appears artistically expert, the clients are inclined to be more intimidated than inspired. They will either resort to copying the therapist, predict their own failure and/or self-sabotage, or request assistance with every step.

When the art process does not go as planned, PLWAs may deny that a problem exists, become agitated – even frantic – or force closure out of fear of an impending disaster. Even in the best therapeutic exchanges, the client's efforts can quickly go awry causing discouragement. After acknowledging these feelings as a natural part of life, the therapist can then model how to maintain, review and adjust the vision, and how to capitalize on 'mistakes' and make them workable. Special attention must be paid to these crucial moments in order to keep them from taking over the client and thereby inadvertently reinforcing feelings of incompetence.

Ultimately, innovating from the unexpected and experimenting with new behaviors can give rise to increased predictability, fluency and originality. Clients come to see the value of persistence and taking calculated risks. They develop trust in their native abilities and become responsible for helping and caring for themselves. They literally take their situations into their own hands, make sense of them and influence their outcome. The presence of powerful superheroes in their imagery speaks to this objective for PLWAs to have a command of their fate. For those fortunate clients with an aptitude for art, this form of therapy often becomes a primary source of strength for them.

A favorite means of depicting mastery is in the use of animals as symbols of authority, willpower, courage, prowess and instinct. The big cats are commonplace. Figure 7.6 entitled 'Mother and Cub' is an accomplished depiction of both beauty and protection. Some animal subjects are endangered species, highlighting vulnerability second only to their natural power with emphasis on fangs, wings, scales and talons as means to survival. Predators, like sharks, snakes, spiders and hawks, are also popular, sublimating the desire to identify with the aggressor as masters of their territory. Birds are often used to symbolize the triumph of the spirit over matter, signifying boundless freedom and possibility.

Figure 7.6 'Mother and Cub'

Communication

The perplexing thoughts, feelings and conflicts that accompany this virus place extraordinary demands on one's verbal abilities since words are linear and precise. PLWAs often feel muted, even the most articulate. When words fail or are forbidden, the visual language of art can still send the message by accomodating the overwhelming impact of HIV/AIDS. 'Beyond Words' (Figure 7.7) includes the familiar bubble of cartoons, however, its ironic blankness is able to express the difficulty of capturing and revealing the world of HIV/AIDS in words. The imagery of PLWAs is filled with simultaneity and contradiction, probably a result of the mixed information they have collected about their lives and their illness.

For those responding to family and societal pressures to keep the secret, they can both have their silence and break it through creative expression. Art makes their guarded internal worlds accessible through an encoded vocabulary that does not betray their caregivers. Many PLWAs instinctively use disguised elements like masks and multiple layers of imagery, metaphors for the barriers which remain, but are no longer invisible when

Figure 7.7 'Beyond Words'

communicated through art. To the trained eye, some of their artwork confides the reality of tragic early life experiences, such as sexual exploitation and other abuses that have gone untreated.

In response to the client's cautiousness, the therapist can ease fears and anxieties about communicating through art by wondering aloud and modeling being open and honest, thereby demonstrating their benefits. PLWAs can be encouraged to use the containing quality of art therapy to relax and reveal themselves at their own pace. Some take refuge in the busy use of materials as a device that makes talking at the same time more comfortable. Eye contact can be a threatening part of interactions with others for many PLWAs and the diversion of focus while making art forgives this inhibition. Lastly, the flow inherent to this physical activity seems to expedite the flow of verbal expression.

Enjoyment

If ease is a kind of pleasure, then dis-ease is a loss of it (Moore 1992). AIDS is a profound example of this definition for most adults who become infected through the sensation-seeking behaviors most associated with its transmission. Substance abuse is often seen as a form of self-medication, a

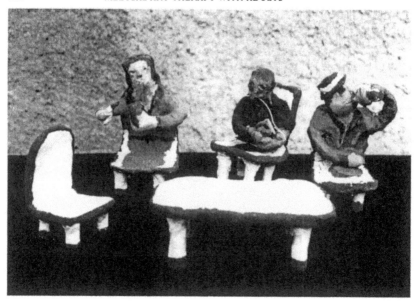

Figure 7.8 'The Definite NOs'

way of 'running from things' – especially strong unpleasant emotions – typically, pain, fear, anger, sorrow, and shame (Johnson 1990). With a positive diagnosis, HIV/AIDS confronts them with their emotional vulnerability, limited coping skills, and their mortality all at once, creating a staggering set of demands for the addict. Figure 7.8, 'The Definite NOs' details the street habits of some PLWAs, with art providing a powerful outlet for transforming and understanding these urges in order to begin healing. The artist explained, 'These are the three things that we shouldn't do – smoke crack, shoot dope, and drink alcohol. They lead to unsafe sex too. Sure they give us a feeling that every man and woman wants; it's a good and natural feeling. Actually you can get it without drugs, but when you get depressed you want it right away. The sky, the plants ... even the bugs can be beautiful – a deep interest. But with drugs, you can't cry over that shit. You can't cry when you're high. The drugs keep everything stashed. You become a rock. So, instead, you gotta get schoolin' on feelings.' He planned to make a sign with the phrase 'I was here' for the empty chair, but never did, suggesting his reluctance to give up his seat.

Deprivation is a central issue for PLWAs, in part due to poverty, but also as a consequence of the disease. The abundance of creative resources is important to minimizing unnecessary tensions and compensating for these losses. The very stuff of art-making is what first attracts many clients to make

a commitment to its use. Art materials can nurture, comfort and fill many voids, especially the ritualized stimulation and soothing effects of drugs. One client was aware of his strong dependence on beads (he called it his 'substance of choice'), and complained as he anticipated withdrawal over a holiday weekend, 'You get us hooked, then string us out, make us go cold turkey.'

For symptomatic PLWAs, alternatives for achieving pleasure and release with their bodies diminish over time; art can remain a viable one when other physical outlets are gone. The possibility of immediate gratification is a wonderful part of its appeal, especially for people who are confronted with chronic worries. In the tradition of sublimation, one client reported, 'For me, art is my safer sex.' The spontaneous play and sensuous movements of art-making focus on the 'here and now' and while engaged in them, the virus vanishes. This remedial power lasts well beyond the moment, shifting attention away from pressing problems; art becomes a way to stay healthy. Some activities can take on an interactive game-like quality, counteracting constriction and building interpersonal safety (Vos Wezeman 1994). Other PLWAs become engrossed in the purposeful diligence of producing art, finding it an intensely satisfying alternative to work.

To assist PLWAs in learning how to enjoy themselves in art, the therapist can model how to laugh at oneself or to be amused by the random 'accidents' that occur when making art. Process-oriented creative techniques without the objective of realistic-looking content are quick to result in escapist thrills. Spin-art, folded painting, printmaking and clay invite easy satisfaction as pleasurable introductions to art-making. Some PLWAs resort to repetitive behaviors as they re-enact traumatic moments without realizing it. For them, play has much deeper meanings and requires the assistance of competent professionals in order to release their issues and help to work them through (Herman 1997).

Belonging

AIDS distinguishes itself as a social disease, and when it surfaces in lives it violates privacy, exposing PLWAs to stigma, racism, misunderstanding, even outright rejection. Feeling contaminated by association, members of a PLWA's community often shun them (at least initially) in an effort to put distance between themselves and such misfortune. These messages may be insinuated or blatantly cruel.

The social aspect of art creation and its display builds acceptance, establishing and normalizing common themes while highlighting the individual within the group. This has a profound value in easing the social suffering that characterizes HIV/AIDS (Sikkema *et al.* 1995). The requisite exchanges in art making and exhibition counteract isolation and teaches healthy interpersonal and self-care skills. The response of others to the humanizing messages in the art of PLWAs also helps create more connections to the greater community (Franklin 1993). Inevitably, viewers of this art see aspects of their own lives reflected in the imagery – consciousness is raised and compassion grows, reducing the emotional distance that characterizes this syndrome.

Cooperation and conflict are central to art making, both as the PLWA struggles with the materials to achieve a satisfying product and as the members of a group negotiate among themselves. Use of a big table is helpful because it promotes independent expression and exploration. By providing a comfortable context in which to interact, PLWAs are encouraged to speak up and reach out, sharing their ideas and opinions in familiar company. These alliances become invaluable to their well-being and sense of togetherness. Giving and receiving help and support occur naturally, and group art teaches the responsibility of one to many, of how each of us influences the fate of others.

Art making defines the basics of boundaries, such as the personal space of each person's lump of clay or the mutual domain of a sheet of mural paper. Homes are a popular theme in the artwork. Inevitably, family issues surface and the art can be used as a medium for addressing and healing wounds and to reinforce connections. Making or viewing a drawing together offers a welcome reprieve, a fresh start. It can also be created as a gift and given as a 'peace offering' or a 'labor of love' to show fondness, gratitude, acceptance and concern.

Legacy

Lastly, art becomes survival itself. By transcending time, art is a durable and tangible proof of one's existence. Through the infinite possibilities of art, PLWAs can make unique and indelible marks in the world, cultivating their uniqueness and ensuring that they will be seen and remembered by others. As a witness to their lives, the art helps each feel personally significant, that they really matter. As the creative process nurtures the life force, it compensates for losses, relieves doubts and gives inspiration. It is generative by nature –

beginning with nothing, conceiving possibilities, affirming the struggle and culminating in creation. The prevalence of plants, trees and flowers in the art of PLWAs asserts the drive toward nurturance, renewal and happiness.

Art is also a method for 'marking time.' The presence of clocks in the imagery of PLWAs speaks directly to this awareness of an attenuated life and the urge to make the most of it. Many images portray restitution, being filled with detailed memories of favorite experiences and significant others, including pets. As a means of life review, some use their art to grieve lost opportunities or to sketch out future plans that may go unrealized. Others indulge in extravagant fantasies, picturing a rich dream world to maintain hope. Angels may be used to symbolize the metaphysical transcendence of time.

A few PLWAs come to see art-making as an opportunity to magically buy or save time in order to extend their lives. They believe that their artwork is an energized part of themselves and as long as it is incomplete, they will live indefinately. The prospect of finishing such a piece becomes a significant source of existential anxiety, so they choose instead to modify it repeatedly, postponing the end.

Conclusion

Every once in a great while an unusual event strips away the facade of security that sustains our daily lives, reducing our constructs to their fundamental impermanence. It is only natural that when that awesome terror initially strikes, it is met by the human urge 'to picture it' – the real meaning of imagination. Regrettably, the iconography that accompanied the discovery of HIV served only to obscure and distort its true nature, granting it fictional proportions and damaging messages that persist despite the factual information now available to the public.

The art of PLWAs explicitly records this cultural and historical context. It articulates the daunting task of first ordering the confusion and ignorance about HIV so PWLAs can conceive of imagery that more accurately and completely depicts their very personal realities. By applying the imagination once again, PLWAs labor to reconfigure how they want their condition to be visualized, framing it from an informed perspective in search of the truth. As risk reduction programs continue to hobble along due to underfunding, art may prove to be a highly effective means to achieving the goal of public education. Art invites viewers to come into intimate contact with the

subjective world of HIV/AIDS without the chance of actual exposure to the virus.

The improved prospect of AIDS-free survival of HIV-infected individuals intensifies the need to provide services that effectively support the adjustment to life with HIV for those infected with it. Even with the promising statistical trends, for PLWAs the world remains a confounding place, and they are still likely to experience the deaths of many of their peers. Without psychological counseling and the support of the wider community, these multiple significant losses and the concommitant traumas are likely to result in serious problems. The authentic relationships that they can form provide the assistance necessary to healing socially and emotionally, even if their bodies never recover (Herman 1997).

Art therapy is uniquely qualified as a response to the needs of PLWAs. The practice of making art is about taking both risks and precautions, seeking pleasure and tolerating frustration – human activities intrinsic to the origin of AIDS. Creative expression involves a flexible sequence of behaviors that provide PLWAs with experiences that inform them about how to plan for and adjust to the unexpected. It stands as a metaphor for their turbulent lives as they strive to synthesize the pieces into a whole that makes sense. Art gives form to feelings and provides a means for symbolic restitution (Edwards 1993). Art helps them in their search for meaning, often demonstrating that they are stronger and wiser than they may have realized. Since positive outlook and personal action are the main reasons most often given by people with HIV for non-progression to AIDS, art-making is likely to contribute greatly to longevity (Troop et al. 1997).

Ultimately, art therapy serves PLWAs well. It provides them with vital opportunities to care about their futures, to convey a positive vision, to transform suffering and to bring us all closer to understanding and acceptance. Even the simplest act of mark-making can generate the substantial rewards of a commitment to self-determination and community-building. This has lifelong consequences for individuals confronted by such an awesome specter as HIV/AIDS and it gives them a chance to celebrate despite it all.

References

Adler, G. and Beckett, A. (1989) 'Psychotherapy of the patient with an HIV infection: Some ethical and therapeutic dilemmas'. *Psychosomatics 30*, 2, 203–207.

Apfel, R. and Telingator, C. (1995) 'What can we learn from children of war?' In S. Geballe, J. Gruendel and W. Andiman (eds) *Forgotten Children of the AIDS Epidemic*. New Haven, CT: Yale University Press.

Beaudin, C. and Chambre, S. (1996) 'HIV/AIDS as a chronic disease: Emergence from the plague model'. *American Behavioral Scientist 39*, 6, 684–706.

Centers For Disease Control and Prevention (1997) *HIVAIDS Surveillance Report 9*, 2, 3–43.

Edwards, G. (1993) 'Art therapy with HIV-positive patients: Hardiness, creativity and meaning'. *The Arts in Psychotherapy 20*, 4, 325–333.

Elia, N. (1997) 'Grief and loss in HIV/AIDS work'. In M. Winiarski (ed) *HIV Mental Health for the 21st Century*. New York: New York University Press.

Eversole, T. (1997) 'Psychotherapy and counseling: Bending the frame'. In M. Winiarski (ed) *HIV Mental Health for the 21st Century*. New York: New York University Press.

Feldman, E. (1993) 'HIV-dementia and countertransference: A case study'. *The Arts In Psychotherapy 20*, 4, 317–323.

Fleming, P., Ward, J., Karon, J., Hanson, D. and De Cock, K. (1998) 'Declines in AIDS incidence and deaths in the USA: A signal change in the epidemic'. *AIDS 12*, suppl. A, S55–S61.

Forsyth, B. (1995) 'A pandemic out of control: The epidemiology of AIDS'. In S. Geballe, J. Gruendel and W. Andiman (eds) *Forgotten Children of the AIDS Epidemic*. New Haven, CT: Yale University Press.

Franklin, M. (1992) 'Art therapy and self-esteem'. *Art Therapy: Journal of the American Art Therapy Association 9*, 2, 78–84.

Franklin, M. (1993) 'AIDS iconography and cultural transformation: Visual and artistic responses to the AIDS crisis'. *The Arts in Psychotherapy 20*, 4, 299–316.

Geiser, R. (1989) 'A therapist's exploration: Face to face with the dark side'. *The Arts in Psychotherapy 16*, 133–136.

Herman, J. (1997) *Trauma and Recovery*. New York: Basic Books.

Johnson, L. (1990) 'Creative therapies in the treatment of addictions: The art of transforming shame'. *The Arts in Psychotherapy 17*, 299–308.

Kaldjian, L., Jekel, J. and Friedland, G. (1998) 'End-of-life decisions in HIV-positive patients: The role of spiritual beliefs'. *AIDS 12*, 103–107.

Malchiodi, C. (1998) *The Art Therapy Sourcebook*. Los Angeles: Lowell House.

Maldonado, M. (1997) 'Trends in HIV/AIDS among women of color'. *National Minority AIDS Council Update*, March, 2–11.

McGoldrick, M., Hines, P., Lee, E. and Preto, N. (1986) 'Mourning rituals: How culture shapes the experience of loss'. *Family Therapy Networker 10*, 6, 28–38.

Meredith, K. and Bathon, R. (1997) 'A comprehensive center for women with HIV'. In M. Winiarski (ed) *HIV Mental Health for the 21st Century*. New York: New York University Press.

Moore, T. (1992) *Care for the Soul*. New York: HarperCollins Publishers.

O'Neill, J. (1997) 'Primary care of the HIV seropositive chemically dependent patient'. *Primary Care 24*, 3, 667–676.

Paige, C. and Johnson, M. (1997) 'Caregiver issues and AIDS orphans: Perspectives from a social worker focus group'. *Journal of The National Medical Association 89*, 10, 684–688.

Piccirillo, E. (1999) 'Hide and seek: The art of living with HIV/AIDS'. In C. Malchiodi (ed) *Medical Art Therapy with Children.* London: Jessica Kingsley Publishers.

Rotherman-Borus, M., Murphy, D. and Miller, S. (1996) 'Intervening with adolescent girls living with HIV'. In A. O'Leary and L. Jemmott (eds) *Women and AIDS: Coping and Caring.* New York: Plenum Press.

Schaffner, B. (1990) 'Psychotherapy with HIV-infected persons'. *New Directions For Mental Health Services 48,* 4, 5–19.

Sikkema, K., Kalichman, S., Kelly, L. and Koob, J. (1995) 'Group intervention to improve coping with AIDS-related bereavement: Model development and an illustrative clinical example'. *AIDS Care 7,* 4, 463, 475.

Starace, F. and Sherr, L. (1998) 'Suicidal behaviors, euthanasia and AIDS'. *AIDS 12,* 339–347.

Stein, T. (1998) *The Social Welfare of Women and Children with HIV and AIDS.* New York: Oxford University Press.

Tasker, M. (1992) *How Can I Tell You? Secrecy and Disclosure with Children when a Family Member has AIDS.* Bethesda, MD: Institute For Family-Centered Care.

Troop, M., Easterbrook, P., Thornton, S., Flynn, R., Gazzard, B. and Catalan, J. (1997) 'Reasons given by patients for "non-progression" in HIV infection'. *AIDS Care 9,* 2, 133–142.

Vos Wezeman, P. (1994) *Creating Compassion, Activities for Understanding HIV/AIDS.* Cleveland, Ohio: The Pilgrim Press.

Winiarski, M. (1991) *AIDS-Related Psychotherapy.* New York: Pergamon Press.

Zegans, L., Gerhard, A. and Coates, T. (1994) 'Psychotherapies for the person with HIV disease'. *Psychiatric Clinics of North America 17,* 1, 149–161.

Tuberculosis

Art Therapy with Patients in Isolation

Irene Rosner David and Shereen Ilusorio

Introduction: history and resurgence of TB

Tuberculosis (TB) is a potentially devastating disease that historically has been a leading killer. In prehistoric time it affected animals, later becoming prevalent in humans in areas with widespread poverty and in crowded cities. This produced the necessary environmental conditions for person-to-person spread of the airborne pathogen of the disease that came to be called the 'great white plague' (Dubos and Dubos 1952). In the early 1600s the incidence of TB increased sharply, and over the next several hundred years the epidemic spread throughout western Europe. It reached colonial North America when European migrants brought the tubercle bacillus with them (Diamond 1992).

Treatment often required surgery and a period of convalescence, based on the approved regimen of the day which was rest in quiet, pleasant surroundings with fresh air, sunshine, and good nutrition (Lerner 1993; Rollier 1952). Tuberculosis sanatoria arose out of a therapeutic concept of 'open-air living' while separating infectious patients from the community (Wilson 1968; 1979).

Before the era of chemotherapy for TB, 50 per cent of cases reportedly resulted in death (American Thoracic Society (ATS) 1992). Since the 1950s, TB had steadily declined because of the availability of effective antituberculosis medications. Public health officials treated it as a disease that had been conquered (Bates and Stead 1993; Boutotte 1993; Nardell 1993; Wilson 1968). However, since 1985, there has been a resurgence of TB with particular treatment and control challenges related to drug-resistant strains

and to non-compliance (Bloom and Murray 1992; Menzies, Rocher and Vissandjee 1993; Pozsik 1993). The World Health Organization estimated in 1996 that there were 8 million new cases of TB and 3 million deaths from the disease (Bloom and Small 1997). The incidence of TB increased significantly for a decade nationwide and more than doubled in New York City (Frieden *et al.* 1993). Since the 1990s, there has been somewhat decreasing incidence due to efforts to control and treat this communicable disease (Buchanan 1997, Davidon *et al.* 1997). Due to compromised immune systems, there is a prevalence of TB among patients with HIV infection (Castro, Valdiserri and Curran 1992; Centers for Disease Control (CDC) 1990; Hopewell 1992), with the highest rate of coinfection, 46 per cent, from New York City (Bayer, Dubler and Landesman 1993; Onorato and McCray 1992). It is thought that homelessness among urban drug users has further contributed to vulnerability and the transmission of TB (Brudney and Dobkin 1991; CDC 1992; Selwyn *et al.* 1989; Wolfe *et al.* 1993).

The resurgence of TB with multidrug-resistant strains poses a serious public health risk in the United States (Bloch *et al.* 1994). If patients do not complete a course of medication, it becomes ineffectual and requires a change to another drug. Nonadherence, therefore, has contributed to the development of treatment resistance (Bloom and Murray 1992; Dunbar-Jacob 1993). The major determinant of outcome is patient compliance, and an official joint statement of the ATS and the CDC (1993b) emphasized the importance of instituting measures designed to foster adherence and to ensure that patients take prescribed drugs. Programs to improve adherence have included strong educational components, the monitoring of treatment, and behavioral approaches (ATS 1992; Morisky *et al.* 1990).

An effective strategy promoting compliant behavior for outpatients has been Directly Observed Therapy (DOT) and the use of incentives. DOT requires that a heathcare provider or other designated, responsible person observe the patient ingesting anti-TB medications. The administration of medication may take place in a clinic, home, workplace, or any agreed upon location. Injecting drug users, who have reported avoiding medical treatment because of fears of detention, are more likely to participate in such a community-based program (Curtis *et al.* 1994). Studies have indicated that when DOT is used, treatment completion rates have increased, while drug resistance and relapse have decreased (CDC 1993a; Weis *et al.* 1994).

The use of incentive schemes rewarding positive health behaviors further fosters adherence. Such enablers include providing car fare to the DOT site, food, clothes, money for child care, conveniently scheduled appointments, and follow-up for missed appointments (ATS 1992). The benefits of such behavioral strategies has been recognized in contributing to compliance. One behaviorally oriented program studied the value of educational counseling with incentives. Enlisting family and friend support, offering positive verbal reinforcement for adherence, and contracting an incentive scheme resulted in higher levels of compliance to medical regimens (Morisky et al. 1990). It is believed that in order to regain control over this communicable disease, DOT programs supported by inducements for compliance should be broadly implemented (ATS 1994; Iseman 1993; Iseman, Cohn and Sbarbaro 1993; Joseph 1993).

The role of art therapy in the treatment of TB: foundations in the past

In 1938, British artist Adrian Hill was convalescing from TB in a sanatorium. During his six-month stay, he became involved in his own artwork, discovering its therapeutic value. Indeed, it was Hill who claimed to have first coined the term 'art therapy' to describe his work (1945). In *Painting Out Illness* (1951), he reflected on his own restlessness and the importance of engaging in an expressive, constructive activity. 'Never does the problem of free-time become so acute as in the period of long-term illness' (p. 13). He was intrigued as to why the act of drawing and painting seemed to help patients come to terms with their traumas and to speed up the rehabilitative process (Waller 1991). He went on to encourage other patients and to advocate for art therapy in sanatoria and hospitals in England and other countries.

Hill was also passionate about the concept of art therapy, and his efforts contributed to the formation of the British Association of Art Therapists (Waller 1991). It seems remarkable to note that the profession apparently had significant roots in a medical setting, with the therapeutic goal of enhancing patients' coping abilities as related to physical conditions and treatments. This had been an important but rarely practiced, specialized area that is only recently returning to the forefront (Malchiodi 1993a, 1993b).

In the late 1940s, Dr Auguste Rollier, director of a well-known European sanatorium in Leysin, Switzerland, was a strong proponent of psychological support. He emphasized the importance of healing the whole person, realizing that patients were not only physically but also emotionally sick

(1952). He believed that rest alone was not enough and could contribute to depression. He encouraged the medical and nursing staff to keep their patients occupied and stimulated. A positive attitude and sense of optimism through constructive activities could made the difference in real recovery (David 1952).

The art therapy program: Bellevue Hospital

As a major municipal medical facility in a city (New York) with a high incidence of the disease, Bellevue Hospital Center serves a significant number of TB patients. Historically, the hospital treated patients as part of New York City's early pioneering programs of TB control (Abel 1997). As many as 40 inpatients with active pulmonary TB who are on strict respiratory isolation precautions may be present at any given time. Such isolation requires confinement in a private room, special ventilation systems, and the wearing of protective facial masks by caregivers.

As in the past, patients are prescribed long-term medication regimens and must remain in the hospital, and in their rooms, while they are actively infectious. It is generally believed that with TB 'the patient does not have the right to refuse treatment for the disease and continue to expose others' (Pozsik 1993, p.1295). In compliance with the New York City Department of Health code, patients at Bellevue who have been previously noncompliant, reluctant to take medications, or attempted to leave prematurely are under orders of detention by the Commissioner of Health. Their isolation is further enforced by the presence of security officers.

These patients' attitudes toward the hospital, disease and treatment involve loss of control, anxiety, and anger. Control is often compromised in physical illness, and with imposed restrictions of TB isolation and detention, it is further diminished. Under such circumstances, artistic activities take on even greater value. One may regain some mastery in the art process, while externalizing feelings related to illness (Rosner 1982b; Rosner David and Sageman 1987). As stated by Hill (1951), TB patients who engaged in art were 'exercising their powers of choice and criticism, a sense of power had now been reached, and with it a sense of well-being' (p.95). Human considerations may become as important as scientific ones in the battle against TB (Grange and Festenstein 1993), and the stage is set for a valuable and highly specialized, renewed area for art therapy.

The authors have been seeing patients for art therapy sessions for approximately four years, with increasing incidence over the past year.

Patients are referred by various members of the interdisciplinary healthcare, most notably from the Psychiatry Liaison Service, which refers patients who are particularly anxious, depressed, or noncompliant. Patients are typically intravenous drug users, many are homeless and may have personality disorders. Lack of cooperation and maladaptive behaviors contribute to problems of noncompliance and drug resistance (Landesman 1993; Sageman 1992). By referring patients to art therapy, caregivers recognize the emotions involved, the engaging qualities, and the opportunity to make isolation rooms more humane. The case material presented in this article focuses on such work with patients in respiratory isolation. Their art reveals images and themes related to their disease, prognosis, and confinement. Interpretations are based on clinical observations, common patient perceptions and graphic representations in medical art therapy.

Case examples

James

Upon initial contact, James was physically very weak. He could barely sit up for more than ten minutes. He had a history of alcohol abuse, homelessness, and a personality disorder, all of which contributed to noncompliance. During several previous hospitalizations, as well as outpatient treatment, James did not complete full courses of medication. This resulted in serious multidrug-resistant TB. He had been in respiratory isolation for a month when referred due to depression and anxiety. During the subsequent nine months of treatment, there were numerous changes in medication in order to find a drug combination that would be effective and curative.

James was verbally very expressive about his feelings of anger, frustration, and anxiety due to his illness, confinement, and prolonged convalescence. He was able to derive positive feelings from his art that served to counteract depression, increase self-esteem, and provide an opportunity to exercise control.

Following infection control guidelines, the art therapist wore a mask. Due to risk of contagion even with this protective measure, art therapy consisted of numerous brief contacts. James preferred to work on his own, once structure for a visual composition was planned. Due to his weak physical condition, most of his artwork was done in bed, using a lapboard or tray table.

Figure 8.1

James' first drawing (Figure 8.1) is a view from his hospital window showing life going on outside at a distance. In the center of the water is a camouflaged, blurred area. The two-way road has a spotted, droplet-like design that is visually suggestive of germs, blood, or lesions. This spotted motif is prevalent throughout this case. In medical art therapy, patients often pictorialize some aspect of their disease or treatment which usually reflects a process of confrontation and integration of bodily changes (Rosner 1982a). The vehicles on the road are moving but do not seem to have a destination as the road, like the bridge, is cut off.

Little, bright red images or spots are scattered over the next drawing (Figure 8.2) in the form of flowers, foliage, and various markings. This pictorialization may be seen as symbolic of the TB bacillus or blood. James had significant hemoptysis, the coughing up of blood, typically bright red, from the bronchi or lungs (Berkow and Talbott 1977).

Figure 8.2

Figure 8.3

James sometimes worked from art reproductions which provided choice, structure, and stimulation. The use of such prints has special value, as they not only expand the repertoire of creative expression but also counteract the visual monotony of months in an isolation room. James' choices of reproductions and associations were also useful as projective techniques. It seems noteworthy that James often chose to draw landscapes, as if to bring the outside into his limited and clinical surroundings. One such drawing provided a calming and soothing effect (Figure 8.3). James said that it gave him a 'sense of peace' and 'while doing art, I can forget that I am here in Bellevue.' Again, there is a blurred area in the center of the water, perhaps a symbolic blemish, and branch-like pathways that resemble bronchial airways.

All the landscapes are from a distant perspective, as if removed from life. This tone continues in the next drawing (Figure 8.4), but now there are figures looking across a body of water. There are houses on the other side and boats in the water, but it seems questionable whether life on the other side will be accessible. The main figure, and a miniature at its side, are seen from

Figure 8.4

Figure 8.5

the rear. Primarily done in brown, they appear stiff and wooden and do not look lifelike or suggest mobility. There is a predator-like animal on the ground which James called a 'crab being roasted,' repeating germ imagery as well as suggesting slow deterioration.

James' first change in subject matter was a well-grounded still life (Figure 8.5). It is a bowl of fruit, rich in color and life. It may embody hope and nurturance; however, the banana is beginning to rot with brown spots, reminiscent of the spots of earlier drawings. There is a window and a picture on the wall, continuing the landscape and distancing elements. The indications of houses are prominent and bright red. The fruit is more than symbolic here, as it literally represents nourishment which is a significant part of the TB treatment regimen. At this time, James took on a more active role by his improved nutrition and by requesting books on TB in order to understand his disease. This motivation seemed to be related to an effort to exercise control and resulted in greater compliance.

The ground is very precarious in the next drawing (Figure 8.6), and the house appears to be sinking. James commented, 'The shack doesn't look right … it's all falling apart … it looks mixed up.' This seems an accurate depiction of his homelessness and physical and emotional instability. James was very aware of his declining condition. Birds, pathways, and trees as

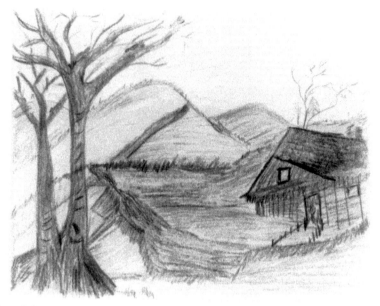

Figure 8.6

Figure 8.7

Figure 8.8

symbols of germs, disease, and anatomy emerge here again. The birds are red and full bodied and adhere to the airway-like branches.

Feelings of isolation, emptiness, and loneliness were embodied in his drawing of a person on a pathway (Figure 8.7). He is holding a stick for balance, appears to be on a slow, long journey, and is surrounded by vast, empty space. At this time James was attempting to maintain hope but was realistically saddened by repeated treatment failures.

Expressive landscapes gave way to greater emotion and images of the TB attack on his body. His last drawings were often more directly of himself, and a blue portrait (Figure 8.8) suggests an unrealistic, alien quality. In addition to conveying fear, the eyes may have exaggerated prominence since they are the only area of a caregiver's face that is visible. Due to the side effects of his medication, James was also experiencing vision and hearing impairment, which may partially account for the emphasis on the eyes and the pointed ears.

James' case of TB was unusually resistant and his prognosis was poor. He was physically deteriorating when he drew 'A Path to Nowhere' (Figure 8.9), which was reflective of his discouragement and agitation after a long period of futile efforts to find an effective drug combination. At this stage James frequently talked about his fear of the future and the possibility of not getting better. His artistic and verbal expression of his perception of the severity of his illness was honestly confronted in this drawing. Visually externalizing

intense emotion provided relief as James was adjusting to the idea that his struggle was beginning to fail. The effect of this drawing is different from his previous artwork in its emotional discharge, agitated graphic quality, and loosely formed images. Pictorial elements again may relate to the body with many branches resembling bronchial airways that perhaps now reflect uncontrollable disease.

Disturbing elements prevail in the last two drawings which reflected his active decline and desperation. He drew his room (Figure 8.10) which had been the world around him for months with realistic items in the foreground. He rendered himself as a skeleton in the background with a sad, rather than frightened face, and indicated 'TB' in his lungs. He included another figure which he said was a doctor, with a strong torso and the caption 'madness,' perhaps because he could not be cured. He also drew himself in the form of a chest X-ray (Figure 8.11) labeling 'TB' and 'cavities' (characteristic of the

Figure 8.9

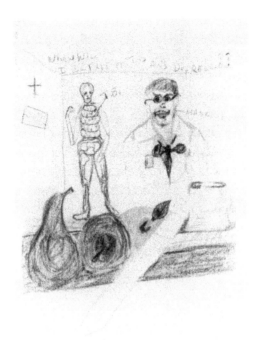

Figure 8.10

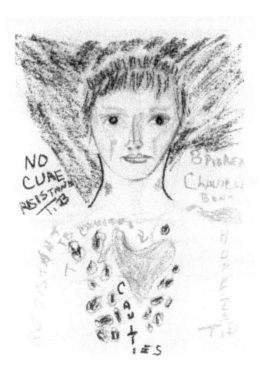

Figure 8.11

lung pathology), and proclaiming 'resistant,' 'no cure,' and 'hopeless.' This was an accurate portrayal and confrontation with the end stage of his illness. His inclusion of words emphasizes the images and elaborates on his anguish.

In James' last drawings a final and direct release of sadness, anger, and emotional turmoil occurred. This intense discharge and graphic representation of his fate may have aided in this transitional phase toward resignation. James' agitation subsided, and he gradually succumbed to his illness. He was receptive and appreciative of the visits that continued when art making was no longer possible. Through the course of his illness and treatment, art therapy served as a link to the outside world, as well as a safe means of emotional expression. It fortified him during hopeful periods and contributed to his compliance with the medical regimen. Through art he increasingly externalized representations of illness and, ultimately, of death.

Ramon

Ramon had been on respiratory isolation for one week when he was referred to art therapy. Although he was described as hostile and noncompliant, he was immediately responsive to the opportunity to draw. In the beginning of the first session he sobbed and talked openly about his medical ordeal. He allied himself to the art therapist, claiming to have been an artist for the police department, drawing faces from witnesses' descriptions of alleged criminals. He doubted his ability to continue to draw well, yet boasted about his talent for portraits, needing to look only once or twice at a subject. His statements of pride in his artistic abilities seemed to fortify his self-esteem.

Ramon asked for paper and black drawing pencils and worked on his own to create a very expressive drawing of a face with a mask over the eyes (Figure 8.12). The mask does not camouflage but, rather, reveals sad eyes. The notion of a facial covering is critical in TB care and isolation. Indeed, this mask merges with, or is an extension of the face. Unlike an opaque respirator mask, this one appears transparent, enabling the viewer to see the eyes and tears behind the obstacle, as well as for the eyes to see outward. Perhaps this represents the partial, guarded existence he was experiencing. Like goggles, the mask provides a measure of protection. It also resembles a harlequin mask with a handle, suggesting that it can be removed to reveal the person. The handle of the mask is ribbon-like, ending in an open scissor image. The transparency may also suggest ambivalence about interpersonal contact and intimacy. Further, it may embody the reality that contact without a mask involves not only emotional risk, but also the real risk of infecting others.

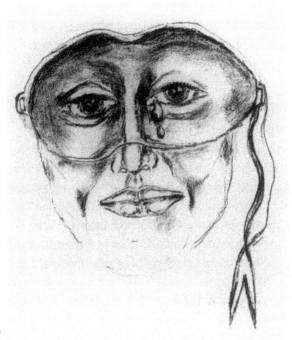

Figure 8.12

There must be a powerful, ominous feeling about the ability to transmit a disease by the simple and natural acts of breathing or coughing.

The most striking aspects of this drawing are the large, teary eyes. This is a very eloquent rendition of feelings of sadness and seclusion. The crying that is apparent behind the mask seemed a valuable and safe release. Ramon did not directly verbalize any associations to the drawing; instead, he distanced himself from the emotions by focusing on the technical aspects. He asked whether the therapist had noticed how well he 'got the shadows' and 'wasn't it good.' It seemed he was also seeking assurance that he was good, needing validation at a time when his self-esteem had been diminished through illness and confinement.

During the course of his hospitatization, Ramon became more compliant. He remained in his isolation room and reliably took his medication. He was no longer hostile, but rather calm, while expressing a range of emotions in art appropriate to the features of his disease and prognosis. Art therapy served also to neutralize a clinical, monotonous atmosphere and, thereby, may have contributed to compliance to medical treatment. The experience enriched his immediate world, as did the supportive relationship with the therapist.

As described by Adrian Hall (1951), the pictures '...often reveal the psychological attitude of the patient towards his illness' (p.47). Further, the 'relief they found in such free self-expression was often reflected in the medical reports of their improved condition' (p.15).

Infection control guidelines and special considerations for art therapy

Caregivers have unique and real concerns when treating patients with infectious TB. Healthcare workers must take special measures to minimize the risk of becoming infected. TB infection, as indicated by tuberculin skin testing, should not be confused with TB disease. If infection occurs, in most cases immunity develops that prevents active disease. Such people are not contagious, as their immune systems also prevent transmission. Further, they may be medicated as a measure to prevent disease activation. The ATS (1992) and the CDC (1990) provide guidelines and recommendations for TB control. Bellevue Hospital follows such guidelines and educates staff regarding patient isolation and strategies to prevent airborne transmission, including environmental and personal safety precautions.

The environmental interventions recommended have been for the facility to increase ventilation and airflow according to specific standards in order to prevent institutional airborne transmission (ATS 1992; Nardell 1993). In the area of personal care, we have adopted the recommendation to use special filtering masks (Figure 8.13) when engaged in art therapy with TB patients (CDC 1990). These disposable 'particulate respirators' cover the mouth and nose and must be closely fitted against the face in order to protect against inhaling droplet nuclei. Greater effort is required to breathe through the masks, and it is therefore quite uncomfortable to wear one for an extended period of time. Due to such discomfort, and in order to minimize risk, we conduct brief sessions, generally no longer than 20 minutes. It is also important to be sensitive to the therapist's appearance, and the responses and issues that may be elicited from the patient (Conlon 1995). Patients may attribute the use of such a protective item to being treated like an outcast or alien. Recent studies indicate that many perceive TB as a severe social stigma (Wolfe et al. 1993), and that duration of illness may be related to feelings of alienation (Sokhey, Vasudeva and Kumar 1990).

Figure 8.13

Figure 8.14

Of historical note is the remarkable similarity between the protective garb of today and that of years ago in caring for contagious patients. The currently used respirator is often referred to as the 'beak' owing to its resemblance to a duck bill (Figure 8.13). Similarly, in 'Traite de la Peste' (Treatise on the Plague) a beak formation is described as protective for the wearer and containing perfume crystals to dilute the potent odor of patients (Figure 8.14).

Another area for consideration involves the art materials. Since organisms would have to be inhaled for TB infection to occur, no particular protective measures have to be undertaken. Following CDC guidelines, art materials fall into the category of 'noncritical items,' since they remain outside the body and are in contact only with intact skin (1990). However, washing materials with soap or detergent is advisable to protect against germs from dirt or secretions. The use of clay should present no problem with regard to TB, but one should always be observant. In the unlikely event that any art material becomes soiled with blood or bodily fluids, it should be discarded or left with the patient. Following such basic infection control practices, the therapist should be able to use the full range of materials in safety.

Lastly, when working with TB patients, the emotions of the therapist should be acknowledged. Although we are well educated on infection control guidelines and diligently implement all recommendations in our work, we realize that some measure of risk does exist. We must be honest about this, as well as accompanying anxieties. In addition, we are often dealing with extremely ill patients and must be prepared to face their deterioration and possible death. To balance this, a caseload is never exclusively comprised of TB patients. This makes the work somewhat less intense and may diminish risk to some degree. Further, as with diseases such as AIDS, care for oneself is vital. The need to express and integrate emotions evoked in medical art therapy is essential, as is having many resources for support and life-enhancing, personal activities (Rosner David and Sageman 1987; White et al. 1991; Winiarski 1991).

Conclusion

The artwork of TB patients in respiratory isolation reflects aspects of the illness and its restrictions. In the authors' clinical experience, images related to anatomy and manifestations of the disease, and emotional themes or perceptions related to being seriously ill and set apart are prevalent.

Art therapy with TB patients clearly presents special issues for the therapist, especially since the incidence of TB is increasing. It is important to follow infection control guidelines which currently focus on the utilization of a respirator mask to avoid airborne transmission and TB infection.

Patients benefit from the artistic expression of their emotions not only regarding the disease and prognosis, but also regarding the unique experience of isolation. Existence within such restriction only worsens the tendency toward non-compliance. Participation in art therapy serves to decrease anxiety and to provide an opportunity to exercise control. The therapeutic gains and enriched atmosphere of their quarters help patients to confront their illness and hospitalization with greater compliance. There may, therefore, be significant implications for art therapy and similar modalities in TB care. With enhanced coping abilities and adherence to treatment regimens, such activities may contribute to efforts to control the spread of the disease.

Lastly, the evocative nature and value of artistic expression for patients with TB are echoed in the past. Throughout history, especially in the nineteenth century, many famous writers, musicians, and artists were thought of as being particularly creative as 'consumptives' suffering from pulmonary TB. Among them, Elizabeth Barrett Browning spoke of the 'butterfly within, fluttering for release' (Dubos and Dubos 1952, p.62). As described by Rene Dubos in *The White Plague* (1952) the disease:

> ...contributed to literature a number of symbols, images and moods, of great emotional force because they were then the expression of impacts received in everyday life. (p.46)

> ...many tuberculous individuals have dazzled the world ... by the passionate energy with which they exploited their frail bodies ... in order to overcome the limitations of disease. (p.61)

Editor's Note: The authors wish to express their appreciation to art therapist Susan Conlon, MA, for her contribution of the case of Ramon for this manuscript, and to Evelyn Altenberg, PhD, Linguistics, for her assistance with the translation of Auguste Rollier's paper.

References

Abel, E.K. (1997) 'Taking the cure to the poor: Patients' responses to New York City's tuberculosis program, 1894–1918.' *American Journal of Public Health 87*, 1, 1808–1815.

American Thoracic Society (ATS) (1992) (Medical Section of the American Lung Association). 'Control of tuberculosis in the United States'. *American Review of Respiratory Disease 146*, 1623–1633.

American Thoracic Society (ATS) (1994) (Medical Section of the American Lung Association). 'Treatment of tuberculosis and tuberculosis infection in adults and children'. *American Journal of Respiratory and Critical Care Medicine 149*, 5, 1359–1374.

Bates, J.H. and Stead, W.W. (1993) 'The history of tuberculosis as a global epidemic'. *Medical Clinics of North America 77*, 6, 1205–1217.

Bayer, R., Dubler, N.N. and Landesman, S. (1993) 'The dual epidemics of tuberculosis and AIDS: Ethical and policy issues in screening and treatment'. *American Journal of Public Health 83*, 5, 649–654.

Berkow, R. and Talbott, J.H. (1977) *The Merck Manual of Diagnosis and Therapy.* Rahway, NJ: Merck.

Bloch, A.B., Cauthen, G.M., Onorato, L.M., Dansbury, K.G., Kelly, G.D., Driver, C.R. and Snider, D.E. (1994) 'Nationwide survey of drug-resistant tuberculosis in the United States'. *Journal of the American Medical Association 271*, 9, 665–671.

Bloom, B.R. and Murray, C.J.L. (1992) 'Tuberculosis: Commentary on a reemergent killer'. *Science 257*, 1055–1064.

Bloom, B.R. and Small, P.M. (1998) 'The evolving relation between humans and mycobacterium tuberculosis.' *New England Journal of Medicine 338*, 10, 677–678.

Boutotte, J. (1993) 'TB, the second time around'. *Nursing 93*, 42–49.

Brudney, K. and Dobkin, J. (1991) 'Resurgent tuberculosis in New York City: Human immunodeficiency virus, homelessness, and the decline of tuberculosis control programs'. *American Review of Respiratory Disease 144*, 4, 745–749.

Buchanan, R.J. (1997) 'Compliance with tuberculosis drug regimens: Incentives and enablers offered by public health departments.' *American Journal of Public Health 87*, 12, 2014–2017.

Castro, K.G., Valdiserri, R.O. and Curran, J.W. (1992) 'Perspectives on HIV/AIDS epidemiology and prevention from the eighth international conference on AIDS'. *American Journal of Public Health 82*, 11, 1465–1469.

Centers for Disease Control (CDC) (1990) 'Guidelines for preventing the transmission of tuberculosis in health-care settings, with special focus on HIV-related issues'. *Morbidity and Mortality Weekly Report 39* (RR–17), 1–29.

Centers for Disease Control (CDC) (1992) 'Tuberculosis among homeless shelter residents'. *Journal of the American Medical Association 267*, 4, 48–84.

Centers for Disease Control (CDC) (1993a) 'Approaches to improving adherence to antituberculosis therapy – South Carolina and New York, 1986–1991'. *Morbidity and Mortality Weekly Report 42*, 4, 74–81.

Centers for Disease Control (CDC) (1993b) 'Initial therapy for tuberculosis in the era of multidrug resistance: Recommendations of the advisory council for the elimination of tuberculosis'. *Morbidity and Mortality Weekly Report 42* (RR–7), 1–8.

Conlon, S. (1995) 'TB, the mask, and me.' *Art Therapy: Journal of the American Art Therapy Association 12*, 1, 72.

Cornell, C. (1988) 'Tuberculosis in hospital employees'. *American Journal of Nursing 88*, 484–486.

Curtis, R., Friedman, S.R., Neaigus, A., Jose, B., Goldstein, M. and Des Jarlais, D.C. (1994) 'Implications of directly observed therapy in tuberculosis control measures among IDUs'. *Public Health Reports 109*, 3, 319–327.

David, R. (1952) Personal communication as a student of Auguste Rollier, M.D., Leysin Sanitorium, Switzerland.

Davidon, A.L., Marmar, M. and Alcabes, P. (1997) 'Geographic diversity in tuberculosis trends and directly observed therapy, New York City, 1991–1994. *American Jounral of Respiratory and Critical Care Medicine 156*, 5, 1495–1500.

Diamond, J. (1992) 'The arrow of disease'. *Discover 13*, 64, 64–73.

Dubos, R. and Dubos, J. (1952) *The White Plague: Tuberculosis, Man, and Society*. Boston: Little Brown.

Dunbar-Jacob, J. (1993) 'Contributions to patient adherence: Is it time to share the blame?' *Health Psychology 12*, 2, 91–92.

Frankel, D.H. (1992) 'USA: Civil liberty and control of tuberculosis'. *Lancet 340*, 8833, 1459.

Frieden, T.R., Sterling, T., Pablos-Mendez, A., Kilburn, J.O., Cauthen, G. M. and Dooley, S.W. (1993) 'The emergence of drug-resistant tuberculosis in New York City'. *New England Journal of Medicine 328*, 8, 521–526.

Grange, J.M. and Festenstein, F. (1993) 'The human dimension of tuberculosis control'. *Tubercule and Lung Disease 74*, 4, 219–222.

Hill, A. (1945) *Art Versus Illness*. London: George Allen and Unwin.

Hill, A. (1951) *Painting Out Illness*. London: Williams and Norgate.

Hopewell, P.C. (1992) 'Impact of human immunodeficiency virus infection on the epidemiology, clinical features, management, and control of tuberculosis'. *Clinical Infectious Diseases 15*, 3, 540–547.

Iseman, M.D. (1993) 'Treatment of multidrug-resistant tuberculosis'. *New England Journal of Medicine 329*, 11, 784–791.

Iseman, M.D., Cohn, D.L. and Sbarbaro, J.A. (1993) 'Directly observed treatment of tuberculosis – We can't afford not to try it'. *New England Journal of Medicine 328*, 8, 576–578.

Joseph, S. (1993) 'Tuberculosis, again'. *American Journal of Public Health 83*, 5, 647–648.

Landesman, S.H. (1993) 'Commentary: Tuberculosis in New York City – The consequences and lessons of failure'. *American Journal of Public Health 83*, 5, 766–768.

Lerner, B.H. (1993) 'New York City's tuberculosis control efforts: The historical limitations of the "war on consumption."' *American Journal of Public Health 83*, 5, 758–766.

Malchiodi, C.A. (1993a) 'Introduction to special issue: Art and medicine'. *Art Therapy: Journal of the American Art Therapy Association 10*, 2, 66–69.

Malchiodi, C.A. (1993b) 'Medical art therapy: Contributions to the field of arts medicine'. *International Journal of Arts Medicine 2*, 2, 28–31.

Menzies, R., Rocher, I. and Vissandjee, B. (1993) 'Factors associated with compliance in treatment of tuberculosis'. *Tubercule and Lung Disease 74*, 1, 32–37.

Morisky, D.E., Malotte, C.K., Choi, P., Davidson, P., Rigler, S., Sugland, B. and Langer, M. (1990) 'A patient education program to improve adherence rates with antituberculosis drug regimens'. *Health Education Quarterly 17*, 3, 253–267.

Nardell, E. (1993) 'Environmental control of tuberculosis'. *Medical Clinics of North America 77*, 6, 1315–1334.

Onorato, L.M. and McCray, E. (1992) 'Prevalence of human immunodeficiency virus infection among patients attending tuberculosis clinics in the United States'. *Journal of Infectious Diseases 165*, 87–92.

Pozsik, C.J. (1993) 'Compliance with tuberculosis therapy'. *Medical Clinics of North America 77*, 6, 1289–1301.

Rollier, A. (1952) 'Der heutige stand der heliotherapie in Leysin [The current state of heliotherapy in Leysin]'. *Strahlentherapie 88*, 442–447.

Rosner, I. (1982a) 'Art therapy in a medical setting'. In A. DiMaria, E. Kramer and I. Rosner (eds) *Art Therapy: A Bridge Between Worlds. Proceedings of the 12th Annual Conference of the American Art Therapy Association.* Reston, VA: AATA.

Rosner, I. (1982b) 'Art therapy with two quadriplegic patients'. *American Journal of Art Therapy 21*, 4, 115–120.

Rosner David, I. and Sageman, S. (1987) 'Psychological aspects of AIDS as seen in art therapy'. *American Journal of Art Therapy 26*, 1, 3–10.

Sageman, S. (1992) 'Drug resistant TB – The new and potentially fatal epidemic: A psychiatric overview of noncompliance with treatment'. Manuscript submitted for publication, Bellevue Hospital, New York University Medical Center.

Selwyn, P.A., Hartel, D., Lewis, V.A., Schoenbaum, E.E., Vermund, S.H., Klein, R.S., Walker, A.T. and Friedland, G.H. (1989) 'A prospective study of the risk of tuberculosis among intravenous drug users with human immunodeficiency virus infection'. *New England Journal of Medicine 320*, 9, 545–550.

Sokhey, G., Vasudeva, P. and Kumar, L. (1990) 'The effect of duration of illness on the personality of allergic and tuberculosis patients'. *Journal of Personality and Clinical Studies 6*, 1, 69–72. (From PsycINFO Database, 1991, American Psychological Association, Abstract No. 78–27963.)

Waller, D. (1991) *Becoming a Profession: The History of Art Therapy in Britain, 1940–1982.* London and New York: Tavistock/Routledge.

Weis, S.E., Slocum, P.C., Blais, F.X., King, B., Nunn, M., Matney, G.B., Gomez, E. and Foresman, B.H. (1994) 'The effect of directly observed therapy on the rates of drug resistance and relapse in tuberculosis'. *New England Journal of Medicine 330*, 17, 1179–1184.

White, S., Fenster, G., Franklin, M., Rosner David, I. and Weiser, J. (1991) 'From outside in and inside out: Viewing AIDS through art therapies window'. *Proceedings of the 22nd Annual Conference of the American Art Therapy Association.* Mundelein, IL: AATA.

Wilson, J. (1968) 'Rise and decline of the tuberculosis sanatorium'. *American Review of Respiratory Disease 98*, 515–516.

Wilson, J. (1979) 'History of the American Thoracic Society'. *American Review of Respiratory Disease 119*, 327–335.

Winiarski, M.G. (1991) *AIDS-Related Psychotherapy.* New York: Pergamon Press.

Wolfe, H., Marmor, M., Moss, A. and Des Jarlais, D. (1993) 'Tuberculosis beliefs among New York City injecting drug users'. *Lancet 341*, 8861, 1658–1659.

External Stress

The Impact of Illness on the Family Structure

Shirley Riley

This chapter discusses the many ways a family is impacted by the illness of a family member and how this may affect the health of the entire system. Families who have had to adjust to the impact of illness are often treated differently than the individual who is ill; the family is not seen as integral part of the illness. Persons outside the family system may assume that only the sick individual should be treated, but the organization and interactions in the family will remain the same if left untreated. Concern for the total support system and assistance in restructuring and realigning relationships is essential for all concerned.

When an individual stumbles and breaks a leg, most people are sympathetic, they rush to be supportive and compare notes on their mishaps. Some well meaning observers might comment that the injured party should have been 'more careful' or 'watched out for hazards'; very few, if any, would say 'Look, that's pathological behavior to break a leg' or 'Don't change your way of living just because you can't walk without crutches.' A cast on a broken leg that reminds the world that a person needs extra help and support while the fracture is healing. Broken bones do not equate with pathology and you will not get well just by a positive attitude.

Not so with families. When one of their members is struck down, by illness, by an accident of birth, or by chronic deterioration, the family is expected to adjust in a short period of time and 'carry on' (Saetersdahl 1997). When the family goes into crisis it is often an invitation for the mental health providers to look at where they are dysfunctional, disengaged, over engaged, or lacking in boundaries; a whole variety of pathologizing descriptions are

laid on their doorstep. If the family appears to 'snap back' to the same level of functioning as they had before the external intrusion of illness, then they are judged recovered.

I am arguing for recognition that with any medical intrusion of serious consequences a family is changed permanently. One family will find hidden strengths to cope with the altered dynamics, others will falter as the familiar assigned roles are severely taxed. In no case can we blame the family system and the members of that system for reacting and experiencing their own form of stress. I suggest that therapy can provide the support that is necessary for the 'break' to heal, just as a real cast helps the leg to mend by protecting and supporting the bone. Again I use the metaphor of a break, the bone will always be a bone that was broken, it will never be exactly the same as before. The leg will function, perhaps close to normal, but the healing process leaves residual marks throughout the entire physiological and psychological systems. Why not let the family have the same privileges? Allow them to heal with the freedom to recognize that the remnants of the trauma will always be with them.

This chapter will explore the broad issues of distress that a family often experiences when a member becomes physically ill or disabled. The family here is defined as a related group of persons with a past history and a present, and with plans for a future; the extended family is also included in this definition. Many families are taking care of elderly relatives and many single parent families rely on the larger family system when they are in a medical crisis. The major difficulty that most families have in adjusting to the intrusion of illness in the family is one of communication (McDaniel 1995; Strozier 1996; Walsh and Anderson 1988). The motivation to be protective of each other is often misunderstood and evolves into a secret that is a burden and barrier to communication.

Successful interventions, such as those provided through art therapy, offer support for all age levels in the family system. Interventions which counter the inclination of the medical providers to pathologize and that work to realign the family system are the help that these families require. I see the course of therapy as a means to hear the different perspectives of each member of the family and facilitate the adjustment period. Everyone involved is affected by the illness, although the actual disease is only present in the patient. Moving from the anxiety provoked by the spoken word, to the relatively unfamiliar mode of speaking through images, provides a non-threatening change for all concerned. Children who are mystified by

adult behavior and parents who are in conflict about sharing their fears and emotions, can find metaphorical ways to convey their messages. I do not believe that attempting to readjust the entire family system is appropriate at this time. Readjustment and realignment of the duties and relationships are the first concern during this phase of the family's life.

Evaluating the stage of development of the family is of major concern for the therapist (Becvar and Becvar 1993; Carter and McGoldrick 1988). A newly formed family will have different resources than a long time relationship. The ages of the children (if any) and the ages of the grandparents and adult siblings are significant. The history of the family's encounter with past illnesses and their beliefs concerning the mental health providers is also a subject the must be explored. If the family has had previous confrontations with medical personnel, it will color their cooperation and influence their view of the present trauma.

There is also a vast difference in coping with a medical crisis from which the patient will recover and dealing with a long term (perhaps permanent) disability. The therapist should be prepared for different dialogues around different circumstances. The choice of a brief model of intervention is preferable. The focus is on solutions, strengths, positive connotations, and outcomes; however, the prolonged stress of a long term disability may need recurrent supportive appointments. Looking at these issues will be addressed in the body of this chapter.

Why art therapy?

The value of art therapy in medical family therapy lies predominantly in the area of giving a 'voice' to members of all ages in the family. When adults are under stress they often have less time for children and for each other. They may be unaware that children have a heightened sensitivity to the shift in the dynamics surrounding them. There may be a conspiracy of silence to protect the children, which may have the opposite effect of producing a vague feeling of guilt or responsibility in youngsters. Stress and illness will also often distance the members of the family as they individually attempt to adjust to the unfamiliar circumstances. If the family is brought together in therapy with the primary goal of illustrating their concerns through the media of images, the words they are hesitant to utter can be transformed into non-verbal messages through art expression.

The use of art expression can give voice to even the youngest child, since drawing is their preferred form of communication. Youngsters think

concretely and representations in art work reflect their stage of development. Adults, in contrast, may prefer to select a magazine picture in which several levels of meaning are imbedded. The art tasks can be a pleasurable balance to the serious difficulties the family is grappling with elsewhere. Because art therapy can be less painful does not imply that the therapy is less meaningful. Relief from the focus on the individual's sickness into generalized art tasks that take everyone's distress into consideration can lighten the environment of illness.

The concrete aspect of the art, the product, also has additional benefits. Often the person who is disabled is unable to come to the therapy sessions. He or she may be in the hospital or too weak to attend. The family has an option of taking the art therapy products home to the patient and sharing the session through the art. This keeps the patient 'in' the family. The patient, if he or she is not too ill, may wish to create a visual response by a simple drawing and send it to the therapy session. The patient feels included and may be the one to instigate hard questions and ask for the painful issues to be confronted. Like the example of the children's distress, the patient may feel as if everyone is talking about him or her and not to him or her. Missing members of the family can also be included in the therapy session. This is accomplished by structuring an art task that allows the other family members to demonstrate though pictures, what they would ask the absent member to contribute (Riley and Malchiodi 1994).

Example

When the father is rendered dysfunctional by illness, perhaps confined to a hospital or nursing home, his role in the family is left vacant. Often the wife attempts to do his job and her own simultaneously, and has nothing left over for anyone. In the art therapy session, I would suggest that everyone in the family make a representation of the responsibilities and roles that the Dad normally performed. Both drawing and collage could be used in this task. After the family created his presence through their art and discussed his contributions, they could cut apart the artwork and redistribute his tasks among all members. Even if the mother has to accept the major share, it would still be useful for everyone (and herself) to see how things had changed.

After agreeing which duty should be assumed by whom, a collage of the tasks assigned to him or her, should be made by each family member. When shifting roles are made clear through the collage pictures (which have

literally been pasted down), there is less fantasizing about them and less avoidance of cooperation. Transforming the confusion about duties into art expressions allows for negotiation as well as an opportunity to express many feelings for which these tasks stand as metaphors. The value of Dad is stated, the fears about loosing him surface, the anger about the alterations in the family is accessible, and recognition that there has been a radical impact on all their lives is apparent. A solution-focused discussion can include even the youngest member of the family, and if extended family members are present, they can be included in the decisions.

Families suffering from the stress of a medical illness in their lives need support. The art tasks should be constructed to help them deal with the hard issues. This is not a time to explore extraneous dynamics unless they contribute to the reorganization of the family. The art work in the example given above, should be shared with the father. His opinion can be included in the redistribution of his role. He will see how he has contributed to the functions of the family, and perhaps make decisions about how he might modify some of his behaviors when recovered. By sharing the art work he continues to be included in the family system. He can discuss how he reacts to being dysfunctional; how he plans to reassume his role; and his fear of being permanently dislodged from his key position in the family. This is the time to make covert change overt. The therapist is in a position to provide help and resources for this shift in the family dynamics.

Choice of theoretical approach

The choice of the solution focused approach which encourages the individual in the family to voice his/her narrative, is a decision I support. The solution focused approach with an emphasis on narrative theory motivates the family members to tell their story and find within the narrative occasions when the problem saturated situation has been alleviated. These exceptions have been overlooked by the narrator and are recognized (and shared) by the therapist as positive exceptions to the problem-system. The clients co-create with the therapist a new ending, or alternative outcome, to the negative script that has been perceived as immutable (Sluzki 1992; White and Epston 1990). Some therapists might suggest a cognitive/behavioral mode (Beck 1995). I personally feel that cognition is not operating on a high plain when a family member is at risk. Others prefer a systems approach, which is useful when there is a need to re-establish the hierarchical structure (Minuchin 1992).

McDaniel, Hepworth and Doherty (1997), have this to say: 'Medical family therapy uses a biopsychosocial system theory to help families to attend to the effects of illness on their emotional lives and family dynamics. Goals for medical family therapy include: better coping with a chronic illness; enhanced communication about illness and care within the family and with health providers; negotiation of management plans and ways to share care; help for making a lifestyle change; and greater acceptance of a physical problem that cannot be cured' (p.31). The advantage of a narrative approach, synthesized with the above goals, encourages the client-family to externalize the distress as separate from the individuals or the family. Distancing from the trauma gives them the power to unite against a common 'enemy.' The enemy is dissolution of the family. Art therapy uses the art product in the same manner. Seeing the problem promotes agency over the crisis. Language (narration) of the traumatic situation can give meaning to the new reality of the family's life. Therapists who use a social constructionist frame for improving the family's revised reality believe that conversation is the most important means of maintaining, modifying, and attributing meaning to everyday life. Therefore, using an externalized illustration of the individual's concern, and the narration that accompanies the imagery, takes advantage of the best clinical approach for families dealing with medical stressors.

Example

A family of five was seen at a children's hospital. They were part of a group for families of disabled children and were being interviewed as a single family before the group convened. Father and mother were well educated and had productive jobs. There were three children: two boys ages nine and eleven, and a girl of seven. The two boys had a serious allergic/digestive problem that limited their diet to just a few items that did not cause reactions that put them at serious health risk. They were hungry most of the time, angry and frustrated at the restrictions, and embarrassed in front of their peers because they could not join in on pizza lunches and other food-related activities. The constant monitoring of the boys' food intake and the stress provoked by this gastrointestinal disease had driven the parents apart. They were on the verge of separating, only the burden of caretaking kept them together.

A pre-group assessment interview was necessary to insure some commonality of goals among the participants in the group. The assessment

task that all the families were asked to do was to 'draw an island and place whatever you need on it to help you survive.' The family was to draw together, talk to each other or work silently, and allow everyone to have a chance to place his/her own images on the island drawing. This family did not work together; the boys took over. They drew diving war planes, bombs exploding, and destruction everywhere. The sister made a few marks, and finally the parents added minimally. They named their drawing Iwo Jima, in honor of the Vietnamese conflict. The art piece exactly reflected their family system at that time.

Both parents looked stricken with sorrow as they viewed the final drawing. The mother remarked; 'I wish everyone could see how sick these boys are ... then we wouldn't be so misunderstood.' She was referring to the fact that the boys looked well and concealed their physical problems. Only their disruptive behavior was noticeable, not the internal illness that prompted the acting out of their frustrations.

Her complaint was not unusual. Often the person who has an obvious disability receives more support than the 'silent' sufferer. The family system bends until it breaks when there is a lack of support and education about relief and caretakers. Fortunately this couple were guided to find respite personnel and day camps for physically ill children; together with couples' therapy they were able to stay together for some time.

This is an example of a family system that was in serious trouble, on the verge of 'blowing up'. The war zone drawing made it clear to everyone concerned that immediate interventions were needed if there was to be any peace in the future. The drawing was such a blatant demonstration of the family system that there was no denying the emergency. With adults like these parents who conceal their distress and anger and pretend to be functioning normally, it is a relief to have the facts clearly illustrated. Verbalizing their frustration and sorrow helped the parents support each other and grieve together over their stressful marriage. This united front helped them put boundaries on their son's behaviors and let the boys know that they were aware of how their disease was 'unfair' and depressing. Most importantly, that they too hated the disease but they loved their sons, a message that often becomes lost in the midst of a medical crisis.

Developmental stage of the family

Every stage of a family's growth cycle has predictable hazards. Young families have crisis with their children; young children are damaged if illness

separates them from their parents. Birth defects and disabilities can change a family system for life. Helping young adults cope with devastating trauma can save their marriage and give the disabled child a sense of identity beyond the handicap. Without providing a peer group with whom to relate, the family may turn into the disability! By that I mean; a method of coping is to over-identify with the problem and name the family (and all members), in other words; the 'diabetic family.' Taking the disability and making it the prime identifying label for everyone is a dysfunctional solution to a serious problem. Individuation has been sacrificed to the medical intrusion. The siblings of the ill boy or girl, or the parent who is not the patient, fuse into a illness-defined family identity which inhibits resolution of the trauma.

Naming has power. Therefore, the therapist must make every effort to offer an alternative to all members who have adopted this method of contending with their problem and remove the label. Art work that is focused on individual strengths, identity before the illness struck, and dreams of the future, are all learning experiences that stimulate individuality without interfering with connections. The art tasks should not be created on a shared piece of paper, which is often suggested for families who need help with connecting. These families need to call upon individuation and cooperation, not fusion. Individual drawings, expressing individual concerns, provide enactment of the goal of individuation without verbal explanation. The process itself will naturally stimulate differentiation. Every art therapy suggestion offered to the clients should further the clinical goals that have been established.

Families that have been together a long time, families that are composed of merged systems, and families that are reunited after long separations will each call for unique interventions. The most important issue to clarify is this: stages of family development provide diverse resources for the clients and therapist. In older families there will probably be a history of past traumatic events. How they were lived through and what coping skills were used can be the subject of an art therapy illustration. Reviewing past solutions (by distancing from the immediate emotional crisis) provides the art makers with an awareness of their skills and a renewed faith in their coping abilities. The art piece also informs the therapist about their strengths and weaknesses, in which directions they will need immediate help, and when to support these skills.

Example

A couple had been together for about ten years; both were professionals and both had established careers. Without warning the husband became very ill and was diagnosed with a type of cancer that attacks the lymph glands. He understood that his chances of recovery were high if he underwent radiation immediately and entered a course of chemotherapy. He agreed, but the treatments were so severe that the man had to give up his work and could do little else than lie on the couch from treatment to treatment. He became depressed and withdrawn. His wife, in the meantime, became impatient with his couch-sitting. There was little pleasure in doing all the house tasks as well as keeping up her profession. The couple had become estranged from their parents and had not communicated with them for several years. Their support system was minimal.

After about two months the patient was so bored with living on the couch that he took out some drawing media he had at home and did a landscape. When he looked at the end results he was startled at the message he saw in the drawing. He called the clinic and made an appointment to see the art therapist. The landscape was of a canyon, steep cliffs, and stony walls that loomed over a pleasant valley. The growth was verdant on the floor of the distant canyon, but it grew more and more sparse toward the crest of the cliffs. What drove him to make the call was the image of a man standing on the edge of the cliff, seemingly about to loose his foothold. He was frightened by the symbol and wise enough to respond to his inner prompting to 'keep from falling.' He spent several of the early sessions 'reading' the metaphors in his first drawing. He saw the cliffs as his challenge; the distant valley as his goal; the thinning timber line as his weakening strength; the lack of foliage related to his hair loss; and the obvious instability of the figure as a self representation. His resolution to counter this negative prophecy was to work out a more positive solution in his art work.

The course of therapy was self-directed. The man drew or painted during the week and brought the art work into the sessions. He reported that while he was deeply engaged in art-making he forgot his pain, nausea, and cramps. He also began to take great pride in his products. They were no longer solely therapy, they were creative, aesthetic productions. Although the artwork was created at home, we did have conversations in the therapy hour. The feelings of abandonment that his wife experienced, the isolation from the family, the subsequent loneliness both partners felt, and the fear of cancer that came between them, were all subjects of therapy. The imagery in the art work

reflected growing integration, competence in using the media, and color awareness, and moved from pictographs to interesting abstracts. I looked forward to seeing them every week. He stayed with his regimen for the full course of his treatment. He was in remission the last I heard, his marriage survived, and they had decided to renew contact with their extended family. I have no illustrations of his art because they were all framed, hung, or given away. He had a new identity as an artist, and he also returned to his original profession with enthusiasm.

Beliefs, myths and the medical profession

The family art therapist dealing with families that have been traumatized when an illness becomes an unwelcome part of their lives, must explore with the members their beliefs about medical assistance. Wright, Watson and Bell (1996) explain this concept:

> How persons experience an illness depends on the beliefs that they have embraced prior to the illness experience, as well as the beliefs that evolve through the experience of the illness. The beliefs that family members hold are often reconstructed after the experience of an illness; conversely, family members' beliefs influence and shape the processes and outcome of illness. (p.55)

Wright provides a list of beliefs about illness:

- Health and illness are subjective judgments made by observers.

- Illness and families are linked in recursive, reciprocal relationships.

- Illness narratives include stories of sickness and suffering that need to be told. Options for managing illness increase options for healing.

- Illness arises and is influenced by interference with fundamental emotional dynamics. (p.56)

How the family and the individual decide who is well and who is sick is also how they describe health. Often the patient is unaware that they are ill until a medical person makes a diagnosis. At this point there is a major disruption in the family dynamics. Some members may disbelieve the diagnosis, others may use it as an explanation for other stress points that have little to do with the illness. The family as a whole may have a belief system about courage, endurance, and dependency and a whole group of related concepts that have bearing on this situation. It is incumbent upon the therapist to explore these

belief systems if the family is to function efficiently in dealing with a medical problem.

Directing the family to make artwork that describes their understanding of the issues listed above, can be very useful. Most adults are reluctant to disagree with the authorities who make diagnosis. They may or may not respect the medical opinions that shape their lives; they may prefer to deny the seriousness of the diagnosis for a multitude of reasons. If the adult is asked to draw or select collage images that reflect his/her belief in the assumption defined by the medical authority, an opportunity is provided to reveal their personal reality. Since talking through images is in contrast to speaking verbally, material that the family member thought needed to be concealed is often exposed. The inhibitors that restrict language and social intercourse are weakened dramatically when the unfamiliar mode of visual communication is utilized. Lack of cooperation with medical treatment plans can be understood if the belief system of a family surfaces in the art therapy product. Processing this material becomes informative to everyone concerned, and clear decisions can be made, rather than operating by passive resistance that may be subverting recovery.

Therapist's issues

Working with a family that is suffering the effects of a medical trauma, as well as providing individualized therapy for the ill member of the family, can be distressing for the therapist. It is hard to keep an involved therapeutic relationship without becoming so entangled that the effect of the therapy is diminished. Therapists must carefully consider their own history of living with illness in themselves and in their family. Without this self examination the family may be asked to believe as the therapist believes in health and health care.

Developing some guidelines is helpful. Remember that illness will disrupt the growth and developmental tasks that would normally occur. Do not neglect to support the 'normal' tension points that most families experience or all the difficulties will be laid on the illness. There are many challenges that impact a family at the same time as their overriding concern with the patient and the effects of the illness (Umana, Gross and McConville 1990).

Therapists working with medical problems have to be educated in many areas. How to face mortality is a hard one. Therapists must also learn how to talk to medical professionals about the illness that is effecting the family, and possible resources to help the family obtain relief. There are sensitive areas

that the therapist must anticipate: ethnicity, what the illness means in the culture of the clients, gender issues and assigned roles in the family, religious beliefs that may impact the medical plan, and the effect of illness on the sexual relationships in the family (Strozier 1996).

The therapist cannot take a passive stance when a family is in crisis. She or he should be well informed as to the best theoretical approach to take, in conjunction with the art therapy modality. The clinician should, as much as possible, normalize the family system, helping the family to organize tasks, such as responsibilities in the home, caretaking, and informing interested relatives and friends about the situation when they call. This form of family therapy is holistic and therapists who are not willing to engage in the complete picture of the family's dilemmas will not serve their needs.

Example

For several years, I followed a family at the clinic through many forms of treatment. The teenage girls were in group therapy and in family therapy with their mother and brother. The mother entered individual treatment when her crippling arthritis forced her to become dependent. She was enraged at her physical dependency, her changed appearance, her forced separation from the man who had supported her and fathered her children, and that she was living alone in financial distress. Her situation was culturally defined; she was a 'second' wife, who's 'husband' visited her on the weekends. He lived with his 'first' family the rest of the week. She had been a beautiful woman until this debilitating and painful disease crippled and distorted her body. She had every right to be enraged.

The sessions with her children were structured. They were directed toward helping them understand how their mother had been affected by her illness, both physically and psychologically, and gave them a forum for expressing their emotions. They felt bound by their culture to be loving and acquiescent to their mother at all times. However, her irrational demands had made them less and less loving and connected. Everyone within the family system was lonely and distressed. The mother was immovable in her anger at her children. She displaced her anger on them, anger that could have been directed at their father, a man who had abandoned her both physically, sexually, and financially. When she lost this relationship she was reduced to 'nothing' in her eyes. Only her religion stood in the way of her suicide. In spite of the tension and blaming, therapy with the younger members of the

family was successful to a degree. The children were able to rotate visits, do household chores, and fill her prescriptions.

There came a day when my client had to go on state disability aid. No one in the family was equipped to walk her through the system. Although it is not usually in the job description of an art therapist, I put on my other hat of family counselor and went down to the state agency with her and helped her apply for welfare. It was a humbling experience. However, it was also a victory. Because I was not asking aid for myself, I was not intimidated by the state officials. We were finished with all the paperwork in only four hours. My greatest concern was: could this severely disabled woman survive the hours of waiting and the stress of the application? I am sure that my intervention with the state authorities on her behalf was far more helpful than a weeks' worth of therapy.

This case does not have a happy ending. The rheumatoid arthritis progressed to such a degree, that she was forced to go to a protected living facility and I could no longer keep in contact. We did touch base now and again, and I had regular follow-up visits with the children. I give this case example to share the conflicts, involvement, and broad responsibilities of the therapist if they take on a case that is impacted by medical problems.

Summary

Offering art therapy to a family that has been disorganized and traumatized by the impact of illness has specific advantages. If the therapist has trained and educated his or herself about the special medical needs of a family experiencing a painful problem, then art therapy can facilitate treatment. Making an art piece that is designed to illuminate the goals of the session can provide the family with the following benefits:

1. Making art is usually pleasant, and therefore introduces a little pleasure in a depressing situation.

2. Working simultaneously with media and color brings the family together at a time when many persons withdraw and are trying to cope alone.

3. Art projects that invite the family members to externalize their thoughts and feelings about the intrusion of illness, provides an opportunity to distance from the problem. Distance allows perspective and the space to solve problems.

4. The art product often reveals material that surfaces 'accidentally', or without conscious volition on the part of the art maker. When the artist self-observes, there are moments when new insights can be helpful.

5. The externalized problem calls attention to other possibilities for solutions, and alternate views of problem solving.

6. Other members of the family can *see* what their siblings and parents are thinking/feeling. Seeing makes the difficulty concrete and diminishes confusion and magical thinking.

7. Art work can be shared with the missing family member who is incapacitated. Keeping the ill person 'in' the family is of great benefit for future re-entry, or a more empathetic final separation.

8. The therapist is informed by the art work and can better support the family and respond to their stress and pain. The social restrictions of language is reduced and the concealed messages can surface, either directly or through the metaphor.

Medical art therapy with families is both the same and different from working with families with behavior or psychological problems. The greatest difference is to change the focus from pathological thinking to holistic planning toward coping and creating a new pattern of family relationships. Finally, it is a challenge for the therapist to face the trauma of the illness with the family and still keep an observant stance that can best support and aid the family. Family medical art therapy treatment may be one of the most complicated and rewarding opportunities in the world of patient-therapist relationships.

References

Beck, J.S. (1995) *Cognitive Therapy: Basics and Beyond.* New York: Guilford Press.

Becvar, D.S. and Becvar, R.J. (1993) *Family Therapy.* Boston: Allyn and Bacon.

Carter, B. and McGoldrick, M. (1988) *Family Life Cycle.* New York: Gardner Press.

Malchiodi, C.A. (1997) *Breaking the Silence: Art Therapy with Children from Violent Homes.* New York: Brunner/Mazel.

McDaniel, S. (1995) *Counseling Families with Chronic Illness.* Alexandria, VA: The Family Psychology and Counseling Series.

McDaniel, S., Hepworth, J. and Doherty, W.J. (1997) *Medical Family Therapy: A Biopsychosocial Approach to Families with Medical Problems.* New York: Basic Books.

Minuchin, S. (1992) *Family Healing: Tales of Hope and Renewal from Family Therapy.* New York: The Free Press.

Riley, S. and Malchiodi, C. (1994) *Integrative Approaches to Family Art Therapy.* Chicago: Magnolia Street Publishers.

Saetersdahl, B. (1997) 'Forbidden suffering: The pollyanna syndrome of the disabled and their families'. *Family Process 36*, 431–436.

Spira, J.L. (1997) *Group Therapy for Medically Ill Patients.* New York: Guilford Press.

Strozier, A.M. (1996) 'Families with chronic illness and disability'. In M. Harway (ed) *Treating the Changing Family.* New York: John Wiley and Sons.

Sluzki, C. (1992) 'Transformations: A blueprint for narrative changes in therapy'. *Family Process 13*, 217–230.

Umana, R.F., Gross, S.J. and McConville, M.T. (1980) *Crisis in the Family.* New York: Gardner Press.

Walsh, F. and Anderson, C. (1988) *Chronic Disorders and the Family.* New York: The Hayworth Press.

White, M. and Epston, D. (1990) *Narrative Means to Therapeutic Ends.* New York: W.W. Norton.

Wright, L.M., Watson, W.L. and Bell, J.M. (1996) *Beliefs: The Heart of Healing in Families and Illness.* New York: Basic Books.

Art Therapy and Cancer

Images of the Hurter and Healer

Virginia M. Minar

Introduction

The primary purpose of any psychotherapist working with cancer patients is to help them deal with the emotional trauma that accompanies the physical and medical aspects of the disease. Art therapy is a viable means for those with chronic or terminal medical conditions to deal with their thoughts and feelings about their past, present, and future, and to uniquely express themselves through this highly personal non-verbal communication. Through art therapy, patients may learn to cope with their particular situation and possibly create a tangible legacy for their families.

Once you have cancer, it becomes a part of your life. As one patient said: 'It's hard to deal with the uncertainty. It's not [just] dealing with cancer that's hard, it's living with it on a daily basis' (Resler 1990, p.4). In assisting any individual to adapt to the cancer experience, the focus is to help the person live within the limits of the condition, yet to the maximum of his or her current capacity. The goals of art therapy in meeting the needs of cancer patients are to allow for ventilation of feelings and discovery of inner strengths that can serve as a support system in compensating for losses and for handling recurring stresses.

The art therapy groups which I conducted were sponsored by the Cancer Care Center of a major metropolitan hospital. Sessions were 90 minutes and we met once a week at the hospital's Women's Health Center. Because of spacial constraints, the size of the groups was limited to five or six patients. Because many patients are anxious about 'making art,' I begin by using a procedure described by Virshup (1978) in *Right Brain People in a Left Brain*

World. Kite string is soaked in india ink and 'dragged across the paper, making abstract designs' (p.13). Some patients prefer to place the inked string on the paper using an up and down movement as they move the string across the picture plane. When satisfied with their black and white design, the patients look at the paper from all sides to find and develop their images with oil pastels.

After the first meeting (during which the ink-string process was used) patients were encouraged to work independently. They were asked to keep a journal of both sketches and writing. Although journal entries often provided motivational material for the images they would later create, many of the women chose to sequence their pictures, building on or refining themes that appeared in earlier works.

Because patients worked independently, pictures would be completed at different times. The completed work would be placed in a mat and hung up for the group to view and absorb the imagery, without comment. Each group member then wrote down on a piece of paper what they would name it if it were their picture. Starting with the artist who created the art work, each person gave their title and explained why they chose it.

During some sessions, when group members were experiencing 'creative blocks,' I would ask them to write Successive Poetry, a technique described by Levy (1978) where the poem is created concurrently by several individuals. I have slightly modified Levy's directions. Each person writes their initials in the lower right hand corner of a piece of paper and then writes a line at the top of the paper. This is the first line of the poem. The paper is passed to the person sitting on the left of the initiator. This person writes a line in response to the first line. It does not need to rhyme. The second person folds the paper back to hide the first line, but leaves the second line visible and passes it on to the next person. 'Each successive member of the group contributes a line ... folds the paper [back] so that the only line any individual sees is the line written by the person directly before [him or] her' (Levy 1978, p.27).

Depending on the size of the group, the poem should go around at least twice. When there is just enough space for a final line, it should be returned to the initiator, identified by their initials. He or she then writes the last line to allow for closure. Each person first reads their poem to themselves, and then reads it out loud. These poems (an example is given below) often stimulated ideas and images for some of the group members to illustrate.

Acceptance

I'm weary of winter, and it hasn't even begun.

The darkness, cold, ice and snow surround me.

My innermost thoughts go deeper and deeper

Like looking at something closely

With a looking glass.

I found that writing in my journal

Helps me to focus my feelings.

Feelings are not right or wrong, they just are.

Acceptance of all your feelings

And doing what you need to do

To work those feelings through is important,

So that when winter finally comes

You will find warmth from your memories.

Images of the hurter and the healer

Cancer patients in individual or group art therapy often create images of 'the hurter' living in their house and 'the healer,' an image which helps the person begin to heal or help the hurt. 'Hurter' images may be of the disease itself, of their feelings as they work through their personal grief, or of the ways in which their lives have been changed. Dark clouds, volcanos, shifting sand, barriers, jagged rocks, explosions, weeds, whirlwinds, whirlpools, chains, seaweed, burning candles, sunsets, serpents, and forests are some of the images that take shape as the patients recognize and define the hurt they experience.

Peggy, a kindergarten teacher and mother of four active boys developed breast cancer in her late thirties. She created a self portrait, 'Caught in a Whirlwind' (Figure 10.1). There are two 'hurters' in this picture, the whirlwind and a hat pin stuck into her hair. She said: 'I felt like I was looking

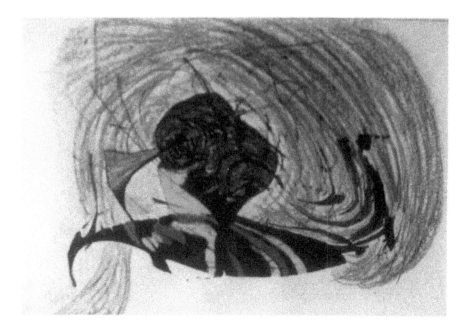

Figure 10.1 'Caught in a Whirlwind'

at my life from a distance, that it was someone else's life not mine. I faced so many questions, decisions and uncertainty – all swirling around! I had lost control.' The pin represented the stabbing feeling, the fear of cancer.

Bea, a 43-year-old high school English teacher, had a modified radical mastectomy. 'Trapped Angel' (Figure 10.2) shows seaweed as the hurter, an image which made her feel caught, not in control. A second hurter symbol, the worm, represented her employer who reneged on a promised promotion after her diagnosis of breast cancer. She is the angelfish fighting her way through the seaweed. During further discussion with the therapist, the worm became a hook representing death which the fish has escaped.

In *The Artist as Therapist*, Robbins (1987) states that in order to deal with the hurt, both the therapist and the cancer patient must direct their efforts 'at improving his [or her] quality of life and affording him [or her] every opportunity to mobilize the healthy forces within his [or her] personality to combat the disease…' (p.187). In mobilizing these forces, images of the healer appear, sometimes in the same picture with the hurter. Each patient sees his or her healer differently. Visual metaphors of God, of family, of friends, of karma, of chakra, and of other support systems emerge. Variations

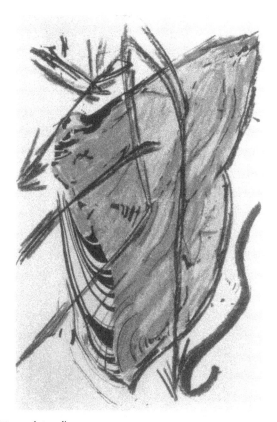

Figure 10.2 'Trapped Angel'

of a strong light source, of healing water, of new horizons, of growing things, of mystical figures, of mandalas, and symbols of love help the cancer patient begin to heal or handle the hurt.

Bea's picture, 'A Feather of Hope' (Figure 10.3), is based on a line from Emily Dickinson's poem 'Hope 1': 'Hope is the thing with feathers that perches in the soul' (Dickinson 1982). While talking about this bold abstract of a feather, Bea said: 'I chose [the] three primary colors to represent the three basic needs of a cancer patient – faith, hope, and a good doctor.' Yellow was faith, the God light! Blue was hope, the color of the spirit that enables you to continue on. Red was the good doctor who is strong, masterful, and warm.' Many cancer patients show God as light; sometimes as the sun, sometimes as a distant glow, and sometimes just by the strong use of the colors yellow or gold. 'God is light and in Him there is no darkness at all' (John 7.38). Regarding the color red, Kreitler and Kreitler (1972) state: 'The intimate

Figure 10.3 'A Feather of Hope'

relation of red with life is attested by the frequent use of red in the magic of healing the sick...' (p.68).

Patients created images of the self as trees, flowers, fish, birds and other living organisms, with the artist desiring or assuming some of the characteristics of the chosen image. In processing her picture 'Serpentine' (Figure 10.4), Joy, a breast-cancer patient, stated: 'Very often I have used a snake-like image. This one is the most recognizable. It was drawn when I was experiencing a great deal of tension, and the therapist encouraged me to draw 'tension'. During the group discussion, someone thought it looked like the release of tension; like a rubber band that had been stretched and released. Joy added: 'I used to think that the snake was a negative image, but I don't anymore. Now I see the snake as being able to endure in hardship, and to slither through all kinds of adversity and come up a winner. If there is such

Figure 10.4 'Serpentine'

a thing as transmigration (rebirth of the soul into another body), I wouldn't mind coming back as a snake ... able to shed my skin and start over when life became too difficult.'

Unice was being treated for stomach cancer. She was involved in chakra meditation which uses the seven vital energy centers in the body as a map to explore who she was, how she became that way, and what she could do to become who she wanted to be. She felt that chakra meditation was helping her to take control of her own healing processes. One of Unice's early images was titled, 'I Seek My Way' in which she presented the seven levels in a pyramid made of lotus petals. Each level was a different color representing the stages of the chakra system (Judith 1996; Kellogg 1987) as 'healer.' At the top of the pyramid, the single light mauve petal represented the seventh chakra through which one may feel integration with God.

When Unice was concentrating on the yellow third chakra which was located in the area of her body affected by the cancer, she created a large mandala-shaped lotus blossom with a yellow center. While yellow represented the hurter (cancer), it supported the self as healer since this chakra is also the center for handling emotional sensitivities and personal

power, important issues in managing self-healing. Within the center, she placed seven seeds representing the chakra levels. She surrounded the yellow center with delicate mauve petals to represent the desired seventh chakra. The petals enlarge as they move outward and are combinations of yellow, green, blue, and mauve. Reaching out from behind the blossom are green vine stems and leaves. Green is the color of the fourth chakra which represents the heart. Through this center, we feel love, from and for others (Judith 1996). Unice was reaching out to others for her support system.

Dee was in her mid-fifties when she had a breast lumpectomy. Two months later she developed colon cancer. Composing a biographical information paragraph for her entries in the 1991 Confronting Cancer Through Art Exhibit sponsored by the Wheaton Franciscan System of

Figure 10.5 'At War'

Milwaukee, Wisconsin, Dee wrote: 'It was during chemotherapy that I entered art therapy, which helps me to uncover hidden emotion. When inner emotions are confused and overwhelming it helps to ... see them take shape on paper. At other times, art is an escape – leaving worry and reality behind, and becoming immersed in color and form.'

Dee, one of the patients that had previous art making experience, based most of her pictures on sketches and notes from her journal. 'At War' (Figure 10.5) was developed from a sketch she drew while watching television news reports about the gulf war. She related the bombing to the first explosive feeling that accompanied the diagnosis of cancer. The hurter was the explosion. But she later said that it 'also signifies the successful use of chemotherapy and radiation at war with my cancer' ... it became fireworks, a victory celebration. This illustrates that the hurter sometimes becomes the healer.

Figure 10.6 'Heart of Tears'

One of Dee's most beautiful pictures 'Heart of Tears' (Figure 10.6) shows both the hurter and the healer in the same picture. In discussing the images, Dee said that it 'expresses the deep inner sadness I've felt with having cancer, but rooted right along with it is an ever-present hope in the goodness that lies ahead.' The hurter is the tear, the self is the broken heart, and the healer is the roots and the vine which represented new growth, new life.

This was the first of many heart images created by a number of patients in different groups. In discussing the meaning of the heart symbol someone in one of the groups mentioned that the Japanese believe you should always listen to your heart. 'Honto desu ka?' – what does the heart say?

When I first met Shelly, she was twelve years old and recovering from her third brain tumor surgery. At the time, the hospital group was made up of adult women. Her oncology nurse asked if Shelly might join the group since she was very interested in art and hoped that art therapy might help her handle some of the sorrow and stress she was feeling. The group members agreed to invite her to join us.

As pre-teenage girls often do, Shelly included the heart symbol in many of her pictures. However, her hearts were not simply decorative. Each one had a definite purpose. In her first picture, using the Virshup (1978) process, she created 'Elephant Walk.' This elephant had no ears, but on the top of his head there was a pink ball of color. Shelly felt this represented the swollen brain, and the missing ears meant that surgery had been performed. These were vivid hurter images. On the ground lay a heart. She said: 'He lost his heart for a while, but it's within reach, so he can get it back.' A little yellow bird, representing her soul, flies overhead guiding the elephant through the jungle, which she felt was no place for a child. In the background Shelly placed an incomplete rainbow which represented hope as the healer. She said: 'While you cannot see the end, I still believe there is something wonderful waiting for me at the end of the rainbow.'

In a family portrait, she represented her father by a heart symbol and in a large self portrait, the heart symbol came to represent the family unit. Shelly's most poignant image was titled 'Tree of Hearts.' She depicted a huge tree trunk and at the bottom of the tree lies a pile of multi-colored, heart-shaped leaves representing those who shunned her when she was ill from the chemotherapy and had lost her hair. The top of the tree is abloom with growing hearts symbolizing both those friends who had remained constant and new friends she had found since her surgery. Here is a perfect

example of the same symbol representing both the hurter and healer in the same picture.

The vine shown in Dee's 'Heart of Tears' (Figure 10.6) was also the first of many vine images. The metaphor of the vine is used in both the Old and the New Testaments. In the Old, the vine represents 'the family of God' and many cancer patients interpret the vine both as their immediate family and as their connection to God. Several patients quoted from the Bible: 'I am the vine, you are the branches. He who abides in me, and I in him, he it is that bears much fruit, for apart from me you can do nothing' (John 15.5).

Although Peggy and Joy were not in the same group, they created very similar vine images representing their nuclear families. Peggy, whose first image was 'Caught in the Whirlwind' (Figure 10.1), also created a piece titled 'Renewed Growth' in which the vine is the healer family. In it there are two large flowers, an elongated blossom (her husband), an oval-shaped blossom (the self), and green leaves representing her four sons. Her main focus was on the relationship between the two blossoms which she said: 'represent my husband and myself ... He has supported and comforted me ... [he] gives me strength and courage to persevere and go on.'

Joy's piece 'Family Vine' had undulating lines similar to her 'Serpentine' (Figure 10.4). In it there is one large circular form with another circle superimposed on top of it. There are three other round forms and one irregular shape on the vine, representing the vine's flowers. When talking about the image, Joy said: 'At first I saw the two dominant circle forms as my breasts with the smaller one being where the cancer occurred. But later, as a pattern emerged [in my body of work], we discovered there are almost always six images that are connected in some way. This represents my immediate family: my husband, myself and four children ... I see the largest circle as actually two circles, one on top of the other representing how close my husband and I have become in the face of multiple stressful experiences.' The irregular shaped flower was representative of a strained relationship with one of the children.

Anne had fought multiple battles with cancer beginning in 1984 with breast cancer. When she entered art therapy in 1991, she had been through eight operations as tumors had spread to her chest and other areas of her body. This patient's first picture included a woman dressed in Madonna-blue robes with a halo-like black and yellow image over her head. The woman is standing on sand-colored ground with black weeds surrounding the figure. The weeds are the cancer hurter. Faith, the healer, is represented by the

Madonna-blue color. Anne called this picture 'Alone' because she felt that once you have cancer you often feel alone in your battle, particularly when you have been dealing with it for a long time. She also believed that the only one she could talk to was God, with the Madonna serving as her messenger.

During group discussion, using the naming process explained on p.228, group members explained their titles as follows: 'Standing on Shifting Sand' – because of the uncertainty of the disease, you never know where it is going next. 'Why Me?' – this person was trying to find the answer to why cancer had happened to her. The group dealt with the question until we agreed that we could also ask: Why not me? 'Women's Woe' – because breast cancer is one of the greatest fears of women since it is projected that as high as one in eight women will have breast cancer in their lifetime. 'Searching' – out there in that desolate environment searching for answers and something or somebody to help her. 'Earning a Halo' – this group member saw the figure as the epitomy of good; someone who was achieving the top. The artist chose to retitle her picture as 'Earning a Halo.' In 1992, Anne received her halo.

Some suggestions for working with cancer patients

Like others who have worked with cancer patients, I have found that one of the greatest fears is abandonment (Dreifuss-Kattan 1990; Yalom 1985). The distress felt at the thought of 'being abandoned, even shunned, by the world of the living' (Yalom 1985, p.23) leads some patients to keep the secret of their disease 'all the while dwelling on the horrible thought that ... [somehow the disease will make them] become less human and, finally, unacceptable to others' (p.23).

Although in working with cancer patients the focus is on the creative process and the expression of thoughts and feelings about living with cancer, the process of art therapy also helps them bond together as a group. Their 'artworks and images have lives of their own' (McNiff 1987, p.38). Group members observe one another's imagery and discover that the picture becomes a reality – created by the artist, but separate from the artist, with a voice of its own. The image 'has an independent existence ... it does not matter whether a person looking at the pictures sees the same story as the person who made it' (McNiff 1987, p.207). Each viewer receives a different message based on personal needs and experiences. The sharing of these messages becomes a bonding ritual.

The Successive Poetry process (Levy 1978) also became a bonding ritual for one of my private practice cancer groups. I would like to share one of their poems with the reader.

The Present

The present is all we know of this life,
But the future holds glory we can only imagine.
So, live fully in the moment.
Each moment is precious
And our life is just a moment
In the scope of eternity.

This enables us to face daily challenge
With a new outlook and attitude.
We simply will not have our moments spoiled
With nonsensical problems;
Instead, we see them as learning opportunities.

Color me blue with a stroke of pink
And a little sunshine on a green meadow.
I am a living collage – shaped and colored
By the people, places and events of my life.
You might call me 'A work of Art.'

I have also found that members of cancer groups are 'deeply supportive to one another' (Yalom 1985, p.99). Being involved in an art therapy group gave the patients a way to express all of their complex feelings in an accepting environment where they did not have to put on a happy face to make those around them feel comfortable. Most of them were also eager to share their experiences in order to educate the public both about their illness and how they felt art therapy had helped them deal with their fears, frustrations, and feelings.

The art therapy group also gave them the opportunity to find meaning outside of themselves. By the activity of making art, by extending and receiving support throughout the process, and by caring for each other, they

found a new sense of purpose for their lives. The religious beliefs of most of the people in my cancer groups were rooted in Judean-Christian doctrines. But, just as they sought out every medical answer for the disease of the body; many began to seek answers to the meaning of life and death in other religions. For example, some self-images reflected a conscious or unconscious desire to believe in *transmigration*. Transmigration is based on the doctrine of *metempsychosis*, the rebirth of the human soul after death into a living human body as yet unendowed with a soul, or into the body of one of the lower animals, (or even into a plant). The idea of metempsychosis was, and remains especially prominent in the native religions of India. The cancer patients with whom I worked saw it as part of reincarnation as defined in Hinduism's Laws of Karma (*Encyclopædia Britannica* 1995; Smith 1958).

Another common cause of stress for the patient involves the patient–doctor relationship. 'Physicians often keep patients [particularly those with advanced cancer] at a considerable psychological distance' (Yalom 1985, p.23). If a doctor is less than secure in his or her relationship with the patient, he/she 'may ... start to use selective denial, communicating half-truths to the patient' (Dreifuss-Kattan 1990, p.82) about the patient's prognosis. This behavior may reflect a doctor's need for self-protection rather than concern for the patient's feelings (Dreifuss-Kattan 1990). In discussing the reasons for this psychological distance, Yalom (1985) states that: 'it is probably to avoid dread of their own death and their sense of guilt, limitation, and futility ... Yet, from the patient's standpoint, this is the time when one needs the physician the most – not for technical aid but for sheer human presence. What the patient needs is contact, to be able to touch others, to voice concerns openly, to be reminded that he or she is not only "apart from" but also "a part of" others' (p.23).

Like Yalom (1985), I have found that those who are able to confront cancer without pretense and with concentrated determination seem to enter 'a mode of existence that is richer than that prior to their illness. Their life perspective... [is] radically altered; the trivial, inconsequential diversions of life [are] seen for what they are ... They ... [appreciate] more fully the elemental features of living: the changing seasons...[the birds singing, the butterflies on the wing], the loving of others' (p.100).

In the beginning of this chapter, I wrote that by being involved in art therapy, patients may create a tangible legacy for their families. Kelly suffered from milo-fibrosis, a blood disease which is a pre-leukemia condition. Kelly was a professional artist who, because of her weakness, could no longer hold

the paint brushes to work on large paintings. After our first meeting, she adopted the Virshup (1978) process as her own and created a series of pictures each containing one or more butterflies. She felt she was as fragile as they were.

'Butterfly Wolf' was her first image. The central image was a wolf-like creature with butterfly wings. The hurter was the wolf (the disease) and the butterfly wings represented the self, wanting to fly away, but trapped as part of an unfamiliar predator. Other members of the group titled the picture 'Terror in Transformation,' 'Disguise,' 'Stalking,' and 'Reawakening.'

Kelly went on to find multiple butterfly images in her random ink designs. She was relieved to find that she could handle this media without pain, and excited to be able to create again, something she hadn't done for several years. She not only worked on her pictures during group sessions, but brought in work she had created at home to share with the group.

In 'Free at Last' Kelly portrays herself as a blue butterfly in three sequential stages. In the first stage she saw herself grounded by the pain. In the second stage she tests her readiness to fly by moving up to cautiously sit on the branch of a plant. Kelly saw the final stage as her acceptance of transformation as the butterfly, which had risen from the depths of despair, is ready to fly away and be 'free at last'. The butterfly image had become her personal healer. At Kelly's funeral, her daughters displayed her butterfly series. Whenever I see a butterfly, I remember Kelly and hope she has found peace in her new level of being.

Conclusion

Art therapy can be a highly effective intervention in helping cancer patients express themselves by using the materials of art to deal with the hurters and discover the healers in their lives. The images they reveal can serve as a catalyst for verbal communication between patient and therapist, and as material for in-depth group discussions.

My experience with cancer patients reaffirmed my belief in the power of art therapy as I realized that it could play a part in helping patients deal with their hurters, recognize their healers, utilize their own strengths to endure this difficult disease, and to live each day as a testimony to the importance of their existence.

References

Dickinson, E. (1982) 'Hope 1'. In M.L. Todd and T.W. Higginson (eds) *Collected Poems of Emily Dickinson*. New York: Avenel Books.

Dreifuss-Kattan, E. (1990) *Cancer Stories: Creativity and Self-repair*. Hillsdale, NJ: Analytic Press.

Encyclopædia Britannica (1995) 'Reincarnation'. *The New Encyclopædia Britannica 9*, 1009.

The Holy Bible (Revised Standard Version) (1952). New York: Thomas Nelson and Sons.

Judith, A. (1996) *Eastern Body, Western Mind: Psychology and the Chakra System as a Path to the Self*. Berkley, CA: Celestial Arts.

Kellogg, J. (1987) *Mandala: Path of Beauty* (3rd edition). Clearwater, FL: Mari.

Kreitler, H. and Kreitler, S. (1972) *The Psychology of the Arts*. Durham, NC: Duke University Press.

Levy, B. (1978) 'Successive poetry in the creative process. The dynamics of creativity'. *Proceedings of the Eighth Annual Conference of the American Art Therapy Association*. AATA, Inc.

McNiff, S. (1987) *Fundamentals of Art Therapy*. Springfield, IL: Charles C. Thomas.

Resler, J. (1990) 'The art of healing: Therapy helps patient deal with her cancer'. *The Milwaukee Sentinel 1*, 4.

Robbins, A. (1987) *The Artist as Therapist*. New York: Human Services Press.

Smith, H. (1958) *Hinduism. The Religions of Man*. New York: Harper and Row.

Virshup, E. (1978) *Right Brain People in a Left Brain World*. Los Angeles: Guild of Tutors Press.

Yalom, I.D. (1985) *The Theory and Practice of Group Psychotherapy* (3rd edition). New York: Basic Books.

Studio-Based Art Therapy for Medically Ill and Physically Disabled Persons

Mary K. McGraw

Though the presenting diagnoses for medically ill and physically disabled persons may differ greatly, each must cope with traumatic events. Each must begin to make sense out of these life changing, often life threatening experiences. There is a common need to make inner and outer worlds congruent; to deal with changes in self and relationships; and to find new methods of coping. My 31 years of clinical experience have demonstrated that a studio-based approach to art therapy, which emphasizes art making and its image-producing, non-verbal qualities, can be central to therapeutic gain. Traditional verbal psychotherapy is often inappropriate or impossible for this patient group because of medical or physical problems. For others, especially those who are acutely ill, newly disabled or terminally ill, words about feelings or fears are often too confrontational (McGraw 1989). Defenses, which provide mechanisms allowing the person to gain control and avoid being overwhelmed by feelings about what has happened, are a necessary part of the healing process.

In 1967, I helped establish the Art Studio – Center for Therapy through the Arts to meet the needs of medically ill and physically disabled persons. It is the oldest hospital-based art therapy program of its kind in the US. Founded as an independent non-profit organization, the Art Studio is located at MetroHealth Medical Center in Cleveland, Ohio. MetroHealth is a 728-bed publically-owned hospital, which provides comprehensive health care services including trauma, intensive and primary care, rehabilitation,

skilled nursing, and wellness programs. The Art Studio was first developed for chronically ill and physically disabled persons. It later expanded to include acute medical and psychiatric patients at the hospital and now serves clients in a community-based program at Fairhill Center for Aging. Its mission is to promote wellness and healing through art therapy.

A creative collaboration

From the outset, the Studio has been innovative in its approach to both funding and service delivery. Its Board of Trustees and administrative director work in collaboration with the Hospital's administration to guarantee the resources necessary to support its program. The Hospital provides funding for two full-time positions and space, supplies, and other logistical support. All other expenses, including four staff salaries, are the responsibility of the Board and administrative director. Income is raised through contributions from individuals, corporations, and foundations, as well as fees from direct service, continuing education programs and various fundraising events, such as annual benefits and the sale of art products.

This collaborative relationship with MetroHealth Medical Center, and outreach to various community resources offers a creative alternative for hospitals and organizations interested in providing arts therapy services. Diverse funding sources are essential in a fiscally restrictive health care climate. Though fundraising and financial stability are an ongoing struggle, support from the private and public sectors has enabled the Studio to survive and grow when other valuable programs have been forced to close down. In 1967, the Art Studio began with an annual budget of $9,000. In 1998, the budget for its hospital and community based programs was over $220,000.

Art studio staff sees a highly diversified patient population, including brain and spinal cord injured, orthopedic, dialysis, oncology, stroke, geriatric, pediatric, chemically dependent, and psychiatric in- and outpatients. An initial contact may begin on our Hospital's intensive care unit and continue through in- and outpatient rehabilitation to our community based art therapy program. More than 1,200 patients and their families are seen annually for a total of over 11,000 individual and group sessions. A majority of these individuals are medically ill and/or physically disabled adults, who are coping with a chronic illness or permanent disability.

A need beyond words

Physical trauma, illness, and their treatment can cause pain, anxiety, depression, anger, and withdrawal. People need alternative ways to experience and express these feelings, since their familiar outlets may no longer be available. Perhaps they've had a stroke and can't talk; or they are paralyzed because of a spinal cord injury and can't play golf, work in their garden, or crochet to decrease anxiety, relax, and relieve tension. They may know why they are angry and depressed, but they can't or don't want to talk about it. Words alone cannot reduce the pain and confusion.

In his book, *Flying Without Wings*, Arnold R. Beisser (1989) describes his feelings when he contracted polio, was totally paralyzed and in an iron lung completely dependent on others:

> At times I felt as if I had lost my human qualities and did not belong to the species Homo sapiens any longer – I had become a 'thing'. As an inanimate object, I was in constant need of attention and care from human beings. My most private and personal functions rested in the hands of others ... I had no words that could adequately describe what I felt. I was exposed utterly and completely. I was vulnerable to everyone and everything. Nothing was private; there was only wordless shame for what I had become. (p.33)

All medically ill and physically disabled persons must cope with feelings about the real or perceived threat their illness has made on their lives. Their futures are uncertain, their relationships are traumatized and they recognize their mortality. Consciously, or not, these issues impact their adjustment and recovery.

In addition, certain disabling conditions cause specific problems that further complicate rehabilitation. People with mobility impairments resulting from quadriplegia, paraplegia, hemiplegia, amputation or burns often have to cope with the sudden onset of the trauma, changed body image, sexual dysfunction, and self-blame. Neurologically impaired individuals, with disabilities resulting from strokes, traumatic brain injury and multiple sclerosis, may also be left with expressive and receptive aphasia, memory loss, confusion and impulse control problems. Acute and chronic medical conditions related to diabetes, heart and pulmonary disease and cancer can lead to progressive debilitation, increased pain and sensory deprivation.

Some people have supportive families and friends and the necessary ego strength to incorporate what has happened and move beyond it. If they and their families are provided the resources to process and integrate the

experience, they can make adjustments and return to psychological and physical health. However, a greater majority of the patients we see have pre-existing psycho/social conditions which have often led to and then complicate the treatment of the current medical problem. Therefore, while helping patients cope with their physical illness, we must also consider these complex associated problems, which include chemical dependency, chronic psychiatric histories and dysfunctional family backgrounds.

The Art Studio staff addresses cognitive and physical problems as a part of the rehabilitation treatment team. We work very closely with other team members to increase motor function, improve memory skills and generally improve cognitive and physical functioning. However, most patients are referred and participate in art therapy for psychosocial issues, such as anxiety, depression, anger and pain management and for help in the adjustment process.

Over the years, we have identified specific ways that art making is beneficial for medical/rehabilitation patients whose needs for expression go beyond words. Since they are hospitalized or being treated for medical reasons, they are often not identified by themselves or others as needing to express their feelings or ask for emotional support. The indirect access to their inner world that is available through the art process provides a positive metaphorical alternative. The art making process and resulting creations uniquely meet the psychosocial needs of these patients in the following ways:

- Direct confrontation is often difficult; defenses are necessary and verbal interaction can be threatening. *Art making can be used as an indirect method of confronting difficult issues; as a way to release or transform with or without words.*

- Physical illness, permanent disability and hospitalization require that a person function according to another person's schedule or routine in an environment that is often anxiety producing and unfamiliar. *In the art studio setting, a person can function at his or her own pace within a non-clinical environment that is humanizing and less threatening.*

- It is especially urgent for hospitalized and/or disabled persons to gain control, decide for themselves and take the initiative. *Art making puts action in the hands and control of the patient, as much as possible. The non-scheduled, open studio model encourages self-initiative within the environment or situation which has taken control away.*

- Physically ill persons experience losses, both real and perceived. Everything else in their lives may be limited or narrowing. *Active participation in the creative process offers the opportunity to expand and grow. The resulting creation lasts beyond the moment and has a physical presence outside of the self that reinforces the experience.*

- A medically ill or physically disabled individual feels alone and as if he or she is the only person with these problems. *The shared art experience provides a common ground and the opportunity to make connections with others coping with similar problems.*

- Illness and enforced inactivity makes verbal contact the only form of expression or, in some cases, impossible as an expressive modality. *Art making provides a physical, self-actualizing expressive modality that is not dependent on words.*

- Persons with medical illness, physical disabilities, and depression may have difficulty beginning things and adapting to new situations. *Each art session provides a kind of beginning point in which the adaptive process can be taught or re-learned.*

- Hospitalized and newly disabled or medically ill persons often can't look directly at the disability or illness because it is not acceptable. *The art making process can accommodate the disability or illness and the accompanying feelings, without focusing on them. This process provides the time for adaptation, resolution, and adjustment.*

- Medically ill or physically disabled persons feel out of touch with the self they used to be and the ways they used to respond. *The art process and product reflect the self and provide a way to re-experience the old self and/or to meet the new self.*

- Physically traumatized persons may be wary of any reference to the need for psychological intervention or assistance with feelings about what has happened to them. They may intuitively seek to protect their psyche while their body is in crisis, feeling that people will think their problem is 'in their head'. *A person's association to art can be much less threatening. It can open ways to the development of a therapeutic relationship with the artist/therapist, which can lead to trust and the ability to accept and seek psychological support.*

Studio-based art therapy

The Art Studio's program has been modeled around a studio-art concept. In this creative environment, that is safe and challenging at the same time, the unique abilities of each individual are nurtured and developed. A person is invited and encouraged to rediscover him or herself through and within the art. In an artist's studio, the emphasis is on the action of making art, not on words. This focus is primary to the Art Studio's approach to art therapy. There may be words, though, about how to make the art – for most of our medically ill or physically disabled patients, the initial contact is made through shared engagement in the creative process. It is here that the therapeutic relationship between the artist/therapist and artist/patient and the patient and his or her art begins.

According to Dr George Streeter (in Streeter, Downham and Montonaro 1992), a founder of the Studio, 'art offers uncontaminated opportunity for being yourself; for revealing your identity as a person ... the world of art therapy offers patients a chance to be that utilizes a broader spectrum of opportunity than words alone make available.' By creating art, a person can recreate him or herself with his or her strengths, issues, and solutions. A person, literally and figuratively, has the control in his or her hands allowing necessary defenses to remain intact. The spoken or unspoken words that are evoked by the images and art making process can then be used to increase the potential for change and resolution (McGraw 1995).

This 'broader spectrum' of studio-based art therapy, described by Dr Streeter as 'the chance to be,' has proven extremely effective in helping patients recover from often overwhelming trauma and disease. Art-centered therapy works because it actively engages people along a dynamic continuum that provides a non-verbal contact with the environment. It helps people re-connect with their inner and outer worlds. It can take uniquely personal forms that are concrete and lasting. These forms reflect the creator's ideas and feelings at a time when he or she may be feeling really alone and out of touch. The tactile process with the materials and the emergent images can be transformative for the patient/artist (Kahn in Kahn, McGraw and Myers 1977).

The act of creating is usually a solitary event. In art-centered therapy, the added element of a shared creative experience is significant to the healing. It is not just applying art to another therapeutic modality, which can ultimately make the art secondary and less effective. It is, instead, *letting the experience of making the art create the situation for the healing to occur.* It is a subtle, but

important, distinction within which lies the phenomenon of art-centered therapy. The creative process has inherent therapeutic properties; but art therapists enhance and increase the potential for healing. They can witness, role model, guide, educate, and assist in the development of feeling/doing skills toward self-actualized, individuated, active expressions of 'self'. The physical action of the art making process carries the person, who may be physically or psychologically immobilized, forward into a new way of being.

Using the language and processes of art, the artist/therapist brings his or her own creativity to the relationship and in that way establishes a mutually trusting atmosphere. Studio-based art therapy takes a variety of forms along a dynamic continuum. At one end of the continuum are educative, creative art experiences, which emphasize experimentation, learning new information, developing motor skills and creative thinking. Here the focus is on the physical properties, or the 'form' of the art making process. This includes line, color, balance, texture and overall organization. At the other end of the continuum are expressive art experiences, which emphasize personal expression, the meaning of the symbols and discussion of feelings. This meaning or 'content' of the art may be both latent and manifest. Here, the focus is on the image and its message.

The studio-based model is extended to the various ways we look at artwork, both with the person who created it and with others who view it. Central to assessing, and processing the art products is consideration of the formal design elements of 'healthy' artwork. This includes the quality of line, shape, texture; the evidence of balance, perspective, and organization. Assessing these elements provides valuable information about the person who created the artwork. Often an 'art critique' approach is used to process artwork with individuals or groups. When appropriate, this might include concrete input about artistic and personal strengths or areas of each that need improvement. Metaphorically, as we discuss the artwork, we are thus able to talk about the person and his or her issues, conflicts, and problem-solving abilities. We are able to role model, respect, and validate the effort and the person. By increasing the power of art to reach a person's inner self, we are able to decrease the art therapist's power and the patient's need for his or her direction or approval.

The Art Studio staff attends rounds, receives written referrals, does formal assessments, charts on progress, and schedules patients as needed. However, independent, drop-in use of the open studio is a central focus or goal for all

patients. For instance, a brain injured patient, originally seen on a scheduled basis in his room by one art therapist because of serious memory and behavior problems may later improve enough to participate in a media exploration 'class' taught by a visiting artist in the Art Studio. No appointments are necessary. Families and friends are invited to participate with patients or on their own, if needed and appropriate. In some cases, one art therapist may work with a family member, while another works with the patient. The impact of a traumatic injury or illness on the whole family can be devastating. The father of a child with a severe brain injury described the experience as a 'three year journey out of the deepest psychological hole I ever hope to encounter' (National Head Injury Foundation 1987, p.2). The opportunity to create something for the 'self' in a supportive, non-judgmental environment helps reduce the helplessness, anxiety and anger that many people feel.

There are only two rules in the Studio: a patient can't hurt him or herself or someone else and can't skip a scheduled appointment or therapy. Art skills are taught, if a patient asks for help or is attending a 'class'; if a patient is frustrated or upset with independent efforts; or if a therapist assesses that a new or increased skill would improve the ability for creative self-expression. Art skills are not taught to make pretty pictures or to please the therapist, doctor, or family. The artwork belongs to the person who created it to keep, give away, sell, or even destroy. Matting, framing, and exhibiting are important parts of the Studio experience. Patients are encouraged to sign their artwork, if they are mentally competent and wish to be identified. This recognition and ownership is an integral component of the studio-based therapeutic process (McGraw 1995).

The art in therapy

Whether patients are involved in art experiences that are directed at learning new skills or finding ways to express painful feelings, the journey begins with involvement in the art-making process. For some individuals with severe physical limitations or immobilizing depression, the involvement may at first be passive. A 40-year-old father of three who loves fishing with his son, but is now a quadriplegic, may watch and guide the art therapist as she or he paints a favorite fishing scene from the patient's memory or a photograph. Or a newly disabled 67-year-old may learn to use her non-dominant hand by working in clay to create a bowl, with the art therapist at first being her hand.

As artists/therapists, we draw upon our own studio work, art training, and the rich history of artists through the ages as resources to help patients begin their journeys. In the Art Studio, we have used the following approaches to introduce new ideas; break down resistance expressed as 'I can't draw;' and provide concrete examples of ways to take the first step.

The lives of artists are used as examples of how professional artists have used their creativity to help them through difficult life situations. For example, Matisse created an innovative body of work at the end of his life when arthritis and poor vision severely limited him physically. Contemporary artist, Chuck Close, now a quadriplegic, not only developed creative adaptive devices so he could continue to paint, but also an exciting new approach to his portrait work. Elizabeth 'Grandma' Layton used her late-in-life discovery of contour drawing to help heal a severe depression that had incapacitated her for decades.

The images of artists are used to show how unique each person is and to emphasize that there is no right or wrong in art. O'Keeffe chose her own path as seen in the unique vision of her flowers and New Mexican landscapes. Monet and Mondrian both began as classically trained realists, but their art work and careers took very different expressive routes. Picasso's body of work is rich in examples of the variety of ways we look at the world.

The techniques of artists are used to reduce fears and feelings of inadequacy by providing examples of the rich world of art beyond realistic drawing and painting: watercolor techniques such as resist and wet paper methods; collage art including tissue, magazine and found objects; printmaking ranging from wood and linoleum cuts to vegetable, styrofoam and monoprints; and various three dimensional art forms using paper mache, plaster, wood scraps and found objects. A core part of the Studio's program are demonstrations of these techniques by guest artists-in-residence. They not only show examples of their own work, but do hands-on workshops with art therapy staff and patients.

All of these examples are integrated and interchanged in a model that combines exploration with education. Participation is geared to the patient's particular need relevant to his or her interests, abilities, and treatment goals. Prints of artist's work, books about their lives, large-print quotes and actual examples of various techniques are available and exhibited in the Studio and in patients' rooms. Sessions may be individual or group and may take place in the Art Studio or at a patient's bedside.

With art as the foundation, patients are also guided in directed creative experiences that focus on specific issues or treatment goals. Table 11.1 sets out a few examples that we have used in our program.

Table 11.1	
Art Therapy Experience	Goal
1. *Draw a picture of:* A person; yourself; your family doing something; or anything that will tell more about you. *Media:* Pencils, markers on paper.	1. To evaluate a person's functional, developmental, cognitive, artistic abilities; to establish a baseline; to help set goals for future sessions.
2. *Do a collage using:* pictures and/or words from magazines; family photos brought from home; scraps of tissue/construction paper torn or cut to make a picture that tells something about you, things you like, colors that please you, etc. *Media:* Magazines, paper, cardboard, scissors, glue.	2. To encourage personal expression; de-emphasize drawing/technical skills for persons insecure/unable to draw; focus on creativity, uniqueness of each person, and personal choice; to assess/work on organization, ability to follow directions, etc.
3. *Pass the portrait:* Begin a picture of yourself; pass it to your left when the group leader directs you to do so; then work on the portrait of the person who's picture you have; continue to work on each one until your picture returns to you; change or leave your picture as you wish. *Media:* Markers, pastels, watercolors, colored pencils, paper.	3. To encourage group interaction/cohesiveness; to decrease anxiety about drawing skills by allowing each person to do as little or as much as they are able; to introduce, in a non-threatening way, techniques of drawing; to promote cooperation and communication through portrait making and follow-up discussion.
4. *Do a picture of:* Self in the past, present and future, using a large sheet of paper, divided equally into thirds; present must be right now, but past and future can be immediate or distant. *Media:* pencils, collage, paint, whatever appropriate for individual or group.	4. To assess how a person views self/disability/adjustments; what is most important – is a person looking forward, backward; is one aspect of life fuller than others; to use in goal setting with patient; to assess progress in adjustment to disability through pre/post treatment drawings.

5. *Create a mask*: One showing the face seen by the world and one showing the face covered by that mask. OR *Create a portrait*: One of the faces seen by the world and one, as if seen by an x-ray, inside your head – your thoughts, feelings, etc. *Media*: Clay, paint, drawing, whatever appropriate for individual or group.	5. To help uncover feelings/thoughts not easy to express; to encourage personal expression; to validate inner and outer worlds; to assess conflict areas, congruence, depression and/or blocked feelings; to increase skills with various media.
6. *Create a monoprint*: Paint a picture – realistic or abstract on a piece of glass. While wet, lay paper on glass, rub back of paper and pull off 'print.' *Media*: Oil or waterbase printing ink and print making paper; glass.	6. To teach new medium; to provide opportunity to learn new information; to improve sequencing and motor skills; to increase self-esteem through sense of accomplishment; to increase independent functioning.
7. *Create yourself as an animal*: Paint, draw or use clay to make yourself as an animal; think about characteristics you admire, think you have or would like to have. *Media*: Whatever appropriate for individual or group.	7. To assess/encourage ability to symbolize/abstract; to promote ability for representative art making; to promote expression of positive/negative qualities of self.

Patients as artists

The value of art therapy for medically ill and physically disabled patients is best understood through the images and words of a person who has participated in our program. Ann's experience with the Art Studio dramatically demonstrates the ways a studio-based program can respond to a wide range of individual needs. Ann was referred to our outpatient brain injury program in 1993. Though Ann had used art and poetry throughout her life to cope with a chronic illness, she was severely depressed and had not been able to create any artwork in many years. In her own words:

> I have had a brainstem tumor since birth; but it went undiagnosed and misdiagnosed until I was 18. This caused me much trauma and despair. Numerous medical problems arise from my tumor. I have seizures, double vision, partial deafness, debilitating vertigo illness with accompanying nausea, fibromyalgia syndrome, sensory anomalies, hydrocephalus, daily headaches, TMJ dysfunction and chronic fatigue. I have had over 60 surgeries and procedures in my lifetime, constant pain, and the social

isolation this imposes brings almost constant anxiety and a battle with depression.

Her isolation and depression were immobilizing. As her poem 'What's Bothering Me?' graphically indicates, Ann knew she needed help:

> My doctor tells me
> To write about
> What's bothering me
> But
> How do I
> Write about
> Some terrible feeling
> Down in the pit
> Of my heart
> That has no words
> Awful enough
> To describe
> What's bothering me?

Since so much of her life was focused on illness, Ann and her art therapist, Ky Wilson, decided to focus on her strengths and interest in art. They balanced their sessions between discussion of self-initiated artwork, directed at personal reflection and the study of art history and media exploration, directed at the development of new skills. Thus Ann could make use of the 'broad spectrum' of studio-based art therapy moving toward an identification with the 'healthy' artist in her, not the 'sick' patient. Though the art therapy session was a time when any problem or issue could be discussed, the focus always led back to art making with its inherent, positive potential for self-discovery, renewal and resolution.

Ann's reflective artwork was usually created at home and brought into the Studio to process with Wilson. These generally small, 8" × 11" mixed media works seemed to serve as vehicles for expressing, releasing, and confronting the pain and the extreme feelings of isolation that illness can bring (McGraw 1995). Figure 11.1, 'On the Inside Looking Out,' is one of Ann's graphic expressions of this isolation and alienation:

> I get so frustrated sometimes as to how to deal with my loneliness, isolation, and ostracism. Not being included is so painful. Often, it is more painful than my physical pain. How do I cope best? Do I stop

Figure 11.1 'On the Inside Looking Out'

looking out of the window or do I break the glass and join them? Is my isolation due to their intolerance or from my fear?

The terror of living a life in which dissociation is a main defense against severe physical and emotional trauma and against people who don't understand, is often the subject of these works. In Figure 11.2, 'The Weight of My World,' Ann powerfully depicts this terror:

> I sometimes get scared that the only reason I'm still alive is because I'm so feisty and stubborn. I fear someday I won't be strong enough to be feisty and stubborn. And then what will happen?

Ann's frustration and anger, at people and at God, are seen in Figures 11.3 and 11.4. 'I Can't Make Up My Mind,' Figure 11.3, is also called 'Yes or No Chaos':

> My mind/spirit always wants to say 'yes!' to activity and life and learning. My body always wants to say 'no!' Whatever I do has to be worth getting sick over. Sometimes I tell God, 'why did you give me such an active mind with such a disabled body?'

Figure 11.2 'The Weight of My World'

Figure 11.3 'I Can't Make Up My Mind'

In response to people's questions about where she hurt, Ann created 'I'm Wired All Wrong All Right,' Figure 11.4:

> I tell them I hurt all over, but they never seem to get it. So out of frustration I made this to show everybody where I hurt – ALL OVER!

The act of giving both form (the image) and content (the meaning) to these feelings gradually seemed to reduce their power and place in her life. The recurring themes and focus on her body, pain, isolation, and patient role began to give way to her real enthusiasm for art, learning relationships and life. In addition, the rich environment of the Art Studio's setting provided a wealth of materials that Ann used to create highly individualistic artwork as seen in the wire collage depicting her 'hurt' in Figure 11.4.

Figure 11.4 'I'm Wired All Wrong All Right'

Though Ann's health no longer permitted her to attend college, she and her art therapist explored major periods in art and selected painting styles to recreate through watercolors and acrylics. As she studied the various styles of these artists and their unique vision of the world, she grew both in her understanding of people and in her confidence as an artist. In Figure 11.5, 'Reality', Ann graphically explores the styles of art she has studied and is able to look at, acknowledge, and honor our similarities and differences:

> It intrigues me how we are so different but so similar at the same time. I wanted to represent this somehow. I cannot pretend to know or judge how life is or has been for another. I can only validate and respect them as they are.

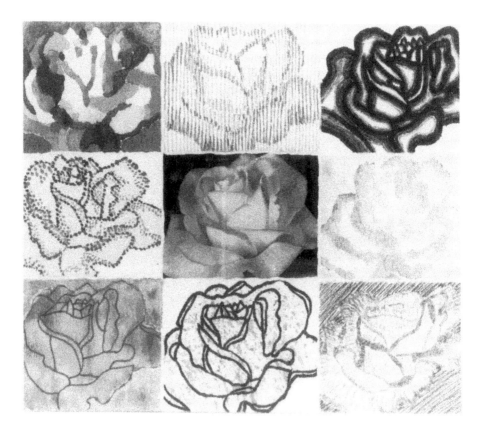

Figure 11. 5 'Reality'

This opportunity to expand beyond the boundaries of her illness and the limits it placed on her was affirming, integrating, and ego building. Her artwork began to reflect her increasing art skills and she was ready to take a big step. Ann had long felt inadequate in her ability to create realistic artwork. Coupled with the feelings of personal inadequacy that accompanied her chronic medical problems, she struggled in her efforts to create a painting from reference and not her imagination. With support from her art therapist, Figure 11.6, 'Ice on Fire', emerges as a break through painting of which she is very proud. A polar field of icebergs at sunset, it is intense in color and rich in reflected reds and oranges.

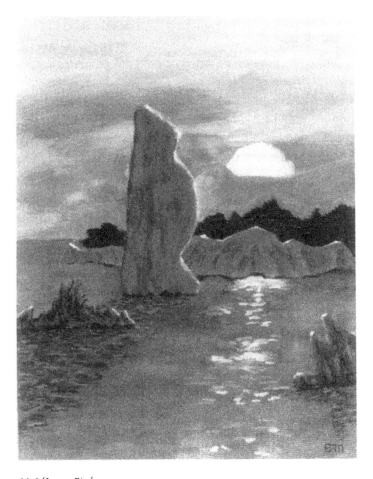

Figure 11.6 'Ice on Fire'

Though Ann usually wrote about her artwork, it wasn't until many months later that she was able to talk about this experience. She chose the subject because she was fascinated with the dichotomy of the sunset's fire on the field of icebergs. She had great anxiety at the beginning of the painting, which she described as 'being terrified at attempting something she hadn't done in almost 20 years.' She started the work in the Art Studio, but completed it at home only after sorting through the feelings, which were the source of her anxiety. Like the icebergs, she said 'they were 90 per cent below the surface.' She realized that she was pressured by her own and other's expectations; by fears about her ability to adequately mix colors; and by her inability to control the outcome. She recognized the connections between these fears and other parts of her life and, with this awareness, 'it all began to come together and the fear left. I realized if I trusted the process, I could do it and the rest was easy.'

Along with Ann's articulate observations, the painting itself speaks eloquently and personally to each of us. It is rich in metaphors about her journey: the treacherous navigation through the icebergs; the strong intersection/meeting of two massive ice forms, one laid flat and the other erect and reaching upward; the struggle between the extremes of fire and ice/health and sickness; and the sunset perhaps giving promise of a passage from old to new ways. In Ann's own words:

> Life keeps happening. Art helps me bring all this emotion and conflict to the surface (literally) where I can begin to make sense of most of it and learn how to deal with the utter senselessness of the rest.

Conclusion

Though the presenting diagnoses and personal stories of the medically ill and physically disabled persons with whom I have worked have differed greatly, each has shared the common need to cope with a traumatic event. Each has struggled to make sense out of a life changing experience and to integrate his or her inner and outer worlds. Words alone cannot reduce the pain and anger that is caused by these events. Even individuals whose physical and cognitive conditions make words possible, find them inadequate. 'I had no words that could adequately describe what I felt ... there was only wordless shame for what I had become' (Beisser 1989, p.33).

Individuals facing serious illness and physical disabilities must find ways to face these complex feelings. Consciously or not, these issues effect their

adjustment and recovery. Active engagement in the creative process provides physical movement and psychic passage toward reconnecting the old and new 'self.' When the artist/patient shifts his or her attention and focus onto the action of the art making, the unconscious and unspoken feelings can take form in the artwork or find release through the process itself. The experience is uniquely personal, lasts beyond the moment, and is multidimensional in its ability to meet individual needs.

A studio-based approach to art therapy provides the creative framework upon which the therapeutic relationship can be built. The emphasis is on the image and the process. Words are used to teach the process and enhance or elaborate on the outcome. The balance, order, and formal elements of art are used to help ground or stabilize the artist/patient. The physical environment is structured to encourage media exploration and physical independence. Step-by-step examples and creative problem solving are a part of the artist/patient/therapist interaction. An atmosphere of positive expectation is balanced with constructive role modeling of the discipline needed to create a work of art.

With the significant decrease in hospital length of stay and insurance coverage for out-patient services, it is even more important to provide creative programs that empower patients and help them gain both coping skills and access to alternative therapeutic services. Many of the people with whom we work face life long disability and chronic illness. Adaptation, resolution, and adjustment takes time. Art making, and the positive gains that can come from the experience, returns control to the patient's hands, literally and figuratively.

Ann's creativity, intelligence, and drive have resulted in an exceptional body of work. Her words and images speak to the healing power of the creative process and the Art Studio's purpose for being. I am deeply appreciative of her generosity in letting me tell her story. Just as she had her needs met through her involvement in the Studio's program, so too have many others. Unlike Ann, however, many of these people will never do another watercolor, collage or ceramic bowl. But they will give what they created to someone they love or hang it over their fireplace at home. It will continue to represent their potential and their ability to find ways to cope with an impossible event. They will remember that they and their artwork were valued even when they couldn't find value in themselves. I know how important this is, because they and their families have told me. Following his discharge, a patient wrote about his feelings:

Your art program recaptured for me a spirit that has been too long dormant and I can never thank you enough for your smiles, your conversation, your encouragement, and your skill in letting me concentrate not on worry, but on those things, which might help my recovery.

Acknowledgements

The author wishes to acknowledge Dr George Streeter and all current and past Art Studio staff for their individual and collective contributions to the Art Studio and the people it serves.

References

Beisser, A.R. (1989) *Flying Without Wings*. New York: Doubleday.

Kahn, K., McGraw, M.K. and Myers, L. (1977) 'A pioneering art therapy program at Highland View'. *Cuyahoga County Hospital Foundation – Quarterly*, 17–20.

McGraw, M.K. (1989) 'Art therapy with brain injured patients'. *American Journal of Art Therapy 20*, 37–44.

McGraw, M.K. (1995) 'The Art Studio: A studio-based art therapy program'. *Art Therapy: Journal of the American Art Therapy Association 12*, 37, 167–174.

National Head Injury Foundation (1987) *Testimony before the Senate Appropriations Subcommittee on Labor, Health and Human Services, Education and Related Agencies – 100th Congress, 1st session*. Washington, DC: NHIF.

Streeter, G., Downham, T. and Montonaro, D. (1992) 'The Art Studio-center for therapy through the arts: A historical review'. *25th Anniversary Historical Catalogue*. Cleveland, OH: The Art Studio.

Resources

American Art Therapy Association (AATA)
1202 Allanson Road
Mundelein, IL60060
847/949-6064
web page: http://www.arttherapy.org; e-mail:arttherapy@ntr.net

Australian Art Therapy Association
PO Box 303
Glebe
New South Wales 2037

British Association of Art Therapists (BAAT)
1 Holford Road
London NW31AD

Child Life Council
11820 Parklawn Drive
Suite 202 Rockville, MD 20852-2529 301/881-7090

Dutch Association for the Creative Therapies (NVKT)
Fivelingo 253, 3524 BN
Utrecht
Netherlands

International Arts Medicine Association(IAMA)
714 Old Lancaster Road,
Bryn Mawr, PA 19010
610/525-3784
web page: http://members.aol.com/iamaorg

International Association for Art
Creativity and Therapy (IAACT)
Rumelinbachweg 20
Basel
Switzerland 4054

International Expressive Arts Therapy Association (IEATA)
PO Box 64126
SanFrancisco, CA 94164
415/522-8959

Japanese Art Therapy Association
3600 Handa-cho
Hamamatsu, University School of Medicine
Dept. of Psychiatry
Hamamatsu, Japan 431

Japanese Society for the Psychopathology of Expression
91 Benton-cho
Shinjuku-ko
Tokyo, Japan 162

Korean Art Therapy Association (KATA)
2288 Daemyung-dong
Taegu, 705-033, Republic of Korea

L'Association des Art-Thérapeutes du Quebec, Inc.
5764 Avenue Monkland
Bureau 301
Montreal
Quebec H4A 1E9

National Art Therapy Association of Canada
1561 Gloucester Road
London
Ontario N6G 2S5

Journals

Art Therapy: Journal of the American Art Therapy Association; available from the AATA, 1202 Allanson Road, Mundelein, IL 60060; 847/949-6064

American Journal of Art Therapy, Vermont College of Norwich University, Montpelier, VT 05602

The Arts in Psychotherapy (formerly *Art Psychotherapy*), Elsevier Science Inc., 660 White Plains Road, Tarrytown, NY 10591-5153

International Journal of Arts-Medicine, MMB Music, Inc., 3526 Washington Avenue, St. Louis, MO 63103; 800/543-3771

Web Sites

Arts for Health in the UK
http://www.artdes.mmu.ac.uk/arts4hth.htm

A national center for advice and information about using the arts in health care and links to other related sites.

Foundation for Hospital Art
http://www.hospitalart.com
A site devoted to painting hospital walls with the help of volunteers worldwide.

Society for the Arts in Healthcare (SAH)
http://www.societyartshealthcare.org

An organization formed in 1991, dedicated to promoting the arts as an integral component of health care. SAH assists in the development and management of arts programs in health care settings and encourages research into the beneficial effects of arts in health care.

The Contributors

Susan Ainlay Anand, MA, ATR-BC, is a Clinical Instructor in the Department of Psychiatry and Human Behavior at the University of Mississippi Medical Center in Jackson, and specializes in art therapy with medically ill and psychiatric patients.

Vinod K. Anand, MD, is Chief of Otolaryngology (Department of Surgery) at the University of Mississippi Medical Center. His special interests include reconstructive surgery for head and neck cancers. He is the author of numerous publications and textbook chapters, and a fellow of the American College of Surgeons, American Academy of Otolaryngology Head and Neck Surgery, and the Society of University Otolaryngologists.

Paul M. Camic, PhD, is an Associate Professor and Director of Health Psychology Training and Director of a new program in Applied Creative Arts at the Chicago School of Professional Psychology. He has previously been on the faculty of Northwestern University Medical School (1989–1996) and served as Director of Behavioral Medicine, University of Chicago (1985–1989).

Holly Feen-Calligan, MAT, ATR-BC, is the coordinator of the art therapy program at Wayne State University, has worked with chemical dependency patients since 1983, and gives frequent lectures on chemical dependency and other topics. She is a PhD candidate at the University of Michigan and is an art therapist on the academic research unit at the Detroit Medical Center.

Shereen Ilusorio, MA, ATR-BC, is an art therapist at Bellevue Hospital Center in New York City and specializes in traumatic brain and rehabilitative medicine.

Vija B. Lusebrink, PhD, ATR-BC, is a Professor Emerita of the School of Allied Sciences, University of Louisville, Kentucky. She has been an art therapy educator for over 23 years and has published numerous articles on imagery and art therapy.

Mary K. McGraw, MA, ATR-BC, is the Clinical Director of the Art Studio-Center for Therapy through the Arts, which she co-founded in 1967 at MetroHealth Medical Center in Cleveland, Ohio. She has pioneered the use of art therapy with medically ill and physically disabled persons for more than 30 years. She currently directs a graduate clinical training program in art therapy at MetroHealth and has a special interest in a studio-based approach to art therapy.

Virginia M. Minar, MS, ATR-BC, recently retired from her private practice. She has been an art therapy instructor at Alverno College and Mount Mary College, Milwaukee, Wisconsin. Previous to her work with cancer patients, Virginia worked for fifteen years as an art exceptional education teacher/therapist with the West-Allis Milwaukee School District. She is a past president of the *American Art Therapy Association* (1995–97).

Emily Piccirillo, MA, ATR-BC, is an art therapist who has worked with people living with AIDS since 1990 and now works with the Family Ties Project, Washington, DC, providing art therapy for children who are infected and affected by AIDS. She is also is the art therapist for a special education elementary and middle school in Landover, Maryland.

Shirley Riley, MA, MFT, ATR, is a family therapist and clinical art therapist and has been a faculty member of Loyola Marymount University and Pepperdine University. She is a recognized expert in the field of family art therapy and has given presentations on family art therapy throughout the US, Canada, Europe and Asia.

Irene Rosner David, MA, ATR-BC, has practiced medical art therapy since 1973 working with a broad range of physically ill and disabled adults. She is the Director of Activity Therapy at Bellevue Hospital Center in New York City, and is currently pursuing a doctoral degree, studying the relationship between art and neurological processes.

Ellen Urbani Hiltebrand, MA, ATR-BC, is an art therapist and coordinator of *Healing Arts*, an organization designed to provide art therapy services to healthcare organizations. She also works at Legacy Health System in Portland, Oregon, integrating art therapy into their cancer rehabilitation program.

Judith Wald, MS, ATR-BC, is an art therapist at New York Presbyterian Hospital, White Plains, New York and an Assistant Professor of Art Therapy at College of New Rochelle, New York. She has developed art therapy programs for psychiatric patients, neurologically-impaired individuals, Alzheimer

patients, stroke victims, and geriatric populations. Judith is the author of numerous chapters and journal articles, serves on the Editorial Board of *Art Therapy,* and has presented workshops and seminars in the US, Canada, and Europe.

Subject Index

AA (Alcoholics Anonymous) 137, 145, 157

AATA (American Art Therapy Association) 13, 50, 139

Acquired Immune Deficiency Syndrome (AIDS) see AIDS/HIV

ACTH (adrenocorticotropic hormone) 119

Acute pain 43

ADL (activities of daily living) 34, 35

Adrenocorticotropic hormone (ACTH) 119

Agnosia (objects, recognition problems) 27, 33, 34

AIDS/HIV
awareness about 163
dementia 167
effect on society 163, 183–184
health professionals, special skills needed 176–177
multigenerational impact 165
myths 166
neurological complications 167
people affected 164–165
physical effects 164, 167
related illnesses 164, 165–166
transmission 164
tuberculosis 166, 190
women 165
see also PLWAs (People living with AIDS)

Alcoholics Anonymous (AA) 137, 145, 157

Alexithymia 89, 93

Alpha brain wave patterns 18

American Art Therapy Association (AATA) 13, 50, 139

American Psychological Association 50

American Thoracic Society (ATS) 189, 190, 204

Amnesty International USA 10

Animals imagery
AIDS patients 179, 180
brain tumor victim 236
sandtray therapy 96, 97, 99, 103, 104, 105
tuberculosis patients 197

Aphasia (language problems) 27, 29, 33, 245

Apraxia (movement difficulties) 27, 34

Art expression
acceptance benefits 247
adaptation benefits 247
in AIDS patients 166–167, 172, 177–186
awakening benefits 19
as basic human need 51
belonging benefits 183–184
in cancer patients 15, 124–129, 239–240
communication benefits 180–181
control, regaining through 16, 117–118, 122, 246
emotions, and 15, 124–131
enjoyment benefits 145, 147, 181–182
enlightenment in drug addiction treatment 144–149
in families 213–215
guided mental imagery, and 51–52, 54, 55
hopelessness and helplessness feelings, reducing through 124–129
interpersonal relationships 16–17
as legacy 184–185, 240–241
mastery benefits 16, 178–179, 192
metaphors, use of 88, 143, 175
as mind-body intervention 17–18
non-clinical benefits 246
non-verbal process, art as 15–16, 245–246, 247, 248
opening up benefits 14–16
as personal empowerment 16–17

relaxation response 18, 87
search for meaning 186
self-growth 16–17, 247
sharing benefits 247, 248
somatic changes, conveying of 19
symptom management, and 17–18
therapists, relationships with 247
transformation and transcendance 19–20
in tuberculosis patients 192, 193, 207
see also Expressive arts; Imagery; Interventions, art therapy
Art interventions see Interventions, art therapy
Art therapy see Art expression; Interventions, art therapy; Medical art therapy
Art Therapy/Addiction Counselor (AT/AC) Network 139
Art-based assessments colours 35
copy a geometric shape 33
draw a clock 33
free choice paintings 35
laryngectomy patients 79–80
self-portraits 34–35
silver stimulus cards 35

stroke survivors, assessment of abilities 33
see also Interventions, art therapy
Artists, role in art therapy 251, 253–260
Arts
as healing agents 9–10
visual 10
Arts-Medicine movement 11
AT/AC (Art Therapy/Addiction Counselor) Network 139
Ataxia (failed muscular co-ordination) 27
ATS (American Thoracic Society) 189, 190, 204
Axial coding, grounded theory analysis 143, 144

BDI (Beck Depression Inventory) 52, 56
Biofeedback 17
Brain infarctions 26
Breast cancer 15, 89
see also Cancer; Sandtray therapy, mastectomy patients
British Association of Art Therapists 191

Cancer
art therapy benefits 13, 15, 63–85, 123–129, 227, 239–240

breast cancer patients, sandtray therapy and 89–109
causes 113–114
cervical carcinoma 166
complementary therapies 87
diagnosis implications 63, 66, 87
dreams, remembering 89
emotions 89, 100, 114–116
families, effects on 68–69, 219–220
hopeless/helpless affective state 116–118
reducing through art therapy 124–129
hormones 119
imagery in healing 17, 227–241
journal entries 228, 235
Kaposi's sarcoma 166
lymphomas 165
melanoma patients 115–116
metastasis 119
opening up, effect on survival 15
personality of patients 89, 113, 114
pyschoneuroimmuno-logy 118–121
stress connection 87, 113, 114, 120–121
see also Chemotherapy; Radiation treatment
Candidiasis 165
CBT
(Cognitive-behavioral

therapy) 18, 47, 50, 57, 215
Centers for Disease Control (CDC) 164, 165, 166, 190, 204
Cerebrovascular accident (CVA) see Strokes
Cervical carcinoma, invasive 166
Chakra meditation 233–234
Chemical dependency see Drug addiction
Chemotherapy
 breast cancer patients 91, 96, 97, 102
 laryngectomy patients 63, 66
 medical art therapy, benefits 13, 15
 short-term survival 116
 tuberculosis 189
Chicago, Open Studio Project in 58
Christianity 233, 237, 240
Chronic pain
 benign 44
 biopsychosocial aspects 45–47
 cost to society 44
 defined 43–44
 expressive arts, role in pain management 47–56
 Gate Control Theory 46
 life-threatening illnesses 44
 mind-body connection 45
 psychoanalysis 45

'search and cure' strategy, not applicable to 44
stimulus-response model 45
see also Acute pain
Coccidioidomycosis 165
Coding procedures, drug theory 140–144
Cognitive-behavioral therapy (CBT) 18, 47, 50, 57, 215
Colour therapy 35, 99–100, 231–234
Complementary therapies 87
 art therapy as 17–19, 138
Constructional apraxia 27
Consumption see Tuberculosis
Content analysis research method 56
Control over illness 16, 117–118, 122, 246
Corticosteroids 119
Creative activity, medical benefits 18–19
Cryptococcosis 166
Cryptosporidiosis 166
CVA (cerebrovascular accident) 25
C.W. Koop Center (1998) 18
Cytomegalovirus 166

Dementia 16, 167
Depression
 AIDS 167, 168
 laryngeal cancer 66, 67–68, 84
 laryngectomy patients 63, 66, 67–68, 84

Serotonin, drug for 18
strokes 27–28, 29
tuberculosis 192, 193
see also Emotions; Stress
Directly Observed Therapy (DOT) 190, 191
Disabled people, art therapy and 243–262
Dreams
 Carl Jung, work of 13
 emotions 88, 108, 123
 function 87–88
 in healing 17
 prodromal 88
 recalling of 88, 89
 recurrent 88
 repetitive 88
 somatic changes and illness 88–89
 surgery 88
 traumatic 88
 women 88
 see also Imagery; Sandtray therapy
Drug addiction
 AIDS 168, 181
 art interventions 149–152
 benefits of art therapy 138, 154–157
 enlightenment in art therapy 144–149, 157–159
 'grounded theory' 138–144
 intervening conditions 153–154
 public health problem 137–138
 tuberculosis 190, 193
Dysarthia (difficulties in pronunciation) 27, 30

Emotions
 art expression 15,
 124–131
 cancer patients 89, 100,
 114–116
 dreams and images 88,
 108, 123
 fight or flight response,
 AIDs patients 175
 and imagery 123
 increasing expression
 through art therapy
 129–131, 132, 138
 opening up 14–16
 stroke patients 27–30
 suppression of 89, 100,
 114–116, 123
 see also Depression;
 Stress
Encephalopathy 166
Enlightenment, drug
 addiction treatment
 144–149, 157–159
Existential philosophy,
 role in pain
 management 51
Expressive aphasia 27
Expressive arts, role in
 pain management
 art making as human
 need 51
 case studies 49–56
 cognitive-behavioral
 therapy 18, 47, 50
 existential philosophy
 51
 imagery 51–52, 54–55
 meditation 50–51, 53,
 54, 55
 music 47, 48–49, 54,
 55
 research methods 56
 visual arts 47–48, 53

 writing 47, 48, 54, 55
 see also Chronic pain

Fairhill Center for Aging
 244
Families, effects of illness
 benefits of art therapy
 212–215, 223–224
 developmental stages
 213, 217–220
 medical assistance,
 beliefs about
 220–221
 theoretical approaches
 to therapy 215–217
Feeling Thermometers 93,
 102

Gate Control Theory
 (GCT), chronic pain
 46
Gestalt therapy 96
Glottis 65
Grounded theory, drug
 addiction 138–144
 art as healing 143
 axial coding 143, 144
 data collection and
 analysis 139–144
 health care changes 143
 open coding 140–143
 selective coding 143
 spectrum disease 141
 treatment programs 141
 underlying turbulence
 141
 in vivo codes 140–141
 waves metaphor 143
Group work, art therapy
 38–41, 83

Hemiparesis (weakness)
 27, 34

Hemiplegia (paralysis) 27,
 34, 245
Hemorrhages 26
Herpes simplex 166
Hinduism 240
Histoplasmosis 166
HIV (Human Immune
 Deficiency Virus) see
 Aids/HIV

Imagery
 abstracts 220
 AIDS patients, artwork
 of 173, 185
 angels 94, 98, 185, 230
 body image 70, 199,
 200, 203
 bridges 102, 104, 106,
 121
 butterflies 241
 cancer patients
 bonding 238
 hurter and healer 17,
 227–241
 image manipulation
 121–132
 sandtray therapy
 89–109
 clocks 185
 drug treatment, role of
 art therapy 149
 emotions 88, 108, 123
 fruit 197
 heart symbol 236
 landscapes 196, 219
 light 89
 masks 202–203
 metaphorical 88, 143,
 175, 219, 230
 mind-body
 communication 89
 multileveled 19, 89, 90,
 108

nature 196, 197–198, 219, 232
pain management 51–52, 54–55
psychological and physiological states, revealing of 123
religion 233, 237, 240
roads 71, 194
role in treatment of illness 13, 17
sandtray therapy, role in 89–90, 91, 92–109
sea creatures 73, 103, 105, 230, 232
serpents 103, 232–233
skeletons 170, 200
spotted motif 194
symbolic 90, 123, 149, 197
TB bacillus 194
vehicles 102–103, 106, 194
war zones 217, 235
see also Animals imagery; Art expression; Chakra meditation; Dreams
Immune system
corticosteroids 119
expression of emotions 116
images 91, 122
pyschoneuroimmuno-logy 118
and relaxation response 18, 87
stress 87, 113–114, 120–121
International Association for the Study of Pain 43
Interventions, art therapy

AIDS patients 174, 175, 176–186
art skills, teaching of 250, 251
biopsychosocial system theory 216
for cancer patients 124–132, 227
see also Sandtray therapy, mastectomy patients
clay work 39, 53, 183, 206, 250
cognitive/behavoral approach 18, 47, 50, 215
collages 55, 126, 174, 214–215, 251, 257
color-feeling wheel 129–130
crafts 37
drawing materials 53, 75
drug addiction treatment 149–159
exhibiting 250
family structures 82–83, 212–224
folded painting 183
framing 250
group work 38–41, 83
ink-string process 228
laryngectomy patients 79–83
matting 250
modeling 181
murals 184
patients as artists 253–260
printmaking 183, 251
social constructionist theory 216

solution focused approach 215
spin-art 183
stroke survivors 36–38
studio based 20, 58, 243–244, 246, 248–262
systems approach 215
three-dimensional art forms 251
for tuberculosis patients 13, 191–207
watercolor techniques 37, 251
see also Art expression; Art-based assessments; Imagery; Post-stroke rehabilitation; Sandtray therapy, mastectomy patients
Intracerebral hemorrhages 26
Isosporiasis 165

Judaism 240

Kaposi's sarcoma 166
Karma, Laws of 240

Laryngectomy patients
anatomy 65–66
art intervention 79–81
cancer symptoms 66
chemotherapy 66
depression 63, 66, 67–68, 84
family, effect on 68–69
hemilaryngectomy 66
immediate postoperative period 67
laryngectomy defined 63

laser surgery 66
Lost Cord Clubs 83
partial laryngectomy 66
preoperative period
 66–67
art session 80
pychological aspects 63,
 66–69, 84
radiation treatment 63,
 66, 68, 84
recurrence of cancer 68
rehabilitation 67–68,
 81–82
supraglottic
 laryngectomy 66
tobacco and alcohol use
 64
see also
 Post-laryngectomy
 art therapy
Larynx 63, 65
Left brain hemishere,
 strokes and 28, 30
life-threatening illness see
 AIDS/HIV; Cancer;
 Tuberculosis
Love, healing power of 10
Lymphomas 165

Malignancy see Cancer
Mastectomy patients see
 Sandtray therapy,
 mastectomy patients
Medical art therapy
 as complementary
 therapy 17–19, 138
 defined 13
 see also Art expression;
 Art-based
 assessments;
 Interventions, art
 therapy;
 Post-laryngectomy

art therapy;
 Post-stroke
 rehabilitation
Meditation 50–51, 53,
 54, 55, 233–234
Metempsychosis 240
MetroHealth Medical
 Center, Art Studio at
 20, 243–244, 246,
 248–262
Mind-body connection
 art therapy 17–19
 chronic pain 45
 imagery 89, 121–122
 personality factors 113
 psychoneuroimmuno-
 logy, cancer patients
 118–121
 stress and disease 87,
 113–114, 120–121
Mindfulness meditation
 50–51, 53, 54, 55
Multidimensional Pain
 Inventory (MPI) 52
Multifocal
 leukoencephalopathy,
 progressive 166, 167
Multiple sclerosis 245
Music, role in pain
 management 47,
 48–49, 54, 55

National Head Injury
 Foundation 250
National Institutes of
 Health 17
NEO Personality
 Inventory, Openness
 factor 90
Neuroendocrine system
 119
Neurological impairment
 167, 245

New York City, TB in
 190, 192–193

Oncology
 psychoneuroimmuno-
 logy, and 118–121
 see also Cancer
Open coding, grounded
 theory analysis
 140–143, 142
Opening up, art
 expression, and 14–16

Pain see Acute pain;
 Chronic pain
Paraplegia 245
Personal empowerment,
 art expression as
 16–17
PLWAs (people living
 with AIDS)
 AIDS as wrath of God
 171, 172
 anger and frustration
 172–173, 173
 artwork 166–167, 174,
 175, 177–186
 blame 171–172
 demographics 164
 denial 170–171, 179
 deprivation 164,
 182–183
 embarrassment
 171–172
 fear 173–175
 guilt 171–172
 newly diagnosed 164
 psychosocial effects
 163, 168–169
 secrecy 169–170
 sexual exploitation 181
 shame 171–172
 street habits 182

uncertainty 173–175
see also AIDS/HIV
Pneumocystis carinii 165
Pneumonia 165
Poetry as therapy 48,
54–55, 228–229,
231, 239
Post-laryngectomy art
therapy
art materials 79
case examples 69–79
communication
problems 84–85
family sessions 82–83
group approaches 83
postoperative sessions
80–81
pre-operative sessions
80
rehabilitation 81–82
special requirements for
health professionals
63–64
team approach 79
treatment goals 81
see also Laryngectomy
patients
Post-stroke rehabilitation
art therapy
benefits 28
goals 36
right hemisphere
lesions 32–33
sessions 36–38
case examples 39–41
group work 38–41, 39,
40
moderate strokes,
survivors of 26
psychological issues,
working through 28
see also Art expression;
Art-based

assessments;
Interventions, art
therapy; Strokes
Post-traumatic stress
disorder (PTSD) 168
Psychosis, AIDS related
167
Pyschoneuroimmunology,
cancer 118–121

Quadriplegia 245

Radiation treatment,
laryngectomy
patients 63, 66, 68,
84
Radiotherapy see
Radiation treatment
Receptive aphasia 27
Rehabilitation
drug treatment 137
laryngectomy patients
67–68, 81–82
stroke patients 26, 28,
29, 36–41
studio based approach
20, 58, 243–244,
246, 248–262
see also Post-stroke
rehabilitation
Relaxation response,
immune system 18, 87
Religion in imagery 233,
237, 240
Right brain hemisphere,
strokes and 28, 30–32

Salmonella septicemia
166
Sandtray therapy,
mastectomy patients
case studies 93–107

chemotherapy 91, 96,
97, 102
directed approach 92,
107
dream imagery 89–90,
91, 92–109
bridges 103, 106
colour white 99–100
jesters 102
knights 102
milk 100–101, 105
Peter Pan 103, 104,
106, 107
pits 100
reports 101, 105
nondirected approach
91–92
role play 92–93, 100
spatial and temporal
arrangements 89, 90
visual and verbal
explorations 92
SD (Standard Deviations)
64
Selective coding,
grounded theory
analysis 143
Serotonin 18
Standford University
Medical Center 15
State-Trait Anxiety
Inventory (STAI) 52,
56
Stress
cancer patients 87, 113,
114, 120–121
family structure, impact
of illness 211–223
Strokes
activities of daily living
(ADL) 34, 35
art expression, benefits
of 16–17

art-based assessments 33–35
causes 26
defined 25–26
depression 27–28, 29
hallucinations 28
ischemic 26
left brain hemisphere 28, 30
physical effects generally 27
pre-morbid aspects 26, 28, 32
psychosocial problems 27–30
right brain hemisphere 28, 30–32
transient ischemic attacks 26
see also Post-stroke rehabilitation
Subarchnoid hemorrhages 26
Subglottis 65
Successive Poetry technique 228, 239
Supraglottis 65

Tai chi 17
TB see Tuberculosis
Therapists, coping skills
AIDS patients 176–177
cultural competence 176–177
death and bereavement, knowledge of 176
family issues 221–223
laryngectomy patients 63–64
self-knowledge 177
tolerance for frustration 177
Thrombosis 26

TIA (transient ischemic attack) 26
Toxoplasmosis 166
Transformation and transcendance, art expression as 19–20
Transmigration 240
Triangulation research method 56
Tuberculosis
AIDS 166, 190
Bellevue Hospital Center example 192–193, 204
case studies 193–204
chemotherapy 189
drug usage 190, 193
drug-resistant strains 189, 190
history 189–190
incentive schemes 190–191
infection control guidelines in art therapy 193, 204–206
resurgence of 189–190
role of art therapy 13, 191–192
sanatoria 189
tubercle bacillus 189
Tumors see Cancer
Type-A personalities, illness and 113
Type-C personalities, illness and 89

University of Mississipi Medical Center 64
U.S. Post-stroke Rehabilitation Guideline Panel 25, 26

Visual analysis research method 56
Visual arts
defined 10
pain management, role in 47–48, 53
Voice box removal 63
see also Laryngectomy patients

Wasting syndrome, HIV 166
Wheaton Franciscan System of Milwaukee 235
World Health Organization 26, 190
Writing, therapeutic role 37, 47, 48, 54, 55, 151

Yoga 17

Zen meditation 50–51, 53, 54, 55

Author Index

Abel, E.K. 192
Abeloff, M. 115
Abrams, E. 14
Achterberg, J. 13, 17, 19, 54, 87, 89, 91, 116, 121, 122, 123
Ader, R. 119
Adler, G. 170
Albert-Puleo, N. 138
Alcabes, P. 190
Aldridge, D. 49, 126
Allen, P.B. 49, 51, 58, 138
Ammann, R. 90
Anand 19
Anderson, C. 212
Anisman, H. 117, 119
Apfel, R. 168
Appleton, V. 14, 118, 126, 127

Bach, P. 34, 35
Bahnson, C.B. 114
Bahnson, M.B. 114
Bailey, J. 145
Baird, S. 113
Baron, P. 63, 123
Barton, R.T. 67
Bates, J.H. 189
Bathon, R. 165
Bauer, J. 145
Bayer, R. 190
Beaudin, C. 163, 164
Beck, A.T. 52
Beck, J.S. 215
Beckett, A. 170

Becvar, D.S. 213
Becvar, R.J. 213
Beisser, A.R. 245, 260
Bell, J.M. 220
Bemis, C. 89
Berkow, R. 194
Bill, W. 157
Biller, H.F. 67
Birkett, D.P. 26, 28, 29, 35
Blais, F.X. 190
Blee, T. 14
Blessing, M.L. 68
Bloch, A.B. 190
Bloom, B.R. 190
Bloom, J. 113, 114
Bonica, J.J. 44
Boring, E.G. 45
Boshier, M. 67
Boutotte, J. 189
Bovbjerg, D. 113, 114, 116, 117, 119, 120, 131
Bradway, K. 90, 91, 92, 106
Breitbart, W. 66, 67
Bronheim, H. 67
Brooks, W. 119
Brudney, K. 190
Buchanan, R.J. 190
Burish, T.G. 87
Burke, K. 138
Burnett, R. 47
Byrne, A. 67, 68

Camic, P.M. 17, 18, 20, 44, 46, 47, 52, 57
Cappellari, L. 89
Carmi, S. 30
Carpenter, J.K. 87, 122
Carter, B. 213
Cartwright, R. 88, 92, 93
Casper, J. 66, 67, 69

Castro, K.G. 190
Catalan, J. 186
Cauthen, G.M. 190
Chambre, S. 163, 164
Chapman, L. 14
Chesky, K.S. 49
Chickerneo, N. 138, 145
Choi, P. 190, 191
Chopra, D. 11, 18, 137
Cline-Elsen, J. 87
Clinifoto 33, 34
Close, C. 251
Coates, T. 167, 176
Cohn, D.L. 191
Colwell, C.M. 49
Conlon, S. 204, 207
Conrad 139
Corbin, J. 139, 140, 143, 153
Costa, P.T. 90
Cotton, M. 123
Councill, T. 124, 127
Cox, T. 114
Craddock, S.G. 138
Creighton, J. 13, 17, 114, 122
Crown, H. 123
Cunningham, A. 113, 114, 115, 116, 119, 122, 131
Curran, J.W. 190
Curtis, R. 190

Dahlberg, C.C. 25, 29, 33
Dansbury, K.G. 190
David, R. 192
Davidon, A.L. 190
Davidson, P. 190, 191
De Cock, K. 164
de Mille, A. 35
Decker, T.W. 87
Derogatis, L. 115
Descartes, R. 45

Dessoille, R. 98
Devine, D. 138
Dhooper, S.S. 66, 68
Diamond, J. 10, 189
Dickinson, E. 231
Dissanayke, E. 51
Dobkin, J. 190
Doherty, W.J. 216
Dooley, S.W. 190
Dossey, B. 17, 19, 121
Downham, T. 248
Dreher, H. 89
Dreifuss-Kattan, E. 14, 63, 115, 116, 124, 129, 238, 240
Driver, C.R. 190
Dropkin, M.J. 67
Dubler, N.N. 190
Dubois, P. 122
Dubos, J. 189, 207
Dubos, R. 189, 207
Dunbar-Jacob, J. 190
Duncan, K. 48
Dunsmore, J. 47

Easterbrook, P. 186
Edwards, G. 163, 178, 186
Elia, N. 165, 176
Epston, D. 215
Erbaugh, J. 52
Erdmann, J. 63
Evans, E. 114
Eversole, T. 177
Eysenck, H.G. 89

Farrelly, M. 67, 68
Feen-Calligan, H. 138
Feldman, E. 167
Fenster, G. 206
Festenstein, F. 192
Fitzmaurice, M.A. 119
Fleming, P. 164

Flynn, P.M. 138
Flynn, R. 186
Flyod, J.W. 49
Fogelberg, P. 113, 114, 116
Fordyce, W.E. 45
Foresman, B.H. 190
Forsyth, B. 165
Foulke, W.E. 138, 147
Fox, B.H. 114, 115
Fox, J. 54
Franklin, B. 164, 174, 175, 178, 184
Frieden, T.R. 190
Friedland, G.H. 176, 190
Friedman, S.R. 190

Gaezer Grossman, F. 121, 123
Gardner, H. 25, 26, 28, 29, 32, 33
Gardner, W.H. 66
Garfield, P. 88
Gazzard, B. 186
Geiser, R. 172
Genest, M. 50
Genser, L. 38
Gergen, J.K. 48
Gergen, M.M. 48
Gerhard, A. 167, 176
Gfeller, K. 51
Gladding, S. 54
Glaser, B. 138
Golden, J.S. 66, 67
Goldstein, M. 190
Gomez, E. 190
Gordon, J.R. 56
Gordon, T.F. 48, 51
Gorman, C. 26
Gorsuch, R. 52
Grange, J.M. 192
Grassi, L. 89
Greenblatt, G.S. 41

Greer, S. 114
Gross, S.J. 221
Grossarth-Maticek, R. 114
Gruber, B.L. 87, 122

Hall, N.R.S. 87, 122
Hammer, E.F. 90
Hanson, D. 164
Hardin, K.N. 44, 45, 46, 47
Harms, E. 147
Hartel, D. 190
Hartman, E. 88
Heller, B.W. 89
Hepworth, J. 216
Herman, J. 183, 186
Hersh, S.P. 87, 122
Herth, K. 126
Herzon, F. 67
Hill, A. 13, 14, 191, 204
Hiltebrand, E.U. 18
Hines, P. 176
Holland, J. 66, 67, 113, 114, 116, 118, 119, 121

Hopewell, P.C. 190
Hrenko, K.D. 152
Hubbard, R.L. 138
Huston, J. 34, 35

Iker, H. 118
Ilusorio, S. 19, 123, 124
Iseman, M.D. 191
Izard, C.E. 116

Jacobi, J. 90
Jaffe, J. 25, 29, 33
Jansen, M.A. 89
Jekel, J. 176
Jenkins, R.A. 87
Jeppson, P.M. 63

Johnson, J.T. 66, 67, 69
Johnson, K. 122
Johnson, L. 156, 157, 182
Johnson, M. 177
Jose, B. 190
Joseph, S. 191
Judith, A. 233, 234
Jung, C.G. 13, 91\endash 92, 100, 106

Kahn, K. 248
Kaldjian, L. 176
Kalff, D. 90
Kalichman, S. 184
Kanzir, D.T. 114
Kapitan, L. 63
Karon, J. 164
Kaye, C. 14
Keefe, F.J. 47
Keegan, L. 48
Keller, T.W. 138, 147
Kellogg, J. 233
Kelly, G.D. 190
Kelly, J. 20
Kelly, L. 184
Kent, C. 51
Kerman, C. 48, 51
Kern-Pilch, K. 124, 127, 129
Kerns, R.D. 52
Kilburn, J.O. 190
King, B. 190
Kirkpatrick, J. 49
Kissen, D.M. 114
Klein, R.S. 190
Klinger, E. 88
Knight, S.J. 46
Kobasa, S. 116, 121
Kolkmeier, L. 17, 19, 121
Kommers, M.S. 66, 68
Koob, J. 184
Korn, E.R. 122

Kornfield, D.S. 66, 68
Koukkou, M. 88
Kramer, M. 88
Kreitler, H. 51, 54, 231
Kreitler, S. 51, 54, 231
Kreuger, K. 68
Kumar, L. 204
Kunnendorf, R.G. 122
Kunz, J.R. 87, 122
Kverno, K.S. 87, 122

Lamberg, L. 88, 92, 93
Landesman, S.H. 190, 193
Langarten, H. 14
Langer, M. 190, 191
Langford, R. 129
LaPesa, M.W. 89, 93
Latanzio, E. 89, 93
Lauria, M. 113, 114, 116
Lawlis, J.F. 13, 17, 54, 87, 89, 91, 122
Layton, E. 251
Lee, E. 176
Lehmann, D. 88
Lerner, A. 54
Lerner, B.H. 189
LeShan, L. 114
Lesswing, N.J. 66, 67, 69
Levenson, J.L. 89
Levy, B. 228, 239
Lewis, V.A. 190
Lichtenthal, S. 63, 124
Lippman, M.E. 119
Locke Sogn, D. 123
Long, J.K. 14, 47, 126
Lucente, F. 67, 68, 69
Lusebrink, V.B. 13, 14, 17, 18, 51, 52, 88, 89, 90, 115, 121, 123
Luskin, R. 52

McCoard, B. 90, 91, 92, 106
McConville, M.T. 221
McCrae, R.R. 90
McCray, E. 190
McDaniel, S. 212, 216
McGoldrick, M. 176, 213
McGraw, M.K. 19, 243, 248, 250
Mackay, M. 114
McLellan 48
McNiff, S. 10, 13, 238
McWhinnie, H.
Maddi, S. 116, 121
Magarey, C.J. 114
Magill-Levreault, L. 49
Maiorana, W. 14
Malchiodi, C.A. 11, 13, 14, 15, 17, 63, 178, 191, 214
Maldonado, M. 164
Malotte, C.K. 190, 191
Mango, C. 63, 123
Marantoc, C.D. 48, 51
Marlatt, G.A. 56
Marmor, M. 190, 204
Martin, V. 89, 93
Mashiah, T. 30
Mathews-Simonton, S. 114, 122
Mathieson, C.M. 68
Matisse, H. 251
Matney, G.B. 190
Medelson, M. 52
Meichenbaum, D. 50
Melisaratos, N. 115
Melzack, R.M. 45, 46
Menzies, R. 190
Meredith, K. 165
Michel, D.E. 49
Miller, L. 47
Miller, N. 137, 150
Miller, S. 165

Minar, V. 19, 63
Minuchin, S. 215
Mock, J. 52
Mondrian, P. 251
Monet, C. 251
Montonaro, D. 248
Moon, B. 51
Moore, R. 138
Moore, T. 166, 181
Morisky, D.E. 190, 191
Morris, T. 114
Moss, A. 190, 204
Muenz, L.R. 89
Murasko, D. 48, 51
Murphy, D. 165
Murray, C.J.L. 190

Nahum, A.M. 66, 67
Nardell, E. 189, 204
Nash, F. 1991
Nash, T.E. 44
Naumberg, M. 123
Neaigus, A. 190
Neal, P. 35
Nunn, M. 190

O'Driscoll, K. 67, 68
O'Neill, J. 176
Onotaro, L.M. 190
Osha, V. 138

Pablos-Mendez, A. 190
Paige, C. 177
Palmer, J. 14
Palmer, S. 14
Pennebaker, J.W. 14, 48
Picasso, P. 251
Piccirillo, E. 16, 176, 178
Pozehl, B. 48
Pozsik, C.J. 190, 192
Preto, N. 176
Puccetti, M. 116

Reimer, M. 67
Resler, J. 227
Ricci, M.L. 129
Richter-Loesl, S. 63
Rider, M.S. 49
Rigler, S. 190, 191
Riley, S. 214
Riley, V. 16, 119
Robbins, A. 230
Rocher, I. 190
Rogers, N. 53
Rollier, A. 189, 191, 207
Rosner, D. 14, 19
Rosner David, I. 14, 123,
 124, 192, 206
Rosner, I. 14, 192, 194
Rossman, M. 114, 121,
 122, 129
Roszman, T. 119
Rotherman-Borus, M. 165
Rounds-Byrant, J.L. 138
Rubin, J.A. 123
Rudloff, L. 63, 123
Rudy, T. 52
Russek, L.G. 10
Russell, J. 124, 126, 127,
 129
Ryce-Menuhin, J. 90

Sabini, M. 123
Sacks, O. 19
Saetersdahl, B. 211
Sageman, S. 14, 192, 193,
 206
Sampson, C. 126
Sandburg, L. 35
Sattilaro, A. 120
Sbarbaro, J.A. 191
Scartelli, J.P. 48
Schaffner, B. 170, 171,
 177
Schmale, A.H. 118
Schmidt, P. 114

Schmitz, R. 48
Schoenbaum, E.E. 190
Schorr, J. 49
Schultz, W. 10
Schwartz, G.E. 10
Scott, J.P. 68
Sedberry, D. 47
Segaller, S. 145
Segraves, K.B. 47
Seligman, M. 117
Selwyn, P.A. 190
Shapiro, P.A. 66, 68
Sheikh, A.A. 122
Sherr, L. 168
Shlain, L. 10
Siegel, A.B. 88, 89, 100,
 105
Siegel, B. 15, 17, 21
Sikkema, K. 184
Silver, R. 35
Simonton, C. 13, 17
Simonton, O.C. 114, 122
Simonton, S. 13, 17
Sklar, L. 117, 119
Slocum, P.C. 190
Small, P.M. 190
Smith, H. 240
Smith, R.C. 88
Snider, D.E. 190
Snyder, S.L. 87
Sokhey, G. 204
Solomon, G. 118
Sourkes, B. 123, 129
Spackman, D.H. 119
Speigel, D. 15, 113, 114
Spielberger, C. 52
Stake, R.E. 56
Stam, H.J. 68
Starace, F. 168
Stead, W.W. 189
Stearns, N. 113, 114, 116
Steele, C. 137
Stein, T. 165

Sterling, T. 190
Sternback, R. 45
Steward, J. 51
Strain, J.J. 67, 68, 69
Strand, D. 91, 92
Strauss, A. 138, 139, 140, 143, 153
Streeter, G. 248
Strozier, A.M. 212, 222
Sugland, B. 190, 191
Sullivan, M.D. 66, 68
Sutherland, J. 113, 119
Suzki, C. 215
Suzuki, S. 50

Talbott, J.H. 194
Tasker, M. 169
Tate, F.B. 63, 123
Telingator, C. 168
Temoshok, L. 89, 114, 115
Tenner, E. 11
Tennessen, J. 91, 92
Thackwray-Emmerson, D. 113, 114, 122
Thornton, S. 186
Todarello, O. 89, 93
Todd, P.B. 114
Tokuda, Y. 128
Tracy, H.W. 34, 35
Troop, M. 186
Tsao, C.C. 48, 51
Turk, D.C. 50, 52
Turk, D.E. 44

Ulman, E. 138
Umana, R.F. 221

Valdiserri, R.O. 190
Van de Castle, R.L. 88, 89
Van Leit, B. 138
Vance, L. 63
Vasudeva, P. 204

Vermund, S.H. 190
Vetter, H. 114
Vilstrup, K. 35
Virshup, E. 227, 236, 241
Visintainer, M. 117
Vissandjee, B. 190
Volpicelli, J. 117
Vos Wezeman, P. 183

Wald, J. 16
Waletzky, L.R. 87, 122
Walker, A.T. 190
Walker, B.G. 107
Wall, P.D. 45, 46
Waller, D. 191
Walsh, F. 212
Walsh, M. 67, 68
Ward, C.H. 52
Ward, J. 164
Watkins, A. 14
Watson, W.L. 220
Weber, M. 67
Weinrib, E.L. 90
Weis, S.E. 190
Weiser, J. 206
Weiss, S.M. 87, 122
Weitz, R. 114
Wesson, K. 68
Wetmore, S.J. 68
Wheelwright, J. 123
White, E.B. 10
White, M. 215
White, S. 206
Whitfield, C. 156–157
Willis, R. 152
Willmuth, M. 14
Wilson, J. 189
Wilson, L.E. 48, 54
Winiarski, M.G. 177, 206
Wolf, J. 14
Wolfe, H. 190, 204
Wright, L.M. 220
Wyatt, D.A. 67, 68, 69

Yalom, I.D. 238, 239, 240
Yin, R.K. 56
Yonkers, A.J. 66, 68

Zadra, A.L. 88
Zegans, L. 167, 176
Zimmerman, L. 48
Zola, M. 116

Milton Keynes UK
Ingram Content Group UK Ltd.
UKHW032020121024
449584UK00006B/108

9 781853 026799